THE POLITICS OF CULTURE

About the Center for Arts and Culture

The Center for Arts and Culture, based in Washington, D.C., is an independent research organization providing analysis and promoting dialogue on issues affecting cultural life. It works with decision makers, scholars, and practitioners from across the arts and the humanities to produce research, gather and evaluate data, and supply information to policymakers and the general public.

The Politics of
CULTURE

Policy Perspectives
for Individuals, Institutions,
and Communities

Edited by
Gigi Bradford, Michael Gary
and Glenn Wallach

The New Press
New York

The Center for Arts and Culture
Washington, D.C.

The publisher is grateful to reproduce the following copyrighted material:

Victoria D. Alexander's "Pictures at an Exhibition: Conflicting Pressures in Museums and the Display of Art" © 1996 by The University of Chicago. All rights reserved.

The American Assembly's "The Arts and the Public Purpose" © 1997.

Alberta Arthurs's "Making Change: Museums and Public Life" prepared for "The Arts and Humanities in Public Life," a conference at the University of Chicago, January, 1999. Reprinted by permission of the author.

Carol Becker's "The Artist As Public Intellectual" from *Education and Cultural Studies*, edited by Henry A. Giroux (New York: Routledge).

William J. Bennett's "The Humanities, the Universities, and Public Policy" reprinted with permission from the American Council on Education. This essay originally appeared in the Summer 1981 issue of *Educational Record*.

Robert Brustein's "Coercive Philanthropy" appeared in *Cultural Calesthenics* (Chicago: Ivan R. Dee, 1998) and is reprinted by permission of the author and the publisher. An earlier version appeared as "Cultural Politics and Coercive Philanthropology" in *Partisan Review*, vol. LXII, no. 2, 1995.

Mary Schmidt Campbell's "A New Mission for the NEA" was originally published in *The Drama Review*, vol. 42, no. 4 (Winter 1998), 5–9. Reprinted by permission of the author.

Néstor García Canclini's "Cultural Policy Options in the Context of Globalization" was originally a chapter in *World Culture Report 1998* (pp. 157–182), © UNESCO 1998. Reprinted with permission of the publisher.

William Cleveland's "Judy Baca: SPARC — The Social and Public Arts Resource Center" originally appeared in *Art in Other Places: Artists at Work in America's Community and Social Institutions* (Praeger Publishers, an imprint of Greenwood Publishing Group, Inc., Westport, Conn.), pp. 237–44. Copyright © 1992 by William Cleveland. Reproduced with permission of Greenwood Publishing Group, Inc. All rights reserved.

Paul DiMaggio's "Social Structure, Institutions, and Cultural Goods: The Case of the United States." Reprinted by permission of Paul DiMaggio. This essay appeared originally in *Social Theory for a Changing Society*, edited by Pierre Bourdieu and James S. Coleman (Boulder: Westview Press, 1991).

Virginia R. Dominguez's "Invoking Culture: The Messy Side of 'Cultural Politics.'" *The South Atlantic Quarterly* 91:1, Winter 92. Copyright © 1992 by Duke University Press.

Michael Kammen's "Culture and the State in America" was originally published in the *Journal of American History* 83 (December 1996): 791–834. Reprinted by permission of the Organization of American Historians.

John Kreidler's "Leverage Lost: Evolution in the Nonprofit Arts Ecosystem" is reprinted with the permission of John Kreidler. An earlier version of this paper appeared in the *Journal of Arts Management, Law and Society*, Summer 1996.

Richard Kurin's "The New Study and Curation of Culture" originally appeared as a chapter in *Reflections of Culture Broker: A View from the Smithsonian* by Richard Kurin; copyright © 1997 by the Smithsonian Institution. Used by permission of the publisher.

Justin Lewis's "Designing a Cultural Policy" from *The Journal of Arts Management, Law and Society*, 24, 41–56 Spring 1994. Reprinted with permission of Helen Dwight Reid Education Foundation. Published by Heldref Publications, 1319 Eighteen Street, N.W., Washington, D.C. 20036-1802. Copyright © 1994.

Ellen McCulloch Lovell's "Commencement Speech, New York Academy of Art, May 21, 1997" reprinted with permission of the author. "Spring Azures" from *New and Selected Poems* by Mary Oliver. Copyright © 1992 by Mary Oliver. Reprinted by permission of Beacon Press, Boston.

President's Committee on the Arts and Humanities, "Creative America: A Report to the President" from *Creative America*.

Bruce A. Seaman's "Arts Impact Studies: A Fashionable Excess" is an edited version of an essay that appeared originally in *Economic Impact of the Arts*, 44–75. Copyright by the National Conference of State Legislators, 1987. Reprinted by permission of the author and the publisher.

Susan L. Siegfried's "The Policy Landscape" is reprinted from *The Art Bulletin* (vol. 79, June 1997): 209–13, with permission from the College Art Association.

Mark J. Stern and Susan C. Seifert's "Re-presenting the City: Arts, Culture, and Diversity in Philadelphia" reprinted with permission of the authors. An earlier version appeared as SIAP Working Paper 3.

Lesley Valdes's "The Age of Audience" is reprinted by permission of *Symphony* magazine © 1996 American Symphony Orchestra League.

Raymond Williams's "Culture Is Ordinary." Copyright © 1959 by *Monthly Review Press*. Reprinted by permission of the Monthly Review Foundation.

Margaret Jane Wyszomirski's "Policy Communities and Policy Influence: Securing a Government Role in Cultural Policy for the Twenty-First Century" from *The Journal of Arts Management, Law and Society*, 25, 192–205, Fall 1995. Reprinted with permission of Helen Dwight Reid Educational Foundation. Published by Heldref Publications, 1319 Eighteen Street, N.E., Washington, D.C. 20036-1802. Copyright © 1995.

Published in the United States by The New Press, New York
Distributed by W. W. Norton & Company, Inc., New York

The New Press was established in 1990 as a not-for-profit alternative to the large, commercial publishing houses currently dominating the book publishing industry. The New Press operates in the public interest rather than for private gain, and is committed to publishing, in innovative ways, works of educational, cultural, and community value that are often deemed insufficiently profitable.

www.thenewpress.com

Printed in Canada

9 8 7 6 5 4 3 2 1

Contents

Part II: Supporting Culture

Frames for Support

Institutions Under Pressure

Artists, Humanists, and Public Life

Part III: Culture and Policy from the Local to the Global

Impacts of Culture on Communities

New Policy Frontiers

Preface

James Allen Smith

If culture is "ordinary," as the British literary theorist Raymond Williams reminds us in the first essay of this volume, the term "cultural policy" is not at all ordinary or familiar to most Americans. In fact, for many in the United States "cultural policy" seems to elicit images of government intervention, stifling aesthetic controls, or centralized bureaucratic decisionmaking—at worst Soviet, at best French. Suspicions abound that cultural policy is somehow alien to these shores. And, indeed, it has been, if cultural policy is conceived as a concerted, large scale national plan for supporting arts and cultural institutions. Instead, in the United States we have plural policies that affect and influence our cultural lives. Those policies are decided at every level of government and they are profoundly influenced by decisions made in the private sector whether by philanthropic foundations, nonprofit cultural organizations, or commercial enterprises.

As the essays of this book demonstrate, cultural policy should be considered an expansive term that embraces many realms of activity. Cultural policy obviously concerns governmental and philanthropic financing for arts and culture, but it also encompasses a range of issues such as freedom of expression, international cultural and artistic exchanges, intellectual property questions, and the effect of corporate consolidation on the nation's artistic life. Our cultural community is also shaped indirectly but significantly by tax policy decisions such as the deduction for charitable contributions, municipal development strategies, educational curriculum requirements, trade initiatives, technology policies, and actions undertaken by other policy fields. On a still broader level, cultural policy addresses basic democratic concerns: matters of identity, diversity, and social harmony; innovation and creativity; and civic engagement and discourse. As political theorist Benjamin Barber reminds us, "Imagination is the link to civil society that art and democracy share. When imagination flourishes in the arts, democracy benefits. When it flourishes in a democracy, the arts and the civil society the arts help to ground also benefit. Imagination is the key to diversity, to civic compassion and to commonality"

[*A Place for Us: How to Make Civil Society and Democracy Strong*, (Hill and Wang, 1998), 111].

Works of the creative imagination have often served public purposes. Early in our history the new U.S. Capitol was decorated with art work resonant of national themes, and federal buildings were constructed in styles evocative of republican traditions; artists and writers were given gainful employment during the Great Depression and their post office murals, explorations of folk traditions, conservation work, and urban guidebooks still remain a meaningful legacy of that era. Municipal governments have routinely celebrated and beautified their cities with parks, monuments, and museums, usually relying on a mix of governmental and private resources; and many cities and regions have come to recognize both the intrinsic value of their cultural heritage and its utility as a tool of economic growth and development.

Cultural policymaking in the United States has often been creative in linking public and private sector initiatives, but it has also been fitful and sometimes fought out on bitterly contested terrain, especially at the national level. Even after the creation of the National Endowment for the Arts and the National Endowment for the Humanities in 1965, policymaking at the federal level remained circumscribed. Budgets were small and have been diminishing over much of the last two decades. From the outset federal resources were conceived primarily as "leverage" for winning support from the private sector or for fostering state and local activity; and the focus was almost exclusively on assisting nonprofit organizations. Indeed, cultural policymaking has been predicated on a characteristically American blend of federalism joined with private philanthropic and commercial initiative.

In the late 1990s, some 3,800 local arts agencies are devoting nearly $700 million to cultural projects; state arts budgets aggregate in excess of $300 million; and private giving for arts, culture, and the humanities from individuals, corporations, and foundations is estimated to exceed $10.5 billion. Arts and cultural institutions, meanwhile, represent an important sector of the economy. The American Assembly report excerpted in this volume offers a "conservative estimate" of 1995 spending on the arts at "roughly $180 billion, or 2.5 percent of the Gross Domestic Product." The numbers roughly double, if all copyright industries—such as music, film, video, publishing, and computer software—are included. The economic sums are consequential; the hybrid policy approaches are complicated.

Rarely, however, have Americans devoted systematic efforts to thinking about the policies that might benefit artists, scholars, cultural institutions, and the public. Since early in the twentieth century we have built academic research centers, public policy think tanks, and governmental research units to explore important policy questions in fields ranging from the environment, social welfare, and health issues to international trade and security policy.

Decade by decade, expertise has grown; data, theory, and analysis have improved policymaking and public understanding in many fields. Yet Americans have been resistant to thinking about culture as a subject for policy research and discussion. Until recently we have done very little to foster research and serious debate about cultural issues.

Why should this be so? It is in part the sheer complexity of defining the contours of a policy terrain that can span, among many other subjects, tax policy, intellectual property, trade negotiations, and First Amendment issues. It is in part the history of fitful and often contested governmental involvement in cultural matters and, at the same time, the predominant role of the private sector, both commercial corporations and not-for-profit organizations in the nation's creative life. It is also, regrettably, the seemingly peripheral nature of cultural concerns when compared to other policy subjects such as defense or the environment.

This volume brings the concept of cultural policy into sharper focus. Decision makers in government, the nonprofit sector, and commercial entities all face the challenges of a complex cultural sector in the century ahead. These articles provide new perspectives and tools for understanding an expanded relationship between culture and policy. They draw on the work of social scientists and historians, policymakers and advocates, administrators and artists. The essays explore the ways in which new technologies, demographic change, and global forces are altering the policy landscape.

It is our hope that this volume will serve as a call to others who want to join us in pushing cultural issues from the wings to center stage in our public discourse. We believe that discussion of cultural matters—those issues concerned with definitions of self and identity; the ties that can bind or separate neighborhoods, communities, and nations; our historical memories and future hopes; our creative impulses and aesthetic pleasures—are central to the well-being of this democracy.

A Note from the Editors

This is the first in a series of book-length publications by the Center for Arts and Culture, an independent Washington-based organization that seeks to bring cultural issues to the core of our democratic discourse.

The Center was established when leaders from the Nathan Cummings Foundation, Howard Gilman Foundation, Thomas S. Kenan Institute for the Arts, Rockefeller Foundation, and Andy Warhol Foundation for the visual arts, among others, began to discuss the need for an independent organization devoted to research, convening, policy development, and communication. They sought to create an institution that could raise the level of thought and discourse surrounding cultural issues. The partisan and ideologically-charged debates about federal cultural funding, support for individual artists, and the many other issues that defined the "culture" wars of the 1980s and 1990s, had narrowed the national conversation about the place of artistic and cultural concerns in a democratic society. Additionally, there seemed to be no venues for thought and conversation about the global cultural interactions of nations, groups, and individuals.

Serious consideration of cultural concerns must be rooted in a community capable of engaging in sustained research as well as generating, articulating, and testing new ideas. The Center serves a unique role in this process. As a non-partisan institution it can provide a forum for careful deliberation on issues from a broad spectrum of opinion in a neutral space. Because it is not linked to one academic institution or field, it can gather scholars from a wider disciplinary spectrum and promote collective projects.

One of the Center's first tasks, therefore, has been to act as a catalyst for the creation of a new kind of policy community. It has begun to construct an intellectual infrastructure for research by creating a network of more than twenty-five university sites where work is either underway or in the planning stages. It has created an on-line bibliography of books and articles, a roster of experts working on a range of relevant topics, and links to other research, service, and policymaking bodies. The Center's efforts draw on lessons

learned in other fields where policy communities have fostered intellectual innovation, framing and evaluating diverse policy approaches, entertaining new ideas and treating old ideas critically. To succeed, such communities should be engaged with policymakers but also able to disseminate ideas to a wider and engaged public.

Subsequent publications and volumes from the Center will address specific topics and provide policy analysis and recommendations in the cultural field. Through public programs at its Washington headquarters and in gatherings across the nation, the Center has begun the process of integrating culture into discussions of policy at the national and local level. In the future it will continue its efforts to promote research and provide specific tools to invigorate the way Americans think and talk about culture.

This volume was made possible in part by a grant from the Nathan Cummings Foundation. The Center has been blessed by the stalwart operating support of the Rockefeller Foundation, the Howard Gilman Foundation, and the J. Paul Getty Trust since its inception. It has also benefitted from important operating and project support from the Bohen Foundation, the Nathan Cummings Foundation, the Ford Foundation, the Horace W. Goldsmith Foundation, the Joyce Foundation, the Thomas S. Kenan Institute for the Arts, the Andrew W. Mellon Foundation, the William Penn Foundation, and the Pew Charitable Trusts.

The staff of the Center for Arts and Culture has labored tirelessly to create this volume. Glenn Wallach, the Center's deputy director, has assembled much of the material and written an introductory essay that places the concept of cultural policy in historical context. He was assisted in the initial stages by Mark Allison, a graduate intern at the Center now completing his studies at the University of Chicago. Michael Gary, senior program associate in the arts and culture program at the Howard Gilman Foundation, has contributed an introductory essay to one of the book's sections and served as co-editor. And Gigi Bradford, the Center's executive director, conceived the volume, wrote introductory essays, and has, above all, shaped and guided the Center through its first years of work.

The editors are grateful to the members of the Center's Research Task Force for their significant role in the development of the volume: Alberta Arthurs, Milton Cummings, William Glade, Stanley Katz, Ruth Ann Stewart, and Margaret Wyszomirski. Staff and interns at the Center have made crucial contributions throughout the process of this book's production. Thanks to: Joy Austin, Malissa Bennett, Allison Brugg, Elanna Haywood, Sharon Kangas, Valerie Resh, Karen Ragsdale, and Thea Petchler.

The Politics of Culture

Introduction

Glenn Wallach

Culture is a word that seems to influence everything at the close of the twen-
tieth century. From op-ed page meditations on violence and the media to uni-
versity seminars on socially-constructed reality, the word contains varied
meanings, even if its most sophisticated scholars offer no single definition of
its significance. Culture carries connotations of everything from the way in-
dividuals make sense of their everyday lives to the most elite, or most com-
mercial, expressions of creative life. It is a description of seemingly natural
processes ("the culture of violence") and it is the prized possession of social
groups ("protecting a vanishing cultural heritage"). For much of the 1990s,
"culture" was the centerpiece word in a series of conflicts in universities and
other arts and cultural institutions. While many of the headlines centered on
a few government grants, what came to be known as "the culture wars"
stretched across political and intellectual life.

Policy, by contrast, seems confined to certain activities. It can be used to
mean government decisions or a framework of rules. It usually inspires ex-
tremely broad definitions like this one: "In general, policy making involves
decisions intended to have wide rather than narrow influences on people and
operations, and which are intended to have more than a short-range impact.
In somewhat less general terms . . . policy making gives direction to the
development and operations of programs, influencing or determining the al-
location of resources vis-à-vis competing demands."[1] Social scientists analyze
how politicians and interest groups swim through the "policy stream," and
leaders of organizations large and small seek to establish consistent and co-
herent policies for their fields.

Rapid changes in the cultural industries and support for the arts and hu-
manities, as well as simmering tensions on the battlefields of the culture wars,
have brought culture and policy together as never before. There is a critical
need for careful assessment and cogent research, but many of the most tangled
problems facing policy maker, practitioner, and citizen alike are deep in the
fabric of existing assumptions and practices. This book offers new ways to

understand familiar topics and reveals how central issues facing policy analysts—decisions that affect citizens, questions of resource allocation, and more—are questions of culture today. These essays identify the outlines of an emerging field. The term is becoming more familiar, but the people who use it often have very different conceptions of what they mean by "cultural policy."

In the United States, several styles of cultural policy have developed from roots in particular traditions and institutions:

—A longstanding American tradition of policies supporting arts institutions that stems from a philanthropic heritage and an intermittent policy of federal patronage;
—An international debate centered in UNESCO since the 1960s;
—A critical academic discourse that has emerged since the 1950s in the work of European social theorists who founded the field of "cultural studies."

Each of these traditions embody and quite literally institutionalize a particular definition of "culture," and particular policy choices flow from each definition. In the American tradition, this definition and those policies can be traced to thinkers in the first half of the nineteenth century who believed a unique American literature and American art were essential to American national identity. The federal, state, and local governments that have supported the arts in our history based their actions in ideas about ART, in capital letters. The role of government in relation to a conception of "culture," by contrast, is primarily a post-World War II phenomenon.

ARTS, "CULTURE," & THE FEDERAL GOVERNMENT

In the 1950s, the notion of a distinct American culture influenced new academic disciplines that searched for enduring myths and symbols in our history, literature, and tradition. The phrase "cultural policy" was also linked to an idea of cultural nationalism, but not in the domestic arena; instead it was a matter of *foreign* policy. From the creation of a State Department Division of Cultural Relations in 1938 and the post-war founding of the United States Information Agency and the Fulbright program, policies related to culture were clearly identified as something that the United States brought to the rest of the world. This approach moved into the fight against international communism. The Congress of Cultural Freedom, for example, engaged in what one historian termed "The Cultural Cold War."[2]

With few exceptions, the word "culture" was a synonym for the performing and visual arts. They were imagined first as precious objects threatened by

a mushrooming mass culture. Senator Jacob Javits summed up this view in 1957 when he called for the federal government "to do something about conserving and developing the performing-arts resources, which today are suffering very seriously and are diminishing because they are concentrated in such few areas, essentially Broadway, Hollywood, radio, and TV."[3] Popular intellectual opinion held that the great abundance of post-war America, which offered expanded leisure time and goods and entertainment opportunities to be consumed in it, also created a need for Americans to find meaning in their lives. Time and again observers in the late 1950s and early 1960s debated the significance of this set of social changes.[4]

A 1960 article by Arthur Schlesinger, Jr., "Notes on a National Cultural Policy," contained the phrase itself. "As the problems of our affluent society become more qualitative and less quantitative, we must expect culture to emerge as a national concern and to respond to a national purpose," he said.[5] Schlesinger, of course, became an adviser to the new President elected in 1960.

A shift in policy making during the Kennedy era responded to a perception that culture was a scarce resource needing protection, just as natural resources had to be conserved, that the arts were linked to a search for meaning amid consumer abundance, and that "culture" was a bulwark against mass society. This was a key context for the belief in an activist vision of government support for the arts and the humanities.[6] Discussions of national policy accelerated with the passage of Congressional legislation in 1965 that created the National Endowments for the Arts and Humanities. But these conversations were primarily about an *arts* policy that used "culture" as a synonym for the arts, particularly the fine and performing arts.[7]

UNESCO AND CULTURAL POLICY

It was during the mid-1960s, at the same time that the National Endowments were first established, that the international community, based in the United Nations Educational, Scientific, and Cultural Organization, began active discussions about something they called "cultural policy." UNESCO understood preserving scarce resources in a very different way than Americans did. We can see this in a 1954 article in UNESCO's journal by the anthropologist Claude Lévi-Strauss that explained why it was more appropriate to call indigenous populations "primitive" instead of "savage." Cultural preservation was closely linked to the culture of indigenous populations throughout the globe and of historically and culturally significant sites.[8]

UNESCO also associated culture with creative arts and state-directed policies toward them, but this was only part of a larger package. In 1970, at an international meeting in Venice, conferees agreed that "the methods of cultural policy are no different from those of general development policy."[9] Participants decided not to define culture, but had ready agreement on what

threatened it: technology, unregulated tourism, and "the penetration of foreign commercialized culture."[10]

The United States' response to a global notion of cultural policy was based in a brand of American exceptionalism. The opening statement at an early planning meeting asserted: "the United States has no official cultural position, either public or private." This stood in marked contrast to Arthur Schlesinger, Jr.'s suggestion at the dawn of the 1960s that "if we are . . . worried about the impact of mass culture, there are strong arguments for an affirmative government policy to help raise standards."[11]

Evidently, that view had not prevailed. One principal reason may be that the first tentative steps toward federal aid to the arts and humanities began just as the cultural consensus that had created those agencies began to break down in the social turbulence of the 1960s. In the face of that upheaval, the very pluralism of America's culture seemed to be the only firm pillar for its policy. This resulted in a much-quoted statement that "lack of action does become then, a kind of cultural policy." An American official argued in 1969 that "the United States cultural policy at this time is the deliberate encouragement of multiple cultural forces."[12] This same line of thought endured into the mid-1980s. Since then, changes in the rest of the world and at home require different approaches.

The United States pursued its policy of no policy and the international community pressed on.[13] A World Conference on Cultural Policies met in Mexico City in 1982. While the first meeting on the subject in 1967 had "decided unanimously against embarking on an attempt to define culture," the Mexico conference plunged in. They saw culture:

> not in the restricted sense of *belles-lettres*, the fine arts, literature, and philosophy, but as the distinctive and specific features and ways of thinking and organizing the lives of every individual and every community.[14]

This definition of culture emphasized "the affirmation of cultural identity." Concerns expressed in 1970 took on a sharper tone as delegates "expressed their alarm at the threats to other cultures represented by the present-day trend towards standardization. . . . They censured and denounced the way the world had been taken over by the mass media and cultural industries in the hands of transnational corporations." It was, in their phrase, "cultural imperialism."[15]

UNESCO announced a World Decade for Cultural Development in 1989. By the time the decade closed it had further developed its notions of cultural policy. The background materials for a 1998 conference on cultural policies for development proclaimed: "the concerns of the state must encompass cultural well-being as part and parcel of social and economic well-being." It urged that cultural policies should "encompass new challenges in the

arts . . . yet . . . embrace human development and the promotion of plu-ralism, as well as the fostering of social cohesion and creativity."[16] It was also in the early 1980s that fears about constraints on freedom of expression by UNESCO's proposed World Information Order contributed to the United States's withdrawal from membership in the organization. Just as UNESCO was expanding its definition of culture, the United States left that conversation to pursue its own path.

Few of the conclusions about cultural identity being at the base of human personality raised by UNESCO through the 1980s and 1990s seem that excep-tional. They are, indeed, basic principles in contemporary academic thought that by the early 1990s were gaining notoriety as "cultural studies."

CULTURAL POLICY/CULTURAL STUDIES

The link between cultural studies and cultural policy has been made explicit by several English and Australian scholars influenced by the work of Ray-mond Williams, Richard Hoggart, and the Birmingham Centre for Contem-porary Cultural Studies. As one of them, Tony Bennett, noted, "virtually all forms of culture are now capable of being fashioned into vehicles for govern-ment programmes of one sort or another. . . . It is indeed precisely these kinds of changes which form part of the material and institutional conditions of existence which have supported the development of cultural studies." That field offers a critical reading of the growth of the idea of culture itself and its basis in hegemonic expressions by a dominant class:

> It was only the development of aesthetic conceptions of culture which allowed the establishment of those discursive coordinates in which elite cultural prac-tices could be detached from their earlier functions . . . and then come to be connected to civilizing programmes in which they could function as instru-ments of cultural "improvement" directed toward the population at large.[17]

Some academics believe that the critical position of resistance to the domi-nant paradigm can be harnessed in "the training of . . . intellectual workers less committed to cultural critique as an instrument for changing conscious-ness than to modifying the functioning of culture by means of technical ad-justment to its governmental deployment."[18] Indeed, Bennett enacted these ideas for a number of years as director of the Key Centre for Cultural Policy at Griffiths University in Australia. They continue to flourish in universities around the world.[19]

If the modern conception of culture is implicated in the creation of distinc-tions between high and low culture and in the notion of culture as something to elevate the masses, this has implications for the traditional American atti-tude toward cultural policy. In the main, though, discussions of culture and

policy in the United States through the 1980s revolved around "the arts," its funding, and its place in education.

AMERICAN CULTURAL POLICY TODAY

Several institutions worked simultaneously, and with some overlap, in the development of the contemporary idea of cultural policy. One marker of the emergence of this phrase was the Library of Congress's decision in the mid 1980s to replace a subject heading which had been in use since 1906, "State encouragement of science, literature, and art," with the heading "cultural policy." It was used for "official government policy toward educational, artistic, intellectual, and other cultural activities and organizations in general."[20]

American academics, particularly in the policy sciences, had been developing a version of cultural policy that focuses on the connections between private and public policy and an expanded definition of the arts and humanities. Influential studies on the economics of the performing arts in the mid-1960s supported by the Rockefeller Brothers Fund and the Twentieth Century Fund formed an early piece of that intellectual framework.[21] These initial studies were based in a utilitarian strain of thinking that began to define culture in ways that gave policy professionals a means to value culture on similar terms as government interventions into other fields. The work of UNESCO was sometimes echoed in America by arts education and administration professionals who linked an idea of cultural policy to community development.[22]

The annual Conference on Social Theory, Politics, and the Arts, the *Journal of Arts Management, Law and Society*, the Association for Cultural Economics, and national arts and humanities advocacy organizations have all promoted the concept of "cultural policy." Another important influence has been the American Assembly at Columbia University.

Founded in 1950 by Dwight Eisenhower, the American Assembly brings together experts to discuss an important policy issue and produce recommendations about it during a long weekend conference. Organizers noted in 1974 that it had taken forty-five Assembly meetings before it ever discussed the arts. Then between 1974 and 1997 it organized five arts and policy-related programs. The meetings of the 1970s and the 1980s adhered closely to the policy of no policy. At the same time, though, they began to make the case that the arts represent a sector of society that required organized policies. They also applied a notion from other policy arenas, as Stanley N. Katz put it in 1984, "many of the 'public' policies are created in the so-called 'private' sector. . . . insofar as we do have a general policy or attitude toward culture, it is in fact the result of the push and pull of a multitude of conflicting public and private policies, most of which were never specifically intended to impact upon the arts."[23]

In the 1990s, as the international Cold War faded, a hot war raged in the academy and arts and cultural institutions. The National Endowment for the Arts, art installations in museums and in public spaces, multicultural college curricula, and the influence of commercial entertainment on values all became flashpoints for bitter controversy.[24] While the heat surrounding these individual issues has faded, the underlying conflict has hardened into what is, in effect, a new cultural cold war *within* American political and intellectual life. This battle became entrenched at the same time that a notion of a diverse cultural sector began to emerge along with scholarship and support from foundations to examine its implications. Also more evident was a group of professionals in arts and culture who could be referred to disdainfully, as one author in 1991 did: "arts administrators, professors of arts administration, directors of foundations, and arts patrons—in other words, the prime architects and beneficiaries of today's cultural policy."[25]

We can see the way the American tradition has changed by contrasting a book entitled *Creative America* published in 1962 to promote the National Cultural Center (now known as the Kennedy Center) and the report also titled *Creative America*, published in 1997 by the President's Committee on the Arts and the Humanities and excerpted in this volume.

The vision of America's creative life in 1962 echoed the consensus of the time, that affluence and mass culture had raised the importance of the arts in bringing meaning to daily life. While the great success of commercial culture was something to be proud of, it was not enough. In words and photographs, the first *Creative America* celebrated individual artists—mostly in the traditional fine arts, with a sprinkling of jazz musicians and Broadway and Hollywood actors. President John Kennedy made the case that an art lover was not "sissy or effete" but someone willing to subject "himself to the sometimes disturbing experience of art." Such an individual "sustains the artist—and seeks only the reward that his life will, in consequence, be the more fully lived."

The key policy problem, critic Joseph Wood Krutch suggested, was "how to promote a rapprochement, to persuade the intellectual and the artist to join rather than to alienate themselves still further from the society which so desperately needs them." The solution: the government should support the artist's individuality so the artist would be free to comment on society and aspire to a greater truth.[26]

The cool, critical loner of Kennedy's America—embodied in the image of the artist—had faded by 1997: "Creative individuals can contribute to public understanding by interpreting their works and by playing their part in community life. A positive cultural environment will be one where the diversity of American culture will be perceived as a source of strength."[27]

The belief that commercial culture was of secondary importance to the work of individual fine artists had changed in thirty-five years to a vision of a complex cultural sector that "comprises amateur associations, non-profit

cultural groups—including libraries, institutions of higher education, historic preservation, and public broadcasting organizations—and portions of commercial creative industries."[28] This notion provided fertile ground for public and private policy towards a complex and changing cultural sector.

The 1998 UNESCO conference, "The Power of Culture," identified policy objectives that operate in a similar world, although most Americans do not think about the cultural sector in relation to these goals—linking cultural policy with development strategies, protecting cultural heritage, or promoting "cultural and linguistic diversity in an information society."[29] International cultural policy is no longer the sole domain of UNESCO. The World Bank is only one of several multilateral organizations beginning to discuss development paradigms in cultural terms.

Globalization and technology have been part of the international policy vocabulary for decades, although they may not have been described in those terms. They are entering into the definition of U.S. cultural policy whether we are ready for them or not. Transformations in global commerce have increased worldwide attention to regulation. The 105th Congress passed copyright extension legislation in part to conform to the international intellectual property regime. As the final essays in this volume demonstrate, however, the impact of global communication and distribution networks on national and regional culture and the consequences of the concentration of production and distribution of films, television, and books in multinational corporations raise a series of complex and contested issues.

Despite this expansion of the field, "culture" still usually enters contemporary United States policy discussions in one of two widely divergent categories: either as a catch-all to cover statistics on everything from teen birthrates to acts of violence on television programs, as in *The Index of Leading Cultural Indicators*[30] compiled recently by former Education Secretary and NEH Chair William Bennett, or as a synonym for the funding that the federal agencies on the arts and humanities receive from Congress. Floating unresolved in most discussions is the conception of culture as a whole way of life and the consequences of that idea for policy makers at all levels of government and in the commercial and non-profit sectors.

Where does this leave us as we look ahead? Scholars, practitioners, and policy makers need to redefine "cultural policy" to mean more than policies toward the arts. They need to imagine culture as influencing the way people live and make sense of their world, and that definition has an impact on policies beyond the funding of arts and cultural institutions. The world economy is changing to one in which the production of ideas and content will drive new domestic and international legislation and arrangements. Simultaneously, we all must recognize the role of culture both in local communities and in a globalized and technologically-driven world. The philanthropic sector must begin to reimagine its place in a complex cultural sector.

This book sets some preliminary boundaries for the policy discussions that lie ahead. The essays reflect various styles of cultural policy research and open avenues for future debate and discussion. They represent only a sampling of the important work being done on many of these questions. The works collected here were for the most part published in the last five years. They could not have been written without the pioneering work of others over the last few decades. That work, along with other studies that could not be included in this single volume, is listed in a guide to further reading. As the landscape of relationships between culture and policy comes into focus, we will all be engaged in mapping this new terrain; it is the ground upon which we all will be living in the next century.

ENDNOTES

1. "Policy: A Working Definition," Vermont Association for Supervision and Curriculum Development. Found at ASCD World Wide Web-site, http://www.cssd.cssd.k12.vt.us/ascd/analys1.htm.
2. Christopher Lasch, "The Cultural Cold War: A Short History of the Congress for Cultural Freedom," in *Towards a New Past*, edited by Barton J. Bernstein (Random House, 1968); also see Peter Coleman, *The Liberal Conspiracy: The Congress for Cultural Freedom and the Struggle for the Mind of Postwar Europe* (Free Press, 1989); and Michael Warner, "Origins of the Congress of Cultural Freedom, 1949–50," *Studies in Intelligence* 38 (#5, 1995).
3. U.S. House Committee on Education and Labor, *Federal Advisory Commission on the Arts* (GPO, 1958), 40.
4. For a contemporary collection of critiques of mass culture see Bernard Rosenberg and David M. White, eds., *Mass Culture: Popular Arts in America* (Free Press, 1957).
5. "Notes on a National Cultural Policy" orig. in *Daedalus*, Spring 1960, reprinted in *The Politics of Hope* (Houghton Mifflin, 1962), 260.
6. For important histories of this period see Milton C. Cummings, Jr., "To Change a Nation's Cultural Policy: The Kennedy Administration and the Arts in the United States, 1961–1963," in *America's Commitment to Culture*, edited by Kevin V. Mulcahy and Margaret Jane Wyszomirski (Westview Press, 1995), and Gary O. Larson, *The Reluctant Patron: The United States Government and the Arts, 1943–1965* (University of Pennsylvania Press, 1983).
7. See, for example, an early discussion shortly after the law was passed, *The Arts in a Democratic Society* (Center for the Study of Democratic Institutions, 1966).
8. "What Is a 'Primitive'?" *UNESCO Courier* 7 (December 1954): 5–7.
9. Intergovernmental Conference on Institutional, Administrative, and Financial Aspects of Cultural Policies, *Final Report* (UNESCO, 1970), 7.
10. Ibid., 11, 42–43.
11. Charles C. Mark, *A Study of Cultural Policy in the United States* (UNESCO, 1969), 9; Schlesinger, "Notes on a National Cultural Policy," 260.
12. Mark, *A Study of Cultural Policy in the United States*, 11.
13. See Stanley N. Katz, "Influences on Public Policies in the United States" in *The Arts and Public Policy in the United States* (Prentice Hall, 1984), 36, and Michael Kammen's "thoughts on not having a cultural policy" in "Culture and the State in America," reprinted in this volume.
14. World Conference on Cultural Policies, Mexico City, 26 July-6 August 1982, *Final Report* (UNESCO, 1982), 7–8.
15. Ibid., 8–9, 11.

16. Intergovernmental Conference on Cultural Policies for Development, *The Power of Culture*, background paper, (1998).
17. Tony Bennett, "Useful Culture," *Cultural Studies* 6 (1992, #3): 403.
18. Ibid., 406.
19. See the essays and source notes by George Yúdice, Mary Schmidt Campbell, and Randy Martin in *Social Text* 17 (Summer 1999): 1–48, for an introduction to the current state of this scholarship in the United States.
20. Ron Goudreau, Editor of Subject Headings, Library of Congress, e-mail communication to author, January 4, 1999; Library of Congress, on-line catalog: SH85–34748.
21. Rockefeller study, *The Performing Arts: Problems and Prospects* (1965); Twentieth Century Fund study, William Baumol and William Bowen: *Performing Arts: The Economic Dilemma* (1966).
22. Ralph Burgard, "Back to Basics: The Need for Cultural Policies," *Design for Arts in Education* 85 (Sept/Oct 1983): 5.
23. "Influences on Public Policies," 23–24.
24. Two of the many collections of documents related to these conflicts are: *Culture Wars: Documents from the Recent Controversies in the Arts*, edited by Richard Bolton (New Press, 1992), and *Culture Wars: Opposing Viewpoints*, edited by Fred Whitehead (Greenhaven Press, 1994).
25. Liza Mundy, "National Endowment for Administrators," *Washington Monthly* 23 (June 1991).
26. Kennedy, "Arts in America," in *Creative America* (New York: The Ridge Press, 1962), 5; Joseph Wood Krutch, "Creative America," in ibid., 126.
27. President's Committee on the Arts and the Humanities, *Creative America* (1997), 32.
28. Ibid., 14.
29. UNESCO, *Final Report: Intergovernmental Conference on Cultural Policies for Development, Stockholm, Sweden, March 30–April 2, 1998* (UNESCO, 1998), 14–17.
30. (Touchstone Books, 1994).

Defining Culture and Cultural Policy

INTRODUCTION
Gigi Bradford

As a sometimes unwitting and unwilling participant in what has been called the culture wars between the United States Congress and the National Endowment for the Arts, I have consistently been struck by the importance of definitions. What is one person's art is another's pornography; one person's cultural exchange is another's imperialism; and one person's educational frill raises another's test scores. The problem is compounded when those unlikely words *culture* and *policy* are yoked together. Culture, many will say, is a vehicle for individual expression; policy is legislation en masse.

Percy Bysshe Shelley wrote: "Poets are the unacknowledged legislators of the world." When I directed the contemporary poetry series at the Folger Shakespeare Library one block from the United States Capitol, I found that phrase especially piquant. Shelley composed *The Defense of Poetry* in 1848, and in it he deliberately contrasted individual creativity with collective rationality. This assumption seems inherent too in many recent cultural conflicts.

As demonstrated by the introduction to this volume and by some of the essays in Part Two, the premise of individuals pitted in creative tension against society has not always held sway. During much of western history, the artist, scribe, or actor reflected and amplified his society. Today's contentious relationship would have confused most of our ancestors.

Many thoughtful people believe that not only is this tension limited to quite recent times, but that the relationship of creativity to society is undergoing a fundamental shift. The culture wars have narrowed important conversations and obscured enormous changes taking place both within the cultural sector and in its connection to the larger world.

World economies have shifted from those focused on industrial production to those centered on creativity and knowledge. In the next century creativity will drive commerce, employment, and trade the way natural resources and industry have influenced economies and societies in the past. If we are indeed in the middle of a global creative revolution, then culture will play significant roles beyond entertainment, edification, or arguments about creative individuals versus stifling societies. Civilizations will become more dependent upon and more reflective of creativity, individuality, and accessible opportunity.

If culture is to assume a larger role on the world stage, conversations about its significance should embrace a wider scope and be based on more accurate information and assessment. The essays in the section titled *Defining Culture and Cultural Policy* provide a scaffold to build that relationship and a framework with which we can connect the ineffable to the structural. They demonstrate that cultural policy is not a set of rules or recommendations per se, but an approach toward complex and mutable relationships, a way to think about issues, a set of tools for a rapidly changing future.

Understanding culture in terms of policy includes thinking about the range and reach of multiple definitions. The essays in this section illustrate that we don't have to agree on one definition of "culture" to concur that thinking about it, providing trusted information and analysis, and crafting coherent policies can make a lasting contribution to our changing society.

Selections in *The Sphere of Culture* draw some working boundaries around the cultural sector. The first two pieces give the reader a sense of the perspectives and choices inherent in the concept of culture as part of an evolving social fabric. Although written forty years ago, Raymond Williams's "Culture Is Ordinary" outlines many of the tensions in the idea of culture and relates them both to his own lived experience and to the ample arena that we now call the cultural sector. He raises fundamental questions about the relationship of everyday life to culture:

> A culture is common meanings, the product of whole people, and offered individual meanings, the product of man's committed personal and social experience.

He also introduces the notion of a cultural hierarchy—that some cultural expressions have been judged better than others—which Paul DiMaggio addresses more fully in his contribution.

Virginia Dominiguez also challenges the notion of a single meaning of culture, and suggests that we need to think about culture as a relative, mutable relationship, not a discrete and static domain. She raises potent issues about the relationship of the word *culture* to the word *policy*, and significantly em-

phasizes how choices regarding a particular definition of culture will result in specific policy consequences. She asks why some things are called culture, why cultural arguments are invoked, and what causes some governments to articulate a cultural policy and others to avoid doing so.

Paul DiMaggio identifies the broad outlines of the U.S. cultural sector through an examination of its evolution in the twentieth century. Beginning with the definition and emergence of cultural capital, its nationalization and institutionalization, he explains how changes in social structure alter the organizational frameworks and market relationships that shape and re-shape cultural economies. DiMaggio's work identifies elements of a cultural sector: institutions that produce expressive works, organizations that manage their production, markets that distribute them, government policies that regulate them. In describing the erosion of the high culture system, he points the way toward several emerging policy concerns that will be reflected in later sections of this book.

Perspectives on Cultural Policy brings us from grappling with definitions to considering policy. Both *The Arts and the Public Purpose* from The American Assembly, and the President's Committee on the Arts and the Humanities' *Creative America* posit an expansive interpretation of culture and its relationship to society. The American Assembly urges artists and curators to consider the public purposes of art and its contributions to society at large; the President's Committee asks audiences and policy makers to recognize the integral contributions of culture to everyday life. Both documents begin the essential redefinition of terms and questioning of assumptions necessary to any potential policy changes.

If policy must begin with clearly articulated values and a framework for discussing those values, the two concluding essays begin to explore that terrain. Justin Lewis focuses on how democratic governments can nurture innovation and diversity. After reminding us how far "cultural policy" stands from mainstream debates, he grounds policy issues in the commercial cultural sector. For Lewis, the response to the free market in culture is based in regulation. Note his emphasis is on a top-down state-wide policy that might well be resisted by many both in American politics and cultural life.

Margaret Wyszomirski's contribution brings readers into the more familiar territory of recent debates about government support for the arts. Wyszomirski argues for a limited government role in concert with the private sector and market forces. She introduces the idea of a policy community and outlines how that community might serve audiences and society in the future. By writing about the intellectual infrastructure necessary to create sound policy and shared values, she demonstrates why it is important that this community generate information, opinion, and sustained debate. As we turn from her pragmatic and focused examination, we begin to formulate a relationship

of *culture* to *policy* and to integrate theories about culture with the specific challenges we face today.

As the culture wars have taught us, we can arrive at the same destination through multiple routes. This section of *The Politics of Culture* allows us to begin thinking about where we're starting from, where we want to go, and why we might want to go there. The next century will usher in enormous changes. How will we make sense of them? What values, what creativity, what innovation and information will help us to define that future?

The Sphere of Culture

Culture Is Ordinary

The bus-stop was outside the cathedral. I had been looking at the Mappa Mundi, with its rivers out of Paradise, and at the chained library, where a party of clergymen had gotten in easily, but where I had waited an hour and cajoled a verger before I even saw the chains. Now, across the street, a cinema advertised the *Six-Five Special* and a cartoon version of *Gulliver's Travels*. The bus arrived, with a driver and conductress deeply absorbed in each other. We went out of the city, over the old bridge, and on through the orchards and the green meadows and the fields red under the plough. Ahead were the Black Mountains, and we climbed among them, watching the steep fields end at the grey walls, beyond which the bracken and heather and whin had not yet been driven back. To the east, along the ridge, stood the line of gray Norman castles; to the west, the fortress wall of the mountains. Then, as we still climbed, the rock changed under us. Here, now, was limestone, and the line of the early iron workings along the scarp. The farming valleys, with their scattered white houses, fell away behind. Ahead of us were the narrower valleys: the steel rolling-mill, the gasworks, the grey terraces, the pitheads. The bus stopped, and the driver and conductress got out, still absorbed. They had done this journey so often, and seen all its stages. It is a journey, in fact, that in one form or another we have all made.

I was born and grew up halfway along that bus journey. Where I lived is still a farming valley, though the road through it is being widened and straightened, to carry the heavy lorries to the north. Not far away, my grandfather, and so back through the generations, worked as a farm labourer until he was turned out of his cottage and, in his fifties, became a roadman. His sons went at thirteen or fourteen onto the farms; his daughters into service. My father, his third son, left the farm at fifteen to be a boy porter on the railway, and later became a signalman, working in a box in this valley until he died. I went up the road to the village school, where a curtain divided the two classes—Second to eight or nine, First to fourteen. At eleven I went to the local grammar school, and later to Cambridge.

Culture is ordinary; that is where we must start. To grow up in that country was to see the shape of a culture, and its modes of change. I could stand on the mountains and look north to the farms and the cathedral, or south to the smoke and the flare of the blast furnace making a second sunset. To grow up in that family was to see the shaping of minds: the learning of new skills, the shifting of relationships, the emergence of different language and ideas. My grandfather, a big hard labourer, wept while he spoke, finely and excitedly, at the parish meeting, of being turned out of his cottage. My father, not long before he died, spoke quietly and happily of when he had started a trade union branch and a Labour Party group in the village, and, without bitterness, of the "kept men" of the new politics. I speak a different idiom, but I think of these same things.

Culture is ordinary; that is the first fact. Every human society has its own shape, its own purposes, its own meanings. Every human society expresses these, in institutions, and in arts and learning. The making of a society is the finding of common meanings and directions, and its growth is an active debate and amendment, under the pressures of experience, contact, and discovery, writing themselves into the land. The growing society is there, yet it is also made and remade in every individual mind. The making of a mind is, first, the slow learning of shapes, purposes, and meanings, so that work, observation, and communication are possible. Then, second, but equal in importance, is the testing of these in experience, the making of new observations, comparisons, and meanings. A culture has two aspects: the known meanings and directions, which its members are trained to; the new observations and meanings, which are offered and tested. These are the ordinary processes of human societies and human minds, and we see through them the nature of a culture: that it is always both traditional and creative; that it is both the most ordinary common meanings and the finest individual meanings. We use the word culture in these two senses: to mean a whole way of life—the common meanings; to mean the arts and learning—the special processes of discovery and creative effort. Some writers reserve the word for one or other of these senses; I insist on both, and on the significance of their conjunction. The questions I ask about our culture are questions about our general and common purposes, yet also questions about deep personal meanings. Culture is ordinary, in every society and in every mind.

Now there are two senses of culture—two colours attached to it—that I know about but refuse to learn. The first I discovered at Cambridge, in a teashop. I was not, by the way, oppressed by Cambridge. I was not cast down by old buildings, for I had come from a country with twenty centuries of history written visibly into the earth: I liked walking through a Tudor court, but it did not make me feel raw. I was not amazed by the experience of a place of learning; I had always known the cathedral, and the bookcases I now sit to

work at in Oxford are of the same design as those in the chained library. Nor was learning, in my family, some strange eccentricity; I was not, on a scholarship in Cambridge, a new kind of animal up a brand-new ladder. Learning was ordinary; we learned where we could. Always, from those scattered white houses, it had made sense to go out and become a scholar or a poet or a teacher. Yet few of us could be spared from the immediate work; a price had been set on this kind of learning, and it was more, much more, than we could individually pay. Now, when we could pay in common, it was a good, ordinary life.

I was not oppressed by the university, but the teashop, acting as if it were one of the older and more respectable departments, was a different matter. Here was culture, not in any sense I knew, but in a special sense: the outward and emphatically visible sign of a special kind of people, cultivated people. They were not, the great majority of them, particularly learned; they practised few arts; but they had it, and they showed you they had it. They are still there, I suppose, still showing it, though even they must be hearing the rude noises from outside, from a few scholars and writers they call—how comforting a label is!—angry young men. As a matter of fact there is no need to be rude. It is simply that if that is culture, we don't want it; we have seen other people living.

But of course it is not culture, and those of my colleagues who, hating the teashop, make culture, on its account, a dirty word, are mistaken. If the people in the teashop go on insisting that culture is their trivial differences of behaviour, their trivial variations of speech habit, we cannot stop them, but we can ignore them. They are not that important, to take culture from where it belongs.

Yet, probably also disliking the teashop, there were writers I read then, who went into the same category in my mind. When I now read a book such as Clive Bell's *Civilisation*, I experience not so much disagreement as stupor. What kind of life can it be, I wonder, to produce this extraordinary fussiness, this extraordinary decision to call certain things culture and then separate them, as with a park wall, from ordinary people and ordinary work? At home we met and made music, listened to it, recited and listened to poems, valued fine language. I have heard better music and better poems since; there is the world to draw on. But I know, from the most ordinary experience, that the interest is there, the capacity is there. Of course, farther along that bus journey, the old social organization in which these things had their place has been broken. People have been driven and concentrated into new kinds of work, new kinds of relationships; work, by the way, which built the park walls, and the houses inside them, and which is now at last bringing, to the unanimous disgust of the teashop, clean and decent and furnished living to the people themselves. Culture is ordinary; through every change let us hold fast to that.

The other sense, or colour, that I refuse to learn, is very different. Only two English words rhyme with culture, and these, as it happens, are sepulture and vulture. We don't yet call museums or galleries or even universities culture-sepultures, but I hear a lot, lately, about culture-vultures (man must rhyme), and I hear also, in the same North Atlantic argot, of do-gooders and high-brows and superior prigs. Now I don't like the teashop, but I don't like this drinking-hole either. I know there are people who are humourless about the arts and learning, and I know there is a difference between goodness and sanctimony. But the growing implications of this spreading argot—the true cant of a new kind of rogue—I regret absolutely. For, honestly, how can any-one use a word like "do-gooder" with this new, offbeat complacency? How can anyone wither himself to a state where he must use these new flip words for any attachment to learning or the arts? It is plain that what may have started as a feeling about hypocrisy, or about pretentiousness (in itself a two-edged word), is becoming a guilt-ridden tic at the mention of any serious stan-dards whatever. And the word "culture" has been heavily compromised by this conditioning: Goering reached for his gun; many reach for their check-books; a growing number, now, reach for the latest bit of argot.

"Good" has been drained of much of its meaning, in these circles, by the exclusion of its ethical content and emphasis on a purely technical standard; to do a good job is better than to be a do-gooder. But do we need reminding that any crook can, in his own terms, do a good job? The smooth reassurance of technical efficiency is no substitute for the whole positive human reference. Yet men who once made this reference, men who were or wanted to be writers or scholars, are now, with every appearance of satisfaction, advertising men, publicity boys, names in the strip newspapers. These men were given skills, given attachments, which are now in the service of the most brazen money-grabbing exploitation of the inexperience of ordinary people. And it is these men—this new, dangerous class—who have invented and disseminated the argot, in an attempt to influence ordinary people—who because they do real work have real standards in the fields they know—against real standards in the fields these men knew and have abandoned. The old cheapjack is still there in the market, with the country boys' half-crowns on his reputed packets of gold rings or watches. He thinks of his victims as a slow, ignorant crowd, but they live, and farm, while he coughs behind his portable stall. The new cheapjack is in offices with contemporary *décor*, using scraps of linguistics psychology and sociology to influence what he thinks of as the mass-mind. He too, however, will have to pick up and move on, and meanwhile we are not to be influenced by his argot; we can simply refuse to learn it. Culture is ordi-nary. An interest in learning or the arts is simple, pleasant, and natural. A desire to know what is best, and to do what is good, is the whole positive nature of man. We are not to be scared from these things by noises.

Virginia R. Dominguez }

Invoking Culture: The Messy Side of "Cultural Politics"

I am an anthropologist. I am supposed to be a student of culture. Until joining the faculty at the University of California-Santa Cruz in the fall of 1991, I taught in Duke's Department of Cultural Anthropology.[1] I subscribe to *Cultural Anthropology*, the newest major journal in the field of anthropology. I have even regularly taught my Duke department's introductory course entitled "Introduction to Cultural Anthropology." But I am quite uncomfortable talking about "culture," and I am less and less alone among my colleagues.[2]

That fact might be curious, but not noteworthy, were it not for the history of the discipline. For most of the twentieth century, anthropologists have followed the lead of German-born Franz Boas in employing a concept of culture deliberately antithetical to the old elite German notion of Kultur.[3] Fighting the racist underpinnings of evolutionism and the assumption of privilege that went hand in hand with European imperialism, anthropologists asserted that culture was a property of all human communities, and that it wasn't a reference to an aspect of a society or an arena within social life but, rather, to the whole of society as constituted by particular perceptions of the world and largely reinforced by particular forms of social, economic, and political organization. Anti-elitism meant a reconceptualization of culture so that it would describe, explain, and apply to all people, and not just to a few privileged populations or classes. "Culture" was strategically invoked to wrest it from the elite and make it a property of the masses. Social class was rarely their analytic unit in the early days, but the mission was still to democratize culture by universalizing its applicability.

As holistic representations have come under scrutiny, especially in the past two decades, anthropologists have noticed the greatly exaggerated picture of pristineness, purity, consensus, and order painted by many of the early anti-elitist ethnographic texts.[4] A school of cognitive anthropologists has responded by trying to restrict culture to patterned cognitive processes—

schemas, classifications, and metaphors.[5] Self-labeled interpretive anthropologists, among them Clifford Geertz, have sought to locate "it" in "public webs" of meaning.[6] British social anthropology has tended to relegate culture to something conceptualized and studied by American anthropologists.[7] Yet despite the critiques, the worries, and the reconceptualizations, at least part of the Boasian legacy remains. I have never met an anthropologist not firmly committed to a populist (rather than elitist) sense of culture.

As these changes have occurred, it has been easier to see the social and political dimensions of scholarly talk about culture, and with them the broader politics of invoking culture. Some of us anthropologists react by increasingly avoiding invoking culture for the purposes of analysis,[8] and have both sympathy and criticism for the contemporary "cultural studies" movement within the humanities.[9] From an anthropological perspective, the commitment to liberate culture from elite forms, claims, and conceptions is commendable but late in coming, and not exactly new. The commitment to employ culture at a time when anthropologists are suspicious of its referentiality or validity seems, on the other hand, curious—making us wonder why. Why, when the concept of culture has such an elitist history, would sympathetic anti-elitists contribute to its discursive objectification by trying to argue for the value of other things *in terms of it?*

So culture stays with us but not, I shall argue, because it is simply a part of life. Rather, because we think and act in terms of it, and we make strategic social and political interventions by invoking it. I am calling that propensity to employ culture (to think, act, and fight with it) "culturalism."

The issue is broader and deeper than the canon debate and far more global in reach than the current American obsession with "multi-culturalism." While we are arguing over the content of canons of knowledge, disputing the value or need for canons, and pointing out the patterns of exclusion evident in curriculums, publishing practices, funding agencies, and museums, we are ironically reinforcing the perception that there is such a "thing" as culture and that it is something of value. But why is culture something of value? Perhaps, more important, why does so much of cultural politics around the world stop short of asking that question?

Two processes converge and overlap to create this late twentieth-century *culturalist* moment. The first is global in scope and begrudgingly Eurocentric; the second, societal in scope and importantly "self"-oriented.[10] In both, criticism is central though not always obvious. Some of it is "about art," "abut literature," and "about music." Much of it, however, is about other things explicated in terms of culture.

To understand what is involved we need to shift the question we're asking. We need to move away from asking *about* culture—what belongs, what doesn't belong, what its characteristics are, whose characteristics are being

imposed and whose are being excluded—and toward asking *what is being accomplished* socially, politically, discursively when the concept of culture is invoked to describe, analyze, argue, justify, and theorize.[11]

A different view of culture and cultural politics emerges when we look socially at the discursive practices of invoking culture, and when we allow ourselves and our own discursive practices to be part of what we study. Specifically, I believe we can get a great deal of mileage from asking (1) when it is that certain things get called "the culture" and others do not; (2) when it is that one sector of society invokes a cultural argument to explain a social, political, or economic reality; (3) when it is that governments make a point of developing and articulating an explicit "cultural policy," while others do not; and (4) when it is that reformist or revolutionary governments call for social, economic, and/or political change by earmarking culture as a preeminent arena for their struggle.

This "thing" that anthropologists have for decades taken to be what we study, describe, decipher, and theorize about can be, and often has been, an ideological mechanism for subordination and social control. A parallel kind of awareness has emerged in literary studies. We have all noted how over the past decade culture has been increasingly earmarked by intellectuals from the so-called third world or an American minority as a necessary, and conceivably effective, site for resistance. Witness the work of Gayatri Spivak, Trin Min-Ha, Edward Said, Ariel Dorfman, and Henry Louis Gates, Jr. But they have, almost uniformly, in my opinion, not taken their critiques far enough. I repeat: Why do they all go along with the discursive objectification of culture when it is precisely that—a historically situated discursive object with a particular European origin and Eurocentric history?[12]

An obvious answer is that something is being socially and politically accomplished in each and every case, though it is often not what the invokers of culture themselves proclaim or believe. It is common for government institutions, social activists, and intellectuals to claim to represent large groups of people—"the nation," "the ethnic group," "the peripheralized minority," "the educated classes."[13] It is also common for that representation to be more imagined than documented. What invoking culture then accomplishes may have more to do with the social and political aspirations of the invokers than with the stated goals of an activist movement, a gatekeeping movement, or a government policy. I am not so much questioning the honesty of those who invoke culture when they do so, as I am questioning the seeming transparency of the reference to culture.

While anthropologists and humanists in the United States debate the best way to conceptualize culture, many, if not most countries in the world today valorize culture enough to issue official "cultural policies," create staff ministries or institutes of culture, and provoke opposition movements articulating

alternative "cultural policies."[14] National visions, nationalist ideologies, and national identities are all implicated, and with them issues of unity, distinctiveness, self-esteem, and civility.[15]

What is involved in calling policies *cultural*? Outsiders looking in might have so naturalized a concept of culture that they might not think twice, unless, of course, what they see in a foreign setting fails to match their sense of the kinds of things culture refers to. Herein lies the rub. It is simultaneously true that the nature of culture is far from obvious, and that its continued discursive deployment suggests sameness and shared understanding.

That paradoxical fact highlights the importance of conceptualizing culture as something invoked rather than something that is. It strikes me that there may be more merit in asking why so many people have an investment in circumscribing "the cultural" (when there are so many arguments about it) than in continuing to debate its ontology. It seems to me that the time may have come to ask questions about our debates and our discussions rather than about whether we are right within those debates and discussions.

It is in this light that "cultural policies" may be illuminating. The fact that so many countries have cultural policies needs to be explained, not taken for granted. The fact that they function as symbolic capital, to use Pierre Bourdieu's term, is not a corollary of, but rather a reason for, their existence.[16] To so function, cultural policies presuppose (1) the objectification of "the cultural"; (2) clarity in the reference to culture; and (3) the belief that government has a say in the shape of a country's culture and that nations are valued and identified by their cultural characteristics. Each of these presuppositions points to ways of raising questions about our debates and discussion.

(1) Calling something a cultural policy implies that there is an arena of life to which it refers that is separable from other arenas for which there might be other types of policies. The discursive carving out of such a thing produces a belief in its referentiality, its "real" existence outside discourse.

Ramifications of this phenomenon are sometimes straightforward, but often unanticipated and paradoxical. It is easy to see that fights over particular cultural policies could be heated and prolonged just like fights over particular economic policies, foreign policies, or energy policies. It is the foreseeable effect of a proposed activity, budget cut, or platform that is the focus of the heated and prolonged debate.

It is less easy to see other consequences of calling something a cultural policy. Consider the nature of this discursive object as it appears in governmental uses and political discussions. To have a cultural policy—and to have it mean something other than everything associated with human beings or everything associated with a particular society—it has to be differentiated from other types of policies. That process of differentiation circumscribes the cultural in ways that make it incompatible with the old anthropological

holism. An anthropologically holistic concept of culture would include economic organization, political processes, intergroup relationships, and technology as integral components of a population's culture, not separate from it.

The logical result is discursive differentiation. The historically situated result is discursive differentiation of a particular inherited sort. While the very notion of a cultural policy does not allow the rebellious, populist, holistic Boasian sense of culture to be employed, two other forms of "the cultural" seem to be "natural" adoptions: either the old German and French notions of Kultur/Culture (and derivative U.S. notions of high culture), or enclave notions of culture that distinguish between minority populations and dominant populations. In Kultur, two types of differentiation coexist: a distinction is made between certain things deemed to be the content of Kultur and other things, and a distinction is made between the people associated with Kultur and those not associated. In enclave notions of culture, there is the appearance of holism but a fundamental differentiation is nonetheless always produced: only small, minority, peripheral, or controlled populations are described holistically, while the dominant population employs substantive differentiations to refer to itself, its activities, and its characteristics. Both of these notions of the cultural are European in origin and have gone hand in hand with class differentiation in Europe and European attitudes toward the rest of the world, especially in the past two centuries.[17]

Unanticipated and contradictory ramifications of articulating cultural policies follow from this fact. Foremost among them is the problem of articulating a cultural policy as a way to fight postcolonial domination. Many non-European countries, especially those long-subjected to direct colonial domination by European powers, indeed make concerted efforts to establish cultural policies that highlight and celebrate forms of creative expression thought to have been developed before the establishment of European hegemony. This is typically perceived to be a form of resistance. Yet it is arguably more a continuation of a form of European ideological hegemony than an example of resistance. Resistance, it is true, is evident in the inclusion of items, genres, and forms not associated with European elites in the category officially identified as cultural; resistance, however, is not evident in the common adoption of a notion of the cultural defined conceptually (as an area of life) in the footsteps of the hierarchical, elite European sense of distinction, value, and aesthetics. Few, if any, of those postcolonial countries' official cultural policies encompass the whole country's economic practices, governmental structures, or technologies; many concern performances, museums, archaeological sites, publications, and the areas of greatest distinction in education.

(2) The discursive objectification of the cultural, combined with the widespread distribution of talk about it, polices about it, and political struggles focusing on it, fosters the presumption of sameness and shared understanding even when people debate the merits and demerits of including specific things

under its rubric. This presumption, in turn, raises the stakes in social and political struggles that invoke culture. For the conviction that there is *something* to be articulated, cherished, shaped, and claimed invites people to want to articulate it, cherish it, shape it, and claim it. It becomes a thing of value and, as a thing of value, it behooves people to invoke it.

The presumption is interesting because it flies in the face of a great deal of evidence that is not hard to come by. Consider the problem of reference for students of cultural politics. Let us say we choose to work on the relationship between cultural policies and national identities. What do we include in our conceptualization, and what do we exclude? We could, of course, proceed by examining formally articulated statements issued by branches of a country's government, officially dubbed as that country's cultural policy. Such distillations of what culture is or should be, and of the kind of intervention state institutions make or should make in that "sector" of the country's life, are useful data, but of a particular sort. They tell us the kinds of activities that are promoted and those that are discouraged by people with determinate positions in a country's power hierarchy. Most students of cultural politics concentrate on the policy side of the concept of cultural policy—who is pushing what activity and why. Lost in the explicit struggles is the less obvious, but nonetheless crucial way in which certain things are being pushed by invoking culture in the first place.

Official articulated cultural policies are examples of situated, motivated practices of invoking culture. If, as students of national identities and cultural policies, we chose to ignore the official cultural policies and concentrate on other phenomena we read as signs of governmental cultural policies or as extragovernmental, autonomous, semi-autonomous, or resistant practices that either we or some of our informants interpreted to be matters of culture, both the data and its scope could end up being quite different. Consider, for example, four different conceptualizations of the possible object of study: (1) clearly articulated official policies issued by government institutions and deemed by these institutions to be about the nation's or the region's culture; (2) practices and patterns not explicitly targeted by any official cultural policy but that researchers identify as sociocultural consequences of government polices (however labeled); (3) public discourse about culture, the range of agreement and disagreement about it and its significance, and the social and political circumstances in which that public discourse exists; and (4) discursive and nondiscursive practices outside government circles that researchers identify as forms of cultural accommodation, innovation, or resistance because their very existence at a particular time and place indexes (or comments on) established institutions and hierarchies of power in the country at large.

These are significantly different things that could all well serve as references for discussions on cultural politics, and, in fact, do. A telling example is the experience of a group of researchers who gathered in June 1990 at the

East-West Center in Honolulu for a week-long workshop on "cultural policies and national identities."[18] Eight scholars (four anthropologists, one folklorist, two sociologists, and a political scientist) had been asked by the Institute for Culture and Communication to write position papers on cultural policies and national identity in the primary country of their own research. Five of these were also native-born citizens of the country on which they were asked to write. A sixth was binational. A seventh, Beijing-born though Taiwanese by ancestry and citizenship. The eighth, an American with years of experience and professional contacts in his research country. Included were position papers on Singapore, Thailand, New Guinea, Japan, the People's Republic of China, and the United States.

Several of us were brought in to comment on the papers, offer comparative suggestions, and help develop a research agenda for the group. These participants added representation from Taiwan, the Solomon Islands, and New Zealand, and substantive knowledge of several Pacific Island countries, Nicaragua, and Israel. I should add that all but one of the participants had obtained graduate degrees (or at least postdoctoral fellowships) from North American universities and were quite proficient in English.

The papers, without exception, were thorough, lengthy, substantive, and insightful, but one thing I cannot say about them is that they shared an obvious subject matter. Three papers dealt with the People's Republic of China. One took as its subject matter "Chinese minority policy and the meaning of minority culture."[19] A second examined the lively public debate and discussion in the 1980s, especially among intellectuals, on *wenhuare*, translated as "culture fever" or "culture mania."[20] The third concepetionalized its topic as the historical and contemporary relationship among the many "ethnic groups (or nationalities)" of China that "have lived and worked in a pluralistic organic whole for thousands of years." Much of this third paper argued for the need for the dominant Han population to help the fifty-five minority groups *modernize* for the benefit of "the pluralistic whole" but without self-degradation.

Discussion of official articulated cultural policies tended to be about "the nation" and its "minority populations." Their connections to "culture" were treated as self-evident. The paper on the media, on the other hand, treated nothing as transparent, except for the fact that many Chinese scholars and intellectuals were constantly invoking culture in comments and essays referring to Confucianism, Marxism, Westernization, Chinese tradition(s), "national character," and Mao Zedong. For some of these scholars, culture is an object of discourse, for others an analytic concept, and for still others the empirical attributes and properties of bounded populations.

Lest we think that this range of answers to the question of the state of cultural policies and national identity is peculiarly "Chinese," let me mention

that the variety in the subject matter and scope of the other papers paralleled the case of the People's Republic of China. The paper on Thailand concentrated on the unitary view of Thai society continuing to be asserted by the state; this meant material on the historical development of the Thai Buddhist Polity, an ideoogy of nationalism, and the ethnic and religious conflicts resulting from the implementation of specific national cultural policies. The position paper on Japan made Japanese identity its subject matter, pointing out that this is the best way to understand the constant talk of Japaneseness among the Japanese (best known these days as the discourse on *Nihonjinron*); the link to culture here was one made simultaneously by my colleague and some of the many participants in the public discourse on *Nihonjinron*. Public discourse was my colleague's primary data and subject matter. Explications of social, historical, economic, technological, and health data in terms of culture constituted its content.

The paper on the United States was triply illuminating. First, I found myself wondering, before reading the paper, what it was someone would write about when asked to write about "cultural policies and national identity" in the United States. The answer was far from clear to me. Second, it was instructive to see that the paper turned out to be about folklore, the profession of folklore, and changes in public institutions' attitudes to "folk" artists, "community," and "traditions." There was no discussion of cultural studies, multiculturalism, the canon debate, the media, or the issue of censorship in the arts. And yet it was a perfectly plausible topic through which to answer the question he was asked to take on. The paper mentioned tension between "elitism" and "cultural pluralism," it broached the institutional tendency to equate "cultural conservation" with the foregrounding of "the arts," and it situated many of these processes and movements within federal granting agencies, professional organizations, and public and private institutions at regional, state, and municipal levels of organization.[21]

The variety of "things" my colleagues took on for this workshop at the East-West Center may surprise people who primarily work with others who share their own specific sense of culture. The fact, though, is that there is very little guarantee that scholarly essays on culture will have much in common, even when you think you are putting together a working group of likeminded researchers.

I don't think I'm exaggerating the point. For a much-used word, culture has little communicative efficiency. And yet it is clear, from the frequency of institutional and public invocations of culture around the world, that it is perceived to have communicative value.

(3) Cultural policies are not innocuous. They are after all governmental policies, even if of a particular kind. If I have called attention earlier to the objectification of the cultural as something we need to examine and not take for granted, I want also to call attention to assumptions embedded in the

policy side of cultural policies. Governments do not have a public say in everything about the practice of everyday life. Governments that come close are considered totalitarian, invasive, and excessively regulatory.[22] That many governments, political movements, and public institutions assert the belief that they have a say in the shape of a country's culture suggests that culture is highlighted as something of special value, in addition to being objectified and presumed.

If we look, in particular, at activist governments seeking to shape a country's culture, we see different degrees of investment in invoking culture. Some countries have clearly articulated, discursively visible cultural policies; others do not. Some countries—not all—have clearly articulated cultural policies that explicitly invoke issues of national identity. Some countries have clearly articulated, discursively visible policies on national identity that explicitly invoke issues of culture.[23]

Activist cultural policies and activist nationalist policies are common among postcolonial countries of the twentieth century, especially those whose territorial boundaries have more to do with European politics than with a precolonial sense of shared peoplehood. While many of us may be accustomed to thinking that "peoples" are "peoples" to a large extent because they share "a culture," there is simply no logical reason to privilege that view of peoplehood.[24] And yet most postcolonial countries of the twentieth century adopt the policy that a cultural policy and a national identity go hand in hand, even when the explicit policy is seemingly contradictory—such as when the government actively promotes cultural pluralism as a way of diffusing tension that could presumably tear the country apart.[25] Both the conceptualization of and the stress on national identity and cultural policy reflect a particular European historical experience, which has enabled them to be thinkable and to be thought necessary.

It is clear that there are different levels of consciousness, interventionism, and activism, if we look comparatively. Unlike many other countries, the United States does not have a Department or Ministry of Culture. Where are we to look to determine the federal government's policy on culture or cultures in (or of) the United States? A colleague of mine in the arts had no trouble mentioning the existence of national-level, federally funded institutions, such as the National Endowment for the Arts and the National Endowment for the Humanities, when I asked her if she though the United States has a cultural policy. But, like the folklore scholar I mentioned above, anthropologists and perhaps historians would have trouble with my colleague's implicit equation of culture with the arts, even if she meant that our government equates culture with the arts. Such an equation buys too unproblematically into an elite Eurocentric view of culture that would ignore issues of language, public rhetoric, immigration policy, education, class, race, and ethnicity that provide both support and challenges to that elite sense of culture as refinement and

aesthetic achievement. Should or shouldn't those other policies be looked at as well by researchers of cultural policies? The United States simply does not have an institutional mechanism for developing, implementing, and debating a single coordinated set of policies perceived to be about the country's culture and its national identity. Arguably, related policies in different spheres of life are developed through a decentralized institutional system usually lacking a single, stated, social vision or longitudinal plan.

It may, in fact, be analytically useful to have countries like the United States without a single clearly articulated and official cultural policy, because it forces us to grapple with the analytic problems embedded in the notions of culture and cultural policy and the practices of invoking them. It is cases like this that compel us to pose questions about the conditions under which countries may or may not develop and highlight official cultural and national identity policies.

Here are some suggestions. I suspect that it is the perception of weakness relative to other countries—however conceptualized and felt—that triggers and drives some official cultural policies. I suspect that high-level government officials become active participants if they believe that sectors of the country's population not well-represented in major levels of government pose a serious threat to a vision of the country they care about or to a social group with which they identify. Likewise, we should then also consider what it means for a country not to have an activist cultural policy. Does it make sense, for example, to interpret the absence of an explicit cultural policy as a sign of national consensus with regard to national identity? Or perhaps as a sign that state institutions are particularly effective and experienced at exercising control in a less visible, more ideologically hegemonic manner reminiscent of Antonio Gramsci's comments about class domination.[26]

I have argued so far that a good part of the reason governments assert their say over the shape of their populations' cultures is that they link the idea of culture with respectability, necessity, unity, and the minimization of divisiveness, especially vis-à-vis the rest of the world. One particular aspect of this linkage requires special mention: the widespread acceptance of the assumption that is culture that defines a nation as the socially, economically, and politically situated product of the latter half of this particular century.

Independent countries in the late twentieth century apparently feel the need to justify (rationalize? legitimate?) their claims to statehood by invoking a cultural argument. Other things have indeed been invoked in the past. A culturalist form of legitimation (or means of attempted unification) takes over in the late twentieth century—the contemporary counterpart of "racial" theories, spiritual theories, economic/class theories, and naturalist theories that dominated previous centuries. Is it somehow linked to conditions currently theorized as "postmodern"? Or perhaps more a reaction to those conditions, or a reflection of those conditions? A push toward global culturalism

has been particularly evident in the work of UNESCO since the late 1960s: the sponsorship of two world conferences on cultural policies (the first in 1970, the second in 1982) and the commissioning and publication in the 1970s and 1980s of well over forty country-by-country reports on cultural policies.

The "ethnicization" of American society over the last twenty years (by which I mean the labeling of many group phenomena as ethnic and the promotion of certain things associated with each group as issues of ethnic pride) is a good example of recent culturalism. The switch from talk of races and immigrant groups to talk of ethnic groups and ethnic identity carries with it what I call the culturalization of difference. A public discourse that promotes intergroup tolerance employs the notion of cultural pluralism, not biological diversity, multilingualism, or class harmony. There appears to be a belief that cultural differences are valid and must be acknowledged. Other conceivable and prior perceptions of difference are treated, by contrast, as at best problematic. By implication, we learn to explain and validate the existence of collective identities by invoking cultural differences and, in the process, promote the view that all legitimate group entities—official "nations" among them—can and must be able to be identified by their cultural characteristics.[27]

It is hard to assess exactly just how much governments with activist cultural policies implicitly adopt these assumptions of legitimacy, rights, and value, but it seems clear that at this historical juncture they are at least semiconsciously responding to the fact that other countries in the world operate under those assumptions.

When I set out ten years ago to do research in Israel, I saw myself studying "the Israeli obsession with ethnicity," not some Israeli obsession with culture.[28] By 1984, however, I had become convinced that a particular objectification of culture was implicated in the Israeli obsession with ethnicity, and was instrumental in perpetuating it. Changes in both the United States and Israel had made me wary of people who invoke culture to explain social, political, or economic phenomena, but they also drew my attention to the frequency with which that happened and the circumstances in which it tended to happen.

By the early 1980s, both the United States and Israel were in the midst of what I call "the ethnic revolution"—a discursive insistence on the celebration of ethnicity conceptualized as the celebration of cultural diversity. As cultural pluralism became the motto for this new public stance toward the nature and maintenance of certain (nonthreatening) social differences, "ethnic culture" typically became essentialized, celebrated, and pinpointed as the source of difference we would have to learn to live with and value.[29] Holism had returned as an instrument of liberal politics seeking an ideological way to counter the devaluation and continued underclass status of large sectors of a country's population.

I had gone to Israel to explore the way in which social, political, and economic domination of one half of Israeli Jews by the other half took place ideologically—without most people knowing or noticing.[30] I had not set out to study cultural differences, or even cultural similarities among Jews in Israel. But the more I heard Israelis make references to cultural differences the more I heard a discourse on culture intersecting the persistent discourse on ethnicity in a highly patterned way: when people talked about there being cultural differences, culture was invoked to explain (justify?) continuing social, economic, and political inequalities.

These perceptions were in step with the work of Iraqi-born Israeli sociologist Sammy Smooha, who had begun to rail against social scientists and politicians for increasingly highlighting cultural differences in Israeli society.[31] I also found support in the work of Argentinian-born Israeli sociologist Shlomo Swirski, who showed that one could get mileage out of asking questions of Ashkenazi (European-origin) Jews, Sephardi ("Middle Eastern"-origin) Jews, and Israeli Arabs within that structure following the model of earlier "dependency theorists."[32] These writers encouraged my impulse to avoid treating culture as some independent variable. I hypothesized that the ongoing public discourse on ethnicity in Israel was a social and political phenomenon that needed to be examined as constructing, much more than reflecting, its referents.

Indeed, the intersection of the discourse on ethnicity with the discourse on culture was powerful and invidious. The alleged backwardness of some sectors of Israeli society was frequently attributed to some aspect of "their culture" or even to the force of "traditionalism" in "their culture." A form of liberal paternalism exonerated individuals, but blamed "the culture" with which they were identified.

So strongly entrenched is this theme in public discourse that when liberal commentators—foremost among them our fellow anthropologists—have sought to counter it, developing an alternative explanation has become de rigueur. Shlomo Swirski's 1981 book, for example (*Orientals and Ashkenazim in Israel: The Ethnic Division of Labor*), was deliberately entitled *Lo Nekhshalim, ela Menukhshalim* in Hebrew, better translated as "not people who have failed, but rather people who have been made to fail." Nitza Droyan, Maurice Roumani, Harvey Goldberg, and the many contributors to the journal *Pe'amim* have taken the strategy of writing the histories of non-European Jewish communities to show how flat and oversimplifying are the images entailed in the charges of cultural traditionalism.[33] Harvey Goldberg, Yoram Bilu, Henry Abramowitz, Shlomo Deshen, Moshe Shokeid, and Alex Weingrod have all taken the tack of analyzing customs, festivals, and rituals deemed "traditional" in Israel and showing how many central features of these "traditions" are in Israel, the Israeli bureaucracy, and the material conditions of their lives in Israel.[34] But in all cases the nemesis is the culturalist

argument that continues to be invoked in the dominant discourse on "the persistence of ethnicity" in Israel.

Note some of the vivid illusions fostered by that pattern of invoking culture. It is tempting to read the use of "culture" to refer to nonelite circles or to large, diverse communities as an adaptation of a populist, anthropological sense of culture. But the fact is that in these situations "cultures" are being evaluated and placed on some hierarchical scale of comparative value with an objectified European culture sitting pretty at the top. This is the elite European/Eurocentric sense of culture masking itself as populist.

The intrinsic hierarchy of the culturalist argument becomes even more evident if we notice what happens when culture is invoked to provide praise, rather than to denigrate. Especially in the context of state institutions, we see a pattern of calling material objects, music, customs, and values of European Jewry *culture (tarbut)*, while relegating the same kinds of things to the discursive status of *heritage (moreshet)* when they come from non-European Jewry.[35] A few activist Sephardi intellectuals have called this distinction the "folklorization" of non-Ashkenazi cultural life, identifying it as yet another ideological way in which the Ashkenazi population structured discrimination into Israeli society. At stake in this stream of public discourse is the question of the future—of what is "good enough" to be valued and continued in contemporary society vs. what can be praised safely as long as it stays in the past. Institutionally, in schools, books, museums, and funding offices the canon remains overwhelming Eurocentric. Only in the still-marginal Sephardi intellectuals' movement called East for Peace, and their magazine, *Apirion*, have I seen any serious discussion in the past decade of how Middle Eastern and North African values and perceptions could be used as the basis for understanding value in the present-day and future Israeli society (regardless of the "ethnic" distribution of the population).[36]

As I encountered this intersection of the discourses on ethnicity and culture, I became increasingly convinced of the enormous hegemonic power of the concept of culture itself and of the practices of invoking it (as well as of not invoking it) in Israel. Pierre Bourdieu's recent work corroborates that finding in the context of French society, by sensitizing us to the ways the upper socioeconomic crusts of contemporary French society employ "taste," "aesthetics," and "culture" as signs of social distinction whose referents get redefined and adjusted, seemingly unconsciously, so that they always differentiate between the social classes of French society.[37] Note that, in such a setting, it isn't just the alleged content of the culture that differentiates; it is the concept of culture itself that carries in its continued discursive usage a huge social, economic, and political value.

But as I turn to other countries, even to other regions, for perspectives on Israeli discourse about culture and the theoretical questions it has compelled me to ask, I am further struck by the apparent success European countries

have had over the past 100 to 150 years convincing the rest of the world that culture is a "thing," that it has value, and that any self-respecting group of people must have it. People may contest the extent to which the content of their culture must be European in origin in order for it to be of value, but they are still overwhelmingly buying into the elite European idea that there is such a thing as culture and that it is through one's culture that one's value is judged. We need only think about China's current "culture fever" or Japan's ongoing *Nihonjinron* or Papua New Guinea's panic about developing a national culture or the Québecois insistence on Québecois cultural identity,[38] or even the fact that most countries of the world today have official ministries of culture, to see my point.

What is, I think, most revealing is the way in which the very idea of hierarchies of value, inherent in the old elite European (and Eurocentric) concept of culture, manifests itself, though differently, in different countries' discourses on culture. This is where global culturalism and societal culturalism intersect but still need to be differentiated. There is a pattern here. In much of the third world—in those countries that are seen as both economically and culturally poor or underdeveloped, whether recently postcolonial or not—we find that the public discourse on culture is part of a broad-ranging collective self-criticism. Cultural policies in these countries don't just describe what there is that the government, the elites, or even the nonelites seek to value; they usually prescribe a particular direction the country should take "culturally" in order to correct for some perceived societal flaw, such as internalized oppression, technological backwardness, destructive intergroup fighting, or a lack of historical awareness.

Such discourses on culture imply that any and all characteristics of the "collective self" are proper and necessary subjects of societal self-criticism. But note that they frame themselves as discourses on "culture." A culturalist argument is implicit in this type of discourse. Asking why it is that "we" are not "better," or "more stable," or "more self-sufficient," or "more independent," or "more influential," and framing one's answers in terms of "culture" implies comparing "cultures," seeing culture as something of value, and perpetuating an objectification which is, by definition, a comparative statement of value. What is interesting is that participants in these discourses of collective self-criticism around the world seem to be unwittingly letting that elite European, Eurocentric notion of culture-as-value serve as the preeminent criterion of value.

The Israeli case provides a useful contrast not because it is a Jewish society or a Middle Eastern society or a plural society or even an embattled society, but because it is (was) a European settler society. A significant segment of the population sees itself as European, not just as aspiring to be European. The still-dominant view is that the value of the society rests on its being Jewish and

"Western" (read: European and Eurocentric). Any positive reference to culture almost always implies a European and Eurocentric culture, which they claim as their own and in contrast to which they disparage others. Criticism of it can seemingly only be specific—in the narrowest sense of culture as art, music, literature, philosophy, and theater. For criticism of other, wider-ranging social, political, or economic referents to be couched in terms of culture would be, I think, to suggest the need for much more of a break with European societies than the majority (or at least the dominant) population seems to want. To engage in major collective self-criticism and attribute problems to the (presumably mainstream Eurocentric) culture would be to criticize this thing they call culture that they objectify, aspire to, and claim as their own. A broad cultural criticism can only take two forms: either criticism of the cultures of "others," or criticism of individual performers and artists whose execution or reproduction of "culture" may not be quite up to snuff.

The most poignant illustration of this constraint is the flourishing of a discourse on Jewish racism among Israeli Jews since the mid-1980s and the almost total absence of references to it in Israel as a problem of Israeli culture. Here is an example of collective self-criticism employing terms other than "culture." Judaism, the Holocaust, morality, Jewishness, Jewish values, secular humanism, tolerance, rights, and mutual respect are the terms and frames of that heated and often pained discussion; culture is not, except when it intersects with the politics of ethnicity, as when someone seeks to "explain" the unworthiness or backwardness of a Sephardic Jew's views or behaviors by attributing their "racism" to "their culture." "Racism" is not, however, ever presented as a criticism of the culture of that Israeli society still hegemonically controlled by Ashkenazi Jews. A particular objectification of culture that is, in the Israeli case, both substantively and conceptually Eurocentric makes it highly unlikely that Israeli discourses on culture would ever be coextensive with its discourses of collective self-criticism.

What does all this mean? We might all already agree that framing certain things as cultural and others as not is neither accidental nor innocent, but I worry that in conceptualizing cultural politics too substantively, empirically, or regionally or locally, intellectuals, community activists, and politicians are, even in acts of resistance against European hegemony, perpetuating the very terms—of hierarchies of differential value—that constitute that hegemony. And in the process we may well be missing the more significant phenomenon—that these struggles are taking place now not because of existing or expanding or narrowing "cultural" differences among groups of people, but because at this point in time much of the world has internalized culture as the marker of difference. In the end, where others see cultural politics as leading to chaos, I see it as homogenizing. And where others bemoan cultural politics

as divisive, I bemoan it as consolidating *a* vision of privilege and difference that remains elite and European in origin and Eurocentric in conception.

Interlocking patterns of global and societal culturalism are late twentieth-century phenomena. They give the appearance of equality of value and multiplicity of form. They project positive images, unlike invocations of race and racism, class and classism, which have long been thought to project only negative images. They imply decentralization. They also tease. They promote a concern held by European elites and extend it throughout much of the world. They centralize and focus discussion of a particular sort when many other sorts had previously coexisted and are logically just as conceivable. And they continue to be used by populations in power to dominate, persuade, control, and justify—taking advantage of the simultaneous communicative inefficiency and community valorization of the cultural.

<div style="text-align:center">ENDNOTES</div>

1. The department's official title; in 1988 the Duke administration split the anthropology department up into a department of cultural anthropology and a department of biological anthropology and anatomy.
2. This past spring (1991) a session I organized for the annual meetings of the American Ethnological Society, which I entitled "Is Culturalism an Improvement on Racism?" drew a standing-room-only crowd. And just six weeks later at a working meeting of heads of area studies programs funded by the Rockefeller Foundation, I discovered that one of my colleagues at the University of Pennsylvania, anthropologist and editor of *Public Culture* Arjun Appadurai, was himself in the middle of drafting a paper on what he is calling culturalist movements. See also Jean Jackson, "Is There a Way to Talk about Making Culture without Making Enemies?" *Dialectical Anthropology* 14 (1989): 127–43.
3. For perspective, see George Stocking, Jr., *Race, Culture, and Evolution: Essays in the History of Anthropology* (New York, 1968), as well as the history of anthropology series that he presently edits for the University of Wisconsin Press.
4. The quickly canonized texts on this subject are George Marcus and Michael Fischer, *Anthropology As Cultural Critique: An Experimental Moment in the Human Sciences* (Chicago, 1986); and *Writing Culture: The Poetics and Politics of Ethnography*, ed. James Clifford and George Marcus (Berkeley, 1986).
5. A representative older collection of such work is *Cognitive Anthropology*, ed. Stephen Tyler (New York, 1969). An up-to-date version is *Cultural Models in Language and Thought*, ed. Dorothy Holland and Naomi Quinn (Cambridge, 1987).
6. I still find Clifford Geertz's *The Interpretation of Cultures* (New York, 1973) to be his seminal work, though his more recent book *Works and Lives: The Anthropologist As Author* (Palo Alto, 1988) extends the analysis to the present-day struggles over ethnographic interpretation. For a broader and interdisciplinary perspective, see *Interpretive Social Science: A Second Look*, ed. Paul Rabinow and William Sullivan (Berkeley, 1987).
7. For decades the field of anthropology in Great Britain has been dominated by the Association of Social Anthropologists, which has stressed social, political, and economic processes, functions, and structures. Of course, many of their earlier ethnographies are among those that have come under critical scrutiny.
8. An earlier generation of anthropologists emerging on the scene in the 1950s and

1960s shared some of the current misgivings when they chose to work on peasantries, urbanization, and political economy, rather than on "tribal" or "primitive" cultures.

9. I know of at least one anthropology conference and several semiprivate workshops commenting on, and critiquing, "cultural studies" within the past two years.

10. I mean self in several senses; individual identity and subjectivity as well as collectivity/community identity and subjectivity, as in struggles for group self-determination. See Virginia R. Dominguez, "How the Self Stacks the Deck," *Anthropology and Humanism Quarterly* 16 (March 1991): 11–14.

11. Peircean pragmatics can fruitfully complement Foucauldian analyses of the link between knowledge and power. See, for example, *Semiotic Mediation: Sociocultural and Psychological Perspectives*, ed. Elizabeth Mertz and Richard Parmentier (Orlando, 1985) in conjunction with Michel Foucault, *The Order of Things: An Archaeology of the Human Sciences* (New York, 1970).

12. Etymological evidence situated in social and political history makes a strong case for this claim, illuminating what James Clifford has called *The Predicament of Culture* (Cambridge, 1989).

13. Intersecting points of view appear in Edward Said, "Representing the Colonized, Anthropology's Interlocutors," *Critical Inquiry* 15 (Winter 1989): 205–25; James Clifford, Virginia R. Dominguez and Trin Min-ha, "The Politics of Representations," in *Discussions in Contemporary Culture*, ed. Hal Foster (Seattle, 1987); and Benedict Anderson, *Imagined Communities: Reflections on the Origin and Spread of Nationalism* (London, 1983).

14. Useful references are the series on country-by-country cultural policies published by UNESCO and those specifically on European countries published by the Council of Europe. Over forty separate volumes of this sort published in the 1970s and 1980s are part of Duke University's libraries' holdings. They include socialist and nonsocialist countries, European, Latin American, African, Middle Eastern, and South and East Asian countries.

15. Especially insightful is *Nationalist Ideologies and the Production of National Cultures*, ed. Richard Fox (Washington, D.C., 1990).

16. Pierre Bourdieu, *Outline of a Theory of Practice*, trans. Richard Nice (Cambridge, 1977), 171–83.

17. See Pierre Bourdieu, *Distinction: A Social Critique of the Judgment of Taste*, trans. Richard Nice (Cambridge, 1984): and Uli Linke, "Folklore, Anthropology, and the Government of Social Life," *Comparative Studies in Society and History* 32 (January 1990): 117–48.

18. Participating were Harumi Befu, Walwipha Burusratanaphand, Chua Beng-Huat, Allen Chun, Burt Feintuch, Lawrence Foanaota, Wari Iamo, Lamont Lindstrom, James Ritchie, Ma Rong, Yos Santasomba, Jacob Simet, David Whisnant, Geoffrey White, David Wu, and Haiou Yang. Revised drafts of the position papers will be published in a volume I am coediting with my East-West Center colleagues Elizabeth Buck, Geoffrey White, and David Wu.

19. For a published version, see David Wu, "Chinese Minority Policy and the Meaning of Minority Culture: The Example of Bai in Yunnan, China," *Human Organization* 49 (March 1990): 1–13.

20. I am grateful to Haiou Yang at the East-West Center for this information and the sources she called to my attention: Wang He, "Traditional Culture and Modernization: A Review of the General Situation of Cultural Studies in China in the Recent Years," *Social Sciences in China* (Winter 1986); and Greremie Barme, "The Chinese Velvet Prison: Culture in the New Age, 1976–1989," 1989.

21. An expanded version of such an exposition can be found in *The Conservation of Culture: Folklorists and the Public Sector*, ed. Burt Feintuch (Lexington, Ky., 1988).

22. We in the United States like to call attention to that problem in other countries though, as Michel Foucault aptly articulated in *Discipline and Punish: The Birth of the*

Prison, trans. Alan Sheridan (New York, 1977), it doesn't take a notoriously totalitarian regime to develop a system that is invasive and highly regulatory.

23. Variants of note are described in Teodor Shanin, "Ethnicity in the Soviet Union: Analytical Perceptions and Political Strategies," *Comparative Studies in Society and History* 31 (July 1989): 409–24; David Whisnant, "Sandinista Cultural Policy: Notes Toward an Analysis in Historical Context," in *Central America: Historical Perspectives on the Contemporary Crisis*, ed. R. Lee Woodward, Jr. (New York, 1988); and Wari Iamo, "Culture in Papua New Guinea Nationalism" (Proceedings of the Symposium on Nationalism in Papua New Guinea, Association for Social Anthropology in Oceania Meetings, Kauai, Hawaii, 20–25 March 1990).

24. See my recent book *People As Subject, People As Object: Selfhood and Peoplehood in Contemporary Israel* (Madison, 1989).

25. Singapore, Lebanon, Canada, and Yugoslavia have all spent much of the post-World War II era promoting intercommunal coexistence and intercultural tolerance in order to survive as unified national entities. The experience of Lebanon and, increasingly, Yugoslavia make it valid to wonder how successful that policy can be in the long run.

26. Antonio Gramsci, *Selections from the Prison Notebooks*, trans. Quintin Hoare and Geoffrey N. Smith (New York, 1971).

27. Two critically insightful takes on the ethnicity literature are Brackette Williams, "A Class Act: Anthropology and the Race to Nation across Ethnic Terrain," *Annual Review of Anthropology* 18 (1989): 401–44; and Phyllis P. Chock, "The Landscape of Enchantment: Redaction in a Theory of Ethnicity," *Cultural Anthropology* 4 (May 1989): 163–81.

28. Dominguez, *People As Subject, People As Object*.

29. A very different counterargument by Fredrik Barth in *Ethnic Groups and Boundaries* (Boston, 1969) was highly influential in certain scholarly circles but not in the most public, popular discourses on ethnicity. Review essays on the Israeli "ethnic revolution" include Harvey Goldberg, "Introduction: Culture and Ethnicity in the Study of Israel," *Ethnic Groups* 1 (1977): 163–86; and Alex Weingrod's introduction and conclusion to *Studies in Israeli Ethnicity: After the Ingathering* (New York, 1985).

30. European-origin Jews (except for most of those from Spain and the Balkan Peninsula who are not considered Ashkenazi) have dominated economic, artistic, and political life in Israel for decades, although by the mid- to late 1970s they stopped being the demographic majority among Israeli Jews. Over half of the Jewish population of Israel comes from North Africa, the Middle East, South Asia, and the Balkan Peninsula and are dubbed Oriental or Sephardic Jews.

31. See, for example, Sammy Smooha, *Israel: Pluralism and Conflict* (London, 1978).

32. Shlomo Swirski, *Orientals and Ashkenazim in Israel: The Ethnic Division of Labor* (in Hebrew) (Haifa, 1981).

33. A fair amount of this literature, including the journal *Pe'amim*, is published in Hebrew, not English (the preferred language for academic publications within the Israeli academy). A good example is Nitza Droyan, *Without a Magic Carpet: Yemenite Settlement in Eretz Israel (1881–1914)* (in Hebrew) (Jerusalem, 1981).

34. For example, Shlomo Deshen and Moshe Shokeid, *The Predicament of Homecoming: Cultural and Social Life of North African Immigrants in Israel* (Ithaca, 1974); Harvey Goldberg, "The Mimuna and the Minority Status of Moroccan Jews," *Ethnology* 17 (1978): 75–87; and *Studies in Israeli Ethnicity*, ed. Alex Weingrod.

35. See chaps. 4 and 5 of my *People as Subject, People as Object*. See also my article "The Politics of Heritage in Contemporary Israel," in Fox, ed., *Nationalist Ideologies and the Production of National Cultures*, 130–47.

36. Alternative publications periodically surface and touch on the issue, but rarely succeed in the long run. The magazine *Iton Akher* is a promising recent example.

37. Bourdieu, *Distinction*.

38. See Richard Handler, *Nationalism and the Politics of Culture in Quebec* (Madison, 1988).

Social Structure, Institutions, and Cultural Goods: The Case of the United States

Research in anthropology, sociology, and other fields unanimously reports that people's choices of expressive goods are profoundly cultural and social. They are cultural in the sense that people respond less to intrinsic attributes of symbolic goods than to particularized meanings instilled in them. They are social, first, because these meanings emerge in social interaction and, second, because the desirability of a cultural good to a consumer depends on the number of identities of its other consumers (Douglas and Isherwood 1979; Granovetter and Soong 1988). Except for economists, who usually apply a utilitarian paradigm of independent choice to people's tastes for art, music, cuisine, and fashion, most scholars agree that cultural goods derive utility from social processes and not from the creature or aesthetic needs of isolated individuals; that different people's decisions about symbolic goods are both interdependent and (insofar as the *social* significance of a good—who else consumes it—fluctuates) unstable; and that demand for cultural goods responds to their socially constructed unit character: Such goods cannot be viewed as bundles of utility-bearing characteristics. In other words, they are consumed for what they say about their consumers to themselves and to others, as inputs into the production of social relations and identities.

Despite this agreement on micro-principles, scholars have found it difficult to characterize change in expressive culture at the societal level. Sociologists and lay people alike customarily discuss change in symbolic economies with reference to broad labels ("mass culture," "the culture of capitalism," "post-modernism") that are flawed in three respects. First, they conflate a variety of dimensions that are empirically and analytically distinct: the orientations and modes of action of actors; the social classification of expressive goods; and dimensions of social structure. Second, the failure to "unpack" such labels systematically renders each interpretation of "cultural change" incomplete;

debate revolves around different *dimensions*, rather than comparing distinctive views of the same phenomena. Third, conventional labels are heavily laden with resonant evaluative overtones.

We need to equip ourselves with a less familiar analytic apparatus. Briefly, societies vary with respect to four dimensions of symbolic classification: *differentiation* (the extent to which cultural goods are grouped into a few or many types or genres); *hierarchy* (the extent to which such types or genres are viewed as vertically arrayed or of equal value); *universality* (the extent to which genre distinctions and hierarchies are commonly recognized); and *symbolic potency* (the extent to which transgressions of boundaries and hierarchies elicit strong negative reactions). Systems of classification are shaped by changes in the organization of cultural authority and in the mode of allocation of cultural goods. Social structure affects the dimensions of symbolic classification by influencing the capacity of actors to organize and the uses to which individuals may put cultural resources (DiMaggio 1987a).

Concretely, I shall argue that changes in social structure and the rise of an open market of cultural goods have weakened institutionalized cultural authority, set off spirals of cultural inflation, and created more differentiated, less hierarchical, less universal, and less symbolically potent systems of cultural classification than those in place during the first part of this century.

Pierre Bourdieu's notion of *cultural capital* (1984) is indispensable for comprehending sociological aspects of the symbolic economy. The importance of the *capital* metaphor lies in the fact that it directs us to both the uses that actors make of cultural competencies in their daily efforts to improve their lot and to institutions that mint, guarantee, and sacralize certain kinds of culture as signs of distinction—that is, to the problem of institutionalized cultural authority. Consequently, analysis of change in the cultural economy requires attention both to individual and collective action *and* to institutions of cultural production and consecration.

I distinguish between *cultural capital*, by which I refer to proficiency in the consumption of the discourse about generally prestigious—that is, institutionally screened and validated—cultural goods, and *cultural resources* (Collins 1979), by which I refer to any form of symbolic mastery that is useful in a specific relational context. Within certain milieus, the ability to speak intelligently about the wheat futures or funny-car racing may be a cultural resource, but neither is a form of cultural capital because neither is generally valorized by a nationally authoritative institutional system.

The difference is not intrinsic to particular expressive goods: Cultural capital and cultural resources must be distinguished empirically. At the micro-level, cultural capital includes those cultural resources that positively affect measures of life chances (educational attainment, marital selection, occupational attainment) within a national population (as opposed to only within local subgroups). At the macro-level, cultural capital can be distinguished

from other cultural resources on the basis of collective investments in formal organizations devoted to its maintenance and consecration.

As Bourdieu and Jean-Claude Passeron (1977) have argued, in most modern industrial societies the university is the specialized institution with the greatest power of consecration. Mass parties or established churches may also play such a role. (I use the term *role* rather than *function* because societies vary not simply in the locus of cultural authority but in the extent to which the cultural authority of *any* institution can be said to extend to the society as a whole—that is, in the extent to which the cultural economy revolves around a centrally valorized currency as opposed to a multiplicity of local bartering arrangements.)

For a society to have cultural capital—sets of cultural goods and capacities that are widely recognized as prestigious—there must be institutions capable of valorizing certain symbolic goods and social groups capable of appropriating them. A society with cultural capital must have a common focus of public life; its culture must be differentiated to some degree, universal enough to admit a common currency of interactional exchange, and hierarchically organized into genres with some ritual potency. In other words, it must be a society with a state, a relatively high level of political incorporation, and substantial institutional differentiation. Thus, the symbolic economy associated with cultural capital comes into being with industrial capitalism.

THE EMERGENCE OF HIGH CULTURE: DIFFERENTIATION AND HIERARCHY

The constitution of certain cultural goods as "cultural capital" was by no means automatic, but rather required collective action on the part of elites. The particulars differed from place to place, but the process occurred from the late eighteenth to early twentieth centuries throughout the industrializing West. In Europe, "high culture" emerged out of court culture as aristocracies were overthrown by or made their peace with rising commercial classes (see, for example, White and White 1965; W. Weber 1976; Tuchman and Fortin 1988; DeNora 1989). In the United States, institutions of high culture emerged as part of a larger process of upper-class formation by urban elites familiar with recent European precedents.

This process was marked by the increasingly public character of cultural consumption. The rise of consumer markets for cultural objects emerged centuries earlier (Altick 1978; Burke 1978; Mukerji 1983), of course, but the extension of the market to new forms of expression and new publics represented a disjunctive step. This was especially the case in the United States, where before 1850, the arts were ordinarily produced and consumed in the home or in public venues characterized by a mixing of genres and classes. Increasingly, after 1870, the arts became the business of organizations that, like the art they

purveyed, were segmented into two fields: the "high" and the "popular." In the United States, within fifty years each of the fields was institutionalized on the national level, and the classifications high and popular (and the contents of each side of this dichotomy) were largely taken for granted. Once these systems were in place and tied, on the one hand, to systems of near-universal secondary and mass higher education and, on the other, to the apparatus of consumer capitalism and mass communications, the stage was set for an enlargement of the role of taste and style in the construction of selves, not just in art but in other domains.

The emergence in the United States of organizations segmenting high and popular culture has been described elsewhere (DiMaggio 1982a and 1982b; Levine 1988). In Boston, representatives of a commercial and industrial upper class established an art museum and a symphony orchestra at the same time they were creating private schools, social clubs, and other institutions that enabled them to maintain a bounded collective life and a distinctive cultural style. Both the museum and the orchestra began as ostensibly institutions providing a range of offerings. As they became more secure, they retained cultural experts who—supported by wealthy patrons—defined canons of "serious" works, expelling others from the collections and repertoire, respectively. In the course of doing so, they established conventions of public demeanor emphasizing restraint and respect, and restricted the public that had access to high culture to the upper and upper-middle class.

Other cities reached the same end point by trajectories that varied with differences in local social structure. By contrast to Boston, New York possessed both a middle-class that was large enough to ensure the viability of commercial orchestras and an elite that was too large and too poorly integrated to monopolize cultural authority. Shifting coalitions within this fragmented elite created numerous orchestras, none of them sufficiently successful to define a single canon of fine-arts music. Competing orchestras sought public favor through product differentiation, light programming, novelties, and extravaganzas long after Boston's symphonic repertoire had become limited and austere. Competition among elites prevented any from wresting control from the orchestra's commercial entrepreneurs (Shanet 1975; Jaher 1982; Martin 1983). Nearly fifty years after the founding of Boston's symphony, financial pressures caused a series of mergers that created the New York Philharmonic Symphony, which adopted a repertoire similar to Boston's. By this time, the increasingly national institutional basis of high and popular cultures had already eroded regional differences.

THE NATIONALIZATION OF HIGH CULTURE: FROM RESOURCE TO CAPITAL

The emergence of the high-popular culture dichotomy as a hierarchical, universal, and symbolically potent system of symbolic classification was more

than an aggregate outcome of separate events in scattered cities. Equally important was the institutionalization of cultural capital at the national level, which entailed both near-universal apprehension (and acknowledgment as legitimate) of the scheme of classification of symbolic goods and the emergence of institutions with the cultural authority to sustain and regulate the currency. Rather than provide a narrative account of this process, I shall simply emphasize three aspects: the systematic construction of national organizational fields, the incorporation by universities of the arts, and the role of commercial culture industries.

The Construction of Organizational Fields

The first step in the vesting of cultural authority over the arts in organizations rather than persons was the creation of U.S. art museums and symphony orchestras. Until the 1920s, however, the "formal" quality of these organizations was more apparent than real; in effect, they were corporate charters draped over the ongoing collective life of the wealthy men and women who organized and controlled them. Little by little, the patrons came to share control with professional experts; and these professionals were quick to organize national associations that sought to shape the development of the institutions over which they exercised nominal authority.

This process was most visible in the museum world, where such organizations as the American Association of Museums, the College Art Association, and the American Federation of Arts were active by the 1920s. Such organizations established national standards for the exhibition and care of objects, the responsibilities of trustees, the design of exhibitions, and the teaching of art in university courses. They also created a national network of museum professionals who shared a common understanding of the artistic culture to which their institutions were devoted.

Equally important were the national foundations—especially the Carnegie Corporation and the Rockefeller philanthropies—that supported this organizational infrastructure (DiMiggio 1988 forthcoming; Lagemann 1990). Whereas before 1920 such foundations were primarily extensions of their founders, afterward they boasted professional staff who took substantial initiative (albeit under their trustees' watchful eyes). Their ideology was "progressive"; that is, they sought to use experts to rationalize the organizations that foundations supported (and thereby to increase their contribution to the public good) (Lagemann 1983). Taken together, the foundations' programs and those of the national associations they supported tended to institutionalize and diffuse elite definitions of high culture and models of high-culture organizations (DiMaggio 1988; Keppel and Duffus 1933; Lagemann 1990).

The Universities

Equally important in the constitution of high culture as cultural capital were the universities. As Bourdieu has argued, the expansion of higher education and the pivotal role of certification for the careers of children of both upper and upper-middle classes in contemporary society have given universities substantial influence over the definition of "official" culture. As keepers of the canons, universities and liberal arts colleges play the key role in disseminating cultural hierarchies in the fields in which they provide instruction.

Although instruction in art, music, and even drama antedates the turn of the century, the arts attained a solid place in university curricula only during the 1920s, in part through the efforts of private philanthropies. In 1876, just seven institutions offered courses in art history or appreciation; in 1916, fewer than one-quarter of U.S. colleges and universities did so; by 1930, such courses were offered by nearly every institution, and faculty who had been strewn among several departments were consolidated in departments of art history. University art history departments, in turn, trained a cadre of art historians whose business it was to make aesthetic judgments according to standard criteria and to develop lists of artists worthy of study. Because these art historians often worked as curators or museum directors and as consultants to art dealers or collectors, they contributed to a nationalization of elite culture. The same was true, to a lesser extent, in music. Courses in art and music made strides in U.S. high schools as well; moreover, the period witnessed a partial shift from courses that emphasized the "doing" of art (for example, training in shape-note singing) to courses in "appreciation" that disseminated the high-culture canon to the increasing proportion of adolescents who attended high school (Hiss and Fansler 1934; Levy 1938).

Commercial Culture Producers

The rise of an institutionalized high culture was inseparable from the emergence of popular culture industries, which provided a profane contrast to the sacred offerings of the former. Such industries arose alongside U.S. museums and orchestras during the same period: first the national vaudeville chains, then the oligopolistic theatre touring operations, the film industry, sound recording, and—by the 1920s—radio broadcasting. The unfortunate emphasis of the Frankfurt School on the "massifying" effects of commercial culture has distracted attention from the role that its producers played in extending popular understanding of and exposure to high culture during the first part of this century. Newspapers publicized the exhibitions of art museums and served as bases for music critics schooled in European traditions. Commercial presses published volumes with titles such as *Standard Symphonies* and *Pictures Every*

Child Should Know. Phonograph record companies offered classical lines. The RCA Victor Company's Educational Department distributed *Music Appreciation with the Victrola for Children* (1923), a guide that provided music teachers with lesson plans keyed to items in the Victor catalogue.

Radio gave a special impetus to the nationalization of the fine-arts music canon, in part because radio depended on live music to fill its program hours during its first decades. (Music accounted for 74 percent of New York City broadcast time in 1927 and 62 percent of Minneapolis-St. Paul radio broadcasts in 1932 [Lundberg et al. 1934].) The National Broadcasting Company even retained famed conductor Walter Damrosch, host of an educational symphony hour, as its "musical counsel."

Popular media extended to small towns and rural areas the heterogeneity that had long existed in U.S. cities. To grasp the interdependence of the popular and elite, consider the origins of the "Grand Ole Opry," the long-running country music program that epitomizes much of what highbrow media critics detest. The "Grand Ole Opry" began as a standard variety show (the "WSM Barn Dance") on Nashville's NBC affiliate, where it followed the network feed of Damrosch's "Music Appreciation Hour." One night in 1927, Damrosch offhandedly criticized musical "realism." The "Barn Dance" host opened his show with a humorous rebuttal. "For the past hour," he added, "we have been listening to music taken largely from Grand Opera, but from now on we will present the Grand Ole Opry!" (Moore 1969). Thus, popular culture defined itself in contrast to an increasingly powerful high-culture model, and radio created a national audience for both (Horowitz 1987).

THE INSTITUTIONALIZATION OF CULTURAL CAPITAL

Thus, it happened that by 1930 a particular selection of European artworks and styles was constituted as cultural capital in the United States—that is, it became hierarchically differentiated from other kinds of culture, symbolically potent, and universally acknowledged. Locally, high culture was anchored in new kinds of formal organizations: art museums, symphony orchestras, opera companies, and, eventually, dance and theatre companies organized according to the nonprofit model. This infrastructure was embedded in a national interorganizational network of professional associations, service organizations, private foundations, and proprietary corporations equipped to profit from the diffusion of art. At the apex of this system were the universities, authorized to validate, inculcate, and—within limits—expand the high-culture artistic, musical, and literary canons. Virtually none of this organized activity existed in 1870; before 1910, the high arts operated almost entirely at the local level. Only later did the arts shift from an urban cultural resource to a national cultural capital.

Much more might be said to this period, especially about the tensions implicit in both local variations in the adoption of institutional models and in the distinctive interests of nationally organized actors, which would often clash with the desire of urban elite status groups for a relatively exclusive and stable high culture. For now, however, it is more important to address three other issues.

First, what were the effects of the institutionalization of high culture as cultural capital? The 1920s witnessed a sharp increase in several indicators of middle- and upper-class interest in the arts: a dramatic rise, for example, in the value of imported artworks; a 75 percent increase in the census count of artists, sculptors, and art teachers between 1920 and 1930; and similar trends in other cultural indicators (Keppel and Duffus 1933). Moreover, scattered surveys from the 1930s point to high levels of radio listenership, piano and phonograph ownership, childhood music lessons, avocational instrument playing, and—to a lesser extent—attendance at live high-culture performing arts events among the middle and upper-middle class (Lundberg et al. 1934; Allard 1939).

At the organizational level, we see the spread of orchestras and art museums to large and mid-sized cities and the widely held assumption that, as the Ogburn Commission report put it, "it is generally agreed that every city of 250,000 population or more can support an art museum" (Keppel 1934). Judith R. Blau's study (1988) of the diffusion of art museums points to the taken-for-granted nature of museums as part of the furniture of large urban places. Whereas before 1900, museum founding was more characteristic of slowly than of rapidly expanding cities (presumably because of the greater stability of upper classes in the former), after 1930, population expansion was positively rather than negatively associated with museum foundings. Moreover, whereas before 1930, change in a city's median level of educational attainment was unrelated to museum foundings, after 1930, increases in educational attainment became a strong predictor, reflecting the incorporation of the fine arts into legitimate school knowledge.

Second, what was the impact on the process of technological change and mass consumption? Certain inventions—the automobile, the telephone, cinema, and radio—were critical in their own right. Telephones and automobiles lowered the cost of interaction among people living substantial distances apart and increased the zone of privacy, permitting persons to segregate audiences and segment social networks to a greater degree than in the past. As Lewis Erenberg (1981) has shown, middle-class and elite night clubs emerged about the same time that automobiles and telephones came into widespread use, expanding opportunities for social interaction outside the home. Presumably the separation of social relations from the home (and from emblems of status the home contained) increased the utility of what Bourdieu (1986) calls "embodied cultural capital," including the display of the self and its achieve-

ments through conversation. Cinema and radio vastly increased the range of social experience, providing an array of imitatable styles and selves with which persons could experiment in the enlarged social space created by the automobile and the telephone.

More generally, as Daniel Bell (1976) has noted, mechanization and advertising rendered style an inescapable force in the lives of the middle class. Mechanization entailed mass production and merchandising of goods that previously had been available only to the rich, but it also meant small-batch production of designer items for the public that shopped in urban department stores. Such stores, often in alliance with museums of art, sought to cultivate the public's aesthetic sensibilities, to enable consumers to distinguish the beautiful and well made from the coarse and insubstantial. Although the effusions of the 1930s—"the granddaughter who buys a new rug discriminatingly is quite as clearly an artist as was her grandmother who, with spinning wheel and loom, made her colorful carpet"—now appear quaint, what is clear is that mechanization and advertising increased the number of distinctions the middle-class American had to make and the number of things there were to know about style (Haggerty 1935, p. 21). Command of such knowledge became a basis for evaluation at the time that such traditional markers of identity as family and place became less reliable.

Finally, my interpretation of this period is at odds with one of two parts of received wisdom about the advent of the mass media. Mass-culture critics correctly alleged that the rise of corporate culture producers turned the arts from producer to consumer goods. This was certainly the case for music: Survey data indicate that the percentage of middle-class Americans taking music lessons and playing instruments was far higher in the 1930s than it is today. (Levels of participation in visual arts and crafts activities appear to be roughly similar, however.)

But mass-culture critics erred in their preoccupation with "brow levels," which owed more to elite ideology than to social research. What was important about the arts that record companies, department stores (sometimes working with art museums), and radio stations brought to the U.S. public was not that they were a "dilute" form of a high culture that had existed in the past in pristine purity. Rather, the very process of definition of a dominant high culture in the arts relied upon the assistance of commercial enterprises in packaging for middle-class consumption an institutionally authorized mix of prestigious cultural goods, much of which had been part of a general popular culture less than a century earlier. Although "middlebrow" products were not to the liking of critics with the greatest stake in maintaining an unwatered cultural currency, they were essential in constituting as cultural capital a public version of the culture that the critics valued.

[46]

THE EROSION OF HIGH CULTURE
IN THE LATE TWENTIETH CENTURY

The United States entered the post-war era with a strongly classified high culture organized around university training of artists and consumers and nonprofit producing and exhibiting organizations commanded by trustees drawn from their communities' wealthiest and often oldest families. Despite rhetorical salutes to the value of education, these institutions were largely in the business of defending three kinds of related symbolic boundaries. One boundary was between fine art and good music—canonized works defined as unique, timeless, and nonutilitarian—and the "degenerate" products of commercial popular culture. Another was social, between people of taste who were capable of the disinterested appreciation of true art (largely the upper and upper-middle class) and the vulgar "mass public." A third was organizational, between governance by trustees and aesthetic specialists on behalf of art for its own sake and the kinds of bureaucratic and market-oriented administrative systems characteristic of commercial enterprises—systems that, it was asserted, would compromise both the freedom of artistic personnel and the integrity of art.

During the last thirty years, the high-culture system has been eroding, and with it the strong classification between a sacred high culture and its profane popular counterpart. This erosion is visible at the level of production in the annexation of advertising and commercial art styles and even objects into fine-arts compositions; in the emergence of performance art out of dramatic, circus, and vaudeville traditions; in the ever-thinning boundary between ballet and modern dance; in the production by opera companies of musical comedy; in the repertoires of chamber ensembles that, like Kronos, mix fine-arts compositions with songs by Jimi Hendrix and Argentinian tango masters; in shifts of composers and performers from rock to orchestral music (Frank Zappa), from jazz to fine arts (Ornette Coleman), from performance art to rock (Laurie Anderson) and country music (k. d. lang), and from porn to performance art (Annie Sprinkle); and in the increasing prominence of what Bourdieu (1965) has called *les arts moyennes*—for example, photography, jazz, new age music, and craft art. Such developments, which are far more numerous than earlier transgressions of genre boundaries and which have lost their predecessors' capacity to shock, are often remarked upon by critics and journalists. But they are poorly understood because of the habit of attributing them either to internal change in specific art worlds or to a postmodern *zeitgeist*, rather than to change in social structure and organization.

I shall argue below that the system of classification of artistic goods is becoming more finely, but also less clearly, differentiated, less universal, and less symbolically potent. The social structure continues to generate high levels of

[47]

demand for the cultural goods with which social identities can be fashioned. But structural changes that weaken the institutional bases of cultural authority transforms this demand into an inflationary spiral, undermining the cultural capital on which the symbolic economy has rested while proliferating weaker currencies.

The engine behind declassification is the market economy. High culture emerged as a status culture of a class in formation; as Max Weber (1968) noted, dynamic markets are inherently antagonistic to status cultures. Markets for culture goods enable consumers to convert financial wealth into symbols of status and drive producers to efface genre boundaries in search of larger audiences. Yet men and women who understood this fact designed the high-culture system in both structure and ideology to buffer a high culture from market forces. So these observations about markets do not by themselves explain why the system now fails to do so.

The answer lies, I believe, in three interacting sources of change. The first is change in social structure, of which two aspects are crucial: a transformation of the U.S. elite from a confederation of cohesive urban upper classes knit together by kinship, place, and culture to a national elite defined by positions of authority in large organizations; and the rise of a massive, college educated, mobile upper-middle class for whom taste and cultural style are important emblems of identity and sources of interpersonal information. The second change is the eclipse of private patronage and the rise of institutional patronage from private foundations, corporations, and an expanding state. A third change, following from the first two, has occurred at the organizational level and can best be characterized as a managerial revolution in the arts. I shall consider each of these developments in turn.

The Changing Basis of Elite Authority

In *Philadelphia Gentlemen*, E. Digby Baltzell noted the "democratization of plutocracy," the decline of the inner-directed upper classes with the destruction of family capitalism and their replacement by a national elite, detached from loyalty of place, whose authority rests on bureaucratic command rather than on kinship; club life, or culture. These fading urban upper classes, at once elites and status groups, formed the principle constituency for and organizers of a bounded high culture. Not only did they create the U.S. high-culture institutions; for many years, they maintained their exclusivity, resisting pressures for expansion. Such resistance was exemplified by the Metropolitan Museum of Art's rejection in the 1930s of a Carnegie Corporation grant that would have supported a branch museum for immigrants on the lower East Side; by the Philadelphia Orchestra's arm's-length relationship to the popular Robin Hood Dell concerts (Arain 1971); by the opposition in

1953 of 91 percent of the board chairmen of the nation's five hundred symphony orchestra to public subsidy for the arts (Hart 1973); and by the ambivalence of museums to educational programs and their tendency, for many years, to schedule them at times of the day when most adults are at work (Zolberg 1986).

With the passing of self-reproducing urban upper classes, the most influential constituency for a strongly bounded high culture vanished. Arts trustees, now more numerous with the vast expansion in the numbers of arts organizations and more likely to be recruited from the corporate middle class, are increasingly open to an expansionist dynamic that pushes their institutions closer to the market and threatens conventional forms of insulation of high-culture audiences and artists alike.

The Social Bases of Increased Demand

Declines in the solidarity and functional importance of traditional urban upper classes explain a decline in resistance to growth by nonprofit arts organizations. They do not, however, explain why consumers demanded more of the exhibitions and performances that these organizations offer. Although much expansion of artistic output during the 1960s and 1970s was fueled by increasing numbers of artists and new sources of subsidy, this output would not have been sustained had it not been for a genuine increase in consumer demand (Heilbron 1984).

If economists were right in viewing demand for symbolic goods as driven by individual utility maximization, we would expect increases in income and leisure time to be the best indicators of artistic consumption; economists often point to aggregate increases in each to explain expansion of demand (Lindner 1970; Scitovsky 1976). Fortunately, we can now test these assumptions at the individual level with high-quality national sample data collected by the U.S. Census Bureau—the Surveys of Public Participation in the Arts of 1982 and 1985. Our analyses of these data demonstrate that the availability of leisure has virtually no influence on whether or not persons attend high-quality arts events and that the influence of income is decidedly secondary (DiMaggio and Ostrower 1990).

The major predictor of arts consumption, of course, is educational attainment. Indeed, it seems reasonable to assume that most of the increase in cultural demand stems from the vast expansion of educational attainment of the 1960s, which resulted in the mass production of art consumers. The familiar imagery of "brow-levels," by which distinct paterns of aesthetic taste are said to map isomorphically onto social strata, is nowhere visible, however. Rather, the Census Bureau data reveal a pattern of *stratification without segmentation.* Highly educated people are more likely to report going to movies and enjoying rock and rhythm-and-blues music. John P. Robinson, et al. (1985) calls this

"the more-more principle": People who attend or like presentations of any kind of art are more likely to attend or like any other.

What we have, then, is a large, well-educated, geographically mobile upper-middle class, with attenuated ties to place and complex role structures that facilitate and reward participation in multiple cultural traditions. Whereas the nineteenth-century urban logic of cohesive status groups militated toward the exclusive allegiance of the members to tightly bounded status cultures, the rapid growth in numbers of the college educated engenders pressures toward cultural inflation (Collins 1977).

The role of formal education in such a social structure is, as Bourdieu has argued, to inculcate not tastes per se but a capacity for aesthetic adaptation: The self and its tastes become a project upon which the middle-class consumer constantly works. In the 1982 U.S. Census Bureau survey, with controls for family background, we found that cultural socialization has been distanced from family socialization—taking place less in the home and more in classes and workshops, both at school and in later life. The product is an eclectic disposition inimicable to a strongly bounded high culture and open to the proliferation of weakly insulated *arts moyennes*, with attributes of both traditionally high and popular cultural forms. This is consistent as well with Judith Blau's finding that the number of arts organizations of selected kinds in U.S. cities (which I interpret as a proxy for the degree of differentiation in styles available to consumers) is a positive function of the size of the educated upper-middle class (Blau 1986).

The Eclipse of the Private Patron and the Rise of Institutional Support

If changes in social structure account for reduced opposition by arts trustees to expansionary growth and the rise in demand for differentiated forms of aesthetic experience, neither by itself explains the large-scale growth of the nonprofit arts. Had arts organizations merely followed existing routines, they would not have captured much of this increased demand, for nonprofits typically respond less quickly to market forces than do their proprietary competitors (Weisbrod 1988).

The rise of institutional sponsorship made a nonprofit response possible, altering the structures, programs, and objectives of the arts organizations that have been their beneficiaries. Increases in institutional funding have been substantial. Support from independent foundations grew from about $12.6 million in 1955 to approximately $350 million in 1984. Corporate assistance, negligible through the early 1960s, rose to nearly $400 million by the mid-1980s. By 1988, federal assistance—virtually nonexistent before 1965—stood at more than $160 million, while state government subsidies amounted to about $300 million.

What explains the massive rise in institutional subsidy? The conventional story is that it was necessary for the arts' survival. As deficits outran the ability of private patrons to cover them, foundations and government stepped in to make up the difference. The most sophisticated and influential version of this argument (Baumol and Bowen 1966) emphasizes increasing deficits due to the inability of arts supplies (like other labor-intensive service industries) to keep pace with technologically induced productivity growth in the manufacturing sector.

Without doubting that this dynamic exists, we may question its centrality to the abrupt growth of institutional patronage in the 1960s and 1970s. First, productivity disparities between the service and manufacturing sectors have always existed; why these disparities should have made institutional support shoot up so rapidly over a particular twenty-year span is not apparent. Indeed, as productivity growth in the economy has slowed with the transition from an industrial to a service economy, the discrepancy between service-sector and overall growth rates has narrowed. Second, it has become apparent that arts organizations can exploit administrative rationalization and marketing techniques to increase revenues significantly. Third, and most important, the economic trials of the arts have been crises of growth, attributable to dramatic expansion both in the size of existing organizations and in the number of arts organization (DiMaggio 1987b).

The rapid increase in foundation support for the arts, led by the Ford Foundation programs of the 1960s, represented a concerted effort to expand the artistic resources available to Americans, not simply to maintain the status quo. The emergence of the first major government program, the New York State Council on the Arts, reflected both the strong ties of Governor Rockefeller to the arts and philanthropic communities and the unique economic significance of the arts industry in that state. The creation of a federal arts agency, the National Endowment for the Arts, in 1965 was a natural concomitant to the expansion of the central state (the United States was the only major power without a cultural agency at the national level) and might have occurred far earlier but for the peculiar political legacy of the New Deal arts programs and the reluctance of traditional performing arts patrons to accept government aid.

Once in place, institutional funding entailed three parallel logics that, in tandem, have tended to erode the power of traditional trustees, expand the definition of art and its public, and—paradoxically—push the nonprofits arts toward dependence on the marketplace. The first of these is the *logic of access*. Almost all institutional patrons encourage grant recipients to increase the size of the publics they serve and, to some extent, take audience expansion as evidence of organizational success. The preoccupation with numbers pushes organizations toward the market and toward marketing, whether

through blockbuster exhibitions, performances of works that appeal to large publics, or—in experimental forms—to post-performance cocktail parties that break down barriers between artists and audience.

A second logic shared by nearly all institutional founders, especially government, is the *logic of accountability*. Accountability is defined, in practice, as the capacity to generate grant proposals and reports containing detailed financial and audience data and in terms of creation of administrative structures consistent with the expectants of institutional patrons. Many such patrons have linked support to nonartistic warrants of organizational virtue, such as marketing schemes, endowment policies, and strategic plans.

One effect of the logic of accountability is to minimize the viability of non-bureaucratically managed organizations, whether performers' collectives or elite institutions with patrimonial, club-like administrative systems. A second is to create new forms of expertise, the possession of which represents a source of power for administrators in their conflicts with trustees and artistic staff. A third is to increase the sheer administrative intensity of arts organizations. In analyses of data from the National Center for Educational Statistics' 1980 Museum Program Survey, we found that both the proportion of revenues received from government and the heterogeneity of funding sources (expressed as a Herfindahl index) significantly increased the proportion of staff and budget that are museums devoted to administration (DiMaggio and Powell 1984).

A final logic of institutional patronage, largely restricted to governmental funders, is the *logic of constituency formation*. From its creation, the National Endowment for the Arts worked to build a national constituency to support its efforts to garner larger appropriations from Congress. Lured by the availability of federal grants, by 1972 every U.S. state had created an arts agency; in turn, many states encouraged the proliferation of local arts agencies, of which there are now roughly three thousand. (Many local agencies now define themselves as "chambers of commerce for the arts," further legitimating the notion of culture as a public service linked to economic growth. California requires the state's three hundred-odd local arts agencies to engage in "community cultural planning and evaluation" as a condition of state support.)

A Managerial Revolution in the Arts

Most nonprofit organizations have ambiguous goals, numerous missions, and multiple constituencies; the internal politics of nonprofits are often characterized by tension between trustees, administrators, and professional staff. In the high-culture organizational model of the first part of the century, trustees and aesthetic professionals shared power. In recent years, institutional funding and organizational growth have altered the balance of influence, rendering administrative staff more numerous and more powerful.

The last two decades have witnessed the emergence of a new cadre of professional arts managers, especially in the performing arts, trained in university arts administration programs or management schools (Peterson 1986). These administrators are accomplishing what might be called, after Burnham and Berle and Means, a managerial revolution in the arts.

The managerialists contended that the profit-making corporation had succumbed to a managerial revolution that altered the operating objectives of the firm. This view has been called into question by an unlikely combination of neo-Marxist sociologists and agency-theory economists, both of whom point to powerful mechanisms that create identity of interest between top executives and major shareholders. It may well be that it is in nonprofit sectors such as the arts—where goals are ambiguous, evaluation difficult, and financial mechanisms that control agency relationships weak—that Berle and Means's ideas are most apt.

The new managers' training and interests make them receptive to calls for growth and administrative reform and frequently hostile both to social exclusionary pressures and aesthetic boundary-drawing. Because administrative hierarchies in the arts are flat, they usually attain executive positions while still in their thirties; further opportunities for upward mobility by job-changing are limited. Moreover, in the performing arts, managerial salaries are tightly tethered to organizational budgets. The managers' best hope for mobility is through rapid and dramatic organizational expansion, accompanied by high levels of grant support and even higher levels of earned income. These goals are consistent both with the orientation of administrative training toward efficiency and rationalization and with the agendas of many of the new institutional patrons that have been the managers' most constant allies.

As with other professional movements, the managerial revolution in the arts is promoted by collective efforts of arts administrators to enhance their status, authority, and career opportunities. Their project has included the establishment of an academic base in university arts administration degree programs, of which more than thirty have formed since the advent of federal arts funding; the systematization of specialized knowledge not easily accessible to trustees; the building of personal ties between managers and corporate and government grantmakers, rendering trustees more dependent; and, in some cases, the elaboration by service organizations of fieldwide standards.

The new administrators participate actively in professional activities in a manner that is both rational and consequential. We created indices of professional participation for art museum directors, orchestra managers, and managing directors of resident theatres surveyed in the early 1980s, tapping involvement in activities sponsored by the major service organizations as well as service on federal state advisory panels. In all three fields, participation was

a significant predictor of managers' salaries, net organization size, gender, and several measures of educational attainment, family background, and professional experience (DiMiggio 1986).

Such participation also appears to have organizational consequences. Melissa Middleton (1989), who studied strategic planning by performing arts organizations in two Connecticut SMSAs, reported that managers' participation in fieldwide networks was a significant predictor of whether their organizations had undertaken formal efforts resulting in multi-year planning documents.

Fieldwise participation also shapes administrators' orientations to their roles. In our study of arts managers, factor analyses of attitude measures yielded indices of managerialism, reflecting an orientation toward rationalization, administrative efficiency, and the market. With appropriate controls, professional participation significantly predicted managerialism among administrators of theaters, art museums, and orchestras. It was also a strong predictor of art museum directors' orientation toward social and educational values (an endemic issue in the museum world). In other words, participation in fieldwide activities appeared to engender and reinforce orientations toward administrative efficiency and (for art museum directors) social missions, as opposed to the orientations toward social and aesthetic exclusivity characteristic of traditional high-culture institutions.

THE FUTURE OF THE CULTURE ECONOMY

The high-culture system rested on three pillars: local status groups committed to the elaboration and maintenance of a relatively static culture based on the high-culture arts; nonprofit arts organizations, insulated from market forces and politics by upper-class patronage and governance; and the system of higher education, which trained specialists in high culture, established and renewed canons in the several art forms, and inculcated in students awareness of and respect for the products of high-culture art worlds.

At least two of these three pillars—the dominance of local status groups and the insulation of nonprofit arts organizations from market forces—are crumbling, and the fate of the third—higher education—is contested. We must not discount the hold that the classification high versus popular still exercises over U.S. culture. Taste remains highly stratified. Theater and dance (and, to lesser extent, craft art, jazz, and literary publishing) have been annexed to the high-culture nonprofit system, and the traditional high arts—classical music, the visual and plastic arts, opera—thrive by historical standards. Yet, in the long run, it is not obvious that the institutional prerequisites for the preservation of centralized cultural authority—and thus for the persistence of a generalized cultural capital—will long remain in place.

At the same time, however, the social structure bases of demand for symbolic goods—wide social range, diffuse social networks, weak corporate primary groups, segmented role structures, and mass higher education—are well established. Even if the arts were to stop functioning as cultural capital tomorrow, demand for symbolic goods would remain high. Intimations of the effects of an extreme decentralization of cultural authority may be gained by observing other cultural spheres where, even more than in the arts, one finds an adumbration and blurring of genres, an increase in things to know and opportunities to make distinctions, and the persistent use by middle-class Americans of symbolic props for the definition of cosmopolitan selves.

Take, for example, the fashion revolution of the past two decades and the emergence of small-scale producers selling varied subpublics a wide variety of styles (Crane 1988). The familiar fashion cycle of the first two-thirds of the century seems to have succumbed to a more or less chronic state of syncretic pluralism. The production regime is based entirely in the market; institutionalized cultural authority is weak; and, although huge enterprises are influential, vacant niches are available to small producers with relatively little capital. In fashion (as in cuisine), the system of classification is highly differentiated, but boundaries are weak, relatively nonhierarchical, and far from universal.

Is this to be the future of the arts? Will the culture of the twenty-first century represent, as Henry Adams predicted in his *Autobiography* "not a unity, but a multiple"? Certainly the trends in the United States suggest that this may be the case. Although I have said little about technology and popular culture, the segmentation of audiences—first, for magazines and radio in the late 1950s (Peterson and Berger 1975), then for television (with the penetration of cable systems above 60 percent by the late 1980s)—cannot but reinforce centrifugal tendencies.

Yet it would be rash to suggest the demise of cultural authority, high culture, and the current place of cultural capital in the symbolic economy. Although demand for cultural goods emerges more or less directly out of social structure, the organization of supply has become to some extent a matter of public choice, embedded in an extensive, albeit highly decentralized, policy apparatus. Four axes of choice (which, to be sure, is more frequently taken by oversight than by decision) are especially important in the short run.

Policy Toward Cultural Pluralism

A current byword in arts policy circles is *cultural pluralism* (or *cultural diversity*), which ordinarily refers to a commitment to the value of (and, by implication, subsidies to artists working in) a variety of cultural traditions, especially those of Americans of Asian, African, and Latin American descent. At their most pragmatic, advocates of cultural pluralism seek a reallocation of

public funds to "minority" arts organizations, including those working in European high-culture traditions. At their most idealistic, cultural pluralists embrace cultural democracy, a communitarian view of art as a collectively created force for community change. Although much talk about cultural pluralism is lip service for the benefit of liberal legislators and minority constituencies, some of it is more than this. And African-American, Hispanic, and Asian political activism, fueled by demographic change (which is occurring most swiftly in the two arts centers of the United States—New York and California), will secure a permanent place for cultural pluralism on the policy agenda.

Cultural pluralism makes problematic the dominance of Euro-American high culture; that is, its advocates ask why artists working in certain traditions—which, more or less by historical accident, have been buffered to some extent from the market—should receive public funds, whereas artists working in traditions that have not been so favored should not. In so doing, they seek to enlist the arts policy enterprise in an effort to reassess, perhaps quite radically, the definition of serious art. If they succeed, the allocational problem—which was solved efficiently, if not equitably, by restricting the focus of most institutional funders to a relatively narrow slice of the artistic spectrum—will be formidable and—barring a dramatic rise in public support that seems unlikely in the short run—the debates will be highly contentious. Such reforms would dilute the cultural authority of universities and most conventional art museums and nonprofit performing arts firms.

Policy Toward Arts Organizations

The general thrust of arts policy in the United States has been toward what is referred to in policy circles as *institutionalization*: nurturing arts organizations, preventing existing organizations from failing, encouraging small organizations to become larger and large organizations to seek immortality. The reasons for this policy are clear enough: The constituency-building imperative leads arts agencies to try to keep their constituents healthy and alive and to respond more quickly to organized constituencies than to unorganized supplicants. Policies of institutionalization and expansion encourage arts organizations to become larger, more bureaucratic, and more dependent on both institutional subsidy and earned income. Although many institutional patrons try to support innovative programming, dependence on earned income (especially in the performing arts, where audiences are organized by subscription) tends to overwhelm such efforts and drive presenting organizations toward safe or commercially rewarding repertoire. Moreover, the emphasis on expansion through earned income has been self-defeating, insofar as larger organizations require more institutional patronage (in absolute

terms) even if a larger proportion of their income is earned through the sale of services.

An alternative policy which would probably be more effective in stimulating innovation (although less effective in maintaining constituencies and providing artistic services to large publics), would be to lower barriers to entry rather than attempting to ensure institutional immorality. To an extent, this would involve doing the opposite of what public agencies now do: focusing grants on new, unproven enterprises, discouraging expansion, investing in organizations with the expectation that many of them would expire. A full embrace of such a policy would be politically suicidal for public agencies. Nonetheless, some pressures are building for a modest reorientation of this kind, which—like cultural pluralism—would tend further to decentralize cultural authority.

Policy Toward Higher Education

Because demand is fueled by higher education, the shape of the university system—the site of the most vigorous debates over the status of high culture (e.g., Bloom 1987, and Bloom's critics)—will also have important implications for the direction in which the cultural economy evolves. Universal higher education would further stimulate demand for and production of symbolic goods; sharp cutbacks in enrollments or an even more massive redirection of students into vocational commuter programs than has already occurred (Brint and Karabel 1989) would restrict demand. By contrast, the stronger the level of support for the traditional humanities disciplines, the better the life chances of the conventional cultural hierarchies.

Policy Toward Mass Communications

A final question with which public policy must come to grips is the extent to which access to information and cultural goods should be allocated by the market. In the nineteenth century, it was believed that cities and philanthropists had a responsibility to make artistic experiences available to the poor, and, indeed, the civic uses of art and music tended to render culture a form of public good. These impulses lessened with the consolidation of a cultural hierarchy in the late nineteenth century, although they were renewed in the New Deal arts projects of the 1930s. As they flagged, however, the problem of a common culture was largely solved when the mass media of radio and television were established as public goods, supported by the sale of audiences to advertisers rather than by the sale of programs to the public.

The rise of cable and other forms of pay television (as well as the instrumental data services being offered to computer users) is converting a much larger portion of culture to a private good and portends both a sharp increase

in cultural inequality and an end to the mass media's role as purveyors of a shared symbolic universe in which most Americans participate. The deregulatory policies of the Reagan administration encouraged the fragmentation of the audience, at the same time facilitating the centralization of economic control over programming. Moreover, the fate of public broadcasting, rendered redundant by the availability of cable to its core audience, becomes ever more clouded. To the extent that the current drift of policy continues, it will reinforce tendencies against universality and toward greater differentiation in U.S. culture.

CONCLUSION

Such policy choices will shape the resolution of two more broadly significant questions affecting our cultural well-being. If the current system of classifying art and sponsoring artistic production and distribution is creaking under the weight of social and political change, can we devise alternative institutions to preserve the autonomy of some artistic practice from the dictates of the economic marketplace? I do not mean to imply that the market is constraining whereas other forms of patronage are benign, any more than I would agree with the often-echoed, nineteenth-century view of the market as a free and neutral means of releasing artists from the yoke of patronage. Rather, I believe that artists are likely to be most productive and creative if they are collectively subject to a variety of constraints rather than just one.

The virtue of the high-culture system is that it succeeded in cordoning off a sector of cultural production from the demands of the marketplace. Its great disadvantage is that it assisted only some kinds of artists in a way that responded to the status interests of the wealthy rather than to the functional needs of either the arts or society. To the extent that the high-culture system erodes, we face the challenge and opportunity of constructing a reclassification of symbolic goods that does not map neatly onto the structure of social inequality—in other words, systems of patronage and cultural authority consistent with a democratic art.

Second, we should anticipate the effects of cultural inflation on the capacity of persons to navigate the relational waters of a complex and highly differentiated organizational society. An advantage of highly bounded and ritually potent cultural classifications is that they possess much communication value, enabling people to connect with others on brief exposure. An advantage of universal classifications is that they provide a common field of discourse. I shall not jump on the bandwagon of the cultural literacy movement, which has failed to grapple seriously with the exercise of domination implicit in any effort to codify significant cultural knowledge (Hirsch 1988). I do, however, believe that Daniel Bell's observation that "the system of social relations is so complex and differentiated, and experiences are so specialized, complicated,

or incomprehensible, that it is difficult to find common symbols" (1976, p. 95) warrants our attention. If the dominant form of cultural capital (which provides a set of common symbols) is devolving into a diffuse set of disparate cultural resources—that is, if authority were to become as decentralized in the arts and literature as in fashion and cuisine—then we should be able to predict what, if any, effect this might have upon social integration and patterns of inequality in cultural property.

The received terminology of lay and academic cultural criticism—phrases such as mass society, highbrow/lowbrow, postmodernism—will not get us very far in addressing such issues. Terms that have entered the sociological vocabulary during the past two decades—cultural capital, cultural industry systems, and others developed by Pierre Bourdieu and his associates in France and Richard Peterson and students of production systems in the United States—will provide more leverage. What such recent progress promises is an analytic sociology of culture, distinct from criticism and textual interpretation, sensitive to the structural and pragmatic aspects of the symbolic economy, rigorously empirical in method and temperament, and thus capable of a comprehension of contemporary cultural change that is independent of the categories of the nineteenth century.

I am grateful to Wendy Griswold, Richard A. Peterson, and the conference's organizers and participants for helpful critical reactions and editorial assistance.

REFERENCES

Allard, Lucille Edna. 1939. *A Study of the Leisure Activities of Certain Elementary School Teachers of Long Island*. New York: Bureau of Publications, Teachers College, Columbia University.

Altick, Richard D. 1978. *The Shows of London*. Cambridge, Mass.: Harvard University Press.

Arian, Edward. 1971. *Brahms, Beethoven and Bureaucracy*. University: University of Alabama Press.

Baumol, William J., and William G. Bowen. 1966. *The Performing Arts: The Economic Dilemma*. Cambridge, Mass.: MIT Press.

Bell, Daniel. 1976. *The Cultural Contradictions of Capitalism*. New York: Basic Books.

Blau, Judith R. 1986. "The Elite Arts, More or Less *De Rigueur*: A Comparative Analysis of Metropolitan Culture." *Social Forces* 64: 875–905.

———. 1988. "Historical Conditions of Museum Development." Paper presented at the annual meetings of the American Sociological Association, August 1988.

Bloom, Allan. 1987. *The Closing of the American Mind*. New York: Simon and Schuster.

Bourdieu, Pierre. 1965. *Un Art Moyen: Essai sur les Usages Sociaux de la Photographie*. Paris: Editions de Minuit.

———. 1984. *Distinction: A Social Critique of the Judgment of Taste*. Translated by Richard Nice. Cambridge, Mass.: Harvard University Press.

————. 1986. "The Forms of Capital." Pp. 241–258 in John G. Richardson, ed., *Handbook of Theory and Research for the Sociology of Education.* Westport, Conn.: Greenwood Press.

Bourdieu, Pierre, and Jean-Claude Passeron. 1977. *Reproduction: In Education, Society, Culture.* Translated by Richard Nice. Beverly Hills: Sage Publications.

Brint, Steven, and Jerome Karabel. 1989. *The Diverted Dream: Community Colleges and the Promise of Educational Opportunity in America, 1900–1985.* New York: Oxford University Press.

Burke, Peter. 1978. *Popular Culture in Early Modern Europe.* London: Temple Smith.

Colllins, Randall. 1977. "Some Comparative Principles of Educational Stratification." *Harvard Educational Review* 47:1–27.

————. 1979. *The Credential Society: An Historical Sociology of Education and Stratification.* New York: Academic Press.

Crane, Diana. 1988. "Fashion Worlds: An Anatomy of Avant-Garde Fashion Tradition." Paper presented at the fourteenth annual Conference on Social Theory, Politics, and the Arts, American University, Washington, D.C., October 1988.

DeNora, Tia. 1989. "Musical Patronage and Social Change at the Time of Beethoven's Arrival in Vienna: A Case for Interpretive Sociology." Manuscript, Department of Sociology, University of California at San Diego.

DiMaggio, Paul. 1982a. "Cultural Entrepreneurship in Nineteenth-Century Boston: The Organization of a High Culture in the United States." *Media, Culture, and Society,* 4:33–50, 303–320.

————. 1982b. "Cultural Entrepreneurship in Nineteenth-Century Boston: The Classification and Framing of American Art." *Media, Culture, and Society* 4:303–322.

————. 1986. *Managers of the Arts: Careers and Opinions of Executives of U.S. Art Museums, Resident Theaters, Symphony Orchestras, and Community Arts Agencies.* Washington, D.C.: Seven Locks Press.

————. 1987a. "Classification in Art." *American Sociological Review* 52:440–455.

————. 1987b. "Nonprofit Organizations in the Production and Distribution of Culture." Pp. 195–220 in Walter W. Powell, ed., *The Nonprofit Sector: A Research Handbook.* New Haven, Conn.: Yale University Press.

————. 1988. "Progressivism in the Arts." *Society* 25:70–75.

————. Forthcoming. "Constructing an Organizational Field As a Professional Project: The Case of Art Museums, 1920–1940." In Walter W. Powell and Paul DiMaggio, eds., *The New Institutionalism in Organizational Analysis.* Chicago: University of Chicago Press.

DiMaggio, Paul, and Francie Ostrower. 1990. "Participation in the Arts by Black and White Americans." *Social Forces* 68 (March).

DiMaggio, Paul, and Walter W. Powell. 1984. "Institutional Isomorphism and Structural Conformity." Manuscript, Sociology Department, Yale University.

Douglas, Mary, and Baron Isherwood. 1979. *The World of Goods: Towards an Anhropology of Consumption.* New York: Norton.

Erenberg, Lewis. 1991. *Steppin' out: New York Night Life and the Transformation of American Culture, 1890–1930.* Chicago: University of Chicago Press.

Granovetter, Mark, and Roland Scoong. 1988. "Threshold Models of Diversity: Chinese Restaurants, Residential Segregation, and the Spiral of Silence," in Clifford Clogg, ed., *Sociological Methodology.* Washington, D.C.: American Sociological Association.

Haggerty, Melvin E. 1935. *Art As a Way of Life*. Minneapolis: University of Minnesota Press.

Hart, Phillip. 1973. *Orpheus in the New World: The Symphony Orchestra as an American Cultural Institution*. New York: W. W. Norton.

Heilbrun, James. 1984. "Once More, with Feeling. The Arts Boom Revisited," in William S. Hendon, ed., *The Economics of Cultural Industries*. Akron, Ohio: Association for Cultural Economics.

Hirsch, E. D. 1988. *Cultural Literacy* (2nd ed.). New York: Vintage.

Hiss, Priscilla, and Roberta Fansler. 1934. *Research in Fine Arts in the Colleges and Universities of the United States*. New York: The Carnegie Corporation.

Horowitz, Joseph. 1987. *Understanding Toscanini: How He Became an American Culture-God and Helped Create a New Audience for Old Music*. Minneapolis: University of Minnesota Press.

Jaher, Frederic Cople. 1982. *The Urban Establishment: Upper Strata in Boston, New York, Charleston, Chicago, and Los Angeles*. Urbana: University of Illinois Press.

Keppel, Frederick P. 1934. "The Arts," in William F. Ogburn, ed., *Recent Social Trends in the United States*. New York: Whittlesey House-McGraw-Hill.

Keppel, Frederick P. and R.B. Duffus. 1933. *The Arts in American Life*. New York: McGraw-Hill.

Lagemann, Ellen Condliffe. 1983. *Private Power for the Public Good: A History of the Carnegie Foundation for the Advancement of Teaching*. Middletown, Conn.: Wesleyan University Press.

————. 1990. *The Politics of Knowledge: A History of the Carnegie Corporation of New York*. Middletown, Conn.: Wesleyan University Press.

Levine, Lawrence. 1988. *Highbrow/Lowbrow: The Emergence of Cultural Hierarchy in America*. Cambridge, Mass.: Harvard University Press.

Levy, Florence N. 1938. *Art Education in the City of New York: A Guidance Study*. New York: School Art League of New York.

Lindner, Staffan B. 1970. *The Harried Leisure Class*. New York: Columbia University Press.

Lundberg, George A., Mirra Komarovsky, and Mary A. McInerny. 1934. *Leisure: A Suburban Study*. New York: Columbia University Press.

Martin, George. 1983. *The Damrosch Dynasty: America's First Family of Music*. Boston: Houghton Mifflin.

Middleton, Melissa. 1989. *Planning As Strategy: The Logic, Symbolism, and Politics of Planning in Nonprofit Organizations*. Ph.D. dissertation, Organizational Behavior Program, Yale University.

Moore, Thurston, ed. *Pictorial History of Country Music*, vol. 1. Denver: Heather Enterprises, 1969.

Mukerji, Chandra. 1983. *From Graven Images: Patterns of Modern Materialism*. Berkeley: University of California Press.

Peterson, Richard A. 1986. "From Impressario to Art Administrator: Formal Accountability in Nonprofit Cultural Organizations." Pp. 161–183 in Paul DiMaggio, ed., *Nonprofit Enterprise in the Arts: Studies in Mission and Constraint*. New York: Oxford University Press.

Peterson, Richard A., and David Berer. 1975. "Cycles in Symbol Production: The Case of Popular Music." *American Sociological Review* 40:158–173.

Robinson, John P., Carol A. Keegan, Terry Hanford, and Timothy Triplett. 1985. *Public Participation in the Arts: Final Report on the 1982 Survey.* Washington, D.C.: Report to the National Endowment for the Arts, Research Division.

Scitovsky, Tibor. 1976. *The Joyless Economy: An Inquiry into Human Satisfaction and Consumer Dissatisfaction.* New York: Oxford University Press.

Shanet, Howard. 1975. *Philharmonic: A History of New York's Orchestra.* Garden City, N.Y.: Doubleday.

Weber, Max. 1968. *Economy and Society,* ed. by Guenther Roth and Claus Wittich. New York: Bedminister Press.

Weber, William M. 1976. *Music and the Middle Class in Nineteenth-Century Europe.* New York: Holmes and Meier.

Weisbrod, Burton. 1988. *The Nonprofit Economy.* Cambridge, Mass.: Harvard University Press.

White, Harrison C., and Cynthia White. 1965. *Canvasses and Careers: Institutional Change in the French Painting World.* New York: John Wiley and Sons.

Zolberg, Vera. 1986. "Tensions of Mission in American Art Museums." Pp. 184–198 in Paul DiMaggio, ed., *Nonprofit Enterprise in the Arts: Studies in Mission and Constraint.* New York: Oxford University Press.

Perspectives on
Cultural Policy

The Arts and the Public Purpose

At this American Assembly, we have tried to find our common concerns and hopes. What may be most significant about our endeavor is the co-operation that it represents. Our intent was to find fresh ground for discourse about the role and place of the arts in American life, and to place the arts in full perspective.

Whatever the responses to the individual recommendations in this report, three important points must not go unnoticed. First, we insist on a recognition that the arts include the whole spectrum of artistic activity in the United States—from Sunday school Christmas pageants to symphony orchestras to fashion design to blockbuster movies. Second, we firmly acknowledge the interdependence of all parts of the arts sector—noting particularly the links between the commercial and not-for-profit parts. Third, we affirm that the arts do serve public purposes and, therefore, are of benefit and concern to all of us. We pledge ourselves to the reinforcement of the interdependence of all the arts and to the public purposes that they serve. We also call on others to join us in these efforts.

THE ARTS IN AMERICAN LIFE

The arts in America derive in unique ways from the pluralism of our society, and from many traditions—preserved, imported, wedded, and put into collision—that originate here and in every country on earth.

The arts in our country celebrate and preserve our national legacy in museums, concert halls, parks, and alternative spaces; they also adhere in the objects and buildings we use every day, and in the music we listen to in our cars, workplaces, homes, and streets. They calm us and excite us, they lift us up and sober us, and they free our spirit from the relentless mill of daily obligations; they entertain as well as instruct us; they help us understand who we are as individuals, as communities, and as a people. Their beauty or rage can fill us with emotion. In grief or celebration, and also in the subtler modes of irritation, amusement, sexiness, or depression, in great works or in the

humblest objects or diversions, they tell our personal and national stories. Through them, Americans examine their national unity and preserve it.

Participation in the arts is a treasured American activity. An overwhelming majority of Americans personally take part in the creation or presentation of art. Americans have accorded a place to all of the arts. Indeed, the arts are so pervasive that we are not always conscious that we are engaging in them when we are.

"The arts," as this description makes clear, are defined broadly by this Assembly. They include the not-for-profit arts and the commercial arts, as well as the range of citizen arts that is referred to as "unincorporated"— community, avocational, traditional, or folk arts, the indigenous arts in their many manifestations. This Assembly resisted calling up the conventional dichotomies that have separated the arts into high and low, fine and folk, professional and amateur, insisting, instead, on a full spectrum concept of an arts sector.

In developing this fresh concept of the arts spectrum, this Assembly offers an associated concept: that a fully functioning, flexible arts sector is institutionalized within our society, and that this sector should figure in public debates with a force and importance equal to that of other sectors, such as science, health, transportation, and education. The arts sector does not have this status yet. But the participants in this Assembly are in agreement that the arts do attend dynamically to the public purposes of the nation, and that the missions and the contributions of the arts should be recognized and reinforced with due seriousness. It is the relationship between the arts and the public interest of all Americans that this Assembly identified and explored.

THE PUBLIC PURPOSES OF THE ARTS

Typically, arts issues have been addressed in terms of the needs of the arts and artists. In contrast, this Assembly presents findings based on a very different assumption: that the arts can and do meet the needs of the nation and its citizens. Public purposes are not static; they change and evolve; they are reinterpreted over time. For our time, in the context of rapid technological, media, and social change, the arts—it can be argued—have special public responsibilities. Through the interpretive and expressive strengths of the arts and of artists, Americans can much more fully live with change and make change meaningful.

This nation's founders perceived the importance of the arts both in civil society and in the marketplace. They wished to establish conditions in which art could flourish. They also commissioned monumental works of art dedicated to the public purpose. Clearly, there is a grounding in the Constitution for the view that the arts serve important public purposes—both in the First Amendment (which reflects the value in a democratic society of diverse views)

and in the copyright clause (which urges Congress to promote the progress of knowledge by granting rights to authors to induce them to be creative). Today, there is a role for the arts in fulfilling some of the public purposes contained in the Preamble of the Constitution. Art is a necessary and important component of a healthy Republic.

This Assembly identified four public mandates that are addressed by the arts.

I. *The arts help to define what it is to be an American:*
- *By building a sense of the nation's identity.* The arts provide the symbols of who we are and what we stand for. They tell the nation's story as it unfolds, defining and redefining that which we hold in common. The arts provide this sense of identity at the national, state, and local levels—in neighborhoods and homes, for the rich and poor.
- *By reinforcing the reality of American pluralism.* This country's diverse populations and its ethnic, indigenous, and historic communities find their voices and parallel histories and share them through many art forms. Through the arts, we cross over—between individuals, geographies, and cultures.
- *By advancing democratic values at home.* The arts encourage association, and provide us with opportunities for shared creativity and shared enterprise. They help us experience community, and invite us to focus together on ideas, issues, and emotions. In doing so, they sustain and deepen the dialogue about the American experiment and democratic values.
- *By advancing democratic values and peace abroad.* America's arts are often advance agents of democracy. They project American values, vitality, and resourcefulness, as well as technological prowess, around the world. This American presence abroad often helps bridge cultural divides and makes cooperation and peaceful relations more possible.

II. *The arts contribute to quality of life and economic growth:*
- *By making America's communities more livable and prosperous.* From murals, songs, and dances to museums, stages, landscapes, and built environments, in cities, suburbs, and towns, the arts make the places we live in better. Not only do the arts provide the grounding of identity and the creation of spirit in communities, they also provide jobs and incentives for community improvement. The arts help to attract new residents and visitors. There are solid studies documenting the importance of the arts in local and regional economies, in inner cities and rural towns.
- *By increasing the nation's prosperity domestically.* The arts sector represents an enormous industry. It provides jobs on a national basis, and attracts visitors from all over the world. In addition, Americans' involvement and education in the arts strengthens the ingenuity and creativity of our workforce and the design and usability of our products and services.
- *By increasing the nation's prosperity globally.* American commercial arts are one of the nation's largest export industries. They dominate world cultural

markets and produce a trade surplus in the billions. The arts also help to design and package American products and services, making them more competitive globally.

III. *The arts help to form an educated and aware citizenry*:
- *By promoting understanding in this diverse society.* Study of the arts can help Americans to understand the experiences that move us and communicate to us, to develop discrimination and judgment, and to gain a sense of our civilization and the civilizations that contribute to ours.
- *By developing competencies in school and at work.* It is now well documented by studies that engagement in the arts has beneficial, measurable effects on cognitive development in children—fostering creativity, problem-solving, team-building and communication skills, discipline, and direction, all desirable citizen qualities. Lifelong learning in the arts provides many of the same benefits.
- *By advancing freedom of inquiry and an open exchange of ideas and values.* The arts invite us to critique what we know, to challenge the conventional, and to consider change. In this way, the arts help the citizenry analyze, interpret, and debate the conditions of national life.

IV. *The arts enhance individual life*:
- *By encouraging individual creativity, spirit, and potential.* American values include, although they are not limited to, creativity, individualism, competence, and a commitment to self-improvement. The arts help to advance these values. The arts can also promote self-fulfillment, spiritually, and respect for tradition. However we define our individual goals, the arts provide meaning and motivation. This enhancement of private goals ultimately serves our collective public purpose.
- *By providing release, relaxation, and entertainment.* In the opinion of most of the participants at this Assembly, providing opportunities for entertainment is a valid public purpose.

THE ARTS SECTOR

This Assembly, in its attempt to define the arts sector, made certain observations regarding the sector's size, organization, participants, customers, and audiences. At the same time, this Assembly recognized that a great deal of additional information is needed for any realistic measure of the sector. The brief analysis presented here frames a general sense of the sector, drawn from the participants' experience and the background materials made available to them.

Size and Financing of the Arts Sector

The arts sector is enormous. A conservative estimate of consumer spending on the arts, entertainment, and communications amounted to roughly $180

billion in 1995, 2.5 percent of the GDP, according to sources prepared for this Assembly. A more comprehensive accounting would include newspaper publishing, magazine publishing, business information services, and interactive digital media from the full arts and entertainment/communications industry, raising the figure to $292 billion. If one includes all copyright industries, the $180 billion number would roughly double.

A principal asset of the commercial arts is the development of, and access to, sophisticated marketing and distribution systems. A principal asset of the not-for-profit arts is intellectual capital, in the form of collections, repertoire, and other creative materials. Both for-profits and not-for-profits draw on artistic talent, and both attempt to develop brand or trade names.

Despite the magnitude of the arts sector, investment in it is risky. Very few art products make money or break even. For instance, in Hollywood, 20 percent of the movies make 80 percent of the revenues, and most feature films lose money. Few Broadway shows recoup their investment. Not-for-profit organizations cannot "earn" all the money it takes to sustain their operations; they have to raise on the order of half their revenues through contributions and grants. For most not-for-profits, grants do not provide sufficient or dependable funding, and the efforts to raise the necessary funds can divert attention away from artistic concerns. Most unincorporated activities rely largely on the in-kind and volunteer contributions of community members.

Commercial, not-for-profit, and unincorporated arts organizations vary greatly in management dimension and stability. Entertainment companies are organized by industry and have increasingly become dominated by a few very large firms, but even these large organizations are unsettled by mergers, takeovers, and the effects of boom-bust cycles. Not-for-profits comprise many autonomous and specialized organizations. The largest and most successful of them may be established and relatively stable, but the existence of many not-for-profits, especially small and mid-sized ones, is precarious. Some unincorporated institutions live day-to-day; most depend on volunteers; others are run as successful small businesses. It is notable that in more rural areas, cultural organizations often serve as dependable, ongoing "centers" of community activity and spirit.

For artists themselves, work in the sector can be risky. Only about one quarter of all artists work solely at their disciplines. Although relatively well educated—40 percent of them have a bachelor's or higher degree—artists are often poorly paid and lack health or retirement benefits. On average, artists earn about $24,000 a year, which is about $7,000 less than other professionals earn. But even these figures are misleading. Few artists earn this much directly in the arts; most earn two-thirds of their income from other, nonartistic jobs. Although a very few artists are among the highest paid people in the United States, these "Star" earners are atypical and skew the average earnings figure upward.

Artists work in all parts of the arts sector and often move back and forth from commercial to not-for-profit to unincorporated settings. In 1990, half of this country's artists worked in for-profit businesses. Slightly more than one-quarter worked for themselves in unincorporated businesses, and about 7 percent were employed by not-for-profit organizations.

The Arts and Their Publics

Commercial arts organizations market to broad, mass, and global audiences, on the one hand, and to niche audiences targeted by specific advertising needs or other corporate objectives, on the other hand. They are, in large part, market driven. Not-for-profits work hard to maintain and expand existing audiences for the artistic fare they specialize in. They are, in large part, mission driven. Unincorporated arts activities depend on donations of time and effort by interested members of their communities.

Everyone in America attends, consumes, encounters, or creates some kind of art each year. A 1992 "Survey of Public Participation in Arts" reports 65 percent of adult Americans watched or listened to the arts primarily produced or presented by not-for-profit arts organizations through the media; 58 percent created or produced these arts themselves; and 43 percent experienced these arts in person. From these numbers, it appears that the electronic experience has become the dominant form of participation in the arts, followed by personal involvement, even for those arts normally associated with the not-for-profit world. The media are the primary means of distribution in both the for-profit and not-for-profit worlds.

A problem for the not-for-profit and unincorporated worlds, and even for independent producers in the commercial world, is that the most effective means of distribution are beyond their reach. This is so whether one is trying to reach a broad or niche audience, unless the niche is very local. The electronic media and the marketing that sells them are expensive; so is the allocation of shelf space in chain book stores, video stores, and other outlets. In the case of the broadcast media and most cable outlets, advertiser objectives and the importance of their revenues dictate what is seen, except in less desirable time segments. And this is so, no matter how deep the pockets of a particular sponsor.

Although the commercial and not-for-profit arts are distinct, cooperation between them occurs regularly. Not-for-profit theaters produce work that goes to Broadway and then on to the movies or television. Performing companies often use both classical music and rock, for example, and other art forms as well. Commercial publishers occasionally look to not-for-profit presses for new products. Movie and television stars, and other commercial artists, work, from time to time, in the not-for-profit sector. Commercial producers look to the not-for-profit world for the development of talent, and

commercial professionals are enabled in the not-for-profit world to hone their skills and to work more experimentally.

A new means of electronic distribution and dissemination is available through the Internet. With its linked architecture, multimedia features, interactive capacity, and global reach, the Internet is proving to be an effective way to provide information about art and to market art, as well as to represent and distribute print, visual, and audio products. It may become particularly effective in the areas of literature and the visual arts, including museum collections. The Internet can also be helpful in fundraising and building audiences and membership. However, given the easy and broad public access to materials on the Internet, intellectual property issues represent a growing concern, one in need of systematic attention.

While there is no substitute for experiencing objects directly or attending live performances, the Internet and other media allow persons far from the museum, the concert hall, or the theater to have access to art that would not otherwise be available to them. They also allow producers and presenters, including those from rural areas, to share their art with those outside their own communities. In addition, the media permit both quiet contemplating and quick scanning of art works at home. Finally, it is possible through the Internet for audiences and artists, on a worldwide basis, to more easily comment on and discuss art.

THE ARTS SECTOR AND PUBLIC PURPOSES

Across the sector, the arts—commercial, not-for-profit, and unincorporated—address public purposes with varying degrees of success. This Assembly believes a number of opportunities exist to increase the arts sector's capability to achieve public purposes. These include:

- more overt and continuous commitment of time and resources by artists and arts organizations to public purposes;
- increased collaboration across the component parts of the arts sector to this end;
- greater attention to the arts sector's general financial security and to funding that advances public purposes;
- improved means of distribution and dissemination to provide access for all Americans to a full range of the arts at reasonable cost;
- renewed attention to, and funding for, preservation of America's artistic heritage;
- improved educational programs in the arts;
- increased and improved data, research, and analysis to support the development of arts policies; and
- improved collaboration among arts sector associations, advocates, and professionals in support of public policies to these ends.

CREATIVE AMERICA:
A REPORT TO THE PRESIDENT

STRENGTHENING DEMOCRACY

Creative America reflects the conviction that a thriving culture is at the core of a vital society. The creative force of the arts and the humanities strengthens our democracy. The members of the President's Committee see the arts and the humanities as a "public good," which benefits all Americans, just as surely as does a strong educational system.

The President's Committee reviewed abundant evidence that participation in the arts and the humanities unlocks the human potential for creativity and lifts us beyond our isolated individualism to shared understanding. History, literature, ethics, and the arts offer lessons on the human condition that connect individuals to the community and overcome the social fragmentation that many Americans feel. To remain a robust civil society, our democratic system needs the arts and the humanities.

The interconnection between culture and democracy is described by Benjamin Barber, who writes in an essay commissioned by the President's Committee that culture and democracy

> share a dependency on one extraordinary human gift, imagination. Imagination is the key to diversity, to civic compassion, and to commonality. It is the faculty by which we stretch ourselves to include others, expand the compass of our interests to discover common ground, and overcome the limits of our parochial selves to become fit subjects to live in democratic community. . . . It is only a mature democracy that fully appreciates these linkages. The arts and humanities are civil society's driving engine, the key to its creativity, its diversity, its imagination, and hence its spontaneousness and liberty.

"A community lives in the minds of its members—in shared assumptions, beliefs, customs and ideas," writes John W. Gardner, founder of Independent Sector.

Every healthy society celebrates its values. They are expressed in the arts, in song, in ritual. They are stated explicitly in historical documents, in ceremonial speeches, in textbooks. They are reflected in stories told around the campfire, in the legends kept alive by old folks, in the fables told to children. . . . Indeed, the Constitution, in addition to being an instrument of governance, is an expression of pledged values.

A society that supports the arts and the humanities is not engaging in philanthropic activity so much as it is assuring the conditions of its own flourishing.

THE RICHNESS OF AMERICAN CULTURE

Our cultural heritage defines us as Americans and reflects the diversity of our people. The promise of democracy and the interactions of many peoples helped to create new ideas and artistic expressions that are uniquely ours. America is indeed a country of creators and innovators. We register 550,000 copyrights for music, art, manuscripts, and software a year and publish 62,000 books.

When we use the word "culture" in this report, we mean those forms of human creativity that are expressed through the arts and those disciplines of the mind described as the humanities, most notably history, languages, literature, and philosophy.

By American culture, we mean both Pueblo dancers and the New York City Ballet; the local historical society as well as the history department of Harvard University; the church choir and the St. Paul Chamber Orchestra; the lone scholar in her cubicle and the citizen debate in a Town Hall. Within American culture, we embrace the treasures preserved in our museums and libraries, the diverse heritage of our many ethnic communities, and the dynamic power of our entertainment industry.

The President's Committee notes that the cultural sector is one of the most integrated areas of American life. "Our diversity is our strength and the foundation of what is uniquely American in art and culture, including jazz, American dance, Twain, Faulkner, Broadway, the Grammy Awards, Richard Wright, and Leontyne Price," author Lerone Bennett, Jr., reminds us.

We use the metaphor of the "border" to describe the combinations and innovations in American cultural development. The perimeter along which opera lived with popular song yielded musical theater. The border between black and white Americans gave us blues, jazz, and rock 'n' roll. It is the border of Texas and Mexico that nurtured the tradition of Tejano music and cuisine. The line along which art and technology touch energizes our film, broadcasting, and recording industries. Where photography and the tape recorder meet history, knowledge is informed by personal narrative.

APPRECIATION AND ORGANIZATION
OF CULTURE

Americans enjoy the arts and the humanities in many ways that are woven into the fabric of everyday life. Our citizens encounter culture every day, when they pass an historic building, read an op-ed piece which illuminates an issue, listen to country music on the radio, enjoy the design of a computer program, or feel moved by a powerful story on screen or stage. When the high school band plays in the Fourth of July parade or a minister preaches about ethical values, people do not think, "I am having an arts and humanities experience." But, in fact, these experiences are rooted in the arts and humanities. They are the everyday signposts that point to how creative and reflective experiences are deeply embedded in our lives.

Just a few indicators of this hunger for cultural experiences emerge from President's Committee research:

- Over a quarter of a million Americans care enough about preserving their architectural legacy to become dues-paying members of the National Trust for Historic Preservation.
- Over the past decade, two million adult readers took part in reading and discussion groups organized by the American Library Association, state humanities councils, and local libraries.
- Museums of all types report large increases in attendance. *The Age of Rubens* exhibition attracted a quarter of a million visitors to the Toledo Museum of Art in Ohio—the largest attendance in the Museum's ninety-three-year history.

In twentieth-century America, especially in the last thirty years of the public-private partnership that sustains cultural life, we have seen a remarkable flowering of the arts and the humanities. There are more opportunities than ever before for our citizens to participate in and be enriched by cultural experiences.

The world of informal cultural groups is an important aspect of American culture that is understudied and often overlooked. A San Francisco foundation survey of "informal arts groups" reported over 100 ethnic dance companies in the Bay Area alone. In 1996, the Tennessee Arts Commission identified over 300 active bluegrass, gospel and blues groups. A blues magazine counts 140 annual blues festivals in the United States, most organized by volunteers.

The intensity of these attachments to specific art forms, local historical traditions, and all kinds of neighborhood and ethnic organizations demonstrates

how the arts and the humanities continually renew themselves and their communities.

INTERPLAY OF AMATEUR, NON-PROFIT AND COMMERCIAL CULTURE

In the United States, amateur, non-profit and commercial creative enterprises all interact and influence each other constantly. A mariachi music revival, supported with government grants, goes mainstream as the popular groups produce recordings. Non-profit presses now publish much of the poetry and experimental fiction that commercial publishers used to present. Popular history books and television programs draw on scholarly research.

This flowing exchange among the amateur, non-profit, and commercial segments of culture deserves special attention because it expands our understanding of how culture operates and of the many avenues for participation. The President's Committee observes that amateur activity enlivens community life and cultivates deeper appreciation of the arts and the humanities. Non-profit organizations offer some separation from marketplace demands, allowing the artists and humanists whom they employ to experiment, develop followings for new productions and revive historical material. Commercial enterprises require substantial investment and take significant risks; many have succeeded in bringing new talent to greater audiences, widening opportunities for American designers, writers, historians, musicians, actors, and others. Commercial firms influence the rest of culture and are influenced by it.

The interplay between non-profit and commercial arts is dramatically revealed in the relationship between non-profit theaters and Broadway's commercial theaters. Because the economics of Broadway work against the development of plays, the task of producing much new work falls to the nation's non-profit regional theaters. Over the past twenty years, 44 percent of the new plays produced on Broadway originated in the non-profit sector. We note that the peak period of importing plays from non-profit theaters—the mid 1970s and early 1980s—coincided with the high point of grant-making activity by the National Endowment of the Arts to regional theaters.

Hollywood, too, draws upon stories and talent developed in the non-profit sector, although there are no studies which describe this relationship precisely. Examples of plays produced in non-profit theaters and later made into movies are: *Driving Miss Daisy, Gin Game, On Golden Pond, Children of a Lesser God, Glengarry Glen Ross,* and *Prelude to a Kiss.*

In publishing—where the United States is the largest market for books in the world, with sales reaching an estimated 20 billion dollars in 1995—there is also a close relationship between the non-profit sector and the commercial field. In the last thirty-five years, commercial publishers have become part of large conglomerates which, emphasizing higher profit margins and more

rapid returns on their investments, concentrate resources on mass market books. New work in fiction, poetry, translation and on scholarly subjects is now published by literary journals, universities, or independent presses. The smaller and non-profit presses have become the stepping stones for many writers on their way to public attention. In 1996, only one of the nominees for the National Book Award in poetry emanated from a large commercial publisher; the other nominees were published by non-profit and other small presses.

We note that the copyright industries—motion pictures and television, the music recording industry, publishing and advertising, and computer software—constitute one of the fastest growing segments of the American economy. The motion picture and television industry has already become one of the most significant export industries in the United States and has supplanted the aerospace and defense industry as the leading employer in the Los Angeles area. The entertainment industry is a dynamic force in the business world, linked to a wide array of other industries, such as telecommunications, consumer products, retail, and fashion.

The relationship these brief examples imply is one that should be examined with more research. The President's Committee urges a greater dialogue among the amateur, non-profit, and commercial creative sectors to explore their common interests, cooperate to preserve cultural material, and perhaps form new partnerships to present the arts and the humanities to a wider public.

We believe that the future vitality of American cultural life will depend on the capacity of our society to nourish amateur participation, to maintain a healthy non-profit sector, and to encourage innovation in commercial creative industries.

INTERDEPENDENT SUPPORT SYSTEM

The nation's cultural support system is a complex structure pieced together from many different sources: earned income; contributions from individuals, corporations and foundations; and grants from local, state, and federal governments. The entire system is interdependent, operating in "synergistic combination," with public and private donor sectors influencing each other and funding different parts within the whole.

Cultural life is affected by the same forces as the rest of society. Factors such as the rate of economic growth, income inequality, stresses on leisure time and a decline in the habit of civic participation all affect active involvement in the arts and the humanities and the earned income of cultural organizations. A strong economy means more discretionary income for cultural experiences, travel, and entertainment. Continued economic growth boosts

the endowment funds of arts and humanities organizations fortunate enough to have them.

Held up by a fragile web of many interdependent strands of support, non-profit cultural organizations are as sensitive to these factors as are other non-profit organizations at the heart of America's public life. This extensive not-for-profit sector is independent of government, yet often carries out joint purposes with federal, state, and local governments. There are thousands of such organizations in this country, providing health care and other services, educating youth, conserving history and presenting our culture. Millions of Americans participate in or are employed by this sector, whether they work at a library, help build houses for low-income citizens, or serve as guides in museums.

Like other non-profit entities, cultural organizations exist for public benefit rather than to make money. Unlike business enterprises, no part of their "net earnings . . . inures to the benefit of any private shareholder or individual" (IRS code). And as part of the non-profit sector, cultural organizations will never earn enough money to cover all their expenses. They do not survive in the marketplace alone.

It is difficult for some Americans to accept the notion that the portion of our cultural life that is nurtured by non-profit organizations requires subsidy. Cultural organizations cannot reduce labor costs or increase productivity enough to make up for inflation.

This "cost disease" means that non-profit cultural organizations never earn as much as they spend. Colleges and universities are in a similar situation; tuition cannot possibly cover the entire cost of educating students. Some highly valued institutions in our society, such as libraries and research institutions, have few sources of earned income.

Our complex, interdependent support system relies heavily on private contributions. Yet there are worrisome signs that new generations and newly profitable businesses are not carrying on the ethic of giving. We see a need for the renewal of American philanthropy. We also believe that families, and religious, educational, and charitable organizations have a responsibility to teach the ethic of philanthropy and voluntarism: to reinforce the understanding that people have the obligation to support that from which they derive benefits.

Although government does not play the major role in funding culture, government influences cultural development in many ways. The health of non-profit organizations—including private foundations—depends in no small part on government policies that value their role in society and help them to flourish. If the role of the federal government in cultural development is modest, it is nonetheless critical. For government funding is a signal to the rest of society that a vital culture is worth supporting.

The increased needs of our society mean that many worthy causes are competing for both government funds and private contributions. The President's Committee investigated many ways for cultural organizations to earn more income and to develop new sources of financial support. We found some room for expanding earned income. And there are ideas for new resources that merit more exploration. We conclude, however, that there is no "silver bullet," no new source or structure that will replace the complex support system that is so unique to America and that generates such a wealth of cultural capital.

THE CULTURAL SECTOR:
ASSETS AND DEFICIENCIES

In preparing *Creative America*, the President's Committee examined the strengths and weaknesses of our cultural support system. Although millions of Americans participate in the humanities and the arts every day and find their lives and communities enriched, there are still barriers that inhibit participation. We are particularly concerned about cultural activities in the nonprofit realm, for without private or public support they cannot be sustained. In size, scope, and participation, the cultural sector demonstrates vitality; but it also shows symptoms of stress and instability that must be addressed if we are to preserve cultural capital and encourage new creativity for the next century.

The United States begins these tasks with significant assets in place:

- resilient and innovative cultural organizations
- a rich variety of cultural communities and traditions
- talented and dedicated artists and scholars
- compelling findings that demonstrate the positive effects of art and humanities education on children's learning and behavior
- a tradition of giving and volunteering
- increasing local and state support for the arts and the humanities
- a dynamic entertainment industry that employs creative talent and has the potential for partnerships with the non-profit sector.

The deficiencies in our cultural development include:

- fragile and threatened cultural institutions
- loss of cultural heritage and traditions
- undercompensated and under-employed artists and scholars
- lack of meaningful arts education for a substantial number of children; weakening of the humanities core curriculum
- economic pressures on Americans' discretionary incomes, pressures on leisure time

- stagnating philanthropy and voluntarism
- a lack of value for the role of culture in society, signalled by the federal government's reduced commitment
- a climate of intolerance for challenging works and ideas.

The members of the President's Committee believe that America's future will be strengthened by a renewed commitment to our cultural life. Fortunately for our citizens, the United States is prospering today. The nation is at peace and although not everyone is sharing in its benefits, the economy is growing. If as a society we value the contributions of the arts and the humanities, we can afford to invest in them. We are rich in resources and spirit; we can afford to champion a Creative America.

Designing a Cultural Policy

Picture, for a moment, the following scene. A politician is holding a press conference during an election campaign. A journalist raises a hand to ask this serious candidate for high office a question: Could the candidate please outline, for the general public, the party's economic policy? The politician looks blank for a moment, hesitates, and looks nervously at his or her advisers. They look back unhelpfully with a faint shrug of the shoulders. The politician, searching desperately for inspiration, decides to play for time. "I'm sorry," he or she haplessly replies, "but what exactly do you mean by economic policy?"

No matter how lame or incoherent we consider many of the economic programs offered to electorates around the world, it is hard to imagine such a scene ever taking place. All serious political parties and candidates have an economic policy of some description, and elections are frequently won and lost on how persuasive they are in advocating it. If, however, we substitute the word "culture" for "economic," then the scene no longer strains credulity. To say that few political parties in most modern industrial nations devote much energy to cultural matters is to state the obvious. Some political parties—most notably in the United States—have no formal cultural policy at all. Others treat the cultural life of their region or nation as a minor or marginal issue, a field in which government can do little more than dabble or occasionally pontificate. The idea of an election being won or lost on the strength of a party's cultural policy is almost unimaginable.

This neglect is both shortsighted and strange. As citizens, we spend our lives amid the products of the cultural industries: most of us watch TV, listen to the radio, go to the movies, and listen to music. Some of us read books, magazines, and newspapers, and many of us play games from softball to Nintendo to Trivial Pursuit. Our environments are visually shaped by planners, architects, and designers, from the clothes we wear to the billboards, buildings, and shopfronts that make up our landscapes. There is nothing fixed or inevitable about this cultural world. It is not the way it is because we, as citizens, have thought about it and decided that it should be so. Certainly our

history, traditions, and desires influence the shape of our culture, but it also looks, feels, and sounds the way it does because of the ill-considered mix of free market forces, government regulations, and subsidies that constitute the political economy of culture.

Not that governments do not deal with cultural matters; they do. They plan, regulate, subsidize, and tinker with a whole array of cultural industries and activities. But they usually do so in an incoherent and piecemeal fashion. In Great Britain, for example, the Home Office, the Department of the Environment, and the Department of Trade and Industry—three large, separate bureaucracies—deal with broadcasting and the other main cultural industries in ways that have little to do with any recognizable cultural policy, while those who are formally in charge of such a policy are consigned to fiddle on the margins of British cultural life in the backwaters of the high arts.

There are, broadly speaking, two approaches to culture in most Western industrial nations. The first is for government to abstain from cultural policy altogether, leaving a society's cultural life in the hands of free market forces. That approach is most clearly exemplified by the United States, although most other Western governments, from Canada to France, allow the free market a substantial role in determining their country's cultural development. The second is for the government to base a cultural policy on fairly traditional, narrow notions of arts and artistic value, thus limiting the state's role to the protection of a limited selection of cultural activities, such as drama or classical music.

These two approaches, I would argue, are neither democratic nor dynamic. Moreover, some of the most prominent debates about culture and the state—in particular, those concerning censorship and government "interference" in culture—can actually be misleading. A new approach will necessarily involve a radical redefinition of the goals of state support for art and culture.

MARKET REGULATION OF CULTURE

There are moments in the lives of the cultural industries when the free market may give birth to a dynamic range of cultural forms and expressions. Such moments tend to occur near the beginning of an industry's life, usually at a time when technology, demographics, and economics combine to create rapid growth in the goods that the industry has to offer. It is at such times that the free marketeer's cry of "Let a thousand flowers bloom" sounds most plausible.

The pop music industry in Britain and North America during the 1960s is a good example of the free market at its most vibrant. That was a period in which technological advances in sound recording and reproduction coincided with the rapid growth of what came to be called the "youth market" fueled by

the baby boom and rapid rates of economic growth. Under these conditions, the pop music industry was able to experiment and diversify, as a seemingly inexhaustible youth market gobbled up almost anything new or interesting that came its way. Like a gawky adolescent, the industry grew in all directions: record companies expanded both in size and in variety. In the United States, throughout the 1950s and 1960s, the number of record labels enjoying chart success grew with each passing year. In 1951, only ten different record labels enjoyed top-ten hits; by 1967, fifty-one different labels shared chart success (Peterson and Berger 1990).

By the end of the decade, that economic diversity had provided an institutional base for a myriad of artistic styles. We had heavy rock (Cream, Jimi Hendrix, early Led Zeppelin), folk rock (Bob Dylan, Joni Mitchell, Van Morrison, Leonard Cohen, Crosby, Stills, Nash & Young, Richie Havens), and techno/progressive rock (Pink Floyd, ELO, Soft Machine). We had a range of styles within blues and rhythm and blues (BB King, the Rolling Stones, Otis Redding, Joe Cocker), and the world of soul music diversified to include the likes of Al Green, Diana Ross, the Temptations, the Isley Brothers, the Jacksons, the Crusaders, Aretha Franklin, and Stevie Wonder, who among them, added jazz, funk, rock, and disco to the soul mix. We had psychedelic music from West Coast bands like the Peanut Butter Conspiracy and Jefferson Airplane, the experimental art rock of Frank Zappa, the Fugs, and the Velvet Underground. Within mainstream pop, styles ranged from the Beatles to the Doors, from the Beach Boys to Bubble Gum. It was a cultural industry, driven by market forces, that embraced innovation and diversity.

But it was not to last. The free market is an inherently contradictory notion: the older it gets, the less free it becomes. The major record companies, with their economies of scale, their ability to survive pricing battles (and hence drive out weaker competition), and their capacity to manipulate demand through advertising, drove out the smaller ones. That is, after all, how capitalism works. As the market began to stabilize around a few major record labels, a form of cultural stagnation set in. What came to the industry's rescue at the end of the 1970s, I shall argue later, was the subversion, rather than the promotion, of free market logic.

The history of cultural industries is not so different, in many respects, from the history of any other kind of industry. Left to its own devices, free market capitalism tends to drift inexorably toward monopoly. Large companies may yield high profits but without any encouragement to do otherwise, free-market-driven companies tend to think only in the short term. Investing in innovation through research and development becomes increasingly uneconomic once stable and reliable markets are established. In the short term, it is cheaper, easier, and less risky to reproduce a successful formula than to invent a new one. Free market forces may give birth to a thousand flowers, but the

same forces will usually ensure that only a few of the hardy old perennials can survive.

The French experiment in community and independent radio in the 1980s was a dramatic illustration of how the free market regulates culture. By opening up the airwaves to all and sundry, the French government inspired a diverse collection of radio stations to begin broadcasting. The radio dial became a playground offering everything from Afro-pop to anarchism. But the experiment ultimately failed because it did little to protect smaller stations from the rules of a marketplace that favored safe, formulaic, and repetitive musical menus designed to deliver the largest possible audience to advertisers.

The television industry in the United States is a case study in this kind of cultural stagnation. Perhaps more than any other comparable television industry, TV in the United States is driven by the desire for profit rather than by any notion of public service. The United States is the richest market for TV programs in the world, but it would be hard to argue that that is reflected in its television culture. Visitors to the United States are often struck by the extraordinary frequency of TV commercials (which take up nearly a quarter of the broadcast time) and by the strange paradox at the heart of the U.S. broadcasting system: there are dozens of channels but precious little variety, or as Bruce Springsteen puts it, "57 channels and nothin' on." The same "hit" formulas are endlessly repeated, while the numerous channels are so many echo chambers, clogged with reruns of those same hits. Even newer channels, such as MTV or VH1, only show what are essentially oft-repeated commercials (music videos), and these have become increasingly bogged down by the dull pursuit of a series of aesthetic formulas (the "heavy metal video," the "rap video," the "dance video," and other video genres are now so full of stylistic conventions that they are instantly recognizable and almost interchangeable).

If this criticism sounds unfair, let me briefly describe what is on offer. I looked at the programming fare for the prime time slot of 9:00 P.M. on Thursday, June 4, 1992 (a day chosen entirely at random) to see what was available to viewers with cable TV in Boston, Massachusetts. Of the four networks, ABC was showing a repeat of an episode of "MacGyver," NBC was showing a repeat of "Cheers," and Fox was showing a repeat of "Beverly Hills 90210." Only CBS was offering anything new—a two hour special called "The Generals," co-hosted by retired General Norman Schwarzkopf. Of the three public television channels (which are, like all the commercial channels, dependent on corporate sponsorship, and which therefore might more accurately be described as "semi-public"), two were hosting fundraisers for themselves (one interspersing it with an old documentary), and the other was showing a rerun of a British drama series. Of the six independent channels, four were showing movies (all of which have been shown on TV before), one was showing a fundraiser for a children's hospital, and one was showing a repeat of a documentary.

Of the twenty main cable channels with scheduled programming (excluding wall-to-wall commercial stations such as MTV, VHI and the Home Shopping Network, and the various religious channels) half were showing movies (previously on general release at the cinema), five were showing sports games, four were showing old TV shows previously broadcast on other networks, and one (CNN) had that staple of low-budget TV, a talk show. This means that from dozens of TV channels, all that was actually being offered in the way of new programs was a documentary feature (nostalgic rather than investigative), a news talk show, and some sports. The rest of television comprised reruns and a selection of feature films less extensive (and in most cases punctuated every seven minutes by commercials) than that of the local video store.

The market logic of this television world is simple. Old programming is cheaper than new programming. New programs are more likely to be successful, in the short term, if they look like old programs. Minority audiences, even if they include hundreds of thousands of people (and particularly if those people do not possess large disposable incomes), are too small to generate enough advertising revenue to create high-quality programming. The best programs, from a financial point of view, are those familiar enough to appeal to the largest number of people and bland enough to avoid offending potential advertisers. When something genuinely innovative does come along, such as "Frank's Place," or "Twin Peaks," it is tolerated only for as long as it can be shown to have the potential to generate the ratings necessary for survival.

That is not to say that nothing new or innovative ever makes it through the filter of immediate market gratification. But the exceptions (such as "Hill Street Blues" or "The Simpsons") are, in a system that churns out thousands of hours of programs every week, staggeringly small in number. The problems with the free market proliferation of TV channels are threefold. First, the degree of market segmentation that the system allows is overstated: too many channels have calculated that it is more profitable to go after the same kind of market as most of the other channels. Second, the system is profoundly undemocratic because some markets (those with high levels of disposable income) will be offered more than others. Third, as the commercial TV space expands, the available advertising revenue is spread thinner and thinner, making the costs of quality new programming increasingly prohibitive. From a commercial point of view, it is safer to punctuate your TV commercials with reruns and schlock than with lovingly produced new programs. More means less.

As Ben Bagdikian (1990) has documented, if we take the U.S. cultural industries as a whole, the Reagan/Bush era of free market deregulation speeded up the trend away from diversity toward concentration of ownership in an elite group of large media corporations like CBS, Time Warner, ABC/Capital Cities, and Rupert Murdoch's News Corporation. A handful of executives

become the society's cultural commissars, and their decisions are based on the generation of income rather than the generation of culture.

The idea that the free market is the best mechanism to serve a society's cultural needs (the public gets what the public wants) is thus deeply flawed. We may want—or need—diversity, but market forces make homogeneity (where the markets are bigger) more profitable. We may, as a society, want innovation, but as individual consumers we are unlikely to find an acceptable way of paying for such a costly commodity in the marketplace. We may, as a society, want a cultural environment that teaches and informs us, that stretches our horizons, but as individual consumers we are most likely to opt for what we already know. The public wants what the public gets.

A free market approach to culture is, ultimately, no more democratic or in the public interest than a free market approach to politics. So, for example, election to public office in the United States, where campaign spending is not subject to strict regulation or public subsidy, is usually determined more by the ability to sell ideas (or candidates) than by their quality or substance. The candidate with most power in the marketplace of "ideas" (i.e., with the money to spend on good public relations) is usually the one who will win the most votes; but as many now acknowledge, such a mandate does not validate the system or the politicians it produces. So it is with the simplistic assertion that our cultural life is best left to the crude laws of the free market.

THE ART OF THE STATE

What is the alternative to a culture disciplined and fashioned by market forces? At a general level, there is only one answer to this question: The state, whether at a local, regional, or national level, must intervene. The specifics of its intervention will involve an appropriate mix of regulation and subsidy.

There is, of course, a tension between an imaginative, creative, and democratic culture and state intervention. Right-wing critics of state support or culture will point with glee to the stifling influence of the state in many areas of cultural life in, for example, the old Soviet Union. Liberals, meanwhile, will wring their hands over the possibilities of state censorship, whether it applies to D. H. Lawrence or the Sex Pistols in Great Britain, or to Robert Mapplethorpe or 2 Live Crew in the United States. The trouble with both these criticisms is that although they have a point, they are both missing a larger one.

Those on the right who extol the virtues of the free market are frequently disingenuous when it comes to culture. Whether it be Spiro Agnew or Ronald Reagan railing against the leftist or "liberal bias" in the U.S. news media (a fantastic proposition if ever there was one), Margaret Thatcher banning books, or Dan Quayle taking the CBS network to task for demeaning "family

values," their objections are politically untenable. One cannot promote the virtues of a free market in culture (as all the aforementioned have) and then complain when it produces something one does not like.

The logic of the free market position is that if there is a demand for something, and if advertisers like it, then that (rather than any broader notion of public interest) is what should determine cultural production, whether newspapers or TV programs. When Thatcher laments the decline of "Victorian values" in popular media representations, or when Quayle objects to a popular program such as "Murphy Brown," they are implicitly suggesting that their own free market approach to the cultural industries is fatally flawed, that the free market does not in fact provide what is in the best interests of the culture. But one cannot have it both ways: an advocate of deregulation who opposes the public funding of television is not really in a credible position to criticize the TV programs made by TV companies operating in a deregulated free market.

The anticensorship position of many of those on the left is less duplicitous but equally myopic. To protest against state censorship may be well intentioned, but it ignores the reality of cultural production in a market economy, where forms of censorship are rife. Market censorship takes a number of forms. That the producers removed a line from an episode of "thirtysomething" about car accidents because it might offend car advertisers was an instance of market censorship. When NBC News reveled in the "flawless" U.S. weaponry during the Gulf War, neglecting to mention that much of that weaponry was made by its parent company General Electric, that was market censorship. When the staunchly Conservative press in Great Britain works to portray the Labour Party as "unelectable" without disclosing why it is in the financial interests of its owners to do so, that is also market censorship. When commercial television in the U.S. cannot show anything, whether it is a soccer game or a drama series, without breaking away every eight minutes for commercials, then the market is manipulating the types of programs we can or cannot see—a form of censorship.

Market censorship, in this sense, refers to more than simply a company's refusal to disclose information that may embarrass its owners or its advertisers, although there are numerous examples, from the sinister to the ludicrous, of such corporate censorship (see for example Lee and Solomon 1990). It is intrinsic in a cultural system that will produce only what is popular or profitable, discarding all else.

The outcry from liberals in the United States when the National Endowment for the Arts was attacked in Congress for funding the homoerotic photography of Robert Mapplethorpe was, in this sense, misplaced. Apart from the fact that the NEA is little more than a drop in a cultural ocean (in 1990, the NEA spent less on opera, ballet, contemporary dance, visual art, etc., than the

Pentagon spent on military bands), to cry censorship in this particular case is to let the entire cultural system, which routinely stereotypes and excludes gay people, off the hook.

While we should be mindful of the dangers of the state's potential to have a withering effect on culture, the state does not have to loom over the cultural industries like a sinister and authoritarian Ministry of Culture. The state can develop an arm's-length approach, operating less as a cultural commissar and more as a cultural catalyst, promoting innovation and diversity within a democratic framework. Unfortunately, there are few examples of governments pursuing such a cultural policy; even progressive governments are notable more for their neglect that their nurturing of cultural life. The poverty of thought and action in this area is not always due to the failure to develop a cultural policy, however. It often derives from the delusion that the state already has one.

ART FOR WHOSE SAKE?

In many countries, state support for culture is restricted not only by fiscal parsimony but by definition. When it comes to public subsidy, the whole realm of culture is invariably reduced to the limited horizons of the "high" arts, a narrow set of cultural activities that are simultaneously at the top and at the margins of our culture. The arts deemed worthy of support tend to have two things in common: they are firmly entrenched within a long-standing set of academic traditions, and they are consumed by the wealthier, better-educated classes. When free marketers lambaste these subsidies as elitist, it is not good enough to respond by attacking them as philistines, for on this count the free marketers are quite right. The aesthetic judgments that classify some cultural activities as better than others are made with almost complete disregard for most people's cultural experiences.

It is not that those responsible for the public funding of culture are purposefully elitist, far from it. Many arts funding agencies, such as the British Arts Council or the American National Endowment for the Arts, publicly voice a commitment to increasing access to the arts. The problem is more one of definition than intention, in the sense that the terrain demarcated as "artistic" is exclusive rather than inclusive. Despite anecdotal evidence to the contrary in artistic circles, surveys repeatedly demonstrate that the things usually funded by these august bodies—classical music, opera, contemporary dance, ballet, theater, art galleries (and the art found therein), and literature—are marginal to most people. Although seven out of ten people claim to have visited a movie theater in the last year, only one in five reports seeing a live dance or ballet performance, and less than one in six admits to having seen any kind of classical or operatic performance (*General Social Surveys 1993*). Indeed, the

people who do attend subsidized arts events tend to be well educated and well-off—precisely those who are already served best (because their high disposable income makes them an attractive group to sell to) by the free market. From an egalitarian point of view, this creates the outrageous inequity in which the majority subsidizes the leisure activities of the privileged few.

This iniquitous cultural system is usually justified on three criteria. One is an aesthetic argument: the high arts, it is asserted, are the only cultural activities worthy of funding. The second argument is economic: the traditional arts, it is claimed, need the money more than, say, television or pop music, both of which are well equipped to survive without subsidy in a free market. They need the money, in other words, simply to stay alive. The third argument is a political one, namely, that it is only by giving public support to the high arts that they can be made affordable to ordinary people. Usually accompanying these three rationales is the self-fulfilling apologia that, because the amount of public money involved is usually so small, it is not something that needs a great deal of justification.

The aesthetic argument is fine in principle—we need, after all, some set of judgments for deciding what and what not to support. The problem is that it rests on an untenable set of distinctions among cultural forms: most classical music may be more complex than most popular music, but that does not necessarily mean that the former is always more creative or sophisticated or that the latter is irredeemably unworthy of "artistic" quality. Indeed, the traditional arts enjoy an academic esteem that perpetuates such distinctions. The more scholarly appreciation heaped upon an art form, the more it appears worthy of critical attention. An art form such as theater may have begun life as mere entertainment, but library corridors full of books abut it have been part of a self-fulfilling process elevating it to the mythical status of art. Our universities and arts agencies are both locked into this ultimately fairly arbitrary cycle of cultural legitimation. This is not to invalidate such critical endeavor but simply to point out that it can limit our cultural horizons by (unwittingly perhaps) designating the more modern cultural forms as mindless fluff.

The economic case for traditional arts funding is similarly short-sighted. It presupposes that while the free market would impoverish the high arts, it enriches the more popular cultural forms. This is a silly idea that originates from a profound ignorance of contemporary culture. Our cultural industries, under the fiscal guidelines of the free market, have not produced the best possible television system and do not promote diversity in the newspaper industry; they neglect innovation in popular music, and generally serve a narrow set of economic interests rather than a broad set of cultural interests. Classical music may become limited, predictable, and bland in a free market system, but so may popular music.

The political advocacy of the traditional arts is either overzealous or strategically naive. The desire to convert the masses to the joys of opera and ballet, just as our ancestors sought to convert conquered peoples to Christianity, can be as oppressive as it is philanthropic. The rap artist may have much to learn from the traditional poet, but so the poet may have much to learn from the rap artist. To assert correctitude in modes of artistic expression is to suppress creativity, not to develop it. More pragmatically, if we have an interest in enriching the life of our culture, we should begin by developing those activities that most people are already engaged in (TV, film, fashion, and so on).

A realistic cultural policy, in other words, means engaging with the things that our society does, not with what we feel our society ought to be doing. Most people watch TV; they do not, as a rule, go to watch plays. A cultural policy should begin by devising ways to improve television rather than dreaming up fruitless plans to drag people back into the theater.

DEVELOPING A CULTURAL POLICY

The politics of culture has many nuances. There are certain cultural values, however, that generate fairly broad agreement. Two notions that receive a great deal of lip service in most state-run cultural agencies are *diversity* and *innovation*: if we are to pursue a democratic, broad-based cultural policy, we need to begin to devise ways of applying those concepts beyond the effete world of high culture and into the cultural mainstream.

There are two tools with which to craft a cultural policy. The cultural industries can be directed and reformed by the regulatory powers of government, or they can be subsidized to support activities that the free market is unwilling or unable to sustain. The concepts of regulation and subsidy are not always straightforward. A democratic government can, in theory, regulate howsoever we desire it to (that is what it is there for). Because the cultural industries are often transnational, however, there are limits to the power of a nation state to legislate effectively. So, for example, the Cuban government's cultural policies may be subverted by the U.S. government's beaming in propaganda over radio or TV. In a rather different way, the Canadian government, or any European government, may be hampered in promoting a public broadcasting policy by the proximity of rich commercial stations in nearby countries. If international cooperation is not forthcoming, regulation in cultural matters will often need to be extremely creative to successfully counter cultural imperialism or the drift toward the lowest common denominators of Western culture.

The trend toward global cultural homogeneity is proceeding at an alarming pace. It is worth noting that during the recently completed GATT negotiations, only the French government mounted any resistance to attempts by the U.S. entertainment industry to take away a country's right to protect its

own culture from being swamped by a deluge of cheap, secondhand Hollywood imports. (The U.S. entertainment industry is, in this respect, in a unique position; its domestic market is so profitable that it can export its products at prices that undercut locally made films or TV programs.) The French won that particular battle, but if free market forces continue to ride roughshod over global culture, it is one they will be forced to fight again and again.

The subsidy of culture is as much a matter of public relations as anything else, inasmuch as it will always be difficult to persuade people to spend public money on something new. In some cases, that means countering some popular illusions. Most people, for example, are under the misconception that public television, supported by government (or, like the British Broadcasting Corporation, with a fund administered by a government agency), costs them money, while commercial television, supported by corporations through advertising, does not. In fact the reverse is often true. TV advertising is expensive, and its cost is passed on to the consumer at the supermarket check-out or the shopping mall. Most TV advertising is also defensive. It is necessary to sustain market shares rather than increase them, so there are few economies of scale to lessen the costs. The hidden costs of commercial TV are necessarily more expensive than public television because consumers must support *two* cultural industries—TV program makers and TV commercial makers— rather than one. TV advertising is, in this sense, an economic as well as a cultural parasite on the industry.

PROMOTING DIVERSITY

Because most modern industrial soieties are culturally heterogeneous rather than organic, one way to evaluate the strength of a cultural industry is by its range and diversity. So, for example, a television system that offers programming for a wide range of tastes, cultures, and sub-cultures is more desirable than one that does not. The U.S. model makes it abundantly clear that the free market, left to its own devices, tends to stifle rather than promote diversity.

The U.S. model also demonstrates that diversity in broadcasting is not to be confused with number of channels. In many ways, the British system, with four main channels, offers the viewers a greater choice of quality programming than the forty or so channels available to viewers in the U.S. (particularly if the viewer has a VCR and can rent movies). Although the British system shows signs of suffering at the deregulatory hands of successive Conservative governments, the early 1980s British model shows many of the benefits of careful regulation and subsidy.

The British system is based on a duopoly of two public (BBC1 and BBC2) and two commercial stations (ITV, a network of independent TV companies, and Channel 4). Commercial space for advertising is limited, not only by the number of channels but by regulations limiting the amount of advertising

that the commercial channels are allowed to show. This regulatory structure actually works in favor of the two commercial channels, allowing them to charge high prices for advertising space and thus glean extremely high revenues to spend on programming without too much intrusion from commercials. The two commercial channels (like the two public channels) were also created in such a way as to allow them to complement one another rather than (as commercial channels tend to do) compete for the same market territory. Because a commercial television franchise in this highly protected environment is virtually a license to print money, the government was able to create a system of cross-subsidy, whereby ITV companies were required to subsidize Channel 4, which in turn was able to invest in a range of minority and innovative programming that would not otherwise have been commercially viable.

Ironically, the Conservative Party created this ingenious system before they developed a broadcasting policy. They have, since discovering that the mantra of "deregulation" could be applied to the media, done their best to destroy this delicate structure by introducing more straightforward forms of market competition.

Although there is cause to celebrate the highly regulated British mix of public and private broadcasting as a method for achieving program quality and diversity, the system is not without its problems. Even though the BBC is, in many ways, independent of the government, it does not have complete fiscal autonomy. The government must approve increases in the BBC's budget (which involves raising the "license fee," a tax on TV ownership), a relationship that compromises the freedom of the BBC to criticize the powers that be. The BBC, under Mrs. Thatcher's reign, became increasingly timid in indulging the more critical members in its ranks. This political pressure also forces the BBC to compete with its commercial rival for ratings, inasmuch as high ratings help justify the level of the license fee.

Another political drawback lies not in the BBC's direct links to government but in its lack of internal democracy. The BBC is much like any other undemocratic corporation (albeit a rather benevolent and bureaucratic one), with its distinctly elitist recruitment record, its "top-down" management system, and its paternalistic attitude toward attempts to broaden access to program making.

Both these problems with the British model could be solved simultaneously, I would argue, by the creation of a more democratic structure of public broadcasting: Its managing bodies should be elected rather than appointed. Such a proposal is, admittedly, much clumsier in practice than in theory; too much democratic decision making can easily lead to bureaucratic inefficiency. The key to its success would be to inscribe it with accountability

across a range of different social, demographic, and interest groups, to *fragment* public broadcasting so that it is able to embrace narrowcasting, serving a multiplicity of communities and interests.

There are two advantages to this model. On the one hand, it would create a political mandate for public media, freeing them from more orthodox governmental pressure. It is, after all, much easier for the government of the day to attack an organization run by appointees than one with a direct mandate from the public. At the same time, it would set in place a set of forces that would encourage fragmentation rather than uniformity, thereby perfectly complementing a commercial system in which ratings push program makers toward uniformity rather than fragmentation.

In an era in which control over the press is falling into fewer and fewer (and more like-minded) corporate hands, there is a strong case for establishing similar forms of public structures in print as well as broadcast media. As A. J. Leibling remarked, the freedom of the press is guaranteed only to those that own one. The various publics that make up contemporary industrial societies would surely benefit from public print media that reflect views that did not originate in corporate boardrooms.

INVESTING IN INNOVATION

The history of capitalism in the developed world suggests that unless encouraged to do otherwise, industry tends to look to the short rather than the long term. Innovation, if it means changing a system of production that can still eke out a profit, is considered a risky long-term luxury. Even in some capitalist/mixed economies, nation states from Germany to Japan have realized that they must play a role if they are to maintain a dynamic industrial base. The more prescient governments have, in one form or another, subsidized research and development in order to maintain an innovative edge. The cultural industries are no different in this respect. If we are interested in providing artists (of whatever kind) the freedom and resources to innovate, then some form of subsidy is required.

During the late 1970s and early 1980s, the British pop music industry, after a decade of increasing stagnation, enjoyed one of its most creative and dynamic periods. A whole range of new styles emerged from this "new wave" in British pop. This musical renaissance had its roots not only in a cultural rebellion against the formulaic monoliths of the mainstream record industry but in the spate of independent record labels that sprang up, promoting new and often unconventional musical styles. Most of these independents were driven by cultural rather than economic goals and operated in defiance of basic free market principles, relying on self-exploitation and low (or nonexistent) profits. They worked, in other words, for love rather than money.

The influence of the independents (or "indies") on the economic structure of the industry was, on one level, fairly negligible. The great majority of independents went to the wall, and even the more successful "indee" labels (like Rough Trade) made only a small dent in the territory owned and controlled by the major record labels. Nevertheless, their cultural influence on the industry was profound. As Mulgan and Worpole (1986) have indicated, the independents' investment in new styles provided the research and development function that the majors were unwilling to subsidize themselves. Thus began an exploitative relationship wherein the more commercially viable acts or styles discovered by the independents could be bought up and made profitable by the major record companies. Although this was certainly bad news for the independent, who lacked the resources to compete effectively for record contracts, the industry as a whole clearly benefited from their input.

It would be shortsighted to conclude that this demonstrates the ability of the free market to innovate without public subsidy. The levels of self-exploitation involved, because they defy free market logic, cannot be (and have not been) sustained. Moreover, as Mulgan and Worpole point out, the state unwittingly played an important role in sustaining those musicians and producers on the economic margins by providing social security payments to young people who were technically unemployed (although not without some bending of the rules on the part of the recipients). What this brief cultural lesson teaches us is that the state can play a useful role in stimulating cultural activity.

The state can help stimulate innovation in the music industry in a number of ways. The most fruitful investment, in musical activity at the grass roots, allows for the spread of a broad-based musical culture, an approach taken by a number of local authorities in Britain in the 1980s (see Lewis 1990). That will involve the subsidy or provision of space for performance, rehearsal, and (at a semi-professional level) recording, to stimulate creative activity at a community arts level. Such activity not only has value in its own right, but it enriches the musical life of a main-stream pop culture, forcing the industry to respond to creative pressures from below rather than regurgitating profitable formats from above.

This kind of investment can be applied to many cultural industries: film, video, even TV program making. Its beauty is that the state does not play the role of arbiter of culture. It merely provides a framework in which culture can, from the bottom upward, grow and develop. The state can, in this sense, promote a democratic rather than a purely market-oriented or elitist culture.

REFERENCES

Bagdikian, Ben. 1990. *The Media Monopoly.* Boston: Beacon Press.

Lee, Martin, and Normal Solomon. 1990. *Unreliable Sources.* New York: Lyle Stuart.

Lewis, Justin. 1990. *Art, Culture, and Enterprise: The Politics of Art and the Cultural Industries.* London: Routledge.

Mulgan, Geoff, and Ken Worpole. 1986. *Saturday Night or Sunday Morning.* London: Comedia.

Peterson, Richard, and David Berger. 1990. Cycles in Symbol Production: The Case of Popular Music. In *On Record*, edited by Simon Frith and Andrew Goodwin. New York: Pantheon.

General Social Surveys. 1993. National Opinion Research Center at the University of Chicago. August.

Margaret Jane Wyszomirski }

POLICY COMMUNITIES AND POLICY INFLUENCE: SECURING A GOVERNMENT ROLE IN CULTURAL POLICY FOR THE TWENTY-FIRST CENTURY

After five years of intense political controversy, both the concept of federal funding for the arts and its administration by the National Endowment for the Arts are under intense challenge. Other federal cultural agencies, such as the National Endowment for the Humanities, the Smithsonian Institution, the Library of Congress, and the Corporation for Public Broadcasting, have also faced criticism. Supporters and opponents of the programs—as well as many neutral observers—have come to the conclusion that this is no way for cultural polices to be made, federal agencies to be administered, or governmental activities to be evaluated. Indeed, the problem in reauthorizing the NEA has been exacerbated by a lack of policy options. For many months, only two options seemed possible—preserve the status quo or eliminate the agency. Then, at the proverbial eleventh hour, when other alternatives surfaced—such as merging the NEA, NEH, and IMS or creating a true endowment—no one could offer much advice about their feasibility, implementation, or possible consequences.

The arts community and its philanthropic supporters have often felt—with some justification—victimized, unlucky, and besieged by the turn of events in recent years. But it can also be argued that many arts advocates have been unwittingly complicitous in these travails—complicitous because they neglected key elements of what might be called the intellectual and political infrastructure of cultural policy. In the discussion that follows, I will introduce readers to concepts and models that are well established in the field of policy analysis. These will be used to examine how the processes and politics surrounding arts policy have operated, to reveal problems in these practices, and to identify some possible improvements.

EXERTING POLICY INFLUENCE:
WHAT IS THE PROBLEM?

The arts battle in the so-called culture wars cannot properly be characterized as a debate, since epithets rather than ideas have generally been its driving force. Indeed, the persuasive power of virtually all of the arguments that helped establish and sustain federal arts support for the past thirty years has eroded. But little effort has been invested in the development of new ideas. The polarized and raucous contention bears little resemblance to a policy discourse because adherents of various positions seldom speak in the same forum, engage each other's assertions, or agree about basic definitions. Because members of the arts community seem to have spent little effort on research, other than self-study, there is little credible analysis or valid evidence to inform policy decisions. Freedom of expression is espoused, but information—when it is available—is seldom freely circulated. Much sponsored research is undertaken for a specific client and given very limited circulation. Service organizations are not always willing to make the data they collect available to others, or they do so with restrictions on its use. The cultural agencies engage in little policy and undertake only limited program evaluation.

In arguments ostensibly over principles, self-interest and ulterior motives have been abundant. Although politics is disavowed, it has been practiced all around. The arts community can agree on few core values. Values that some members have asserted—such as excellence and art for art's sake—have been challenged by both insiders and outsiders. Amidst such ambiguity, the translation or linkage of arts community values to basic political principles or to broad interests of the general public has been virtually impossible.

Policymakers in Congress or the agencies have been cast as stalwart champions or regarded as venal or, perhaps, villainous. Meanwhile, the founding generation of political and conceptual leadership is passing, and little is being done to cultivate its successors. The processes of policymaking are too often perceived to be politics by another name—and therefore capricious and tainted. Until quite recently, the very terms, "cultural policy" or "arts policy," have been anathema to many members of the American arts community. Some seem to regard policy as a coercive means of governmental control. They fail to realize that policy, when duly legitimized, confers authority on programs and justifies the allocation of public resources. Accountability is seen as an onerous bureaucratic or political burden rather than as the other side of the coin of public trust and public support. There has been much confusion about accountability: does it concern process, results, or goals? Does accountability in one aspect substitute for another, or are all aspects of accountability complementary?

Today—and for the foreseeable future—members of the arts community must deal with new participants and new ideas in what they had thought of as "their" policy monopoly. Some of the new participants disagree over basic assumptions and are hostile to federal funding for the arts. Others hold different perspectives on the possible goals of arts policy or advance different programmatic or procedural preferences. Some critics of public art programs have been able to play fast and loose with accusation, innuendo, and exaggeration, as they seek to redefine issues to further their own agendas rather than to promote good public policy. Learning to deal with such "outsiders" has challenged—and unsettled—many members of the arts community.

Each federal cultural agency and its constituency have operated, in large part, autonomously, emphasizing uniqueness rather than finding common cause and mutual interests. Responsible policymakers have been caught between the unreasonable and the nonnegotiable, and between the unthinking and the unthinkable. The resultant policy dilemmas have imposed rising political costs on most participants, who cannot untie a metaphorical Gordian knot but who lack alternatives that might cut through it.

Ironically, at the very moment when policy awareness has dawned, the NEA and its cultural constituency (as well as its philanthropic supporters) are discovering that they lack some basic resources for policy effectiveness and are hindered by being only a truncated and fragmented policy community. Long focused on preserving the status quo, members of the arts community were slow to see this situation until quite recently. For over a decade, the arts community and the NEA successfully fended off partisan changes in program emphases, administrative operations, budget allocations, and agency organization—variations that characterize most federal agencies as they navigate changes of presidential administration. In the process, constructive adaptation and flexibility were resisted at the cost of eroding bipartisan political support and waning public commitment to the very principle of federal support for the arts. In their quest to avoid politicization, the arts community confused politics with policy and therefore failed to understand what the policy system is, how it works, how to influence the agenda, and where to find political allies. Focused on their particular needs and interests, many members of the arts community lost sight of political, economic, and social changes that would frame the context in which policies affecting them would develop.

Things were not always this way. Historically, foundations played a key role in fostering policy innovation and public entrepreneurship in cultural affairs. In the 1960s, American foundations were crucial in developing arguments and generating momentum for governmental support of the arts and humanities through studies and highly visible task forces. These included the Keeney report on the status of the humanities in American life (1964), the Rockefeller report on the performing arts (1965), the Baumol and Bowen study sponsored by the Twentieth Century Fund (1966), and the

Belmont report on museums (1969). Then, for twenty-five years, foundations helped to foster a sense of community within the various arts disciplines while underwriting (as did the NEA) the development of national service organizations. In addition, foundations and the NEA worked to catalyze greater financial support for the arts, through audience development, increased corporate contributions, and advocacy for expanded federal, state and local government funding.

Together, institutional philanthropy (foundation and corporate) and government patronage helped build a nationwide infrastructure of institutions for the production, distribution, and preservation of culture, as well as an interdependent financial support system for these activities. In one assessment of the governmental programs that were developed between 1965 and 1990, political scientist Milton C. Cummings, Jr., of Johns Hopkins University observed,

> A remarkable system of government aid for the arts has been fashioned over the last thirty years. . . . It builds on, and supplements, the extraordinary preexisting system of private philanthropy for the arts in America . . . involve[s] a considerable range of . . . federal programs; [has] been large enough [to have] had a major impact on the development of the arts in America. . . . Taken together, the scope and depth of government programs to promote the arts are of a magnitude that would have been undreamed of just thirty years ago. . . . [They] have played an important role in the remarkable flowering of the arts that has occurred in the United States over the last generation. (Cummings 1991, 76–77)

When the NEA was established, members of the arts community were concerned with the problems of financial deficits, inequitable public access, and benign neglect. Now, the arts community confronts a political deficit, a negative policy image, and conflicting public demands. Today, the intellectual infrastructure for the generation of new policy concepts and options is insufficient to the task of relegitimating public arts policy and meeting the challenges of the twenty-first century. Alone, the NEA and its arts constituency cannot effectively function as a cultural policy community. If philanthropic supporters want to address these deficiencies, attention must turn to developing a fully articulated cultural policy community, to rebuilding and extending its intellectual and informational infrastructure, to catalyzing political and public support, and to promoting new leadership. Clues to how this might be done can be found through a clearer understanding of what a policy community is and how it functions. It can also be fostered by studying the components and lifecycles of policy systems, how the policy agenda can be influenced, and by reference to the ways that other policy communities and systems function.

POLICY COMMUNITIES:
NURTURING IDEAS AND OPTIONS

Policy communities are networks of specialists in a given policy area, drawn from inside and outside of government, spanning a range of partisan and ideological perspectives. They include congressional staff, academics, consultants, interest group analysts, and administrators with planning, evaluation, program, and budgeting expertise. Frequently, former officials are involved. Foundation program officers, as well as state and local administrators and legislative staff, may also be included. Some participants act as sounding boards and others as technical experts. Yet others perform the role of "policy entrepreneurs" who are willing to invest time, energy, reputation, and perhaps money in the effort to influence public debate and shape public policy. As James A. Smith noted in his book *The Idea Brokers*, policy entrepreneurs

> play the role of interpreter of public policy at times and some have legitimate claims as policy specialists. . . . They mobilize resources to push a particular proposal, create coalitions among diverse groups of researchers and activists, foster the careers of able and committed aspirants to membership in the policy elite, and initiate new journals and other publishing enterprises. (Smith 1991, 225–26)

Sometimes think tanks provide forums for policy community gatherings. In other cases, university-based programs and research centers serve that function. "Peak associations"—that is, associations of associations—can also serve as community conveners. Inclusion in policy communities is not a matter of invitation or of groupthink; it is defined by demonstrated interest and experienced commitment. Members share common concerns but do not always exhibit common perspectives.

In his now classic study of policy agenda-setting process, Michigan political scientist John Kingdon observed,

> Ideas float around in such communities. Specialists have their conceptions, their vague notions of future directions, and their more specific proposals. They try out their ideas on others by going to lunch, circulating papers, publishing articles, holding hearings, presenting testimony, and drafting and pushing legislative proposals. The process often . . . takes years. . . . Some ideas survive and prosper; some proposals are taken more seriously than others. (Kingdon 1984, 122–23)

He goes on,

As officials and those close to them encounter ideas and proposals, they evaluate them, argue with one another, marshal evidence and argument in support or opposition, persuade one another, solve intellectual puzzles, and become entrapped in intellectual dilemmas. . . . Policymaking is often a process of creating intellectual puzzles, getting into intellectual minds, and then extracting people from these dilemmas. . . . Lobbyists marshal their arguments as well as their numbers. . . . Both the substance of the ideas and political pressure are . . . important in moving some subjects into prominence and in keeping other subjects low on governmental agendas. (Kingdon 1984, 131–33)

Such community dynamics can be seen clearly in other policy areas. For example, in the health policy field, foundation grants helped support the activities of the Health Staff Seminars in Washington, D.C., as well as the more informal meetings of the Jackson Hole group that was something of a brain trust behind many recent health care reform proposals. Among nonprofit organizations more generally, a sense of common identity, shared interests, and research resources has been cultivated through the meetings, research forums, and theory-building and data collection projects of the Independent Sector and a new network of university research centers and educational programs that focus on the nonprofit sector. In the broad arena of science policy, the Carnegie Corporation of New York supported a five-year Commission on Science, Technology, and Government. The commission was composed of leaders from the various scientific disciplines and engineering, research, education, industry, and government with an interest in science and technology. Through task forces, background papers, sponsored research, and public reports, the commission sought to foster a policy community dialogue. The dialogue explored ways that the relationships among public, private, and nonprofit interests in the science and technology policy system might be made more effective. Options were developed regarding how science and technology might further societal goals in education, economic prosperity, international affairs, and environmental policy.

There are no comparable forums in the fields of arts policy or cultural policy, although there are indications that these might be fostered. For example, meetings of the President's Committee on the Arts and Humanities have on occasion served as policy forums. The biennial Getty Conference on Arts Education has been effective in convening and helping to promote a dialogue in arts education. Few think tanks have devoted resources and attention to cultural matters. Those that do—such as the Heritage Foundation, the Center for the Study of Popular Culture, and, to a lesser extent, the American Enterprise Institute—have tended to be critics of federal cultural agencies and their programs. Periodically, private foundations have revisited the subject of public television and its policy issues (most recently with the Twentieth Century Fund's report *Quality Time?*).

In contrast, since the landmark reports of the 1960s, American foundations have done little to underwrite the development of an intellectual infrastructure for arts policy. Such forums and activities are crucial to the maintenance and effectiveness of policy communities. Policy dialogue, issue identification, and option development should be ongoing efforts and need multiple venues and a long-term commitment. Successful new policy ideas do not just happen; they must be seeded and nurtured. They are the fruits of extensive thought and effort by fertile, interactive, and context-sensitive policy communities.

THE ARTS:
A FRAGMENTED POLICY COMMUNITY

Although policy communities vary greatly in their degree of specialization and cohesion, the arts community is fragmented, incomplete, and uncoordinated. It is fragmented by, for example, discipline, generation, ethnicity, and geography. It is incomplete—many community components are disorganized, and key resources (particularly information, evaluation, and analysis) are woefully underdeveloped. And it is uncoordinated—many community segments are essentially strangers to one another and have few occasions to interact. In other words, to become more policy effective, the present arts community needs to evolve into at least an arts policy community, if not into an even more extended, cultural policy community.

At present, the arts community tends to cluster in specialized communities: dance or theater; museums or symphonies; state or local art agencies; grant makers or scholars. This pattern can be seen in the flock of specialized peer panels and of field panels that the NEA convenes each year. Even within distinct groupings, there may be more specialized associations. For example, the theater world has TCG and LORT, as well as the League of Broadway Theaters and Producers and others. Conversely, a specialized group may encompass substantial diversity. The museum community crosses disciplinary boundaries to include art, history, and science museums. The Conference Group on Social Theory, Politics, and the Arts includes scholars from sociology, political science, survey research, and art history, as well as occasional art administrators, art educators, and art consultants. Before it was disbanded, the Congressional Arts Caucus brought together over 200 members of the House of Representatives from both parties who expressed an interest in the arts. Yet despite such variations, the forums of the arts community continue to be geared to segmented professional development, communication, program administration, and sporadic political mobilization. Meanwhile, few policymakers encounter policy scholars in the field, and the academic and practitioner wings of the community are largely strangers to one another. Interaction among policymakers, practitioners, and policy scholars is much richer in fields of public policy.

What are the implications and ramifications of such fragmentation? First, studies of other policy communities indicate that community fragmentation leads to policy fragmentation. That is, each issue and program tends to be designed and implemented without reference to others in the same or related policy systems. This would seem to be the case both in the arts specifically and in cultural affairs more generally. As a consequence, cultural agencies and their programs may fail to anticipate the range of implications and unintended consequences of their actions. Little thought is given to the relative merits of programs across a range of disciplines, to the potential impact on the arts as a whole, or to what public benefits that might accrue. Alternatively, the value of the lessons of experience and experimentation in any segment of the arts community is diminished by fragmentation, because the policy knowledge has few channels for cross-communication. Instead, it is common to hear members of the arts community assert their uniqueness, that is, how what works in theater will not apply in dance, how museums differ from artists' organizations, and so forth. Yet clearly, at some levels of comparison and conceptualization, dance and theater deal with the visual arts. Both museums and dance companies express concern for preservation, and similar concerns cross over into the humanities and heritage sectors as well. Customizing programs has certain benefits. But much is also to be gained from comparisons and from discovering broad programs and policies that can accommodate variations.

Second, fragmentation inhibits the cultivation of common outlooks, values, and ways of thinking. In other words, fragmentation hinders both paradigm and option development. The truncated character of the arts policy community as well as its fragmentation creates a particularly insidious problem. On the one hand, members of the arts community do share—to a substantial extent—outlooks and values and language. On the other hand, those commonalities do not seem to hold sufficient sway when it comes to cultural policy. The clash between accusations of censorship and demands for accountability demonstrates a serious difference in values. Likewise, competing ideas about what constitutes "excellence" in the arts and about the relative merits of peer versus public review indicate other fundamental fissures. Within the fragmented arts community, such differences have festered because there are few mechanisms for reconciliation or accommodation among conflicting perspectives.

Finally, fragmentation breeds instability and vulnerability. Without broadly agreed-upon and resilient paradigms, fragmented policy communities are susceptible to crises. Crises occur for many reasons—as a consequence of volatile shifts in agenda focus and public perceptions, program flaws or failures, and inadequate or unstable leadership. Fragmented policy communities may be particularly vulnerable to changes in context for two reasons. First, fragmentation implies a certain narrowness of interests that may limit the scope of environmental scans. Second, the organizational consequences of

fragmentation can be costly and inefficient, thus leaving few resources for investment in the development of policy capital. Consequently, fragmented policy systems—like the arts—may lack adequate systems for "early warning" about environmental shifts and therefore may find themselves in a reactive position with few contingency plans. Fragmented systems are also likely to become complacent about the status quo because they devote little attention to considering alternatives.

Ultimately, fragmentation, incompleteness, and lack of coordination have impeded the ability of the arts community to deal with crises and change. However, these flaws are not inherent and need not be fatal.

PUTTING THE PIECES TOGETHER: IMPLICATIONS FOR ACTION

The foregoing discussion of policy in the arts attempted to survey the role, structure, and functions of a policy community in the making of public policy. At least two other policy "maps" could also be drawn: one of the stages of policymaking and a second concerning the institutional elements and political dynamics of the policy subgovernment. All three schematics could then be overlaid to get a multidimensional picture of policymaking processes to identify how they might be influenced.

In our book *America's Commitment to Culture*, my colleagues and I dealt with the arts policy subgovernment at some length. Therefore, I will not revisit that subject here. As to the policymaking process, a full discussion is clearly beyond the scope of this essay. However, it is worth noting that, despite the historical emphases of the arts community, policymaking is not limited to what are essentially its middle phases of budgeting and program administration. Surely, one of the lessons of the "art wars" has been that greater attention must be paid to both the beginning and the end phases of the policy process. That is, how does one set agendas and influence which issues attract political attention? Also who gets to define how issues are characterized, and how can this influence be exerted? In both instances, the arts community lost the initiative, as it focused on the middle phases of the policy process. Alternatively a later stage of the policy process is highlighted by the growing demand for evaluation in an environment of increased competition for funds and escalating public demands for accountability in government. Policy evaluation serves important functions: legitimating ongoing programs, identifying ways that programs and policies can be improved, and anticipating problems and criticism before they become political issues. Failure to evaluate can allow opponents to determine the standards that will apply and to dominate the assessment process when it does occur.

The "patron state" model in the United States seems to be waning. Consequently, one of two general courses of action suggests itself. Either a new

policy paradigm and a changed governmental role must be invented, or the idea of a federal role in cultural affairs may have to be abandoned. To be innovative requires developing a policy community, rebuilding the policy system, and broadening policymaking engagement.

Foundations could reassert their historic role in galvanizing new ideas and new leadership. To some extent, everyone has an interest in promoting "good" public policy—policy that is regarded as legitimate, feasible, and effective. But designing, enacting, and administering such policy is seldom a matter of discovery or revelation, although good luck and a sense of timing are helpful. Rather, good policy is the product of a complex process that requires three key ingredients: ideas, politics, and leadership. This suggests two general strategies, both of which also have implications for fostering leadership:

1. Stimulate mechanisms that foster policy ideas—from the articulation of core values and a central paradigm to the development of program models and policy options. For example:

• *Underwriting forums and projects that promote the expansion of a policy dialogue and the development of a functioning cultural policy community.* A multiyear blue ribbon commission could be created to explore how the arts and cultural activities can help government and society achieve national goals while preserving vital creative resources and institutions. Another activity might be supporting forums for the discussion of policy options. Some questions to address here might be, How could a national trust fund be created and operated? What might closer collaboration among cultural agencies look like? What are the most effective roles for the national, state, regional, and local agencies? What innovative ways can be found to improve the financial self-sufficiency and stability of arts organizations? How can new talent and creativity be encouraged? How can cost sharing arrangements among cultural institutions be fostered, and in what circumstances do they seem to work? Are there ways in which the nonprofit and for-profit segments of the cultural industries can work with one another—and what are the pros and cons of such engagement? The list of questions could be long and the range of solutions quite wide. Yet unless such questions are raised and the possible answers thoughtfully examined, the arts community will continue to find itself relying on improvisation and hoping for inspiration in the midst of crises.

• *Investing in the intellectual infrastructure of cultural policy by supporting better information, communication, analysis, and evaluation.* New policy rationales must be developed because the old ones have lost persuasive power. The deficit dilemma of arts organizations is less compelling in the face of the pervasive national budget deficit. Economic impact has been oversold and fails to capture the full value of the arts. Art for art's sake has come to look like a

special interest claim that ignores much of the public. Access to the arts has become more equitable, particularly in geographic terms. Questions to consider include, How can we demonstrate the impact of cultural policies and programs? What are public expectations and attitudes about the arts and about arts policies and what shapes them? What is the size of the arts sector and what are the trends in its finances, artistic activities, and administrative practices? Are they common across the arts community or do they vary by geography, size, or art form? Unless more information, thought, and dialogue are brought to bear on those and many other questions, the arts community will remain confined to anecdote, belief, and assertion in any future policy debates.

• *Exploring how we can learn from comparison.* Many other policy areas look at the experience of other countries for policy ideas, options, and indicators. In education, policymakers debate the effectiveness of the Japanese system; in health policy they argue about the merits of the Canadian plan. At the creation of the NEA we looked to the British model; now much might be learned (and mistakes avoided) from a better understanding of how other countries practice cultural policy. Similarly, many policy fields learn from the experience of state governments, which are presented as "laboratories of democracy." Several states have engaged in various entrepreneurial activities and are experimenting with program alternatives. Innovation and option testing could be facilitated if such comparative information and analysis were expanded and shared.

2. Assist in efforts to enhance the political effectiveness of the arts and other cultural communities. In operation, this might involve the following:

• *Supporting projects that foster a supportive public.* Understanding public attitudes and opinion is the first step toward broadening and strengthening popular support. Most other policy areas have extensive and longitudinal polling data; arts institutions themselves engage in considerable market analysis. Yet the arts policy maker knows very little about relevant public opinion and even less about its dynamics.

• *Fostering coalition-building efforts.* This needs to be done both within the arts community and among the various cultural communities. It might be addressed through targeted grant activity and/or through special application requirements. The goal would be twofold: to get groups and associations to develop working relationships that can evolve into political coalitions and to establish a network of possible future allies.

• *Helping the arts community rebuild a political base among federal institutions and officials.* Turnover among public officials and their staffs is a persistent fact, although the magnitude of Congressional change that has occurred

in the past four years is exceptional. Therefore, means must be created to bring together the arts community, current and potential officials, and their advisers. Other policy communities sponsor events where incumbents and candidates can become familiar with the concerns, conditions, and options of that community, and where the community, can learn of the views, attitudes, and interests of officials. Concomitantly, communication and familiarity are broadly cultivated—not just with a select few but with all relevant legislative committee members and the staff. Similarly, former leaders of federal cultural agencies could be organized into a virtual alumni association in which they could network more effectively with other participants in the arts community. Currently, much of this political talent and experience is wasted, and the arts community is denied the benefits of counsel and access that such individuals can contribute, whether they are out of office or between official positions.

Access, interaction, and information exchange help build political capital that can be used as issues and crises arise. Furthermore, such interactions are critical regardless of what happens to the NEA. Other federal policies affect the arts, and public support is essential to their continuation or enactment. The future and fortunes of the public, private, and nonprofit sectors are integrally intertwined; hence policy will never become irrelevant.

• *Cultivating better and expanded relations between the arts community and key intermediaries such as journalists, commentators, think tanks, and political party organizations.* Few political journalists are conversant with the issues and programs of federal cultural policy, yet they are crucial links in interpreting these to the public as well as to public officials. Conversely, few arts journalists, who are accustomed to writing for the leisure, living, or style sections of newspapers, are practiced reporters of politics or policy processes. Other policy communities, such as the science or environmental ones, have made special efforts to expand the press's knowledge of and exposure to their experts and information. The arts should do likewise. Similarly, many policy communities work at establishing links and connections to broad-based think tanks as well as to political party institutions such as the Democratic or Republican National Committees. All these venues have extensive contacts with a range of public officials as well as private sector leaders. Getting on their agendas, networking at their meetings, and contributing to their understanding of the public interest are long-term investments in advocacy effectiveness and policy awareness.

What might happen if nothing is done to address the weaknesses of the arts policy community and the deficiencies of the art policy system? Let's assume that the current system is not in stasis; rather it has been destabilized, has lost its compass and broken its rudder. If one accepts this assumption, then doing

nothing will only allow conditions to worsen. What then might ensue? It is likely that parts of the institutional infrastructure of the arts will crumble. Some worry that some state arts agencies will be undermined as a result of national controversy. Others fear that some regional arts organizations, as well as a number of middle-size arts organizations, will be squeezed out of a weakened financial support system. The arts community is highly likely to further fragment into separate disciplinary segments. While we struggle to keep current operations afloat, certain preservation needs may go unmet, and we all may lose, irretrievably, pieces of our cultural heritage. Some promising new talent will probably be deflected into other endeavors or face stunted careers. Politically, the arts—already enfeebled—may slide into sterility, impotence, and, ultimately, irrelevancy. Arts policy will become recessive, and the nation's cultural policies will consist only of entertainment and communications. In this, the United States will be out of tune with other nations, many of which have renewed concern for their cultural interests and recast their cultural policies with a clearer sense of purpose and worth.

Like the specter of the future in *The Christmas Carol* of Charles Dickens, I present merely the shadows of what might be—not what will be. Actions taken and directions set in the months ahead can be decisive in the eventual outcome. If there is any lesson to be drawn from the recent years of controversy, it is neither frustration nor fatalism.

In commenting on the efforts by the U.S. House of Representatives to shut down the NEA and NEH, a respected arts advocate commented, "The sad fact is that after all these years we still have to justify support for the arts. It's discouraging to have to make the same arguments over and over." It would be even sadder if the arts community and its philanthropic supporters could not summon the vision and the will to find new arguments, to muster better evidence, to cultivate greater political resources, and to acquire the policy proficiencies needed to be more effective in the future.

REFERENCES

American Association of Museums, 1969. *America's Museums: The Belmont Report.* Washington, D.C.: AAM.

American Council of Learned Societies, with the Council of Graduate Schools in the United States, and the United Chapters of Phi Beta Kappa. 1964. *Report of the Commission on the Humanities.* New York: ACLS.

Baumol, William J., and William G. Bowen, 1966. *Performing Arts: The Economic Dilemma.* New York: Twentieth Century Fund.

Cummings, Milton C., Jr. 1991. Government and the Arts: An Overview. In *Public Money and the Muse*, ed. S. Benedict. New York: Norton.

Kingdon, John W. 1984. *Agendas, Alternatives, and Public Policies.* Boston: Little, Brown.

Mulcahy, Kevin V., and Margaret Jane Wyszomirski, eds. 1995. *America's Commitment to Culture: Government and the Arts.* Boulder, Colo.: Westview.

Rockefeller Brothers Fund. 1965. *The Performing Arts: Problems and Prospects.* New York: McGraw Hill.

Smith, James A. 1991. *The Idea Brokers: Think Tanks and the Rise of the New Policy Elite.* New York: Free Press.

Twentieth Century Fund. 1993. *Quality Time?: Report of the Task Force on Public Television.* New York: Twentieth Century Fund.

Supporting Culture

INTRODUCTION
Michael Gary

Over the past decade, survival in the cultural field has grown increasingly complicated for artists, scholars, and institutions alike. Reasons range from significantly reduced federal appropriations to the less visible but equally serious drop in private-sector giving. The recent chilly climate of budget cuts and the debate over the legitimate role of government support has led the cultural community to reflect on alternative ways to restore and increase public funding for the arts, and to promote the important role played by the arts and humanities in our nation's life.

The essays in *Defining Culture and Cultural Policy* focus on our changing understanding of the cultural sector and the need for developing an effective cultural policy community. Over the course of our nation's history, support for the arts and culture emerged through an amalgamation of direct and indirect, centralized and localized means. Grants flowed from federal, state, and local agencies, private philanthropic organizations, corporations, and individual donations. Provisions and exemptions in copyright and tax law, and a diverse array of instruments in immigration, trade, and telecommunications policy reinforce direct financial support. Despite its fragmentary appearance and the recurrent opacity of articulated policies, our nation's commitment to culture is substantial. *Supporting Culture* examines key pressure points in this interdependent system, beginning with a broad, sectoral focus, narrowing down to the organizational level, and concluding with the individual creative cultural worker.

We begin with an historian's view of the ambivalent relationship between government and culture over time. Michael Kammen traces the development of our compound, pluralistic system of support to uniquely American roots, typifying the nation's recurrent fears of centralized power. While this com-

plex mixture of public and private funds can work synergistically, it can just as frequently give rise to a highly combustible and unstable atmosphere. Kammen suggests that greater collaboration and coordination between all levels of support may help to depoliticize culture.

Mary Schmidt Campbell's unique perspective on public support for the arts was forged over the course of a career that has included stints at the helm of a major nonprofit institution, the largest municipal arts agency in the United States, and, presently, a leading arts conservatory. In "A New Mission for the NEA," she reviews the agency's principal achievements over the past thirty years while drawing attention to its ultimate failure to engage the public's imagination and support. While public funding has enhanced cultural variety and diversity, it has not brought about deeper cultural understanding or reconciliation. The success of the entertainment industry, often drawing on talent nurtured in noncommercial arenas, sometimes diverts audiences and artists from attending, supporting, or working in nonprofit cultural organizations. The oppositional imagination that has been so vital in twentieth century cultural life often undermines the broad public sentiment that is necessary to sustain government support for the arts. And finally, the long-standing assumptions that have sustained public sector activities have been challenged by the concept of privatization, which has questioned the appropriate role of government in culture and in virtually every other sector of American life.

Moving to systems theory, John Kreidler likens the development of the nonprofit system of support to a Ponzi scheme, promising unlimited gains but delivering diminished returns over time. Kreidler argues that if organizations are to survive into the next century, they will have to adapt quickly to the changing realities of the nonprofit arts sector, including the evaporation of discounted labor, contributed income, and audiences. As Kreidler's article suggests, nonprofit arts groups increasingly need to model their organizational structures upon the collaborative and improvisational nature of the artist's creative process. They require flexible structures which will continually adapt to suit the needs of both artists and audiences.

Cultural policies emerge from the everyday decisions taking place in cultural organizations as they endeavor to adapt to their changing environment. "Institutional Pressures" focuses on external forces affecting the individual organizations which inhabit the broader cultural ecosystem. A healthy nonprofit organization needs diversified funding streams so that losses in any one area do not detrimentally affect its overall fiscal health and impinge upon other resources such as staff, services, and programming. Increasingly, nonprofits are mimicking the broader commercial market as they try to become more self-reliant, seeking more creative alliances with the corporate sector through sponsorships, tax credits, and advertising support; pushing for

greater efficiency through the adoption of business methods; and looking for new ways to increase earned income.

In "The Age of Audience," music critic Lesley Valdes examines the changing marketing principles and strategies used by symphony orchestras to maintain and develop future audiences. Outreach activities range from the development of Websites to novel programming such as adult education programs, themed concerts, multi-media events, and earlier start times. The challenge for institutions is to adapt to changes in society without detrimentally affecting their missions.

In "Pictures at an Exhibition," sociologist Victoria Alexander examines the influence of funder preferences on the programmatic output of museums. She concludes that while the differing objectives of government, corporate, and foundation giving do affect exhibition format (e.g., popular formats such as blockbuster and travelling exhibitions), they do not act upon exhibition content. Museums, she suggests, balance their curatorial and financial needs by shifting resources internally in order to cover underfunded exhibitions and projects.

In "Making Change: Museums and Public Life," Alberta Arthurs urges museum administrators and curators to identify the policy assumptions inherent in their day-to-day decision-making and institutional practice. While practitioners complain that policy research and formulation is removed from their experience, Arthurs suggests that the most significant policy activities are made by the institutions themselves in their priorities, budget making, and operational tactics. Over the past decade, museums have made enormous strides in considering complex themes of identity, broadening community participation, and developing educational programs for audiences of all ages. Arthurs calls for self-conscious assessment of the policy consequences of routine action in the development of policy.

In "Cultural Politics and Coercive Philanthropy," Robert Brustein questions arts organization practices that pay close attention to contemporary social trends. Despite decreases in funding and increased institutional pressures, Brustein sees public and private funders demanding that arts organizations fulfill social objectives for the public good. The "arts as handmaiden" approach, as it has been termed, has most certainly been on the rise across the nation over the past decade. Brustein feels that the use of utilitarian rather than aesthetic criteria will amount to bad art and less than effective social utility.

In the structures of support that have developed over the past thirty years, creative cultural workers often come last. We tend to think more often in institutional terms than in terms of individual voices. Support for individual artists and humanists is difficult to come by, particularly with the NEA's direct support for individual artists limited to writers and only a small number of grants available from the private philanthropic community due to complex

federal rules for giving money to individuals. The final three essays of this section focus on the potential and distinctive contributions of artists and scholars to sound cultural policy formulation. Creative cultural workers help to situate us in the world, expressing and exploring all that it means to be human. The landscape they create ranges across the caverns of the deeply personal to the wider expanses of social and political, encompassing the profound, the commonplace, and all that lies between.

William Bennett, focusing on humanistically trained scholars, and Carol Becker and Ellen McCulloch Lovell, concentrating on visual artists, argue that these fields confront the complexity of the world in creative ways and communicate that complexity in a language or through media that can expand the range of our public discourse. As Becker puts it, "It is in their role as critics of society and as mirrors of society that I have come to see artists as negotiating the public realm, often ignored, unheard, and misunderstood but nonetheless tenacious in their insistence on pressing society with a reflection of itself—whether it seeks such representation or does not, whether it chooses to look or does not."

As they stand on the threshold of a new century, with their overall health weakened over the past decade, American arts and cultural institutions are entering a major transitional period. An array of challenges, some long-term and others just developing, threaten to inhibit further development. Some of the emergent issues will be explored in the final section of this volume. Perhaps the various systems of public and private support that have evolved over our nation's short history, and in particular over the past century, are inadequate to maintain a vital cultural life into the twenty-first century. The essays in this section help shed some much needed light on new paradigms and strategies to address these complicated challenges.

Frames for Support

Culture and the State in America

During 1989–1990 the National Endowment for the Arts (NEA) underwent a fierce attack because it indirectly funded allegedly anti-Christian work by Andres Serrano and an exhibition of photographs by Robert Mapplethorpe considered pornographic by some. In 1991 a revisionist, didactic display of western art at the National Museum of American Art (part of the Smithsonian Institution) aroused congressional ire. Yet that fracas now seems, in retrospect, fairly calm compared to the controversy generated in 1994–1995 by "The Last, Act" a long-planned exhibition concerning the end of World War II in the Pacific slated to appear in the National Air and Space Museum, part of the Smithsonian. It was cancelled by the secretary of the Smithsonian because of immense political pressure and adverse publicity emanating from veterans' organizations and from Capitol Hill.

Throughout 1995 those who hoped to eliminate entirely the National Endowment for the Humanities (NEH), the NEA, the Institute of Museum Services, and the Corporation for Public Broadcasting and to reduce support for the National Trust for Historic Preservation did not succeed, but they did achieve devastating budgetary cuts. Moreover, Speaker of the House Newt Gingrich insisted in a two-page essay in *Time* magazine that "removing cultural funding from the federal budget ultimately will improve the arts and the country."[1]

These controversies and attacks, taken together, have had me wondering why it is that most nations in the world have a ministry of culture in some form, whereas the United States does not. Indeed, the very notion seems politically inconceivable in this country. It has been proposed from time to time, most notably in 1936–1938 (offered in Congress during Franklin D. Roosevelt's second term as the Coffee-Pepper bill), but each time abortively.[2] It has been considered and rejected by several presidential administrations. Comparative investigation of State support for cultural projects, examined in historical perspective, provides grist for the mill of anyone inclined toward a belief in American exceptionalism, by which I mean difference, not superiority.[3]

The purpose of this essay, therefore, is to examine the development of a historical context that has shaped contemporary relationships between government and culture in the United States along with contested attitudes concerning those relationships. I am persuaded that our controversies (as well as our current options) cannot be understood without historical perspective.

As a historian who entered the profession in the mid-1960s, my own views on this subject have been formed by essential legislation and events that occurred in 1965, a year that seems to me the pivotal (and positive) turning point in the relationship between government and culture in the United States. I do not believe that the Federal government should have or seek a national cultural policy in the French sense, meaning a specific agenda for a ministry of culture and related agencies determined in a highly centralized fashion.[4] I do, however, believe in governmental funding at all levels, sometimes on a collaborative basis, for cultural programs and institutions of many different sorts. Although I certainly cherish and applaud support from foundations, corporations, and private individuals, there are cultural imperatives, ranging from preservation to scholarly innovation, that will only be achieved with encouragement and help from the State. Although he carries the idea to an extremist conclusion that I do not share, I am intrigued by an assertion once made by the philosopher Horace Kallen: "There are human capacities which it is the function of the state to liberate and to protect in growth; and the failure of the state as a government to accomplish this automatically makes for its abolition."[5]

COMPLEXITIES, IRONIES, AND ANOMALIES

Numerous complexities, ironies, and historical anomalies are evident in the relationship between government and culture in the United States. Three of them seem especially noteworthy. First, it has not simply been persons uninterested in cultural programs and those with a reflexive distrust of federal expansion who have opposed government support for culture in the United States. To be sure, such conservative politicians as congressmen George A. Donero of Michigan, H. R. Gross of Iowa, and Howard W. Smith of Virginia were frequent and formidable opponents. When legislation creating the two endowments neared passage in 1965, it was the irrepressible Representative Gross who offered an amendment that would have expanded the definition of arts activity to include belly dancing, baseball, football, golf, tennis, squash, pinochle, and poker. A year later, when the Historic Preservation Act moved haltingly toward approval, Representative Craig Hosmer of California presented a comic version of a time-honored argument in opposition, using Al Capp's America as his point of reference. "Let us keep the hands of Washington, its resources, and its politics out of the arena of local historical interest," he

declared. "In short, if Jubilation T. Cornpone's birthplace is to be preserved, Dog-patch should do it."[6]

Gross and Hosmer provide familiar voices of protest. Much less expected, however, is the opposition, mainly before 1965 to be sure, of such creative figures in American culture as the painters Edward Hopper and Thomas Hart Benton, the musician Duke Ellington, and the writers George Jean Nathan, Gilbert Seldes, and John Cheever. The painter John Sloan said that he would welcome a ministry of culture because then he would know where the enemy was. And in 1962 Russell Lynes, a widely read cultural observer, warned that

> those who administer the subsidies first must decide what is art and what is not art, and they will have to draw the line between the "popular" arts and the "serious" arts, a distinction difficult to define. . . . Having decided what is serious, it will follow that those who dispense the funds will also decide what is safe . . . able to be defended with reasonable equanimity before a Congressional committee.[7]

From a historian's perspective, then, there really has been an astonishing reversal. We tend to forget that in 1964–1965, when the NEA was being hesitantly created, some of the most prestigious artists, art critics, and arts institutions felt suspicious of politicians and believed that they had more to lose than to gain from any involvement in the political process. Three decades later that pattern of mistrust has been turned inside out. Now it is numerous politicians who regard artists and arts organizations as tainted and unreliable. Consequently the former feel that they have much to lose if they endorse government backing of cultural programs.

A second anomaly worthy of attention arises from the fact that the United States does not lag behind all other industrialized countries in *every* approach to preserving the national heritage and environmental culture. We were the very first to set aside large and spectacular natural areas as national parks, a precedent followed by Canada and eventually by other countries. Moreover, the United States created a precedent in 1917–1918 when it became the first nation to allow tax deductions for cultural gifts to museums and nonprofit cultural organizations. The pertinent legislation has been altered several times since, sometimes in ways that seem inconsistent to the point of being bizarre, but the operative principle has been an immense boon to cultural institutions. Moreover, the principle has become increasingly attractive to European countries during the past decade or so.[8]

A third complexity verges upon anomaly in the eyes of some, but is not widely or well understood. In accord with our commitment to a federal system of government, we have had state agencies for the arts since the early 1960s and a network of state humanities councils since the mid-1970s. Their

existence is reasonably well known to scholars, to nonprofit organizations such as local historical societies, and to civic leaders. Less familiar, though, are the separate state offices of "cultural affairs" (in some but not all states), which frequently have as their primary mission the promotion of tourism and related commercial activities within the state. Quite a few of these agencies have been created in recent decades to do at the state level, and with little or no controversy, what many Americans apparently mistrust at the national level. In North Carolina what is now called the Department of Cultural Resources was the first such cabinet-level entity to be established in any of the United States. It emerged from the State Government Reorganizaton Act of 1971 as the Department of Art, Culture, and History. The legislature of West Virginia created a Division of Culture and History in 1977 that includes five sections: Archives and History, Historic Preservation, Arts and Humanities, Museums, and an administrative unit. The state museums of New Mexico are run by the Office of Cultural Affairs. In Iowa the Cultural Affairs Advisory Council's mission is to advise the director of the Department of Cultural Affairs on "how best to increase the incorporation of cultural activities as valued and integral components of everyday living in Iowa." Wyoming now has a Division of Cultural Resources. In Hawaii the State Foundation on Culture and the Arts prepares programs designed to promote and stimulate participation in the arts, culture, and humanities.[9]

As more American states create such governmental departments and programs, the process suggests a gradual, almost evolutionary (rather than revolutionary) departure from the long-standing preference for leaving to private and local groups decisions affecting the creation and conduct of cultural institutions. In some states these bureaus cooperate harmoniously with the state arts and humanities councils, while in others rivalry exists; in a few the bureaus keep one eye nervously on the state legislature and the other one warily on the arts and humanities councils that really ought to be their natural allies.

THOUGHTS ON NOT HAVING A NATIONAL CULTURAL POLICY

At the end of the 1960s the United Nations Educational, Scientific, and Cultural Organization (UNESCO) mobilized in Monaco a Round-Table Meeting on Cultural Policies and commissioned booklets about State cultural programs in diverse nations of the world. The paper prepared for presentation in Monaco by representatives of the United States opened with this categorical yet enigmatic statement: "The United States has no official cultural position, either public or private." The author of the booklet that resulted, Charles C. Mark, called his opening chapter "Cultural Policy within the Federal Framework" and offered this explanatory definition: "The United States cultural policy at this time is the deliberate encouragement of multiple cultural forces

in keeping with the pluralistic traditions of the nation, restricting the federal contribution to that of a minor financial role, and a major role as imaginative leader and partner, and the central focus of national cultural needs."[10]

Roger Stevens, the first chairman of NEA (1965–1969), declared that his agency did not have a cultural policy as such; his successor, Nancy Hanks, reiterated that position. By the autumn of 1977, however, spokesmen for the Carter administration asserted that by means of task forces in tandem with state and national conferences, a cultural policy for the United States would be forthcoming. The following year Joan Mondale, the wife of Vice President Walter Mondale, led a concerted effort to activate the Federal Council on the Arts and the Humanities, which had been inert since its legislative creation in 1965. One of the council's first responsibilities would be to review "the arts and cultural policy of the United States."[11] Ambivalence and uncertainties ensued. In 1980 Rep. Sidney R. Yates of Chicago, chairman of the House Appropriations Subcommittee on Interior and Related Agencies, requested, a full-scale review of both NEH and NEA operations. The report that emerged more than eight months later concluded that NEA had failed to "develop and promote a national policy for the arts." When Yates called for clarification of NEA's objectives, its chairman, Livingston Biddle, was distressed on the grounds that compliance would require him to become a "cultural czar" and exercise control, a role highly inappropriate in a democratic society. After two intense days of hearings, Congressman Yates shelved the committee report and did not subsequently mention the need for a national cultural policy. Former congressman Thomas J. Downey puts it this way, semifacetiously: "We have a cultural policy by the seat of our pants. We do it for ad hoc."[12]

I am persuaded that what emerged during the Carter years—namely, the desire by a few people to articulate a national cultural policy—represented an aberration, albeit a recurrent one in the American past. For the most part we have not had such a policy because it has seemed inappropriate in such a heterogeneous society as well as a potential flash point in the view of many political leaders. (The 1965 legislation creating the two endowments explicitly advocated "a broadly conceived national party of *support* for the humanities and the arts.") Ever since the administration of John F. Kennedy, despite very significant changes in the visibility of cultural activities in public life, it has remained inexpedient or imprudent to advocate a full-blown national cultural policy.[13]

A notable exception to that generalization, however, involves Nelson A. Rockefeller, a man who once remarked that "it takes courage to vote for culture when you're in public life." Rockefeller remained a staunch advocate of government support for culture. New York created the first state council on the arts in 1960, a major precedent, during Rockefeller's first term as governor, and not by happenstance. Nancy Hanks served her apprenticeship as an arts administrator when Rockefeller hired her as a member of his advisory

staff. It has not been adequately recognized that John F. Kennedy, Lyndon B. Johnson, and Richard M. Nixon all, despite personal reluctance, accepted the idea of federal support for culture because Nelson Rockefeller loomed as a potential threat for the presidency. Political consultants warned them that the active governmental role envisioned by Rockefeller appealed to an increasing number of major campaign contributors and influential local elites as well as voters. That was the advice given to Nixon, for example, by Leonard Garment, his closest adviser on cultural matters. It is revealing that directly following his reelection in 1972, Nixon no longer felt any need to keep pace with Rockefeller's free-wheeling agenda for cultural programs. "The arts are not our people," Nixon told his aide H. R. Haldeman. "We should dump the whole culture business."[14]

Nixon unleashed his cynicism once he knew that he would never again have to compete with Rockefeller for the White House. When John F. Kennedy campaigned in 1960 he refused to commit himself to federal support for cultural programs. During his presidency, according to August Heckscher, Kennedy always used the word "marginal" when questions of federal funding arose. And considering Lyndon Johnson's rage at writers and artists as a result of their critical reaction to his foreign policy and, more particularly, their negative response to the White House Festival of the Arts in June 1965, it seems almost a miracle that only a few months later he signed the legislation that created the NEH and NEA.[15]

So the United States government has never had a national cultural policy— unless the decision *not* to have one can, in some perverse way, be considered a policy of sorts. (Unquestionably, creation of the national endowments in 1965 marked a notable break with tradition and legitimized the concept of *federal* support for culture.) Two partial exceptions to my assertion ought to be acknowledged, however.

It became apparent during the first half of the nineteenth century that public architecture would follow the classical revival model, a policy strengthened and extended between 1836 and 1851 when Robert Mills served as architect of public buildings in Washington, D.C. Having been a student of Thomas Jefferson, James Hoban, and Benjamin H. Latrobe, Mills mingled Palladian, Roman, and Greek motifs. By the end of his tenure, a pattern had been firmly established that would endure. Although Mills certainly did not create the classical revival, he made it ubiquitous in prominent public structures. In this particular instance, the government's architectural policy turned out to be the lengthened shadow of one man's drafting board and engineering skills.[16]

The second partial exception, in my view, occurred during the Cold War decades, most notably 1946 to 1974, when a pervasive concern to combat and contain Communism prompted an unprecedented yet uncoordinated array of

initiatives by the federal government to export American culture as exemplary illustrations of what the free world had to offer Europe as well as developing nations. A new position was created, undersecretary of state for cultural affairs, with Archibald MacLeish as the first incumbent—the closest American counterpart, perhaps, to André Malraux of France. The State Department actually purchased and sent seventy-nine works by contemporary artists abroad for exhibitions. The Fulbright Scholarship Program emerged. The United States Information Agency came into being in 1953, and soon it had jazz bands such as Dizzy Gillespie's making international tours. Such exports achieved undeniable popularity wherever they went, and they were perceived as the music of individualism, freedom, pluralism, and dissent—fundamental qualities obliterated by Communism.[17]

From 1950 until 1967 the Central Intelligence Agency (CIA) covertly funded the Congress for Cultural Freedom, whose publications ranged from the widely admired monthly magazine *Encounter* to a slew of foreign-language journals. What their editors and authors held in common was a liberal or even a radical hostility to Communism. Although Allen W. Dulles and other leaders of the CIA did not exactly share the values of such men as Dwight Macdonald and Melvin Lasky, they assumed that anticommunist statements coming from the left would carry special credibility.[18]

After 1963, when rumors of CIA support for the Congress for Cultural Freedom began to spread, the organization became discredited, especially following the escalation of United States bombing of North Vietnam in the spring of 1965. Stalwarts such as George Kennan, however, defended the millions of dollars used by the CIA to disseminate Western values, and he based his support on curious yet symptomatic grounds. "The flap about CIA money was quite unwarranted," Kennan wrote. "This country has no ministry of culture, and the CIA was obliged to do what it could to try to fill the gap. It should be praised for having done so, and not criticized."[19] I find it intriguing that an American ministry of culture, rarely considered politically viable by anyone, might be envisioned by George Kennan as an appropriate vehicle for anticommunist and ideologically related literature.

CULTURE AND THE STATE BEFORE 1965

Taking the long view, some unsuccessful efforts at government support, some highly expedient initiatives, and some embryonic moves provide historical context for the major breakthrough that occurred in 1965 yet also help to explain why many participants in the polity still have ambivalent or even negative feelings about the existence of NEH and NEA.

Let's begin late in 1825, when President John Quincy Adams sent Congress his recommendations for a national university, astronomical observatories,

and related programs. Congress scornfully rejected his initiatives, and they never even reached the stage of serious consideration. Martin Van Buren and John C. Calhoun led the opposition with contemptuous charges of "centralization," a catchphrase that would become a standard rallying cry for more than a century among opponents of federal support for cultural projects.[20]

The federal government funded exploring expeditions at intervals throughout the nineteenth century, the best known being the ones led by Meriwether Lewis and William Clark, Capt. Charles Wilkes, Ferdinand V. Hayden, and John Wesley Powell. Although each of their ventures had scientific objectives, sometimes including ethnography, they received validation primarily because they served the national interest, and in the trans-Mississippi West especially, they also opened entrepreneurial vistas, ranging from railroad routes to water use for agriculture and ranching.[21]

The early history of the Smithsonian Institution provides us with a symptomatic object lesson for the subsequent story of government and culture in the United States: uncertain, politically troubled, and contentious. In the very year of the institution's inception, 1846, a Princeton scholar offered these rhetorical warnings to Joseph Henry, the first secretary (that is, director):

> Is there any adequate security for the success or right conduct of an Institution under the control of Congress, in which that body have a right and will feel it to be a duty to interfere? Will it not be subject to party influences, and to the harassing questionings of coarse and incompetent men? Are you the man to have your motives and actions canvassed by such men as are to be found on the floor of our Congress?

As for inconsistency and uncertainty, Henry spent much of his tenure as secretary, 1846 to 1878, trying to *prevent* any merger between a proposed national museum and the Smithsonian. His successor, Spencer Baird, however, promptly reversed that policy.[22] There would be many other vacillations and reversals in years to come. Cultural institutions, like any other kind, are bound to redirect their course; but the Smithsonian's prominence and its peculiar circumstances as a privately endowed public institution meant that its policies would be closely scrutinized. Unpredictability in those policies, especially under Baird's successor, Samuel P. Langley, made it all the more likely that the Smithsonian would come to be regarded as the "nation's attic," an institution of memory rather than its guiding gyroscope or compass for cultural affairs.

In 1904, two years before his death, Secretary Langley included at the outset of his annual report an upbeat assessment of the Smithsonian's political autonomy. He even specified the principal sources of that sheltered status: Congress and the institution's Board of Regents.

The appreciation of the work of the Institution by the American people is best testified by their representatives in Congress. This has been clearly demonstrated through many successive terms regardless of political change; by the judgment with which their representatives upon the Board of Regents are selected; by the care by which they protect the Institution in its freedom from political entanglements.[23]

During the 1920s, a decade prior to the one we customarily emphasize in regard to federal support for cultural activities, the American film industry received major federal support. It should be acknowledged, however, that the film industry's "angel" was the Commerce Department, which assumed that it was helping to sustain a fledgling but potentially important international industry, rather than "culture" as such. When World War II cut off the extremely lucrative European marker that provided half of the income for Walt Disney's corporate enterprises, the United States government helped Disney develop audiences in Latin America. In 1941, moreover, when Disney was on the verge of bankruptcy, the federal government began to commission propaganda films that became Disney's mainstay for the duration of World War II.[24]

The proliferation of cultural programs during the New Deal—almost entirely for reasons of economic relief rather than as a result of any sudden epiphany about the importance of art for its own sake—has been so well documented that it requires no more than a mention here. Writers and painters, sculptors and photographers, folklorists and dramatists were able to feed their families, sustain or even launch careers, and they made some innovative as well as enduring contributions to the arts in the United States.[25]

We cannot ignore, however, the lingering hostility that led Congress to end these programs in the years 1939–1941. It was not simply that the programs had already served their purpose, or that funds and human resources had to be redirected to a global military struggle. A great many politicians did not believe the products had justified the expense. Congressmen had not been converted to the notion that government had a permanent role to play as a cultural entrepreneur or advocate. And theatrical productions, in particular, came to be regarded as leftist critiques of traditional American values. Representative Clifton Woodrum of Virginia, chairman of the House Appropriations Committee, expressed his determination to "get the government out of the theater business," and he succeeded.[26]

Nevertheless the mid-and later 1940s, not customarily regarded as a propitious decade for governmental support of culture, produced promises of changes to come. Discussions of a national portrait gallery occurred even as World War II drew to a close. (The initiative for such a gallery dated back to the efforts of the painter Charles Wilson Peale in the early national period;

was raised again when the British Portrait Gallery was created in 1856; resurfaced once more after World War I when paintings of the Versailles peace treaty negotiators and war heroes like General John J. Pershing were commissioned; and was envisioned by Andrew Mellon during the 1930s when he purchased works specifically for a portrait gallery that would be a separate entity from the projected National Gallery of Art.) As an illustration of how indirect support for the arts could occur, in 1949 Alan Lomax got Woody Guthrie a job writing and singing songs about venerable disease for a radio program on personal hygiene sponsored by the United States government. (Guthrie produced at least nine songs, a few of them clever and moving but most considered raunchy or outrageous.)[27]

During the 1950s the long-standing pattern of hesitancy and inconsistency persisted. In 1954 a special subcommittee of the House Committee on Education and Labor considered bills to establish arts foundations and commissions, including a proposed national memorial theater. A majority recommended against the bill, explaining that it would be an inappropriate expenditure of federal funds. "It is a matter better suited for state, local, and private initiative," they said. A forceful minority report, however, called attention to the propaganda value to the Soviet government if the United States stopped participating in international festivals of art, music, and drama. A New Jersey Democrat warned that the Soviet Union and its satellite states "picture our citizens as gum-chewing, insensitive, materialistic barbarians." Albert H. Bosch, a Republican from New York City, responded and probably spoke for many Americans at that time: "We are dubious, to say the least, of the contention that people abroad are drawn more easily to Communism because we have failed to subsidize, or nationalize, the cultural arts in the United States." No one involved in that dialogue, however, had said anything about *nationalizing* the arts.[28]

Change was clearly in the air by the later 1950s—notably an awakening sense of popular pride in American cultural activities, broadly defined, and the proliferation of cultural centers all across the country that could house those programs. The renaissance in American cultural awareness customarily identified with the Kennedy years actually had is genesis several years before Kennedy took office. In 1960, for example, *Life* magazine devoted a laudatory two-page editorial in its twenty-fifth anniversary issue to "The New Role for Culture."[29] Simultaneously, the American Assembly, based at Columbia University (created in 1950 by Dwight D. Eisenhower while he served as president of Columbia and later acquiring quasi-official status), invited August Heckscher, a patrician long prominent in New York's cultural life, to contribute an essay concerning "The Quality of American Culture" to a volume published in 1960 under the title *Goals for Americans: Programs for Action in the Sixties, Comprising the Report of the President's Commission on National Goals.*

The penultimate section of Heckscher's essay, called "Government and the Arts," acknowledged that "where government has entered directly into the field of art, the experience has too often been disheartening. Political influences have exerted themselves. . . . The art which has been encouraged under official auspices has almost always favored the less adventurous and the more classically hide-bound schools." Heckscher then proceeded to turn the discussion in a new direction, one that would be followed during the Kennedy and Johnson administrations and beyond. "From this experience," Heckscher observed,

> leading figures in the art world have drawn the conclusion that anything is better than the intrusion of government. It may be questioned, however, whether such men are not thinking too narrowly as professionals, without adequate understanding of the governmental methods and institutions which in other fields, no less delicate than art, have permitted the political system to act with detachment and a regard for the highest and most sophisticated standards.

(Heckscher clearly had the National Science Foundation in mind.) During 1961 and 1962, when John F. Kennedy and his advisers briefly considered the creation of a cabinet-level department of fine arts or cultural affairs, August Heckscher was envisioned as the secretary of such a department. He served JFK as special consultant on the arts in 1962–1963.[30]

Meanwhile, in the spring of 1960, eight months before moving from Harvard University to Washington as special assistant to the president, Arthur M. Schlesinger, Jr., published a short piece titled "Notes on a National Cultural Policy." Much of it addressed what he called "the problem of television" and revealed a perspective very different from the hands-off stance of cultural critics from Gilbert Seldes's generation. Schlesinger insisted, "Government has not only the power but the obligation to help establish standards in media, like television and radio, which exist by public sufferance." There seemed to be no other way, he continued, "to rescue television from the downward spiral of competitive debasement." Much in this vigorous piece anticipated the famous address given by the head of the Federal Communication Commission (FCC) Newton N. Minow in May 1961 to the National Association of Broadcasters, the well-remembered "Vast Wasteland" speech in which Minow threatened government regulation in order to improve the quality of television. (Late in 1960 Walter Lippman called for the creation of a federal television network because he felt that program quality on the commercial network was so low.)[31]

In his final two pages Schlesinger moved more expansively to the difficult issue of broad responsibility for cultural policy in general. He acknowledged that compared with regulation of the media, "the case for government concern over other arts rests on a less clear-cut juridical basis." He reminded

readers that John Quincy Adams had "clearly stated that a government's right and duty to improve the condition of citizens applied no less to 'moral, political, [and] intellectual improvement.'" Schlesinger did not mention that most Americans had ignored President Adams. He did concede, however, that "the problem of government encouragement of the arts is not a simple one, and it has never been satisfactorily solved." Schlesinger's closing remarks anticipated the new endowment initiatives implemented in 1965, whose emergence has been fully described in several histories and memoirs.

> Government is finding itself more and more involved in matters of cultural standards and endeavor. The Commission of Fine Arts, the Committee on Government and Art, the National Cultural Center, the Mellon Gallery, the poet at the Library of Congress, the art exhibits under State Department sponsorship, the cultural exchange programs—these represent only a sampling of federal activity in the arts. If we are going to have so much activity anyway . . . there are strong arguments for an affirmative governmental policy to help raise standards. . . . Whereas many civilized countries subsidize the arts, we tend to tax them. [A series of recommendations followed.] . . . As the problems of our affluent society become more qualitative and less quantitative, we must expect culture to emerge as a matter of national concern and to respond to a national purpose.[32]

The extent to which Schlesinger's recommendations (along with those of Robert Lumiansky of the American Council of Learned Societies and others a few years later) were implemented during the mid-1960s and after surely must have exceeded even the wildest dreams of any wistful or visionary academic historian.

SOME PROBLEMATIC DEVELOPMENTS SINCE 1965

The history of governmental support for cultural programs and related activities during the past three decades is familiar in certain respects yet obscure and sorely misunderstood in many others.[33] Although space does not permit even a cursory survey, I want to call attention to four problematic issues.

First, because the perspective of a tension between "quality and equality" has been troublesome, most of the conferences and blue-ribbon reports that have appeared since 1965 emphasize, *pari passu,* the goals of "supporting excellence" and "reaching all Americans." One rubric that has resulted from these dual goals is "excellence and equity." Many of the key figures in the post-1965 period have believed that they could square the circle and achieve both. Hence Ronald Berman at NEH and Nancy Hanks at NEA both loved the so-called blockbuster museum exhibits during the 1970s because they brought first-rate materials to audiences of unprecedented size. When Joan Mondale

led the Federal Council on the Arts and the Humanities late in the 1970s, she declared: "If being an elitist means being for quality, then yes, I am for quality. If being a populist means accessibility, then yes, I am a populist. I want the arts to be accessible."[34] Key participants have insisted over the past twenty-five years that "excellence versus equality" is a false dichotomy, a non-issue, a diversion that obscures more important matters. As I read through pertinent texts and historical records, however, it is clear that keen observers have regarded the tension as real and problematic. Many crucial policy makers, moreover, are divided, explicitly advocating more emphasis either on excellence or on the democratization of resources and opportunities.[35]

I find it curious that in so much of the discourse (including speeches, testimony, and commission reports) "excellence" is casually used with positive implications while "elitism" has pejorative connotations. Yet many of the advocates of excellence are elitists in wanting quality control, and many of the so-called elitists are guilty of nothing more than insisting upon rigorous peer review procedures because they believe that taxpayers' money should be used accountably to support those projects most likely to have enduring value. Livingston Biddle, who drafted much of the 1965 legislation that created the endowments, recently clarified for me his vision at that time: Excellence would be made available to the largest number of people, which is not the same thing as "trying to make everyone excellent," an unrealistic goal.[36]

My second observation is that the art forms that are most distinctively American—musical theater, modern dance, jazz, folk art, and film—had to struggle very hard indeed to achieve recognition as genuine cultural treasures. For many years, for example, the NEA was not notably supportive of jazz, a pattern that changed in 1977–1978 because Billy Taylor, the jazz pianist, played a persuasive role on the National Council for the Arts, the governing council of NEA.[37]

The third problematic issue is that the two endowments have sparred with each other on occasion, competing in ways that were not constructive for the politics of culture in the United States. Nancy Hanks and Ronald Berman (the heads of NEA and NEH, respectively) had different agendas during the 1970s and developed a cordial disdain for one another, although each endowment, at other times, has done much to sustain its sibling politically. Moreover, relations have not always been optimal between NEA and the National Assembly of State Arts Agencies. Ever since the mid-1970s many of the state arts agencies have wanted something closer to *partnership* with their federal parent, and not just patronage. They have sought, even demanded, a larger role in policy formation.[38]

My fourth observation concerns a phenomenon that may, in the long run, be just as significant as the much-noticed politicization of the endowments: the proliferation of state humanities councils and state and local arts agencies. State arts agencies first appeared early in the 1960s, were mandated by the

federal legislation of 1965, and became a complex, architectonic reality by the mid-1970s, and a major source of cultural funding by the 1980s.

The structural and funding differences between the state agencies and councils are significant but not widely or well understood. All arts agencies are funded by their states as well as by NEA (at a higher percentage of its annual budget than what NEH is required to provide for its dependents). They are much broader in their operations than the state humanities councils, and collectively they now receive four times as much funding, per annum, as NEA itself. State arts agencies fund institutions, organizations, and individuals. They are the single most important source of support for the arts, and their work is supplemented by local arts agencies that are funded by the states, mayors' office, small foundations, businesses, and county boards.[39]

State humanities councils, on the other hand, are not state agencies. They are comparatively small nonprofit organizations that fund projects, usually ones involving support for scholars along with other expenses associated with a program. Because they do not fund institutions, they tend to be mission- and theme-driven. More often than not, their objective is to shape a civic culture in their respective states by providing support for humanities programs that engage public (that is, nonacademic) audiences. A fundamental distinction also remains as true today as it was thirty years ago: most people who are at all interested in culture understand what the arts are and mean far better than they understand what the humanities are all about. According to a catch-phrase that some administrators use, "If they do it, it's art. If they talk it, it's humanities."[40]

The unwanted aspect of this bilevel, federal, yet asymmetrical structure is that rivalries and tensions occasionally between the state and national bodies. (For those with historical knowledge reaching back to New Deal cultural programs, this offers a vivid sense of *déjà vu*. The state-based writers' projects during the 1930s chaffed at the degree of control exercised by officials in Washington). The competitiveness and occasional resentments are more serious on the arts side than on the humanities side. There has also been cooperation, and during 1995 the state bodies did a great deal that was politically efficacious in helping, quite literally, to save the national endowments.[41]

The endowments and their state programs have gone far beyond the New Deal arts projects in intellectual coherence and enduring value. New Deal relief programs improved people's cultural lives in ways that were positive yet utilitarian and largely passive in terms of public engagement. There were guidebooks, murals, and plays for viewers to enjoy. But the cultural heritage of the United States was more often romanticized than preserved; and the New Deal programs provided scant basis for the public to become culturally interactive, except perhaps to protest some murals that they did not want in their local post offices and courthouses.[42]

In contrast, engagement has been a major success of government support at several levels over the past thirty years: preservation, creation, dissemination, and interaction. Museum attendance and activities have reached unprecedented and unanticipated levels during the past quarter century. Diverse stimuli are responsible, but a very major one, surely, has come from initiatives supplied by both endowments.[43]

Essential though they were at the time, New Deal projects did not sustain exhibits of history and art (accompanied by conferences and symposia) that enlarged understanding of American culture in multifaceted ways. They did not support seminars for the enrichment of teachers and the overall improvement of education. They did not sustain humanistic research, especially long-term projects that require collaborative efforts, such as bibliographies, encyclopedias, dictionaries, and critical translations. They did not launch interactive public programs by promoting partnerships among libraries, historical societies, universities, and schools. They did not engage the public culture through innovative films with compelling humanistic content, up-to-date interpretation of historic sites, and stimulating occasions that bring scholars together with lay audiences.

Despite some slips of judgment, inevitable elements of trial and error, and unhelpful competitiveness and bureaucratization, the two endowments, the Smithsonian Institution, the Institute of Museum Services, the National Park Service, the National Trust for Historic Preservation, and the array of state cultural agencies that have emerged or been transformed during the past generation, all have redefined their mandates and modes of operation as circumstances dictated. In doing so they have altered not merely the nature but the very meaning of public culture in the United States.

If we believe that culture is a necessity rather than a luxury, if we feel that public dialogue and comprehension of a heterogeneous social heritage are essential, if we are committed to a more inclusive audience for scholarship, then there simply has to be sufficient governmental support for such an agenda. What our historical experience has shown, beyond any doubt, is that public money spent on cultural programs has a multiplier effect—not only economically but in *participation by people*. What the critics of State support for culture dismally fail to understand is that a diminution or elimination of public support will not prompt an increase in private support. Quite the contrary, it leads to a loss of private support. That, in turn, impoverishes the nation, with implications and outcomes that are truly lamentable.[44]

COMPARISONS AND EXPLANATIONS

Most industrialized nations and many of the so-called developing ones have cabinet-level ministries of culture. Poland, Denmark, Argentina, Haiti, and France are among the highly diverse examples. André Malraux wrote the

script for such a department in France, and the actress Melina Mercouri made its Greek analogue quite visible. In Spain the minister of culture played an important role in 1992–1993 when his country arranged a genuine coup: the acquisition for $350 million of a phenomenal art collection belonging to the Swiss industrialist Baron Hans Heinrich Thyssen-Bornemisza.[45]

Because a full-scale comparative study of these ministries has not yet been made, however, those of us in the United States who think about them at all tend to assume that they must do pretty much the same things because they have fundamentally similar titles and mandates. In reality there is significant variation. (The European Economic Community even has a commissioner of cultural affairs; and the European ministers of culture meet regularly on a monthly or sometimes bi-monthly basis to discuss their differences and possible modes of cooperation.)

The French Ministry of Culture, created in 1959 under Malraux, who earnestly wished to democratize culture, is probably the best known and surely the most publicized. A four-page explanation of the government's cultural policy, prepared in 1983, begins:

> France has long had a tradition of supporting the arts. French monarchs considered themselves protectors of the arts, and since the republic was founded the public sector has viewed "culture" (the arts and the humanities) as its responsibility to encourage. And though private support for the arts and the humanities has existed, the major thrust most often has come from the central government if only to preserve the heritage of the country.

Although particular projects or initiatives of the minister may turn out to be controversial, the ministry itself normally is not.[46]

In Germany, by way of contrast, because it is a federal republic but also because of pressure from the western Allies following World War II, the establishment and maintenance of most cultural facilities is the responsibility of provincial government (*Länder*). The Allies wanted an end to State-controlled culture as propaganda. All legislation pertaining to cultural matters, therefore, with a few exceptions, is the prerogative of the separate federal states. There is no federal ministry of culture.[47]

In Great Britain, where the Department of National Heritage enjoys cabinet-level status, the most significant connections between culture and the state for more than four decades have been found in national museums and archaeological sites, in broadcasting, in arts councils, and in historic preservation activities. Under prime ministers Margaret Thatcher and John Major, however, the Department of National Heritage has been quite candid about is entrepreneurial aspirations. It also runs the National Lottery (a modest portion of the take goes to support cultural programs), it advocates "sport and recreation," and it lists as its sixth objective on page one of its informational

brochure that it seeks to "encourage inward [from abroad] and domestic tourism so that the industry can both make its full contribution to the economy and increase opportunities for access to our culture and heritage."[48]

In Botswana, the Ministry of Culture deals primarily with the preservation of aboriginal culture because the Bushmen of the Kalahari are a diminishing presence. In some other so-called developing nations the ministry of culture enjoys an autonomous existence; in some it is combined with the ministry of education; and often it is mainly concerned with tourism. In Brazil individual states have secretaries for cultural affairs. In Bahia during the early 1990s, for example, that position was held by Gilberto Gil, an immensely popular musician and advocate of Afro-Brazilian culture.

To the best of my knowledge, virtually no historian has systematically examined two closely related questions: Why is the United States so distinctive in not having a ministry of culture? And why is that office comparatively noncontroversial in some nations yet politically or ideologically problematic in others—above all, in our own? Although I cannot answer those questions exhaustively, I would at least like to propose a plausible hypothesis.

Suppose we consider those countries of continental Europe where the ministry of culture not only is ordinarily noncontroversial, but where the cultural authority of the State is highly centralized—a concentration of control long feared and resented by so many in the United States. We can illuminate the contrast if we look back more than three centuries to a period when the consolidation of royal power occurred in such sovereign entities as France and what became the Austro-Hungarian Empire.[49]

Because the appearance of royal strength and attendant splendor mattered a great deal, patronage of the arts developed in an uncontested manner. The Habsburgs seem to have sponsored music because the Roman Catholic Church had done so. The Bourbons were more attracted by theater, and the French were especially partial toward regally supported architecture and music. The Louvre, which became the model for all state art museums, had its origins in the French royal picture collections. It opened as a public museum in 1793, at the height of the French Revolution. Whatever their pet projects may have been, and they changed from one ruler to the next, all of these regimes established and sustained cultural institutions on a grand scale: opera houses, theaters, museums, and so forth. Equally important, perhaps, they created an enduring environment in which support of the arts came to be widely accepted, both among those at the very apex of the social pyramid and among those who aspired to be. Even municipalities felt a sense of civic responsibility for culture. In 1767, for example, the city of Paris decided that it would make an annual subvention to the Opéra.[50]

What seems notable and significant is that such supportive attitudes survived the overthrow or decline of absolute monarchy, enlightened or otherwise. Moreover, the diverse regimes that succeeded those absolute rulers

continued to support the cultural institutions that had been lavishly established by the dynasties they replaced. (In nineteenth-century France a struggle took place between Church and State for control of cultural patronage.) The blurred lines of distinction that dated back to the later Renaissance—did cultural patronage truly come from the State, or from the private purse of a monarch or some noble grandee? —remained ambiguous, albeit less so, even in the nineteenth and early twentieth centuries.

By contrast, in countries whose destinies were determined by the Protestant Reformation and by the evolution of constitutional monarchy, such as Great Britain and the Netherlands—the nations that founded the colonies that became the original United States—kings and queens did not find themselves in such an absolute position to spend quite so lavishly on cultural projects as a means of glorifying their reigns. Consequently they relied more heavily on what we would consider the private sector, as a matter both of policy and of necessity. Moreover, the appearance (if not always the reality) of austerity required by Calvinism, even in historically modified forms, would not allow for the kinds of cultural luxury and artistic life that continued to flourish in Roman Catholic countries such as France and Austria-Hungary.

The constitutional monarchies were not exactly abstemious, to be sure; they also provided varying amounts of cultural patronage. But compared with the courts of central and southern Europe, conspicuous consumption in the realm of culture was not commonplace. The historian Janet Minihan demonstrated how stingily Parliament supported the British Museum during the nineteenth century, and as a consequence that national treasure grew haphazardly. Although the government eventually purchased those notorious Greek marble reliefs from Lord Elgin, it did so reluctantly and ungraciously.[51]

In sum, State support for cultural endeavors has obviously been much weaker in the United States than in Europe. We can locate the antecedents of our own reluctance to spend public money on artistic and humanistic programs in the eighteenth- and especially the nineteenth-century cultural costiveness of the very countries that colonized what became British North America. We also know that Congress looked carefully at the Arts Council of Great Britain as a model when launching the two endowments in 1964–1965, especially in seeking to maximize protection for the endowments from political interference. In 1946 Britain became the first country to create a quasi-autonomous nongovernmental organization (QUANGO) to be the primary conduit for government support of the arts.[52]

In closing this section devoted to comparisons, it is essential to acknowledge a major irony.[53] For more than a decade now there have been clear signs that European countries are increasingly interested in and attracted to the American model. Without exception they all insist that they would like a

policy of decentralizing support for art and culture. More particularly, as governmental budgets grow leaner, political leaders abroad express envy for the American tradition of private support. They are especially fascinated by the use of matching grants even though there have been only modest attempts to implement that mechanism in Europe. Matching grants have worked successfully at the provincial level in Canada.[54]

Owing to economic contraction, moreover, Europeans are becoming more inclined to emphasize excellence above equity and to insist that cultural creativity can be encouraged but not purchased. We now hear echoes of a letter written by Gustave Flaubert back in 1853.

> Have you ever remarked how all *authority* is stupid concerning Art? Our wonderful governments (kings or republics) imagine that they have only to order work to be done, and it will be forthcoming. They set up prizes, encouragements, academies, and they forget only one thing, one little thing without which nothing can live: the *atmosphere*.[55]

When budgets shrink in our own time, encouraging an optimal "atmosphere" looks like a prudent yet easy alternative. Mere encouragement is not sufficient, however.

CONCLUSION

Anxiety at the prospect of a Leviathan State—ranging from social services to cultural programs—has been a long-standing and persistent legacy in American political culture. Fears about centralization prompted the opposition of Van Buren, Calhoun, and many others to the cultural and scientific agendas of John Quincy Adams. Those concerns resurfaced prominently during the later years of Franklin D. Roosevelt's second administration, once again during the early years of Ronald Reagan's presidency, and in 1995 when Republicans sought to fulfill their contract with America.[56]

I believe that such nagging concerns can be turned to the advantage of those who value cultural growth, achievement, and institutions—in particular, those of us who are persuaded that the NEH has been the single most source of support for humanistic endeavors in the United States during the past generation. Major cultural organizations and significant, broad-gauge scholarship must be sustained at the national level. Federal dollars are absolutely indispensable in order to leverage local and private funds. The federal imprimatur has meant legitimacy for cultural programs at all levels.

An important rationale for fostering closer collaboration between federal and state entities (meaning consultation and the sharing of resources) is that it might help depoliticize culture. Support at the state and local levels is less likely to provoke controversy. Cultural localism and regionalism may not

make a big splash, but neither do they ordinarily alienate citizens and suffer from distortion or sensationalism in the national media. Increased cooperation among levels and sources of government support simply makes sense in a country that everyone acknowledges is diverse in taste levels, opinions, and what is perceived as the public interest. It is worth bearing in mind that Nancy Hanks's phenomenal success as the chair of NEA owed a great deal to her carefully organized network of support at the grass roots. Former congressman Thomas J. Downey, who chaired the Congressional Arts Caucus from 1982 until 1987, regarded the state arts agencies as "invaluable" because they constantly pressured members of Congress and made them aware that support for cultural programs was both essential and politically viable. As Downey put it, they provided validation from the districts on economic as well as cultural grounds. They also undercut those who contended that federal support for the arts was elitist.[57]

It is particularly noteworthy, I believe, that during the 1995 campaign to save the NEH and NEA, advocates scored effective points by constantly calling attention to positive achievements made at the state and local levels. Those are the levels most appealing to members of Congress, and we cannot escape the reality that we are discussing a highly political process. Congressional supporters of cultural programs are partial to the phrase "building from the bottom up." That's a crucial reason why the state councils and agencies are so essential.

From the perspective of historians, state programs have had, and will continue to have, the salutary effect of broadening the audience for history. They transmit far beyond academe new historical interpretations and an understanding of what American history is all about—something that many scholars have long been saying needs to be done. State councils transmit money to local historical societies and discussion groups that meet at public libraries; and professional historians play a prominent role on state humanities councils. They can have a profoundly influential impact by determining what kinds of history will be disseminated and discussed at the grass-roots level.

I do not for a moment mean to suggest that the state agencies and councils are prepared or able to resolve all the vexed issues involving culture and government in the United States. Historical experience has demonstrated their limitations. Generalizations about fifty-six different entities are dangerous, but overall they are more oriented to the contemporary than to the historical. They do not *directly* support scholarship. Their assistance to museums goes for public and educational programs rather than for basic curatorial, cataloging, or even exhibition needs. Some members of the state councils have even been disdainful of scholarship.[58]

State and local cultural organizations do things that complement what only the national entities are able to do. We need *all* of them, working in concert, if we genuinely hope to achieve excellence *and* equity. It is imperative

that we strengthen the connective links of cultural federalism because that is often the way American governmental politics works most successfully.

Earlier, when I supplied cursory descriptions of the state humanities councils and arts agencies, I emphasized contrasts between the two because their histories are so asymmetrical and not clearly understood. There is, however, a key area in which they have been moving in sync. In more than thirty states (by the mid-1990s) the state agencies and councils do some cooperative or shared programming. Several states now have a joint standing committee on the arts and the humanities, a collaborative arrangement in which Ohio has been the leader.[59]

For about two decades the humanities councils have emphasized what they call the public humanities, the dissemination of fresh perspectives to a broad, nonacademic audience. As the philosopher Charles Frankel phrased it: "Nothing has happened of greater importance in the history of American humanistic scholarship than the invitation of the government to scholars to think in a more public fashion, and to think and teach with the presence of their fellow citizens in mind."[60]

Similarly, both NEA and the state arts agencies have promoted what is called "the new public art," meaning art put in public places for its own sake rather than the commemoration of some politician or military hero. Doing so entails a vision of art that can humanize and enliven public places—art to be enjoyed. Needless to say, the sculpture *Tilted Arc* by Richard Serra did not achieve such an outcome in lower Manhattan, but responsibility for that debacle rests with misunderstanding on all sides. Alexander Calder's *Grand Vitesse*, a comparable commission for Grand Rapids, Michigan, provides an illustration of communication and explanation eventually leading not merely to acceptance but to pride.[61]

It may help clarify our thinking if we reflect comparatively on the historically determined nature of our situation. During the eighteenth century, what later became Germany was a fragmented set of societies partially bonded by a common culture. A *Kulturvolk* existed rather than a cohesive polity. In the nineteenth century, after the fall of Napoleon, when Germans wanted a political structure worthy of that rich culture and commensurate with it, they regarded the nation that emerged as a *Kulturstaat*: a state defined by the vigorous presence of a common culture.[62]

In striking contrast, when the United States emerged as a nation in 1789 it came to be defined by its distinctive *political* structure and by the Founders' desire and rationale for that republican structure. Unlike Germany, the country did not yet possess a defined common culture; and it might well be argued that the task of defining a common culture in the United States has become more difficult, rather than less, in the intervening two centuries.

Henry Adams perceived that problematic reality more than a century ago when he wrote an open letter to the American Historical Association, which he served as president in 1894. He fully anticipated the flowering of intellectual and cultural diversity in the United States. An effort to "hold together the persons interested in history is worth making," he wrote. Yet his candid realism followed directly. "That we should ever act on public opinion with the weight of one compact and one energetic conviction is hardly to be expected, but that one day or another we shall be compelled to act individually or in groups I cannot doubt."[63]

I feel certain that solutions to the complex interaction between culture and the State in the United States can be found in improved institutional and organizational relationships—connections that belong under a rubric that might be called cultural federalism. The State now has a strong tradition of encouraging and supporting cultural activities when doing so seems to be in the interest of the State. That is exactly why federal support for culture accelerated during the Cold War decades.

It is no coincidence that a broadly based acceptance of government support for culture waned precipitously once the Cold War ended in 1989. Many of those who had long feared alien ideologies have subsequently projected their anxieties onto domestic "enemies," such as artists, intellectuals, and institutions that communicated unfamiliar views or unconventional positions critical of orthodox pieties. The historic hostility toward unusual, dissident, or revisionist views described so forcefully by Richard Hofstadter in 1963 resurfaced with renewed political potency after 1989, resulting in mistrust of artists, intellectuals, and many cultural programs because they appeared elitist, "revisionist," or unpatriotic.[64]

Cultural federalism—government support for cultural needs along with collaboration *at all levels*—could go a long way toward minimizing anti-intellectualism, fear of innovation, and mistrust of constructive cultural criticism. That is why the notion of public humanities really matters. It is an idea whose time has come because it is sorely needed at this juncture.

I want to thank the following for their critical yet constructive readings of this essay in draft form, even though they still may not share some of my views: Susan Armeny, Thomas Bender, Paul J. DiMaggio, Douglas S. Greenberg, Neil Harris, John Higham, James A. Hijiya, Arnita A. Jones, Stanley N. Katz, Walter LeFeber, Sheldon Meyer, Mary Beth Norton, Dwight T. Pitcaithley, Richard Polenberg, Joe H. Silbey, and David Thelen. I am also very grateful to Steven L. Kaplan and Jamil Zainaldin for information and insights.

NOTES

1. Newt Gingrich, "Cultural Funding: A Reply," *Time*, Aug. 21, 1995, pp. 70–71.
2. A. Hunter Dupree, *Science in the Federal Government: A History of Policies and*

Activities (1957; Baltimore, 1986), 215–20, 293; Richard McKinzie, *The New Deal for Artists* (Princeton, 1973); 151–54, 185; Gary O. Larson, *The Reluctant Patron: The United States Government and the Arts, 1943–1965* (Philadelphia, 1983), 42, 221.

3. J. Mark Davidson Schuster, *Supporting the Arts: An International Comparative Study* (Washington, 1985); Richard M. Merelman. *Partial Visions: Culture and Politics in Britain, Canada, and the United States* (Madison, 1991) Throughout this article the word *state* is capitalized, following political scientists' usage, when it refers to government in general and lowercased when it refers to particular governments.

4. On the French approach, see *New York Times*, Feb. 25, 1996, p. 12.

5. Horace Kallen, *Culture and Democracy in the United States: Studies in the Group Psychology of the American Peoples* (New York, 1924), 123.

6. Stephen Miller, *Excellence & Equity: The National Endowment for the Humanities* (Lexington, Ky., 1984), 21–22; *Congressional Record*, 89 Cong., 2 sess., Sept. 19, 1966, p. 22957.

7. See Gail Levin, *Edward Hopper: An Intimate Biography* (New York, 1995) 277; McKinzie, *New Deal for Artists*, 58; Jerre Mangione, *The Dream and the Deal: The Federal Writers' Project, 1935–1943* (Boston, 1972), 102–3; Michaael Kammen, *The Lively Arts: Gilbert Seldes and the Transformation of Cultural Criticism in the United States* (New York, 1996), 11–12, 200, 319, 371. For John Sloan's remark, see Alice Goldfarb Marquis, *Art Lessons: Learning from the Rise and Fall of Public Arts Funding* (New York, 1995), 242–43. Russell Lynes, *Confessions of a Dilettante* (New York, 1966), 22–23. As late as 1953 symphony orchestra directors were almost unanimously opposed to any government subvention for orchestras, preferring to rely on socially to rely on socially elite patrons and foundations. See Marquis, *Art Lessons*, 30.

8. Alfred Runte, *National Park: The American Experience* (London 1979), esp chaps. 2, 12. Hal Rothman, *Preserving Different Pasts: The American National Monuments* (Urbana, 1989). Marquis, *Art Lessons*, 170–71; Schuster *Supporting the Arts*. In 1991 private individuals contributed $8.8 bilion to the arts and humanities in tax-deductible donations, a figure widely worked and deeply envied abroad. See Marquis, *Art Lessons*, 170.

9. See Lisa A. Marcus, ed. *North Carolina Manual, 1933–1994* (Raleigh, 1994), 268–75; and Sharon J. Marcus, ed., *The National Directory of State Agencies* (Gaithersburg, 1989).

10. Charles C. Mark, *A Study of Cultural Policy in the Unitd States* (Paris, 1969), 11. For an astute accouint of the historical background, see Stanley N. Katz, "Influences on Public Policies in the United States," in *The Arts and Public Policy in the United States*, ed. W. McNeil Lowry (Englewood Cliffs, 1984), 23–37. Cf. Margaret Jane Wyszomirski, "The Politics of Art: Nancy Hanks and the National Endowment for the Arts," in *Leadership and Innovation: A Biographical Perspective on Entrepreneurs in Government*, ed. Jameson W. Doig and Erwin C. Hargrove (Baltimore, 1987), 207–45, esp. 219–20.

11. Marquis, *Art Lessons*, 88; Michael Straight, *Twigs for an Eagle's Nest: Government and the Arts, 1965–1978* (New York, 1979), 96; Michael Macdonald Mooney, *The Ministry of Culture: Connections among Art, Money, and Politics* (New York, 1980), 49, 250–51. More than one scholar considers it a functional "myth" that the United States has no national arts policy. See Margaret Jane Wyszomirski, "Federal Cultural Support: Toward a New Paradigm?" *Journal of Arts Management, Law, and Society*, 25 (Spring 1995), 76–77.

12. Marquis, *Art Lessons* 157; Livingston Biddle, *Our Government and the Arts: A Perspective from the Inside* (New York, 1988), chap. 55, esp. pp. 398–99; Thomas J. Downey interview by Michael Kammen, Jan. 11, 1996, notes (in Michael Kammen's possession). Cf. Samuel Lipman, "The State of National Cutural Policy," in *Culture and Democracy: Social and Ethical Issues in Public Support for the Arts and Humanities*, ed. Andrew Buchwalter (Boulder, 1992), 47–57.

13. Miller, *Excellence & Equity*, 54 (emphasis added); Terri Lynn Cornwell, "Party Platforms and the Arts," in *Art, Ideology, and Politics*, ed. Judith H. Balfe and Margaret Jane Wyszomirski (New York, 1985), 252–53.

14. Marquis, *Art Lessons*, 42, 96–97, 93; H. R. Haldeman, *The Haldeman Diaries: Inside the Nixon White House* (CD-ROM) (Santa Monica, Sony ImageSoft, 1994), Nov. 11, Nov. 20, 1972.

15. August Heckscher inteview by Kammen, Dec. 19, 1995, notes (in Kammen's possession). For John F. Kennedy's vagueness on what the government might actually do in support of culture, see *Public Papers of the Presidents of the United States: John F. Kennedy, Containing the Public Messages, Speeches, and Statements of the President, Jan. 1 to Nov. 22, 1963* (3 vols. Washington, 1962–1964), III, chap. 16, esp. pp. 427, 448, 450.

16. Rhodri Windsor Liscombe, *Altogether American: Robert Mills, Architect and Engineer, 1781–1855* (New York, 1994).

17. For raised eyebrows by art critics in response to this innovation, especially its emphasis on modern art, see *New York Times*, Oct. 6, 1946, sec. 2, p. 8. For Congressional resistance and actual curtailment in 1947, see *ibid.*, May 6, 1947, pp. 1, 5. Gilbert Seldes, "MacLeish: Minister of Culture," *Esquire*, 23 (June 1945), 103; Taylor D. Littleton and Maltby Sykes, *Advancing American Art: Painting, Politics, and Cultural Confrontation at Mid-Century* (Tuscaloosa, 1989); Jane De Hart Mathews, "Art and Politics in Cold War America," *American Historical Review*, 81 (Oct. 1976), 762–87; *New York Times*, May 19, 1996, p. 35.

18. Peter Coleman, *The Liberal Conspiracy: The Congress for Cultural Freedom and the Struggle for the Mind of Postwar Europe* (New York, 1989); Christopher Lasch, "The Cultural Cold War: A Short History of the Congress for Cultural Freedom," in *Towards a New Past: Dissenting Essays in American History*, ed. Barton J. Bernstein (New York, 1968), 348–49

19. For George Kennan's statement, see Coleman, *Liberal Conspiracy*, 234. For the Central Intelligence Agency's (CIA) public defense of its policy, see Thomas W. Braden, "I'm Glad the CIA Is 'Immoral,'" *Saturday Evening Post*, May 20, 1967, pp. 12, 14.

20. Mary W. M. Hargreaves, *The Presidency of John Quincy Adams* (Lawrence, 1985), 165–72; James D. Richardson, comp., *Messages and Papers of the Presidents, 1789–1897* (10 vols. Washington, 1899), II, 311–17.

21. See William Stanton, *The Great United States Exploring Expedition of 1838–1842* (Berkeley, 1975); William H. Goetzmann, *Exploration and Empire: The Explorer and the Scientist in the Winning of the American West* (New York, 1966); and Wallace Stegner, *Beyond the Hundredth Meridian: John Wesley Powell and the Second Opening of the West* (Boston, 1954).

22. Wilcomb E. Washburn, "Joseph Henry's Conception of the Purpose of the Smithsonian Institution," in *A Cabinet of Curiosities: Five Episodes in the Evolution of American Museums*, ed. Walter Muir Whitehill (Charlottesville, 1967), 113, 145–46.

23. *Annual Report of the Board of Regents of the Smithsonian Institution for the Year Ending June 30, 1904* (Washington, 1905), 5–6.

24. Victoria de Grazia, "Mass Culture and Sovereignty: The American Challenge to European Cinemas, 1920–1960," *Journal of Modern History*, 61 (March 1989), 59; Ariel Dorfman and Armand Mattelart, *How to Read Donald Duck: Imperialist Ideology in the Disney Comic* (New York, 1975), 18–19.

25. See, among others, Mangione, *Dream and the Deal;* Karal Ann Marling, *Wall-to-Wall America: A Cultural History of Post-Office Murals in the Great Depression* (Minneapolis, 1982); Barbara Melosh, *Endearing Culture: Manhood and Womanhood in New Deal Public Art and Theater* (Washington, 1991); and Michael Kammen, *Mystic Chords of Memory: The Transformation of Tradition in American Culture* (New York, 1991), chap. 14.

26. Mangione, *Dream and the Deal, 321–22*. See also Melosh, *Engendering Culture; Jane*

De Hart Mathews, The Federal Theater, 1935–1939: Plays, Relief, and Politics (Princeton, 1967); and Carol Brightman, *Writing Dangerously: Mary McCarthy and Her World* (New York, 1992), 258.

27. Marcia Pointon, "Imaging Nationalism in the Cold War: The Foundation of the American National Portarit Gallery," *Journal of American Studies, 26* (Dec. 1992), 368; Joe Klein, *Woody Guthrie: A Life* (New York, 1980), 363.

28. On the House committee discussion, see *New York Times*, Sept. 29, 1954, sec. A. p. 25. See also Karal Ann Marling, *As Seen on TV: The Visual Culture of Everyday Life in the 1950s* (Cambridge, Mass., 1994), 270.

29. "The New Role for Culture" *Life,* Dec. 26, 1960, pp. 44–45. See also William Attwood, "A New Look at America," *Look,* July 12, 1955, pp. 48–54.

30. August Heckscher, "The Quality of American Culture," in *Goals for Americans: Programs for Action in the Sixties* . . . (New York, 1960), 141. See also August Heckscher, *The Public Happiness* (New York, 1962); and August Heckscher, *The Arts and the National Government: A Report to the President* (Washington, 1963). In November 1963, the *New York Times* announced that Richard N. Goodwin would succeed Heckscher, who had left the position in June. The article noted that many in Washington were puzzled by the delay in naming a successor. One observer said "You hear a lot of talk about culture in this town, but there's not much action." *New York Times,* Nov. 22, 1963, p. 35. See Richard N. Goodwin, *Remembering America: A Voice from the Sixties* (Boston, 1988), 222–25.

31. Arthur M. Schlesinger, Jr., *The Politics of Hope* (Boston, 1962), 254–61, esp., 255; James L. Baughman, *The Republic of Mass Culture: Journalism, Filmmaking, and Broadcasting in America since 1941* (Baltimore, 1992), p. 95.

32. Schlesinger, *Politics of Hope*, 259–60.

33. See Milton C. Cummings, "To Change a Nation's Cultural Policy: The Kennedy Administration and the Arts in the United States, 1961–1963," in *Public Policy and the Arts,* ed. K. V. Mulcahy and C. R. Swaim (Boulder, 1982), 141–68; Milton C. Cummings, "Government and the Arts: An Overview," in *Public Money and the Muse.* ed. Stephen Benedict (New York, 1991), 31–79.

34. Ronald Berman, *Culture and Politics* (Lanham, 1984), chap. 8. For Joan Mondale's statement, see Mooney, *Ministry of Culure,* 21. Whether the humanities can "provide a level of excellence toward which all should strive and through which all can derive pleasure" was the focus of a major conference, "Government and the Humanities," held in 1978 at the Lyndon B. Johnson School of Public Affairs, University of Texas, Austin. See Kenneth W. Tolo, ed., *Government and the Humanities: Toward a National Cultural Policy* (Austin, 1979), 1–2, 7–8, 28, 33–34, 38, 70, 71, 74, 131. For a comment by Mondale similar to the one quoted above, see *ibid.,* 7–8.

35. See Tolo ed., *Government and the Humanities,* 134 and passim. Judith Huggins Balfe to editor, *New York Times,* March 22, 1994, sec. A. p. 18, Joseph Duffey to Michael Kammen. Jan. 18, 1996 (in Kammen's possession).

36. Straight, *Twigs for an Eagle's Nest,* 175. Marquis, *Art Lessons,* 165. Livingston Biddle interview by Kammen, Jan. 11, 1996, notes (in Kammen's possession).

37. See Marquis, *Art Lessons, 180.* Biddle interview

38. Biddle, *Our Government and the Arts, 319–20, 330–31;* Berman, *Culture and Politics,* 47,. 148, 151–58; Marquis, *Art Lessons,* 106–8, 110, 112, 139, 229; Margaret Jane Wyszomirski, "The Politics of Arts Policy: Subgovernment to Issue Network," in *America's Commitment to Culture: Government and the Arts,* ed. Kevin J. Mulcahy and Margaret Jane Wyszomirski (Boulder, 1995), 58.

39. Jeffrey Love, "Sorting Out Our Roles: The State Arts Agencies and the NEA," *Journal of Arts Management and the Law,* 21 (Fall 1991), 215–26; Jonathan Katz interview by Kammen, Jan. 10, 1996, notes (in Kammen's possession). (Katz is director of the National Assembly of State Arts Agencies.) I have learned from pamphlets received from Katz and from the seminar led by Robert L. Lynch,

president of the National Assembly of Local Arts Agencies; Feb. 13, 1996, at the American Council of Learned Societies offices in New York City.

40. For Charles Frankel's version of this phrasing in 1978, see Tolo, ed., *Government and the Humanities,* 124. Jamil Zainaldin, president of the Federation of State Humanities Councils, to Kammen, Dec. 4, 12, 1995, enclosing brochures and pamphlets (in Kammen's possession).

41. Monty Noam Penkower, *The Federal Writers' Project: A Study in Government Patronage of the Arts* (Urbana, 1977), 26–27, 29, 31–33, 39, 48, 50, 98. For illustrations of grass-roots support for retaining the national endowments and the state-based councils, see *New Orleans Times-Picayune,* Jan. 15, 1995; *Maine Sunday Telegram,* Jan. 22, 1995, see. C, p. 4; *Wichita Eagle,* Jan. 30, 1995, sec. A. p. 11; *Hartford Courant* Feb. 8, 1995, sec. A, pp. 1, 8; *Boston Sunday Globe,* April 23, 1995, sec. NH, p. 2; *Albuquerque Journal,* June 19, 1995, sec. A, p. 7; *Box Elder* [Brigham City, Utah] *New Journal,* Aug, 9, 1995, p. 2. On Aug. 21, 1995, radio station KPBS of northern California did a program on the impact of humanities funding in northern California. Similar programs aired in other states. On April 7, 1995, the "CBS Evening News" "Eye on America" did a close-up of "The Piney Woods Opry" in Abita Springs, Louisiana. Similar close-ups appeared on the other major networks.

42. See McKinzie, *New Deal for Artists;* Marling, *Wall-to-Wall America;* Melosh, *Engendering Culture.*

43. See Fannie Taylor and Anthony L. Barresi, *The Arts at a New Frontier: The National Endowment for the Arts* (New York, 1984); Mulcahy and Wyszomirski, eds., *America's Commitment to Culture.*

44. There were 160 local arts agencies in 1965; there are 3,800 in 1996. In 1983 state support for the NEH state humanities councils was $150,000. By 1995 it was close to $3 million. See Nina Kressner Cobb, *Looking Ahead: Private Sector Giving to the Arts and the Humanities* (Washington, 1995); Commission on the Humanities. *The Humanities in American Life* (Berkeley, 1980); and Merrill D. Peterson, *The Humanities and the American Promise: Report of the Colloquium on the Humanities and the American People* (Chicago, 1987).

45. Thematic issue, "Paying for Culture," *Annals of the American Academy of Political and Social Science,* 471 (Jan. 1984), esp. 117–31. On Spain, see *New York Times Sunday Magazine,* Oct. 4, 1992, p. 27; *New York Times,* June 19, 1993, p. 1.

46. Robert Wangermée, *Cultural Policy in France* (Strasbourg, 1991); Antoine Bernard, *Le Ministère des Affaires Culturelles et la Mission Culturelle de la Collectivité* (The ministry of cultural affairs and the cultural mission of the collectivity)(Paris, 1968). See *New York Times,* March 24, 1993, sec. C, p. 15; and *Ministère de la Culture, de la Communication et des Grands Travaux* (Ministry of Culture, Communication, and Public Monuments) (Paris, 1990), an elegant promotional booklet.

47. Schuster, *Supporting the Arts,* 18.

48. Janet Minihan, *The Nationalization of Culture: The Development of State Subsidies to the Arts in Great Britain* (New York, 1977); Raymond Williams, "The Arts Council," in Raymond Williams, *Resources of Hope: Culture, Democracy, Socialism* (London, 1989), 41–55. The essay dates from 1979.

49. For helpful information and insights supporting the four paragraphs that follow, see Frederick Dorian, *Commitment to Culture: Art Patronage in Europe, Its Significance for America* (Pittsburgh, 1964); Milton C. Cummings, Jr., and Ricahrd S. Katz, "Government and the Arts: An Overview," in *The Patron State,* ed. Milton C. Cummings, Jr., and Richard S. Katz (New York, 1987), 5–7; John Pick, *The Arts in a State: A Study of Government Arts Policies from Ancient Greece to the Present* (Bristol, 1988).

50. See Martin Warnke, *The Court Artist: On the Ancestry of the Modern Artist* (1985; Cambridge, Eng., 1993); Andrew McClellan, *Inventing the Louvre: Art, Politics, and the Origins of the Modern Museum in Eighteenth-Century Paris* (Cambridge, Eng.,

1994); and Cecil Gould, *Trophy of Conquest: The Musée Napoléon and the Creation of the Louvre* (London, 1965).

51. Minihan, *Nationalization of Culture,* esp. 9, 12, 18; Shannon Hunter Hurtado, "The Promotion of the Visual Arts in Britain, 1835–1860," *Canadian Journal of History*, 28 (April 1993), 59–80.

52. John S. Harris, *Government Patronage of the Arts in Great Britain* (Chicago, 1970).

53. There is an unnoticed lesser irony. In 1989, the very year of the Robert Mapplethorpe exhibition brouhaha, Beijing's Museum of Fine Arts in the puritanical People's Republic of China mounted an exhibition of nude paintings to stimulate ticket sales. The show set a new attendance record for the museum. See also Jainying Zha, *China Pop* (New York, 1995), 105.

54. See Schuster, *Supporting the Arts*, 1, 41, 48; Dorian, *Commitment to Culture*, 446–47; Christopher Price, "Culture in a Cold Climate," *Annals of the American Academy of Political and Social Science*, 471 (Jan. 1984), 122; Hans F. Dahl, "In the Market's Place: Cultural Policy in Norway," *ibid.*, 123, 127; *Toronto Globe and Mail*, May 10, 1995, sec. A, p. 21; and *New York Times*, Nov. 14, 1995, sec. C, p. 13.

55. Gustave Flaubert to Louise Colet, [Dec. 28, 1853], in *The Letters of Gustave Flaubert, 1830–1857*, ed. and trans. Francis Steegmller (2 vols. Cambridge, Mass., 1980), I, 206.

56. See Albert Jay Nock, *Our Enemy, the State* (New York, 1935); and Wilfred M. McClay, *The Masterless: Self and Society in Modern America* (Chapel Hill , 1994), 222–23.

57. William J. Keens. "The Arts Caucus: Coming of Age in Washington," *American Art*, 14 (March 1983), 16–21. Downey interview.

58. For the view that absolute partnership between state and national entities is unattainable because achieving a consensus among the diverse sectors and policy makers, public and private, is impossible, see Paul J. DiMaggio, "Can Culture Survive the Marketplace?," in *Nonprofit Enterprise in the Arts: Studies in Mission and Constraint*, ed. Paul J. DiMaggio (New York, 1986), 73.

59. Jamil Zainaldin interview by Kammen, Jan. 11, 1996, notes (in Kammen's possession).

60. Merrill D. Peterson, "The Case for the Public Humanities," in *The Humanities and the American Promise* [Report of the Colloquium on the Humanities and the American People] (Austin, 1987), 5–19; *National Task Force on Scholarship and the Public Humanities*, American Council of Learned Societies Occasional Paper, no. 11 (New York, 1990). For Charles Frankel's statement, see Miller, *Excellence & Equity*, 130.

61. Special issue, "Critical Issues in Public Art," *Art Journal*, 48 (Winter 1980); Margaret Jane Wyszomirski, "Public Art Issues," in *Arts and the States: Current Legislation*, ed. Catherine Underhill (Denver, 1988), 3; Casey Nelson Blake, "An Atmosphere of Effrontery: Richard Serra, *Tilted Arc*, and the Crisis of Public Art," in *The Power of Culture: Critical Essays in American History*, ed. Richard Wightman Fox and T.J. Jackson Lears (Chicago, 1993), 270–71.

62. See James J. Sheehan, *German History, 1770–1866* (New York, 1989), chaps, 3, 6, 9, 13.

63. Henry Adams, *The Degradation of the Democratic Dogma* (1919; New York, 1969), 125.

64. See Richard Hofstadter, *Anti-intellectualism in American Life* (New York, 1963).

A New Mission for the NEA

Years ago, when I was New York City's Cultural Affairs Commissioner, I would join the periodic ritual pilgrimages to Washington, D.C., to plead the case for the National Endowment for the Arts. Then, as now, the NEA was threatened with extinction. Then, as now, a devoted congregation of arts organizations, artists, and friends of the arts responded to the threat by filling the Capitol with impassioned supplications for the NEA's continued survival. The ending was always the same—the NEA was saved. And so the ritual played itself out (with minor variations) year after year after year.

Perhaps it is now time for a change.

Perhaps it is time to realize that despite Herculean efforts, the NEA has not grown any stronger, cultural groups as a whole have not reaped increased benefits, and, if anything, the result of all of the unrelenting lobbying may be inversely proportional to the effort, draining precious time, resources, and creative energies from the very groups the NEA is meant to serve. After thirty years, instead of lobbying Congress, cultural groups may be better served using their time and energies to reenvision government support of the arts, to rethink the rationale for the endowments, and to reconsider its leadership structure, funding sources, decision-making processes, and impact on American public life. We should do so not only from the point of view of the producers of that art but from the point of view of the consumers—the American public.

Calling for a rethinking of the NEA by no means casts aspersion on the considerable accomplishments of the NEA to date. What the Endowment has achieved in consort with a host of other federal agencies and in partnership with state and local agencies and the private sector in the post-civil rights, post-modernist era has been nothing short of transformational.

Where once there had been a monochromatic cultural canvas, essentially male and Eurocentric, there is now a quilt of disparate cultural traditions that have revealed to the country its truly hybrid vernaculars. This period of exploding heterogeneity has taken place at the same time that there has been an enormous growth in the importance of art and culture to the American

economy. In the past decade, there has been a commercial boom in the creation of cultural products for export—what has become the second most important industry to the United States' balance of trade. Public funding, which supports an array of not-for-profit organizations—artistic, research and development laboratories—has, in effect, subsidized virtually all aspects of the commercial sector. Finally, the NEA and other instruments of public funding have sustained the post-World War II modernist and post-modernist ethos that has established this country as one of the cultural and intellectual centers of the world. In those three areas alone—creating a diverse cultural landscape in the post-civil rights era; subsidizing the commercial sector and fueling the American economy, and sustaining the United States as a global intellectual center—public funding has been crucial.

Ironically, however, what has been the greatest strengths of public funding may now have planted the seeds for the most troubling dilemmas. Theatre critic Margo Jefferson has said that the great triumph of American art is that it has violated assumptions. If it is true for American art, it is also true that the great triumph of public funding of the past thirty years is that it has permitted the country to violate its assumptions about what a cultural organization is and what an artist and, ultimately, art are. Perhaps the most important violation of an assumption was the challenge to a homogeneous landscape.

As reasoned in the original legislation, access to the arts and humanities would give the average American an understanding of the American past in all of its pluralistic complexity: "The arts and the humanities reflect the high place accorded by the American people to the nation's rich cultural heritage and to the fostering of mutual respect for the diverse beliefs and values of all persons and groups." Diversity was the mandate of the Endowments, and there is no question that diversity has been achieved. Having achieved this diversity, however, the Endowments are now witnessing a public deeply uncomfortable with its ramifications.

Instead of a cheerful quilt, some Americans, as is evident from the response of certain members of Congress and the radical right, when confronted with that diversity, see a grotesquely surrealist montage in which the familiar, the orderly, and the predictable have been juxtaposed with the unfamiliar, the bizarre, and the unorthodox, where the constituent parts are jangling and difficult to confront. Like East and West Germany breaking down the Berlin Wall, the United States—a previously bifurcated country—has opened up and exposed divisions and differences unfathomably deep and seemingly unbridgeable. To some, the difference between the *Nutcracker Suite* and Thelonius Monk is too great to reconcile. What some see as the height of classicism others see as irrelevant Eurocentrism. What some see as a bold act of imagination others see as incomprehensible and cacophonous. What public funding brought was cultural diversity without cultural recognition or reconciliation.

THE COMMERCIAL ARENA

If cultural diversity has been an assault on the public, the commercial arena has been a distraction. Few could have foreseen the extent to which commercial outlets would sweep over American culture like a snowstorm, blanketing with their sheer number, visibility, and accessibility the country's time, energy, and resources. Voracious in their appetite for other art forms, commercial outlets like film and television, for example, consume actors, musicians, set designers, visual artists, and writers—many of whom may have worked in more conventional mediums such as painting and sculpture or theater, or in less remunerative venues such as orchestras, dance companies, and regional theatre companies. More recently, multimedia art has added urgently to the need for new creative talent, placing a strain on conventional venues that supported traditional art forms. From both sides, from the artist and the audience, commercial art forms are consumptive, using up time, energy, and attention like scarce oxygen in an underwater tank. From the vantage point of the practicing artist, new commercial venues are looking for creative talent, making it difficult for not-for-profits to compete with the high-paying salaries of commercial outlets. From the vantage point of the audience, as David Denby wrote so cogently in a *New Yorker* article, the glut of new forms is creating a mass of information, content, and material difficult to digest and comprehend. Its attention divided and diverted, the general public is challenged to focus on "the arts" as a unified whole. Given the deluge of entertainment that seems to be arriving in an ever increasing number of vehicles, it may be difficult for the public to reasonably consume both the product of the not-for-profit community as well as the commercial world. A public awash in and distracted by *Titanic* and "Seinfeld" might ask, "What does the NEA mean to me?"

The question is ironic since so much of the commercial area is subsidized by the not-for-profit arena. In some cases the relationship between the commercial sector and the not-for-profit has been direct and symbiotic. Broadway experienced hugely successful seasons in recent years in which several hit shows—*Rent, Bring In Da Noise* . . . , and the revival of *Chicago*—were workshopped in not-for-profit venues. Director Julie Taymor and choreographer Garth Fagan honed their skills in not-or-profit venues before they dazzled Broadway with *The Lion King*. The relationship is not unlike the one the old Bell Laboratories had to AT&T, where creative exploration sometimes did and sometimes did not lead to a commercially viable product but was considered valuable nonetheless. The not-for-profit creative zones are of value to both the economic marketplace and to the marketplace of ideas. Even with the recognition of the codependence between the commercial and noncommercial sectors of American culture, the point remains: With the tradi-

tion of the commercial arena so firmly entrenched in this country and with the public so inundated with art as well as entertainment, the competition for time and resources from both artist and audience has escalated.

THE MODERNIST ETHOS AND THE SUBVERSIVE IMAGINATION

Yet a third dilemma for the public is the ascendancy of modernism in the post-WWII era and its role in establishing the United States—especially New York—as an international intellectual and cultural center. Inherent in modernism is a subversiveness that fits with the intense individualism and wild West, pioneering spirit of the American imagination. From Alfred Jarry to Picasso to Duchamp's urinal and the collages of John Heartfield and the etchings of George Grosz there is a stinging oppositional voice in twentieth-century European modernism that pokes fun at art, satirizes bourgeois tastes and respectability, and occasionally provides trenchant social commentary. When some of those artists immigrated to New York, they brought with them an irreverence that found a hospitable welcome in the New World. Like the works of Duchamp, those of Andres Serrano or Robert Mapplethorpe are not meant to be comforting to a bourgeois sensibility. In New York, for example, Franklin Furnace (now existing only in cyberspace) and the Kitchen exist expressly to jolt complacent expectations about the boundaries of art. There are similar venues in other U.S. cities. By their very nature artists who follow the tradition of the subversive imagination create a wedge between themselves and the public. Especially now, for a public used to being entertained and pandered to in an ever increasing deluge of electronic music, film, television, and interactive media, the strain of contemporary art that ignores, baffles, or makes fun of its audience runs the risk of offending that audience. As important as the subversive imagination has been—challenging, reinventing American culture—it has done little to engage a public asked to support it.

This brings me to yet another dilemma, one that extends far beyond the arts, and that is the very idea of the public sector in American life. For many years, we took for granted the idea that universally excellent public education, good public libraries, reliable public information, the ability to go to outstanding public colleges and universities were the entitlements of citizens in our democratic culture. Now we are beginning to realize that the very idea of a public sphere in American culture has been under siege. At least since the Reagan administration, the conservative wing of American politics has challenged the idea that government has any role whatsoever in the support of a viable public sector. Privatization is the word that's been coined to describe this systematic abandonment of the public sphere and the adoption of a kind of Darwinian, laissez-faire approach to public life.

The ambivalence toward public structures is evident in the changes in NEA legislation. Over thirty years ago, the authors of the Endowment's enabling legislation produced a twelve-page, eloquently written document in clear and persuasive language that made a compelling case for public support of the arts. Today, the legislation, endlessly revised and amended, is a garbled contradictory mess with no clear rationale for support. Clearly, it's time to reenvision the idea of public life in general and, in particular, public support of the arts. Taking into account the NEA's accomplishments and the extent to which its achievements have changed the cultural landscape in the past thirty years, I outline below some considerations such reenvisioning might entail:

1. Leadership: Because the Endowment is so fundamental to the continued creative and economic sense of renewal in our country, there should be appropriate recognition of its importance by elevating its chairperson to a cabinet-level post. As cultural transactions grow increasingly global and transnational, it is noteworthy that in many other countries the person in charge of culture is a high-ranking minister. This lack of visibility has had an adverse effect on the NEA. Over the years, the Endowment has been remote from the public. Few would know what we stand to lose should we lose the NEA altogether. A more visible position for the leadership would help address this situation productively. Dr. Everett Koop changed a nation's outlook on smoking by skillfully using his cabinet-level post as Surgeon General as a bully pulpit. In New York City there is the model of the City's Cultural Affairs Commission which is on the level of the Mayor's Cabinet and is, therefore, given the same authority as every other aspect of city government.

2. Creative Risk-Taking: Legislated into the NEA's mandate should be a provision for the support of bold, risk-taking experimentation which, like preserves for endangered species, is protected from all kinds of poaching. One way to do this is by creating a special source of funds or a trust explicitly for nontraditional work; a special tax on the income of commercial cultural products for such work might underscore its independence from the political process.

3. Decision-Making Process: There needs to be a decision-making process for the awarding of grants that is less tied to the interests of specific artistic disciplines and includes the consumers of art and culture as well as the producers. Peer panel review served the Endowment well as it was growing, and an array of groups established themselves. Over the years, however, the reliance on peers alone has limited rather than broadened the Endowment's sense of the wider public, which it also serves.

4. Cultural Pluralism: In the enabling legislation the idea of diversity was prominently discussed throughout, and the NEA has succeeded in encouraging programmatic diversity in terms of the projects offered by a wide range of institutions. What it now requires is structural diversity that is within the boards, staffs, and patronage systems of institutions. The infrastructure of

cultural institutions in and of itself is a vital expression of a community, and a sense of reconciliation will come only if the management of difference goes beyond programmatic offerings.

5. Public Schools: The NEA should have a role in making sure that there is a substantial presence of the arts in the public schools. Whether the NEA mandates that schools should offer the study of theatre, visual arts, media, etc., or support attendance at cultural events, or offer the study of the history of art and culture, the Endowment can participate in setting national standards.

6. Art, Science, and Technology: Creativity in its broadest sense, the sense of discovery and inquiry should be considered inclusively as technology becomes evermore intrusive in our lives. Perhaps an Endowment of Science, Technology, and the Arts, as in Great Britain, would be more appropriate.

Times have changed. The demographics of the country have changed. The NEA needs to change and to consider, in light of its considerable achievements, what its role will be in the new millennium.

John Kreidler }

LEVERAGE LOST:
EVOLUTION IN THE NONPROFIT
ARTS ECOSYSTEM[1]

Awake, arise, or be forever fallen!
John Milton, *Paradise Lost*

A s the twenty-first century arrives, the arts in America exist in a vast array of styles, disciplines, and organizational structures. The purpose here is to examine one major organizational component of the American arts scene, the nonprofit sector, as an organic system[2] that has progressed through distinct stages over the past century. Although the nonprofit arts world contains thousands of organizations populated by tens of thousands of artists, administrators, technicians, trustees and donors, few are aware of its origins and the influences that have shaped its evolution.

As with participants in most large organizational systems, the citizens of the nonprofit arts world find it difficult to perceive changes, even massive developments, that occur gradually. The natural tendency is to assume that the arts firmament is unchanging, marked by an occasional meteor that leaves a momentary trace. In the early 1990s, it was widely believed within the arts community that nonprofit organizations were experiencing extreme financial pressure due to governmental funding reductions and lethargy in the American economy. These pressures were often described as temporary hardships that would soon fade, thereby enabling arts organizations to return to more normal conditions. Government funding reductions and a weak economy were certainly of consequence to nonprofit art organizations, but by themselves these pressures did not fully account for the deep changes that are now becoming discernible. Now that the decade is over, government support at the state and local levels is relatively stable, and the economy is strong. Still, it is apparent that the nonprofit arts have entered a significantly new age. In this

era, the old formulas of finance, labor supply, nonprofit organizational structure, and audience demand are failing to maintain the status quo.

Early in the twentieth century, astrophysicists learned that the universe is not static, but rather is expanding in every direction and subject to the interplay of immense forces. The nonprofit arts are also a complex and changing system, and as this system has gradually evolved, the defining trends and influences, like planets in a solar system, have occasionally aligned in ways that have produced striking new directions. The advent of the Ford Foundation's major arts initiatives, beginning in the late 1950s, represented a decisive moment in the subsequent progression of the arts in America. This paper will refer to that period from the late 1950s to 1990 as "The Ford Era," though it is acknowledged that many other funders and leaders played crucial roles in the arts during that period. Ford was not alone, but their policies set a style that endures today.

THE PRE-FORD ERA:
PROPRIETARY ORGANIZATIONS
AND DISCOUNTED WAGES

Classic economic theory predicts that, at a given price, consumers will demand a set amount of a good or service, which will be supplied by producers. The marketplace, then, is an ecosystem constantly seeking an equilibrium that embraces prices, supply, demand, and a host of other influences. Throughout the past century, the dynamics of the marketplace have had a fundamental influence on the development of commercial and nonprofit organizations that produce art in the United States.

Today, in part due to a movement that was set in motion by the Ford Foundation, the great majority of arts organizations operate as nonprofit corporations. As a result, it is easy to forget that the earlier prevalent model for arts organizations in the United States was that of the individual proprietorship.[3] In the nineteenth century, many theaters, orchestras, opera companies, performing arts impresarios, and even some museums, operated as for-profit enterprises managed by individual owners. As with other commercial ventures, these proprietorships had to meet the test of the marketplace: to provide services responsive to market demand at a competitive price, or cease to exist. This seemingly straightforward and endlessly studied relationship of marketplace influences has always been complicated in the arts, however, by the willingness of American artists and other arts workers to accept deeply discounted compensation for their labor.

In any attempt to understand the artistic ecosystem of the United States, it is of paramount importance to grasp the significance of discounted labor. In comparison to most occupations, artists and other arts workers (technical and management personnel) tend to accept a higher measure of nonmonetary re-

wards, that is, the gratification of producing art, as compensation for their work. By accepting these nonmonetary rewards, artistic workers, in effect, discount the cash price of their labor. One way to conceive of the value of this discount is to estimate it as the difference between the wages that artists typically earn and the wages earned by workers with comparable skill levels.

Market prices and consumer demand have never fully accounted for the output of artistic goods and services produced by American artists and arts organizations. Indeed, artists and arts organizations often give little consideration to market demand and prices in their determinations of how much and what kinds of art they produce. Even chronic indifference of the market may not induce an artist to change the amount or character of the produced art. This behavior usually would be catastrophic for a farmer or manufacturer, but it has long been commonplace among artists and arts organizations.[4]

With the arrival of the twentieth century, proprietary arts organizations began to wane. According to economists William J. Baumol and William G. Bowen,[5] the number of touring theater companies stood at 327 at the turn of the century, but declined to less than 100 by 1915. After 1932, the number never rose above 25. The traditional commercial forms of theater, vaudeville and circus declined or vanished in the face of the new medium of movies. Other performing arts forms were also affected by the new technologies of recorded music and radio, and ultimately by television. Some observers viewed these developments as the death of the live performing arts, and while it is evident that many proprietary performing arts organizations dissolved, it is not so clear that the overall output of arts goods and services was declining at all.

Supportive trends in public education, economic prosperity, leisure time, societal acceptance of the arts, immigration, and population growth coincided in the early twentieth century, all of which favored strong demand for artistic goods and services, and growth in the number of artists. The new technologies of film, audio recording, radio, and television, however, began to strip away from the old proprietary arts world the most popular and lucrative forms of production. Vaudeville became "The Ed Sullivan Show" and the custom easel painting became the mass produced offset print. Whereas broadbased audiences, comprised of both commoners and educated, well-to-do elites, had once attended proprietary productions of Shakespeare, even in small towns and mining camps across the nation, in the twentieth century the commoners began to gravitate toward the movie houses and other new technologies, leaving mostly the elite to patronize an assortment of proprietary high art. In response, the production mechanism for high art began to be reconstituted in the form of nonprofit organizations, thereby enabling aficionados to maintain their favored art forms by replacing lost earned revenues with personal contributions.

The nonprofit model remained at its core, however, a money-making enterprise. To this day, American nonprofit arts organizations derive, on average, about half of their income from sales revenues.[6] The remainder of the necessary income, however, began to come from individual contributors, the majority of whom were well-educated, upper-income connoisseurs who had an artistic, familial, or social stake in the continuation of particular arts organizations. Also during the early twentieth century, a few foundations, starting with the Carnegie Foundation, began to award a scattering of grants to nonprofit arts organizations, and local governments directed increasing support to publicly operated museums and performing arts halls.

By the end of the pre-Ford epoch (the late 1950s), the American arts ecosystem was characterized by a significantly reduced and still declining cadre of high art proprietorships, a small but steadily growing group of nonprofit and civic arts organizations, and a booming popular arts and entertainment sector operating commercially and reaping the advantages of a variety of technologies. More consumers were being served by these commercial and nonprofit systems of arts delivery than at any previous time in American history.

THE FORD ERA (1957–1990):
LEVERAGE GAINED

Despite the ample progress of the pre-Ford era in the production of both high and popular art, America had a hefty cultural inferiority complex by the late 1950s, by no means a new phenomenon in the nation's history. Our high art, in at least some circles, was not high enough, and too much of the artistic initiative had been conceded to the new populist technologies. The vigor of American culture was plainly visible and audible in its popular music, dance, and television, but less evident in many high art disciplines.

In the 1960 presidential election, a strong undercurrent was the rejection of the low-brow 1950s style personified by Richard Nixon,[7] in favor of the high-culture style epitomized by John Kennedy. During his presidency, Kennedy would distinguish his administration through widely publicized appearances by internationally renowned artists at the White House, and Mrs. Kennedy became the symbol of high international fashion. With the emergence of America as the world's post-war economic dynamo, there was an increasing mandate for comparable supremacy in the arts and culture, including cuisine and fashion.

A New Supply of Contributed Income

Just as the mood of American culture was changing, a startling new invention appeared on the art scene: the arts grant. Popularized by the Ford Foundation in the late 1950s, the arts grant was a vehicle for the long term advancement of

individual nonprofit arts organizations, as well as a means for the strategic development of the entire nonprofit arts sector. As created by Ford, these grants were national in their distribution, and seen as a form of highly leveraged investment, rather than the simple personalized charity that had characterized the pre-Ford era.

Until the arrival of the Ford Foundation's broad vision of arts funding, virtually all cultural philanthropy had been vested with individuals, and generally lacking in any strategic intent. Most cultural philanthropy in the pre-Ford era consisted of individual patrons providing gifts to their favorite nonprofit arts organization, motivated by their love of art or sense of civic duty. While these gifts were often significant in the life of a given institution, they were rarely associated with a formally constructed plan for that institution's progression, and even less often with a grand scheme for systemic advancement of the entire arts field.

If anyone deserves credit for inventing the arts grant it is W. McNeil Lowry, the Ford Foundation's Vice President for the Arts from 1957 to 1976. Over a span of twenty years the Ford Foundation invested more than $400 million in:

- The financial revitalization of existing major nonprofit arts institutions including elimination of debt, establishment of endowments and operating reserves, and support of building campaigns;
- The establishment of new regional nonprofit arts organizations, especially theater and dance companies, to decentralize the arts beyond the city limits of New York;
- The formation and advancement of a battery of arts service organizations, such as the Theater Communications Group, to promote broad sectors of the arts, and;
- The enhancement of conservatories and visual art schools to generate a labor supply to complement the emergence of stronger, more decentralized and numerous arts institutions.

It is highly significant that the Ford Foundation viewed itself as a catalyst for these major developments, but not as the perpetual funder. The majority of Ford's grants were limited to less than five years duration and required matching support two to four times greater than the amount awarded by the Foundation. So, while Ford was attempting to increase the capacity of arts organizations to manage themselves on a fiscally sound basis and increase program output, the assumption was that other sources of money, both contributed and earned, would support long term maintenance. The concept of the matching grant, accordingly, was not merely to assemble additional funds to accomplish a specific purpose, such as a cash reserve for a museum; it was also a tactic intended to recruit new donors, who would continue a pattern

of support long after Ford had moved on to other projects. This extended pattern of support was the most important form of leverage that Ford was to achieve.

The leverage element of the Ford strategy succeeded brilliantly. Whereas only a few institutional funding sources had entered the realm of arts philanthropy in the pre-Ford era (notably Carnegie, Rockefeller, and Mellon), a virtual cascade of foundations, corporations, and governmental agencies now became active art funders, and many of them, knowingly or unknowingly, emulated Ford's approach to institutional advancement and high leverage funding. The evolution of this highly pluralistic institutional funding system for the arts had no precedent in the U.S. or any other nation. Even today, this institutional funding system, involving many hundreds of foundations, corporations and governmental agencies, remains unique in the world. Nor was this approach in any way limited to the domain of nonprofit arts organizations. Similarly vigorous applications of funding leverage were to be found in many other initiatives launched by Ford and other national funding sources during the 1960s, including the Johnson Administration's monumental "War on Poverty," which often required matching contributions from state and local government.

Borrowing from physics, Ford's influence on arts funding can be likened to a chain reaction. Ford's leadership, both by the example of its grants and through direct political advocacy, was highly instrumental in the formation of the National Endowment for the Arts (NEA): a federal agency conceived during the Kennedy Administration and inaugurated in 1965 by the Johnson Administration. Major initiatives of the NEA, including its Treasury Funds, state block grants, and Challenge and Advancement programs, owe much to the Ford strategies of leverage, decentralization, and institutional expansion. Moreover, from the beginning, the preponderance of NEA grants was made on a matching basis. The logic was, and remains, that the NEA would stimulate a broad and ever-expanding base of funding from individuals and institutional funders that would carry most of the weight of sustaining contributed income for the nonprofit arts economy.

Prior to the NEA's founding in 1965, only four states operated arts funding agencies. With the stimulus of the NEA's block grants, all states and territories had founded arts agencies by 1980. This growing snowball of state and federal arts funding, in turn, led to the formation of more than 3,000 local arts councils, a quarter of which were organized as units of local government while the remaining three quarters were formed as nonprofit organizations, often with some formal link to local government.

Aside from this pyramidal evolution of governmental funding, two other philanthropic branches grew from the Ford roots: foundation and corporate support of the arts. Foundation and corporate funding for the arts had been

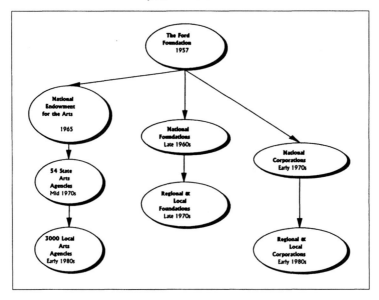

The Evolution of
Institutional Arts Funding

minuscule prior to the Ford era, and that which did exist was mostly moti-
vated by the same drives that stimulated individual arts patrons: love of art
and civic duty. The first to follow the Ford example were some of the large
national foundations, but even greater numbers of regional and local founda-
tions were to join the cultural funding movement by the mid 1970s. Many of
these foundations would employ specialized staff to formulate funding strat-
egies and analyze grant applications, again taking a cue from Ford, which was
among the first foundations to utilize professional staff for these purposes. By
1990, the end of the Ford era, the aggregate arts funding from foundations
alone would surpass $1 billion per year,[8] more than three times the amount
spent by state and national governmental arts agencies, and about equal to
total national, state, and local expenditures on the arts.

The corporate arts funding movement started somewhat later than the
foundations and was spearheaded by a few national leaders including Exxon,
Dayton Hudson, Philip Morris, and AT&T. Although corporate funding did
not attain the same level as foundations and government, and was more im-
mersed in marketing agendas (and therefore less concerned with the strategic
advancement of the arts), corporate funding was considered by many to be the
fastest growing source of contributed income for the arts in the early 1980s.

The result of the entry of government, foundation, and corporate funding

sources into the arts economy during the Ford era was quite dramatic. According to 1980 data collected on nonprofit arts organizations in the San Francisco Bay Area,[9] 45% of total income was earned and 55% came from all contributed sources. Of the contributed funds, 25% was provided by individual patrons, 18% by government,[10] 7% by foundations and 4% by corporations. Although similar figures are not available for the comparatively small sector of nonprofit arts groups in the pre-Ford era, it is evident that a strikingly different pattern must have prevailed. The preponderance of funds in that time were either earned through sales or donated by individuals.

Besides helping to fuel expansion of the population of artists and arts organizations, the most significant effect of Ford era institutional funding was that it channeled the formation of new high art organizations into a nonprofit structure, rather than the proprietary mode that characterized the pre-Ford era. In the case of one metropolitan region, the San Francisco Bay area, only twenty to thirty nonprofit arts organizations were in existence in the late 1950s, while a far greater number of theaters, musical ensembles, performing arts presenters, and galleries were operating on a for-profit basis. By the late 1980s, at the end of the Ford era, the Bay Area contained approximately 1,000 nonprofit arts organizations,[11] and far fewer proprietary arts organizations continued to operate. Commercial art galleries remained significant, though much of the vigor in contemporary visual art had gravitated to nonprofit galleries and artist-run spaces. Virtually no commercial theaters were operating, and almost all commercial performing arts presenting had ceased. The arts organization profile evident in the San Francisco Bay Area may be somewhat atypical, but high growth in the number of nonprofits combined with a decline in the commercial high art sector to have been the pattern in all metropolitan regions in the United States.

A New Supply of Discounted Artistic Labor

While the Ford Foundation and NEA deserve much credit for their early support of the nonprofit arts movement, by far the most significant factor in this movement's origin and rapid build-up was the arrival, in the 1960s, of a huge generation of artists, technicians, and administrators, driven not by funding or economic gain, but rather by their own desire to produce art.

The willingness of this new generation of arts workers to heavily discount its wages is borne out by various studies. Richard Harvey Brown of the University of Maryland's Survey Research Center notes that:

> government data on various artists occupations for 1970 and 1980 revealed that the number of art workers had increased by 48 percent, whereas their earnings during this period had decreased by 37 percent. In 1980, the average income of an artist living in Massachusetts as $13,008, of which only $4,535 was income

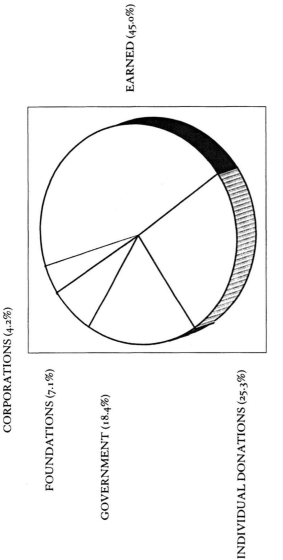

EARNED (45.0%)

CORPORATIONS (4.2%)

FOUNDATIONS (7.1%)

GOVERNMENT (18.4%)

INDIVIDUAL DONATIONS (25.3%)

Income Sources of 218 San Francisco Bay Area
Nonprofit Arts Organizations, 1980

earned from art. No other occupation has such highly trained people who must earn most of their penurious incomes outside their field.[12]

Two reports issued by the National Endowment for the Arts amplify the growth in the number of artists and their willingness to discount their income:

- The artist labor force grew steadily from 1971 to 1980 and increased by 323,000 persons, or 46 percent.
- The most chronic artist unemployment existed among actors, with rates during the decade (of the 1970s) ranging between 31 percent and 48 percent. As many as 10,000 actors were out of work in 1979.[13]
- Most (visual) artists do not support themselves by selling their work. Median art income for the artists sampled was $718 in 1968. Median production costs were $1,450, approximately twice the median income. Not only do artists fail to make much money for their art, but they generally spend much more producing it than they make.[14]

The Ford era generation of arts workers described in the foregoing studies founded an unprecedented number of arts organizations, clearly not because of financial rewards or arts grants, but rather because they had the training and desire to produce art. This training and desire resulted from several broad influences that coincided at roughly the same moment:

- Significant shifts in societal values (free speech, free art, free love);
- A peak in the American economy, which provided not only philanthropic resources to support the arts, but also an abundance of job opportunities that supplied arts workers with income that enabled them to work in their off-hours for minimal compensation in nonprofit arts organizations;
- The arrival of the massive baby-boom generation on American college campuses, which provided the core labor supply for Ford era arts organizations;
- The momentary ascendancy of liberal arts education, which provided training for a new generation of arts workers while also providing a basis for future high arts consumerism;
- A high water mark in leisure time. According to economist Juliet Schor,[15] leisure for the average working American reached an apogee in 1971.

Implications of the Ford Era

In summary, then, it was the sheer number of inspired and educated youth that provided the main fuel for the Ford Era. In an earlier time, this labor force probably would have founded a wave of new arts enterprises using the proprietary model. In the 1960s, however, the nonprofit model was available and convenient, besides fitting the contemporary anti-business ethos. More-

over, the nonprofit model had the benefit of heavy backing from the new circle of institutional arts funders led by the Ford Foundation, though many, probably the great majority, of start-up nonprofit arts organizations began without the prior commitment of a grant.

Although the Ford era was largely driven by discounted labor, and secondarily by institutional funders, it could never afford to ignore consumer demand. As in all eras, much art was produced for its own sake with no concern for its consumer appeal. Nevertheless, the high arts in America, even with the advent of institutional funding and nonprofit organizations, continued to depend far more heavily on earned revenues than their counterparts in virtually all industrialized nations. In some modern European countries, government subsidies alone accounted for 80 percent or more of a typical organization's budget.[16]

In the United States, by contrast, client-based revenues have remained critical to the survival of most nonprofit arts organizations, so as these groups proliferated in the Ford era, they tended to devote considerable energy to sales. Indeed, many government, foundation and corporate funding sources insisted on the development of a paying client base and often provided grants toward that end. Even without pressure from the funders and economic necessity, many arts organizations were imbued with the ethic of public service and willingly did their best to attract large followings. Thus, the Ford era was more than a partnership between nonprofit arts organizations and friendly funding sources that appreciated high art. It was also a period when the clientele of the high arts rebounded, in part driven by increased supply, but also by advances in education, societal values, economic prosperity and leisure time, the same factors that spawned the new generation of arts workers.

As the Ford era evolved, however, it could be fairly said that most of the new consumer demand came from a relatively well-defined segment of the population: persons with high levels of formal education. This point has been confirmed by virtually all surveys of performing arts and museum audiences over the past three decades. Thus, though the nonprofit movement in the arts was partially founded on the ideal of public service, an unintentional result was that most of the beneficiaries came from a narrow band of society. What was true at the outset of the Ford Era was at least as true at the end. Most of the public obtained its arts and entertainment from commercial sources. While the nonprofit arts were expanding in organizational numbers and output, the big money and most of the technological innovation continued to reside in commercial broadcasting, musical recording, movie production, multimedia, and a host of new home electronic media.

THE POST-FORD ERA (1990 TO PRESENT): LEVERAGE LOST

Just as abundant cheap labor and institutional funding were the defining elements of the Ford era, stagnation in these two resources is now defining the

post-Ford era. Despite the Ford era's remarkable successes in preserving and advancing American high art under the nonprofit banner, it was not a period that could be sustained.

Trends in Contributed Income

The most obvious, though rarely acknowledged, reason that it could not last indefinitely was that the institutional money supply could not continue to grow. An early assumption of many arts funders, including Ford, was that high leverage funding would stimulate other sources of contributed income for the arts, most notably from government, that would provide a steady and expanding flow of revenues: the so-called "pump priming" or "seed funding" strategy. Meanwhile, government was using the same logic to justify its arts funding. Each year, the National Endowment for the Arts would partially argue the case for its appropriation bill in Congress by pointing out that each dollar of Federal funding of the arts would stimulate a manifold return in arts support from private sector funders.[17] Similarly, state arts agencies would employ this same rationale in their annual appropriation processes. Over the years, many public funding agencies would commission economic impact studies that would attempt to demonstrate not only the leverage of governmental dollars on private sector contributions, but also the effects of public arts spending on commercial sector revenues and on the generation of sales and income tax revenues.

Today, the leverage concept continues to be advanced by many governmental arts agencies as a primary rationale for public funding of the arts, even though much private sector and governmental arts funding has been on a flat or even downward trajectory for several years. Some private funders, as well, continue to operate matching grant and challenge grant programs that assume the potential for high funding leverage.

Any student of biological, physical, or economic systems would immediately recognize the flaw in the logic of funding leverage, as it has been practiced not only in the arts, but also throughout the nonprofit sector. A fundamental tenet of systems studies is the "free lunch" principle: no system can depend on the unlimited growth of resources. The leveraged funding strategy of the Ford era can be likened to a chain letter, a Ponzi scheme,[18] or any other pyramidal growth system. The initiators of chain letters and Ponzi schemes often claim that, for a small investment, a virtually limitless return will be realized, and though initially this prophecy may appear to be feasible, inevitably all such arrangements must fail because resources are finite. In other words, there is no perpetual free lunch. Ultimately, funding leverage will become unsustainable.

Although reduced or stagnant funding from governmental and private sources is now a pervasive topic in the nonprofit arts world, the emergence of

this trend has been fairly gradual, and it is commonly believed that the reductions are a temporary aberration[19] of the economy. The state of the economy certainly does influence the resources to many funders, as well as the buying power of arts consumers. Nevertheless, to singularly blame the economy for the substantial pressures now bearing on the nonprofit arts sector ignores the hard reality that for three decades the arts were able to rely on exponential growth in financial and labor resources, and now the chain reaction started in part by the Ford Foundation, with the best intentions and spectacular results, has arrived at a point of systemic purgatory.

This point is illustrated in the following table, which compares the rates of growth in institutional arts funding from the early 1980s through the mid 1990s.[20]

Rates of Growth in Institutional Arts Funding

Year	Foundations (est.)		NEA	
	Amt*	%Change**	Amt*	%Change**
1983	658.4		131.2	
1986	805.8	11.3	143.7	(0.5)
1989	1,076.0	18.0	150.7	(7.3)
1992	1,357.9	11.6	154.7	(9.4)
1996	1,688.0	11.2	72.2	(58.2)

*Dollar figures in millions

**Percentage change in constant dollars; inflation adjustment based on CPI where 1982–1984 = 100

Rates of Growth in Institutional Arts Funding

Year	State Arts Agencies		Local Arts Agencies (est.)	
	Amt*	%Change**	Amt*	%Change**
1983	104.9		181.0	
1986	166.3	44.0	211.0	6.1
1989	230.1	22.3	300.0	25.7
1992	213.4	(18.0)	365.0	7.5
1996	262.2	9.9	374.0	(8.5)

*Dollar figures in millions

**Percentage change in constant dollars; inflation adjustment based on CPI where 1982–1984 = 100

The most positive interpretation of this table is that institutional funding, with the exception of the NEA, has not been plummeting, and indeed, some

modest growth is apparent among foundations and state arts agencies. However, the overall pattern presented by these figures is lower rates of growth in institutional funding, or even negative growth, in the mid 1990s, and arts organizations are experiencing difficulty in adjusting their operational thinking to this new pattern, which is a partial cause of their current stress.

Among foundations, which outweigh all other institutional funding sources combined, arts giving is down as a percentage of all foundation giving from 13.3 percent in 1992 to 12.2 percent in 1996—the lowest level reported in the 1980s and 1990s. Given the strong performance of the economy and the stock market, the amount of foundation funding of the arts increased even though the percentage of arts funding fell, but the drop in percentage could be a long term signal that the arts have lost some of the popular appeal that they held in foundations throughout the Ford era.

Trends in Labor

While the loss of funding leverage is a major problem for nonprofit arts organizations, an even bigger, though less acknowledged, issue is the loss of labor leverage. The most elemental force in the massive growth of arts organizations in the early Ford years was the arrival of a large new generation of artists and other art workers who were willing to support their work through discounted wages. The continuation of Ford era nonprofit organizations is, therefore, fundamentally tied to the ongoing availability of this core resource. For three reasons, the outlook is not good for the sustainability of discounted labor: a significant portion of the veteran generation that founded the Ford era organizations is departing, it is not being adequately replaced by a new generation of discounted labor, and artists are making no progress in earning monetary compensation from the practice of their art.

The departure of the veterans is principally due to a simple axiom of aging: as one becomes older, the expectation of earning more increases. During the early Ford years in particular, tens of thousands of young people entered the arts with little thought of it being a career that would bring adequate compensation. The 1960s economy was so robust, the cost of living was so low, and job opportunities so abundant, that a young person with a college degree could easily become a writer, curator, dancer, or lighting technician, often by holding a supplementary non-arts job. As this generation of arts workers has aged, however, the expectation of making money has increased.

As expectations of making money have been escalating for veteran arts workers, their actual wages have made little, if any, progress. According to 1996 survey data from four metropolitan areas gathered by Joan Jeffri of Columbia University,[21] median gross income for artists of all disciplines was $25,000, but only one-fifth of this amount was derived from the practice of art. Adjusted for inflation, these figures are quite close to the results of an identical

survey conducted by Columbia in 1988. According to Ms. Jeffri, these data disprove the myth of the starving artist, but it remains apparent that income is a weak inducement to maintain veteran artists or to attract a younger generation to join the profession. Moreover, artistic professions continue to lose ground in compensation relative to many other high education/high skill professions.

One of the common stories among young performing artists of the 1960s was their pilgrimage to a large city, often New York, where they worked for almost no wages for a theater or dance company. In those years, an entry level job for a college graduate might be $5–8,000 for a fully professional position in teaching, accounting or management. For these young performing artists, however, survival was a matter of living in shared housing, earning money in a menial part time job, and maybe receiving assistance from parents. In New York City, many nonprofit performing arts organizations with annual production seasons learned how to supplement their workers' wages through periodic layoffs that made them eligible for state unemployment insurance. So, while these young performers were usually aware that their worth on the open job market was $5–8,000, they might accept little or no compensation with few regrets. In effect, they were donating all or most of the value of their labor to the dance or theater company in which they worked.

Today, these veteran arts workers are in their forties and fifties. At this point in their careers, they may be earning annual wages of $25–40,000 from both artistic and non-artistic work, no longer living in shared housing, intolerant of periodic layoffs, and almost certainly receiving no help from their parents. Moreover, the open job market has far fewer opportunities for their skills, and the time for developing the qualifications to enter an alternative career is past or becoming short. For many of these veterans, the realities of acquiring equity in a house, saving for retirement, obtaining medical insurance, or helping their children through college have become grim.[22] Given their levels of education, advanced skills and seniority, these veterans feel entitled to incomes more in the range of $50–75,000, and yet only a small fraction of them, especially in small and medium size arts organizations, are able to reach this expectation. The net effect, then, is that the veterans are giving up more income to work in the arts today than they were in the early years of the Ford era, and the pressure of their need for increased income is a major cause of their exodus from the field.

In the bygone days of the early Ford era, labor exerted its own form of leverage. Artists would start new organizations, which became magnets for yet other arts workers, even without strong economic incentives. As long as labor was inexpensive, new nonprofit organizations provided a nexus for artistic labor to pursue its need to produce work. In the post-Ford era, however, it appears that this leverage has been lost, or at least diminished, with respect

to a younger generation of arts workers. Fewer in this generation are majoring in the liberal arts, and for those who do, there is less often the desire to take a chance on a low paying career with minimal long term security. A more typical strategy among undergraduates is to prepare for highly paid occupations, and to work hard at getting an entry level position with good prospects for advancement. A corollary of this change in career perspective is that within the relatively small pool of young college graduates who are willing to work in the nonprofit arts sector, there is often a demand for higher starting wages. Ironically, it is not unusual to find cases in which veteran arts workers are leaving the field, and being replaced by younger, less experienced workers, who start at wages comparable to those of the departing veterans.

A problem that compounds the dual trends of reduced discounted labor and reductions in grant funding is the apparent slippage in public demand for the services of some nonprofit arts organizations. In recent years, much of the performing arts industry (operas, symphonies, theaters, and dance companies) has reported lower audience results. Here is an instance in which the recession of the early 1990s may have had a significant impact; but it is also likely that several other trends, all of them likely to last well beyond the recession, are significant. In essence, these longer lasting trends are reversals in the very factors that gave rise to the Ford era:

- Societal Values. The nonprofit arts sector has received a public relations blow from the spectacle of Congressional muckraking over the various controversial grants awarded by the National Endowment for the Arts. At a time when "family values" are in ascendancy, it has become increasingly difficult to justify public spending on art that challenges the societal mainstream. In some ways, the arts have once again become discredited as a career: not a place for successful, virtuous people.

- Education. According to many authorities, overall literacy and educational attainment have slipped, and many arts education programs have been reduced or eliminated. These trends in general education and arts education are particularly worrisome for the arts because of their exceedingly long term impact. Whereas societal values and economic prosperity may shift over spans of several years, changes in the educational system tend to be more glacial, and the impact on individuals can be lifelong. Thus, if a child establishes no arts literacy, especially during the early primary school years, the likelihood of that child becoming an artist or an active participant in the arts may be significantly diminished.

Given that much of a baby boom generation graduated from the educational system at or near its pinnacle, one might suppose that this relatively affluent group would now be a prime source of new and stable audience support for the arts in the 1990s, even if the participation of subsequent generations is being dampened by a weakened educational system. The book *Megatrends 2000*[23] predicted a strong upward trend in arts audiences in the

1990s resulting from the well-educated baby boom generation's arrival at its prime income earning years. Unfortunately, there is little evidence that this trend is materializing, with the possible exception of museum audiences, which are growing. Overall, it is quite possible that the baby boom generation will be less engaged in the arts than their parents' generation.

- Leisure Time. Judith Huggins Balfe suggest that the baby boom generation is approaching its leisure time in a manner different from its parents' generation.[24] Given the pressure of work, Ms. Balfe sees a reluctance within the baby boom generation to commit itself in advance to a schedule of leisure time activities. Thus, this generation is less likely to buy season tickets because it wants to retain freedom of choice and the opportunity to attend activities spontaneously. This generation also may be reluctant to purchase even a single ticket to a high art event that requires arrival at a set time, and constrains the audience to a silent, passive posture until the performance ends. Rather, the increasing preference may be shifting to forms of art, such as museums, literary salons, and jazz, that are more interactive, flexible with regard to arrival and departure times, and less constraining on one's behavior.

- Demographic Change. Whereas the sheer size of the baby boom generation had an influence on the number of artists and audience members available to support the nonprofit arts build-up of the Ford era, population dynamics of a different sort are shaping the post-Ford era. Post-Ford is a more racially and culturally diverse time, and many nonprofit organizations based on the high art tastes of an educated and mostly white elite are finding it difficult to adapt to a more multi-hued audience.

Implications of the Post-Ford Era

The main point of this paper has been to examine the nonprofit arts sector as a complex organic system that has been shaped by at least a half dozen major trends over the past century. While in retrospect it may be possible to trace the confluent forces that led to the bounty of the Ford era, it is another matter entirely to predict how the ecosystem will evolve into the future. Any system affected by large-scale external influences must necessarily adjust its behavior. Systems tend to be so complex, however, that prediction of their behavior is impossible. In recognition of the chaotic behavior of social, economic, and environmental systems, an emerging view among planning authorities[25] is to prepare for alternative futures, rather than betting everything on any single projection of the future.

There is, perhaps, one reasonably safe assertion that can be made about the near term direction of the nonprofit arts ecosystem: that for the present, the arts will have no choice but to adapt to the circumstances of less discounted labor and contributed income, and, in some instances, flat or declining consumer demand as well. The most likely result will be an overall decline in the

number of nonprofit arts organizations, along with a reduction in the production of program services: exhibitions, performances, and so forth. This near term prediction does not imply that every nonprofit arts organization will follow a declining course, but rather that the nonprofit arts ecosystem as a whole will have to come into equilibrium with reductions in these resources. Other nonprofit fields, including environmental, social service, and educational organizations, which expanded rapidly in response to the growth of discounted labor and institutional funding in the 1960–1990 era, may experience similar declines.

Many, though by no means all, larger institutions have buffered themselves from some of the exigencies of the post-Ford environment through enhanced capitalization (buildings, cash reserves, equipment, and endowments), reasonably adequate employee compensation, and multiple streams of contributed income from individual donors and institutional grants, complemented by dependable flows of earned revenues based on loyal audiences. For many of the major arts institutions, especially in the performing arts, audiences have tailed off in recent years, but given their diverse resource bases, large institutions can often manage their way through this hardship. Cuts are made in various cost categories, emphasis is devoted to increased earned and contributed income, endowments are bolstered, and the ship stays afloat.

Surely, the most vulnerable organizations are the small and medium size arts groups that have had the highest reliance on inexpensive labor and grants. In the San Francisco Bay Area, for example, more than 95 percent of the nonprofit arts groups fall into the small or medium size range using, as a rough standard, organizations with annual operating budgets of less than $1.5 million. For many small and medium size arts organizations, fine-tuning of costs and income sources may not be enough. The departure of the founding generation of artists and administrators, and the subsequent inability of organizations to recruit employees of comparable skill and commitment, may be fatal. The loss of one or two key funding services, usually in the form of previously reliable governmental or foundation grants, may have the same effect.

In a few instances, small, weakly capitalized arts organizations eventually declare legal bankruptcy, though the more common pattern is to retreat from a position of operating as a year-round organization, and instead operate from project to project as resources permit. Another tactic is to abandon operation as an independent nonprofit organization, and to function thereafter under the aegis of a nonprofit fiscal sponsor. Some attempts at merger are also in evidence, but examples of success are few in number.

All of these tactics for reducing fixed costs have in common one feature: a continued need for a supply of discounted labor, without which existence in any organizational structure is not possible. With the possible exceptions of the top echelon of orchestral musicians and a handful of superstars scattered throughout the performing, visual and literary arts, the compensation

and status of the American artist are not substantially different from the pre-Ford days.

For those who came of age in the Ford era and became acclimatized to its nonprofit mode of operation, the realities of the post-Ford era may seem harsh or even hostile. For artists, administrators, and board members, the operation of nonprofit arts organizations has become a thoroughly learned culture with deeply ingrained assumptions about values, ways of conducting business, and sources of support. As with any established culture, it will not be an easy task to adapt to new circumstances. From a historical perspective, it can be seen that the American nonprofit model was always built upon the foundation of the earlier proprietary system, which required of arts workers a combination of personal economic sacrifice and the ability to attract paying customers. If the post-Ford era comes to resemble an earlier time when entrepreneurial skills were essential to survival, it is likely that many organizations founded in the Ford era will experience trouble making the necessary adjustments, or even discontinue operations rather than accept any compromise of refined high art standards that cannot be supported, at least partially, in the market-place. Thus, an issue today is whether and how the model of the nonprofit arts organization, which has flourished for only a brief moment in the history of the arts, will continue to be a viable, versatile, and publicly useful instrument for artistic production.

Workers involved with the day-to-day operations of nonprofit arts organizations will increasingly have to ask a personally difficult, but fundamental, question, "How long will we be willing to carry on our work in the nonprofit arts in full acknowledge of the ongoing necessity of sacrificing personal income?" In effect, an audit of the human resources of an arts organization, which revealed the likely career trajectories of current staffs and volunteers, along with an appraisal of the likely flow of new recruits, would provide a clearer understanding of sustainability than a financial audit.

Arts funders who have an abiding interest in the advancement of nonprofit arts organizations should be equally interested in the arts labor supply. In most instances, grant funding will not be sufficient to offset the value lost to arts organizations through labor attrition. Given the fragility of many non-profit arts organizations, funders who pursue their usual role of using grants to influence production quality, audience size and composition, fundraising capacity, and financial stability may find that their interventions exert little positive influence. Worse yet, interventions made in the absence of a thorough understanding of the new systemic realities of nonprofit arts organizations, including the key issue of waning labor resources, may result in what systems authorities call, "unintended consequences." Trying to boost audiences, for example, may push an already stressed organization, that should be focused on reducing fixed costs, over the brink.

Although funders are sometimes potent enough to award grants that make a material difference in an organization's long term advancement, it is an open question whether any foundation, corporation, or governmental agency, even a coalition of funders working together, could succeed with an intervention that would change the course of the entire arts ecosystem, in a fashion comparable to the Ford Foundation in the 1960s. The post-Ford environment has no single funding institution that could muster the unilateral impact of the Ford Foundation's ventures into national dispersal of the arts and building up entire sectors of the arts, such as regional theater and ballet companies. The post-Ford landscape of funders is so decentralized and pluralistic that any plausible cooperative effort would seem to have little chance of achieving broad systemic change.

Assuming that governmental and private arts funders could assemble resources comparable to those of the Ford Foundation in its heyday, there is no obvious leverage point in the post-Ford environment. Some funders are fond of the idea that massive improvements in arts education would help to reverse declines in audiences; but would enhanced education by itself be enough to offset negative public attitudes toward artistic expression, declining leisure time, slippage in middle class prosperity, and the constant pressure of new entertainment technologies? Each of these trends is driven by massive forces in the American economy, society, and political order that surround and dwarf the nonprofit arts. So, for those with the ambition of rivaling the legacy of McNeil Lowry, there may be no choice but to await a more favorable alignment of the planets, when a leverage point, once again, becomes manifest.

Although the moment may not be ripe for grand strategies, there is no cause to abandon all that arose during the Ford era. In comparison to the last years of the pre-Ford era (the decade following World War II), the high arts sector of the post-Ford era is much larger and more robust. Enough nutrient remains in the nonprofit arts ecosystem to support the conviction that many Ford era organizations will make the necessary adjustments to the new conditions, and thereafter prosper and mature. Even in cases wherein nonprofit organizations cease operation, their resident artists may well continue to find other organizational structures to support their work.

And who knows? A new planetary alignment could arise at any moment and define an era beyond post-Ford. While it is highly unlikely that the next age will be shaped by the same coincidence of forces that unleashed the boom of the Ford era, there is no reason to expect that the presently prevailing trends in resources, societal values, population dynamics, technology, education, and leisure will become frozen in a permanent orbit. Paraphrasing John Milton in *Paradise Lost*, there is no need to be forever fallen if nonprofit arts organizations awake and arise to the new realities of our time.

NOTES

1. Author's note: an earlier version of this paper appeared in *The Journal of Arts Management, Law, and Society,* Summer 1996, published by Heldref Publications, Washington D.C.

2. Throughout this paper, an effort is made to describe the nonprofit arts world as a complex system. The approach used in this analysis owes much to the work of two noted systems authorities: Barry Richmond, President of High Performance Systems in Hanover, New Hampshire, publisher of a systems modeling program entitled "i think" and MIT professor Peter Senge, author of *The Fifth Discipline: The Art & Practice of the Learning Organization* (New York: Doubleday Dell Publishing Group, Inc., 1990)

3. The nineteenth-century world of proprietary arts organizations is thoroughly described in Lawrence Levine's book, *Highbrow/Lowbrow: The Emergence of Cultural Hierarchy in America*, which documents the popularity and economic class diversity of audiences before the advent of nonprofit organizations (Cambridge: Harvard University Press, 1990).

4. The concept of discounted labor is, by no means, limited to the arts. Teaching, for example, is often cited as a profession in which the practitioners sacrifice some fraction of their wages for the nonmonetary rewards of working as educators.

5. Baumol, William J. and William G. Bowen. *Performing Arts, The Economic Dilemma* (New York: Twentieth Century Fund, 1966), pp. 81–83.

6. In most industrialized nations, earned income forms a far smaller fraction of the total income needed to operate arts organizations. In some instances, government subsidies provide the majority of the operating income. See Milton C. Cummings, Jr., and J. Mark Davidson Schuster, eds. *Who's to Pay for the Arts? The International Search for Models of Arts Support* (New York, N.Y.: ACA Books, 1989)

7. Ironically, President Nixon, in the 1970s, was to become a strong supporter of high art through his approval of quantum budget increases for the National Endowment for the Arts. Throughout his administration, Mr. Nixon made a point of attending performing arts events and inviting artists to the White House.

8. Weber, Nathan and Loren Renz. *Arts Funding: A Report on Foundation and Corporate Grantmaking Trends* (New York, N.Y.: Foundation Center, 1993)

9. San Francisco Foundation. *Artsfax 1981* (San Francisco, Calif., 1981). 1980 data are used for this chart because that year falls in the middle years of the Ford era when broad diversification of contributed funding sources had already become a well-established pattern.

10. One of the notable features of the governmental support in 1980 was that a significant portion of it was still derived from Federal CETA funds (Comprehensive Employment and Training Act), which were allocated to state and local jurisdictions for public service jobs for unemployed workers. According to figures compiled by the U.S. Department of Labor and the National Endowment for the Arts in 1976, approximately 10,000 artists and related workers received CETA jobs, at an annual cost of more than $60 million nationwide. Economic recovery in the early 1980s, along with the agenda of the newly elected Reagan administration, brought an abrupt end to this source of funding.

11. Myllyluoma, Jaana and Lester M. Salamon. *The San Francisco Bay Area Nonprofit Sector: An Update* (Baltimore, Md.: Institute for Policy Studies, The Johns Hopkins University, 1992).

12. Brown, Richard Harvey, "Art As a Commodity" from Swaim, C. Richard ed. *The Modern Muse: The Support and Condition of Artists* (New York: ACA Books, 1989), pp. 19–20.

13. *Artist Employment and Unemployment 1971–1980* (Washington D.C.: NEA Research Division Report No. 16, 1982), p. 7.

14. *Visual Artists in Houston, Minneapolis, Washington and San Francisco: Earnings and*

Exhibition Opportunities (Washington D.C.: NEA Research Division Report No. 18), p. 18.

15. Schor, Juliet. *The Overworked American: The Unexpected Decline of Leisure* (New York: Basic Books, 1991).

16. Milton C. Cummings, Jr., and Richard S. Katz, eds. *The Patron State: Government and the Arts in Europe, North America, and Japan* (New York: Oxford University Press, 1987).

17. A recent news release of the NEA claims that each dollar of Federal arts funding yields $11 of private sector contributions.

18. A Ponzi Scheme is an illegal form of fraud in which investors are promised high rates of return that are achieved in the short run by paying early investors with funds derived from later investors. The seemingly high rates of return serve as a magnet for later investors who believe that they too can become rich. Inevitably, many investors lose all or much of their committed resources. Systems theorists would use the term "positive feedback" to describe pyramidal growth schemes. Positive feedback is an inherently destablizing characteristic of some systems.

19. Margaret Jane Wyszomirski notes that the high growth of NEA funding in the 1970's led to a mythic belief that large increases in Federal appropriations for the arts would continue into the future. Instead, ". . . the NEA's budgetary growth in the 1970's was quite anomalous and could not be sustained indefinitely." "From Accord to Discord: Arts Policy During and After the Culture Wars," from Mulcahy, Kevin V. and Margaret Jane Wyszomirski eds. *America's Commitment to Culture* (Boulder, Colo.: Westview Press, 1995) p. 19. This article describes several other myths and misconceptions that arose during the early years of the NEA which have proved to be impediments to clear-sighted policy development in the 1990s.

20. Renz, Loren and Lawrence, Steven. *Arts Funding: An Update of Foundation Trends, Third Edition* (New York: The Foundation Center, 1998), p. 4.

21. Jeffri, Joan and Robert Greenblat. *Information on Artists - II* (New York: Columbia University, Research Center for Arts and Culture, 1998).

22. For an insightful description of the evolution of the arts labor supply at the end of the 1980s, see McDaniel, Nello and George Thorn. *The Quiet Crisis in the Arts* (New York: FEDAPT, 1991) pp. 14 – 15.

23. Naisbitt, John and Patricia Aburdene. *Megatrends 2000: Ten New Directions for the 1990's* (New York: William Morrow and Co., 1990).

24. Balfe, Judith Huggins. "The Baby-Boom Generation: Lost Patrons, Lost Audience?" from Wyszomirski, Margaret Jane and Pat Clubb, eds. *The Cost of Culture: Patterns and Prospects of Private Arts Patronage* (New York: ACA Books, 1989).

25. See, for example, Stacey, Ralph D. *Managing the Unknowable: Strategic Boundaries Between Order and Chaos in Organizations* (San Francisco, Calif.: Jossey-Bass Publishers, 1992).

Institutions Under Pressure

THE AGE OF AUDIENCE

A little sympathy for the Baby Boomers, please. Bad enough to have shouldered such a silly moniker and then, too, for half a century, to have one's collective statistics poked and prodded into demographic studies and media forecasts. Now, as members of this truly ubiquitous generation turn fifty, they hear the tssk-tssks of sociologists speculating on their impact—or lack thereof—on the performing arts.

"Aging Audiences Point to Grim Arts Future," *The New York Times* pronounced on its front page, after examining *Age and Arts Participation with a Focus on the Baby Boom Cohort: 1982–1992*, a study prepared for the National Endowment for the Arts and released to the press two months before its publication date. *Tribulations of the Not-So-Living Arts*, the newspaper of cultural eminence continued a week later. And whence come these tribulations? From the habits of Baby Boomers and their children, according to the study that tracked attendance for seven art forms in 1982 and a decade after, using information gained from the U.S. Census. Though the study found evidence of rising attendance rates for museums, its implications for the symphony orchestra were sobering. Audiences are declining for every age under 50, it concluded, while the number of non-concertgoers rises.

"If these trends continue, the future is grim, and what disturbs me is there's so much denial out there," says Judith Huggins Balfe, co-author of one of two studies that were combined for the NEA report. Sociologists usually avoid giving advice, Balfe says, though it's clear she believes orchestras must "pay attention to who is *not* in your audience: Outreach, outreach, outreach!"

Advice is cheap, and demographics are not infallible. As might be expected, the study hit orchestra leaders like a lead balloon. But the denial Balfe deplores is not much in evidence among them, and many orchestras are taking steps to accommodate their evolving audiences.

Initiatives like New Connections are making return guests of first-time visitors to the Los Angeles Philharmonic. This orientation series includes a tour of the music center, dinner, and informal discussions before and after the

performance. The Philharmonic is also seeking new listeners via its Symphonix World Wide Web site. Several dozen orchestras now offer Web access, including the New York Philharmonic and San Francisco Symphony. Cyber-outreach and unconventional programming are being tested for an Oregon Symphony project titled LIVE ("Live, Interactive, Visionary, Eclectic"). Executive Director Joseph Horowitz's leadership at the Brooklyn Philharmonic has brought the revamping of its regular subscription series to accommodate themed concert events that attach films and lectures to weekend concerts. Innovative programs such as "East Meets West," showing the influence of the Orient on Western music, and "From the New World," exploring Antonin Dvorák's use of the American musical vernacular, are being packaged and shared with other orchestras—a strategy echoing the co-productions of the opera world.

Websites, focus groups, novel programming, accelerated not-for-children-only education programs, super-segmented marketing—the orchestra field is trying "lots of things to make connections," notes Henry Fogel, president of the Chicago Symphony Orchestra. "I absolutely agree that we must go after the non-participants," Fogel says, using the research lingo of the NEA report. But he adds, "I'm a little frustrated that [the study] is being taken as gospel. We've got lots of people in our audiences who are under fifty and even under forty."

BEHIND THE BOOM

Demographics aren't just numbers, of course. "They're attitudes, patterns, psychocultural behaviors," points out Fred Miller, a Bostonian who specializes in change management and helping corporations accommodate the changing lifestyles and mindsets of the generations born from 1946 to 1965 (the so-called Boomers) and from 1974 to the present (which Miller dubs the Baby Boomlet). "The first thing you have to remember is that these are big cohorts," he says, using the demographic term for groups of people born and socialized together and assumed to have some behaviors in common. Some eighty million strong, Boomers account for roughly one-third of the country's total population of 264 million. (The Boomlet numbers around seventy-two million).

Whizzing along cyberhighways, society is changing—and with staggering velocity. How could its institutions not change, too? The orchestra's mission is evolving, says Miller, who urges his symphony orchestra clients first to acknowledge, then "to find appropriate ways to play off these changing social dynamics."

As orchestras are learning, the Boomers were raised to be more independent than previous generations and they favor a speedy, personalized economy. Their needs come first; their needs vary. "People are staying away

for reasons of transportation and security and unfamiliarity with the Music Center," Los Angeles Managing Director Ernest Fleischmann learned during focus groups that prompted this season's New Connections programs. The series has drawn a multicultural crowd of diverse ages, and Fleischmann says he was surprised to find that "people are indicating a willingness to return several times a season and spend up to $45 an evening."

The needs of peripatetic commuters have inspired the New York Philharmonic's two-season-old Rush Hour Concerts—shorter, intermissionless weekday concerts that begin at 6:45 p.m. and have an audience out in time to catch the train back to Connecticut or Long Island.

New Connections and Rush Hour repertoire is drawn from the programs of subscription concerts. As Fleischmann notes, "We've got to do what we do best," by which he means "wonderful programs," freshly performed. Fleischmann rejects the warhorse approach to programming, often touted as an audience builder. There's too much tired repertoire that audiences don't care if they hear, and musicians don't want to perform, he says. An audience can hear the players' commitment across the footlights, just as players sense and need an audience's committed attention. Los Angeles Philharmonic Music Director Esa-Pekka Salonen and his players demonstrated this recently with an Igor Stravinsky subscription program that sold out and had audiences cheering. "And it was all symphony music—no soloist," Fleischmann says with pride.

For Marin Alsop, music director of the Concordia Chamber Symphony in Manhattan and the Colorado Symphony in Denver, fresh performances include unconventional material—cartoons, for example. Instead of a standard overture, Alsop might open with a Scott Bradley score for a Tom & Jerry cartoon that is projected in the hall as the orchestra plays. Alsop has used this attention-getter for programs of American music—Bernstein, say, or John Adams—or when she conducts the score of a Charlie Chaplin film like *City Lights*. "We do mixed-media a lot," says Alsop, who has created a mock-radio-show format for one symphonic program, and a Gospel version of Handel's *Messiah* for another.

"People aren't coming because they don't think what we're doing is relevant to their lives," says Alsop, who believes, however, that "once you build a bridge, get 'em in once or twice," newcomers will return. She thinks it's wrong and "kind of unfair to lump people together according to age: A lot of older people are excited about what we're doing," not just the forty-somethings who respond to her film evenings and cartoons. "Repertoire can be made more accessible and comfortable but still be first class. We're trying to create evenings of meaning and discovery," she says. Alsop uses the Concordia "as an incubator" for programs she repeats in Denver or at the Saint Louis Symphony Orchestra, where she is Creative Chair (a post similar to Bobby McFerrin's with the user-friendly Saint Paul Chamber Orchestra).

PODIUM TALK

Alsop, McFerrin, Salonen—these conductors and countless others are taking time out during concerts for informal talks to the audience that are increasingly viewed as audience builders. "People want to learn and they need to feel more comfortable," says Henry Fogel, whose "pet peeve is that over the last century we've made the music seem forbidding to our audiences. We've surrounded them with program notes they can't understand. There's been a sense of smugness, an in-group superiority."

One orchestra determined to break down that sense of superiority—and the conceptions of race, class, and formality that go with it—is the San Antonio Symphony, whose slogan, "The San Antonio Symphony is for you," is elaborated on the orchestra's concert hotline and emphasized in all its print and media material. Whatever your age, race, occupation, or class, says Marketing Director Covita Moroney, "we'll make sure you see yourself in our ads."

In San Antonio, podium talk is not only emphasized, it's bilingual. Music Director Christopher Wilkins, says Moroney, "loves languages and speaks several, but he accelerated his study of Spanish so that he could speak to his listeners."

San Antonio is 57 percent Hispanic, though until Wilkins's arrival five seasons ago, the orchestra's audience did not reflect a sizable portion of this population, according to Moroney. She credits Wilkins's Hispanic-sensitive concert programs and attention to inclusive marketing with a 37 percent increase in the orchestra's total audience since Wilkins became music director in 1991.

Indeed, Wilkins's efforts are gaining a reputation industry-wide. "Chris is something of a folk hero down there," says Chicago's Fogel. Wilkins is aided in his programming efforts by two Hispanic-American composers-in-residence, Alice Gomez and Edward C. Garza. One well-received Garza premiere, for example, paid homage to a *Tejano* hero as it wove a button accordion (common in traditional music of Hispanic Texans) into the symphonic texture. A spring program paired a symphony by Sibelius with a concerto for string quartet and orchestra by the Spanish-born Cuban composer Juliá Orbón, with the Cuarteto Latinamericano as guest artists.

"We're hoping that Christopher's going to put together a Latin American program for us," says the Brooklyn Philharmonic's Horowitz, who would then produce the event with his orchestra following its San Antonio premiere. This could be something along the lines of San Antonio's upcoming multimedia production with flamenco dancer Pilar Rioja. "Chris is the logical collaborator for us," says Horowitz, referring to the two orchestras' mutual

interest in creating multicultural, multi-media programs that can be shared. "Once you're doing more than a concert," he continues, "it makes sense to share costs like that of a program book; it also widens possibilities for sponsorship."

DEMOGRAPHICS AND DIVERSITY

According to Horowitz, the Brooklyn Philharmonic plays to a visibly younger, more informal, and more diverse audience than the typical orchestra. This, too, is the aim of the San Antonio Symphony. Notes Moroney: "The population bulge we see in this city is with the under-thirty Hispanics. We're [already] the way most of America will probably be in ten or fifteen years."

For most orchestras, social issues—such as the awareness of cultural diversity—have arrived belatedly. Those that intend to serve and keep new audiences, however, would do well to remember their social history. Many Boomers came of age during the tumultuous sixties, campaigned for civil rights, and championed women's issues and Gay Liberation. "Their children will be the first to fully accept mixed races and gender-bending sex roles," says change specialist Miller, noting that orchestra programming and marketing as inclusive as San Antonio's will be increasingly needed.

Henry Fogel concedes that the Chicago Symphony wasn't among the first to create a diversity initiative. But this season, he says, the orchestra's new diversity program is going ahead full steam. He cites *African Portraits* for (among other things) orchestra, chorus, African drummers, jazz quartet, vocal soloists and a griot (cantor). Fogel programmed the work by Hannibal (formerly known as both Hannibal Peterson and Hannibal Lokumbe) after experiencing a 1993 New York performance by the American Composers Orchestra at the national Conference of the American Symphony Orchestra League.

"*African Portraits* changed the composition of our audience for an entire week," Fogel enthuses. "We did four performances and a non-subscription event that was pushed in the black community. They were totally sold out. It got a screaming ovation every night."

Another multicultural event that brought in new audiences for the Chicago Symphony was "East Meets West," a program developed by Brooklyn's Joseph Horowitz. Following a full-length orchestral program that included Asian-influenced works by Ravel and Rimsky-Korsakov, an authentic gamelan orchestra came onstage to perform. "This was a very long night," says Fogel, who expected some of his audience "to get up and leave—but nobody did. They cheered. Audiences are looking for excitement, for a way to make connections."

Horowitz has overseen the creation of many such themed weekend musical encounters for his Brooklyn audience. He calls them "multi-media" because they include film, lectures, a TV monitor, and novel demonstrations. Another kind of multi-media experiment, tried recently by the Philadelphia Orchestra, played off the ubiquity of television. Video monitors were placed in the hall during a concert so that members of the audience could see close-ups of players on stage. Audience surveys were collected after the monitors' debut last winter; results were generally positive. The John S. and James L. Knight Foundation is funding Philadelphia's pilot as well as major initiatives for seven other orchestras under the rubric "The Magic of Music." Says Knight Program Executive Penelope McPhee: "We didn't get into this because of what the demographers were saying. We saw orchestras were struggling, that they weren't connecting with their audiences."

Does a television monitor in the concert hall make connections between the audience and the cello section? Is it as innocuous as screens showing plays to the stadium crowd during a baseball game? Or is it simply annoying? McPhee concedes that the Philadelphia experiment is a rather tame application of the medium. But so many orchestras were talking about trying this kind of video treatment, she says, that the foundation felt the results from an orchestra with Philadelphia's eminence would carry weight for the industry. "Everyone's struggling with television," she adds.

Other multi-media experiments were underway at the Saint Paul Chamber Orchestra, which has combined video monitors, art, dance, and narration in a new, one-hour concert format devoted to explaining and demystifying a single piece of music. The Knight Foundation has also funded Brooklyn's themed co-productions, which are called Interplays (and are also being developed for schools), and Los Angeles's Symphonix Website, whose highly interactive offerings include chat-forums with Music Director Salonen and Philharmonic players.

HIGH TECH

The Boomers teethed on television, their children on a computer mouse. No way these generations won't expect their entertainment highwired. A reminder from Fred Miller: "Boomers were the first to move from the record to the portable tape. They expect music to be portable and on-demand. They were the first to buy music labeled, 'Recorded Live.' Think about what that means, then push the boundaries further," he says, envisioning a scenario "five or six years down the road.

"I'm sitting in a hotel room in California and realize I'm not going to be able to use my Boston Symphony Orchestra tickets," Miller proposes. Figuring in Eastern Standard Time, let's say the concert will begin in a half-hour.

No problem: "I log onto the BSO website from my laptop computer, and request that my seats be exchanged for two on-line. I put on my earphones and virtual reality helmet . . . Maybe I'll decide to spend part of the concert sitting in the middle of the BSO strings. Or maybe I'll hook up with a friend in London and we'll hear the music together." (The friend will have to be a night owl given the time difference.)

"Symphony orchestras have made enormous advances, but one of the things they'll have to challenge is what it means to be in the hall. If you're wired up, are you still there?" asks Miller.

According to Grant Hiroshima, director of information systems at the Los Angeles Philharmonic and a major force behind its Symphonix Website, the technology already exists to digitize an orchestra performance from concert hall into cyberspace. But so many logistical and financial ramifications remain to be worked out, says Hiroshima, that he hesitates to give any target date for cyberconcertgoing. He implies, though, that whenever such mindbogglers are feasible, Los Angeles is likely to be among the first to try them out.

"We need symphonic music—but its delivery systems are going to change," concurs McPhee.

SEGMENTS AND SAMPLERS

If delivering a concert direct from the hall into your laptop computer is too daunting for most orchestras to consider yet, there is no doubt that most are already rethinking their twenty-first century marketing strategies, keeping in mind the attitudes and behaviors of post-war generations.

As Miller points out, "There is no mass market anymore. It's particle marketing: segments of segments. Look at your magazine stand. Can you find a mass market publication?" Miller attributes this to what he calls the "options mentality" shared by Boomers. "This group makes up its own mind and it demands choices." That's why you're seeing so many short and varied subscription series these days—the "six packs" that most orchestras rate positively. "We've got a Favorites series, a Celebrity, a Pops, and even a Build-Your-Own," says Baltimore Symphony Executive Director John Gidwitz, adding that the sampler strategy has strengthened ticket sales.

According to Miller, the next boundary to push is moving from the all-symphonic series to one that would cross arts boundaries, mixing and matching an orchestra performance with a movie, a dance event, maybe even sports. "They go to a baseball game, to line dancing, to a movie, and the symphony. This group listens to everything. Offer them a six-pack that's not all Coke."

So far, sample series geared to age, primarily singles and youth, are marketing priorities at many orchestras. Take, for instance, The Philadelphia Orchestra's ClassiXLive series, targeted to the so-called "Generation X." It consists of four non-subscription evenings, each themed (e.g. Valentine's Day,

Halloween, People's Choice) and offering a post-concert party with refreshments and live entertainment. Nineteen percent of the audiences for these events have become regular subscribers, says Marketing Director Jean Brubaker, who considers this result "hugh" in comparison to the normal three to five percent rate of return for other outreach events.

The Atlanta Symphony Orchestra is trying to capture several segments at once, but particularly family members, with its Saturday Sample Matinees. These offer free lunch before an intermissionless concert of repertoire drawn from its subscription concerts. Often a guest narrator is featured, as on a recent winter Saturday when Atlanta Braves announcer Don Sutton appeared onstage with Music Director Yoel Levi for an informal discussion-demonstration—you might call it a play-by-play—of Berlioz's *Symphonie fantastique.*

"We're doing a lot of soul-searching," Levi says of Atlanta's audience outreach, stressing that he wants to stay away from gimmicks, and wants "to concentrate on repertoire and performance, on the care and maintenance of a world-class orchestra." Levi does like the ASO's coupon book for concerts, which operates essentially as money. It's called a FlexPass and is selling well, Levi says. So is the twenty-coupon book issued by the Los Angeles Philharmonic. "PhilharMoney," as it's called, has dramatically spurred single-ticket sales, says Managing Director Ernest Fleischmann, who explains: "Subscription sales on a per-concert basis vary from 1,500 to 1,600 a concert, but we're selling 1,000 single tickets per event as a result of this PhilharMoney. It really seems to be working." According to Miller, the next marketing strategy to address Boomers' need for flexibility will be ticket sales by the equivalent of an ATM. Or maybe ticketless credit-card purchases like those now being used by some airlines. "Tickets slow down the process of change," Miller says.

"These conveniences will come. When was the last time you stood in line at the bank?" Baltimore's Gidwitz remarks. "Though I doubt the symphony will be on the cutting edge; our customers are used to more traditional methods.

"The information revolution we're experiencing is breathtaking—as fundamental as the nineteenth century's Industrial Revolution," Gidwitz continues, noting that technology's nano-second timing and "invisibility" make predictions even more foolhardy than in centuries past. "The whole world's not going to change. Many things will alter, but not everything," he cautions, reminding orchestras to play the music they believe in—to "do what we do best. Delivery systems will change. But the taste for the arts will not. They are the embodiment of the human spirit."

Victoria D. Alexander]

PICTURES AT AN EXHIBITION: CONFLICTING PRESSURES IN MUSEUMS AND THE DISPLAY OF ART[1]

INTRODUCTION

How environmental pressures impinge on organizations is an important topic in organizations research. The main themes of this literature center around environmental influence, while the problem of organizational response is somewhat more peripheral. If environments do influence organizations, then environmental effects should be apparent in organizational outcomes; however, outcomes are also shaped by internal management.

This chapter examines environmental pressures in a type of organization where the process is very vivid, in art museums. Art museums face an uncertain budget every year and must work constantly to raise funds. Museums rely on large, external donors. Further, museum exhibitions are sponsored directly by various funders, notably individual philanthropists, foundations, corporations, and government agencies. Thus, there is a very clear connection between external force (funder) and organizational output (exhibition). In this chapter, I address two main questions: (1) What is the size and direction of external funders' influence on exhibitions? (2) How do curators manage the conflict between responsiveness to funders' wishes and their own normative views about what is desirable and proper in museum exhibitions?

More specifically, I want to know how different types of funders sponsor various formats and contents of exhibitions and whether funding patterns change what goes on view in museums. In general, I expect that funders' choices of the exhibitions they sponsor will correspond to their funding goals, which I infer from the research literature on the cultural sponsorship of each funder type. I also expect that curators will try to maintain the ability to mount the prestigious, scholarly exhibitions they prefer.

To examine these questions, I created a data set of 4,026 exhibitions from large American art museums from 1960 to 1986. There are four independent variables that indicate whether an exhibition was supported by an individual, a corporation, a government agency, or a foundation. Exhibitions can be sponsored by more than one funder type. Exhibitions not supported by any of these funder types are termed "internally funded" and serve as the reference category. Dependent variables include measures of the format and content of exhibitions, indicating whether exhibitions are popular, accessible, and/or scholarly and what styles of art they contain. I first examine the association of funder and exhibition types at the level of individual exhibitions and then examine changes in the exhibition pool as a whole before and after a shift in the types of funding available to museums. The data in the analysis speak directly to the environment-output link and sidestep the curator's role. Thus, they are strong indicators of the impact of environmental pressures on organizational outputs. I will infer the curator's role from output results, from anecdotal evidence in interviews I have conducted, and from qualitative information in museums' annual reports.

I hope to refine our understanding of conflicting pressures on organizations, as well as demonstrate the usefulness of organizational theory to researchers interested in the sociology of culture. Most important, I argue that managers are actors, not just reactors, and they strive to maintain their autonomy, their normative visions, and the legitimacy of their organizations as they handle external demands. In museums, they use a variety of strategies, such as buffering, resource shifting, multivocality, innovation, and creative enactment (described below), to manage conflicting pressures.

EXTERNAL INFLUENCE ON MUSEUMS

Central to my argument is the idea that all philanthropists have goals or objectives that focus their giving. If government agencies, corporations, foundations, and elite individuals do not have the same goals, perhaps different sources of giving will encourage different types of art. In other words, the goals of external parties may structure the type of art exhibited. Museums mount exhibitions, all of which cost money. Museums are highly dependent on concentrated sources of funds for exhibitions. In order to maintain such funding, museums conform to the demands of those who supply resources— for example, they mount shows that conform to funder preferences.

Both resource dependency and institutional theories also predict that managers will react to external pressures in an attempt to maintain autonomy and control (Pfeffer and Salancik 1978; Oliver 1991). Further, institutional theorists argue that organizations make decisions based on legitimacy as well as tangible resource flows (Powell and DiMaggio 1991; Meyer and Scott 1992). Museums are highly symbolic organizations and their resources depend on

their reputations (Balfe 1987); consequently, institutional theory and resource dependency theory come together to clarify environmental influences on art museums and museums' responses.

I explore the question of how the funding environment affects the presentation of art in two ways. First, I explore how funders are linked to the format of art exhibitions, the specific methods by which art is packaged in exhibitions. Retrospectives and surveys are traditional formats of art exhibitions; blockbusters, traveling exhibitions, and theme shows are examples of nontraditional formats. Second, I examine funders' association with the artistic content of shows, the artistic styles of artworks in an exhibition. "Fine art" from the western canon of high art comprises traditional-content subjects; noncanonical works, such as works from the commercial or decorative arts, are more accessible and nontraditional exhibition subjects.

It is important to note that whatever influence funders have on museum exhibitions is more probabilistic than causal (see Lieberson 1985). Funders do not force a museum to mount any particular type of exhibition. Rather, a museum has a portfolio of exhibition types that it is willing to mount. Similarly, funders have an implicit portfolio of shows they are willing to fund. When a museum accepts external funding, the result is an increase in the number of exhibitions where the portfolios overlap. Funding increases the odds of certain ranges of exhibitions. As Becker (1982, p. 92) states, "Available resources make some things possible, some things easy, and others harder; every pattern of availability reflects the workings of some kind of social organization and becomes part of the pattern of constraints and possibilities that shapes the art produced." This image of exhibitions multiplying in the overlap of portfolios is a funding effects hypothesis. It suggests that funder preferences translate directly into exhibitions. The mechanism of the funding effect works at the level of the exhibition pool (funders disproportionally support particular types of exhibitions, increasing the prevalence of those types), rather than at the exhibition level (funders do not force museums to change individual exhibitions).

CONFLICTING PRESSURES

All philanthropists have goals or objectives that focus their giving (Dauber 1993). I argue that different goals favor different artworks. Here, I review literature on four types of funders to make predictions about types of exhibitions each funder might prefer. I focus on differences among preferences for (1) popular exhibitions, that is, exhibitions attracting broad audiences, (2) accessible exhibitions, that is, shows that are easy to understand without extensive training in art history, and (3) the traditional scholarly exhibitions, that is, those resting on solid art-historical merit and research. The first variable,

popular exhibitions, refers to the format of exhibitions. The second two, accessible and scholarly exhibitions, encompass both the format and the artistic content of exhibitions. Although many researchers and practitioners have speculated about these funders and their effects on cultural organizations, no research has systemically examined the impact of funders on museum exhibitions.[2] Let me be clear that to characterize funders, I am necessarily oversimplifying (see Alexander [1996c] for a more detailed and thorough discussion of funder preferences).

Wealthy Individuals

Individual art patrons are connoisseurs. They often love the art they sponsor and have a good deal of knowledge about it (Balfe 1993a; Robinson 1987). Further, traditional patrons are uninterested in attracting broad audiences to museums, and such wealthy philanthropists prefer smaller, narrower exhibitions, both for the safety of the objects they may have personally lent to the museum, and because they are interested in gaining status as connoisseurs of rare or esoteric works (Odendahl 1990; see also Weber 1946; Bourdieu 1984). In terms of the main exhibition variables, I expect that individuals will tend to fund scholarly exhibitions, given their knowledge of art. But as their target audience is a small, elite group (Balfe 1993b), individual funders are not likely to fund either popular exhibitions or accessible exhibitions.

Elite philanthropists are not entirely selfless as benefactors of the arts. As Odendahl (1990) argues, elite individuals tend to favor philanthropy that is beneficial especially to the upper classes. Further, the monetary value of tax incentives and the market value of art play an important role in the philanthropic decisions of wealthy collectors (Odendahl 1987b; Moulin 1987), or they are motivated by other personal goals (Dauber 1993). Along these lines, then, another goal of elite collectors is having their collections exhibited in museums so museums can conserve, appraise, store, market, or otherwise help them with the care of their art objects.

Corporations

Corporate leaders often believe that cultural philanthropy is a good way to improve corporate reputations (Galaskiewicz 1985; Useem 1985). Studies of corporate philanthropy agree that "corporate self-interest" is of leading importance when corporations decide to fund art (Useem 1987; Useem and Kutner 1986). Corporations are more interested in public relations and publicity value than they are in the art per se and tend to fund museums whose programs attract a large, appreciative, middle-class audience (Porter 1981).[3] In a study of corporate art collections, Martorella (1990) demonstrates that corporations are conservative and that they tend to collect more easily understood

pieces of contemporary art. Thus, I expect that corporations will tend to fund popular exhibitions (because they wish to reach a larger audience) and accessible exhibitions (because they are conservative, popularly oriented collectors), but will tend not to fund scholarly exhibitions.

Government

To characterize the goals of government agencies, I will discuss the two major players in the government arena: the National Endowment for the Arts (NEA) and state arts councils. The NEA is guided by the principles (in its charter) of making art available to more people and helping museums better serve the citizens of the United States. The arts panels that distribute the NEA monies are made up of arts professionals, who may have more art-historical concerns. Thus, there is a tension in the NEA between sponsoring broad, popular exhibitions and narrow, scholarly exhibitions (Galligan 1993). The NEA must balance these demands. And as DiMaggio (1991b) argues, state arts councils are not that different from the NEA. Both types of government agency have to meet similar political imperatives. An essential goal of both is self-perpetuation. To achieve this, they need to maintain their prestige and to garner supporters. Support must come from two quarters: from the art world and from the political arena. Art supporters, whose future grants are at stake, may be more active than populist supporters; on the other hand, if arts funding looks like a boondoggle for elites, government agencies are liable to come under political attack. Consequently, a judicious mix of scholarly and popular exhibitions is called for, in order for the government to retain both art and political supporters (see DiMaggio 1991b, pp. 229–30). Thus, I expect that government agencies will tend to fund popular exhibitions, scholarly exhibitions, and accessible exhibitions.

Further, government agencies are the only funders among the four types profiled that are explicitly interested in expanding audiences beyond the traditional middle and upper classes that currently consume much art (DiMaggio and Useem 1978). Education and outreach are a part of most grants given by the NEA and state arts agencies. In this respect, government is likely to sponsor art of interest to lower classes or marginalized groups, that is, nontraditional audiences. In addition, the NEA has special programs for exhibitions of work by living artists. I expect, then, that government will strongly support shows of contemporary art.

Foundations

Foundations are the forgotten funders in studies of arts support (DiMaggio 1986c, p. 113). DiMaggio (1986c) reports that foundations tend to be conservative in their funding patterns. Foundations tend to support well-established

organizations that are in the foundations' own communities. Large, visible foundations are important exceptions to this pattern, but as DiMaggio demonstrates, the few large, active, and innovative foundations are not representative of most foundations (although the exceptional, large, visible foundations may be particularly important supporters of the large, visible museums I study). DiMaggio's work suggests that foundations do not place much emphasis on audiences. This would lead to the hypothesis that foundations tend not to fund popular or accessible exhibitions. Odendahl (1987a) points out that founding families retain control over most foundations, including many large ones. Consequently, foundations may have giving preferences similar to those of elite individuals. There is little information about the preferences of foundations for art scholarship, however, so I would only tentatively suggest that foundations tend to fund scholarly exhibitions.

Curators

Museum curators are professional art historians whose prestige rests on the scholarliness and quality of their work, including the exhibitions they mount.[4] Museum curators professionalized in the 1920s and were well-established by the 1930s (DiMaggio 1991c; Meyer 1979). Museum curators were instrumental in institutionalizing a vision of museums that focused on conservation and scholarship, as opposed to such matters as education, public outreach, and exhibitions (DiMaggio 1991c; Zolberg 1974, 1981). What these art historians believe about museum integrity comes from their background and professional training. I will call the influence of these beliefs "normative forces," following DiMaggio and Powell (1983).

Curators hold advanced degrees in art history, usually Ph.D.'s (Allen 1974, pp. 137–39; Zolberg 1986), and are "object oriented" and uninterested in public education (Zolberg 1986, p. 192). In this regard, I expect that curators will like to mount exhibitions that are scholarly and will be uninterested in popular or accessible exhibitions.

Increasing Conflict

The philanthropy of elite individuals has been associated with American art museums since the end of the nineteenth century, when museums became institutionalized (DiMaggio 1982a, 1982b). In contrast, corporations did not begin to provide significant funds for the arts until the sixties (Porter 1981; Gingrich 1969). The NEA was established in 1965, and state arts councils followed shortly thereafter, as federal block grants encouraged their formation. All states had arts councils by 1967 (DiMaggio 1991b, p. 218). Since the mid-1960s, then, federal and state government agencies and corporations, along

with foundations, have increasingly funded museums (DiMaggio 1986*a*). These new funders are called "institutional funders," to distinguish them from individual philanthropists (DiMaggio 1986*a*; Crane 1987, pp. 5–9).[5]

Curators have had plenty of time to become used to the influence of individual patrons, whose interests overlap with their own (Zolberg 1986). Indeed, individual funding of museums was institutionalized before the curatorial profession solidified. But the goals of the institutional funders are not the same as those of traditional museum sponsors. Moreover, the goals of corporate and government funders conflict with normatively defined goals of museum curators. Since the preferences and biases of the institutional funders conflict with the visions already institutionalized in museums, new funding creates problems for museum personnel. Table 1 summarizes the orientation of the funders and curators, as presented in the literature.

TABLE 1

SUMMARY OF THE ORIENTATION OF STAKEHOLDERS IN MUSEUM EXHIBITIONS

	INTEREST			
	Popular Exhibitions	Accessible Exhibitions	Scholarly Exhibitions	Other Concerns
STAKEHOLDER				
Individual philanthropist . .	No	No	Yes	Own collection
Corporate funder	Yes	Yes	No	. . .
Government funder	Yes	Yes	Yes	Nontraditional audiences, living artists
Foundation funder	No	No	Yes(?)	. . .
Museum curator	No	No	Yes	. . .

MUSEUM RESPONSES

In all organizations, managers seek autonomy from demands from the external environment (Pfeffer and Salancik 1978; Meyer and Rowan 1977; Oliver 1991). Further, because they operate in an institutional environment, museum managers must maintain the legitimacy of their museums. Indeed, to the extent that external demands conflict with curators' ideas of what grants them legitimacy, they may actively resist these demands. Research on many nonprofit organizations suggests that legitimacy considerations are the key to whether managers try to deflect environmental demands (Alexander 1996*a*). Museum curators operate in a normative context where their views of art and

scholarship will shape their behavior. Along these lines, one would hypothesize that museum curators will endeavor to maintain the organization's legitimacy as they mount exhibitions. I test this possibility by examining the exhibition pool to determine whether it changes.

I have proposed a model of environmental pressures that suggests that shifts in funding will change the overall mix of exhibitions as funders disproportionally sponsor exhibitions they prefer. This model implies that museums passively accept external resources by mounting more exhibitions of the type that funders prefer. It suggests that as museums become more reliant on external funders, the exhibition pool will include more exhibitions that reflect the tastes of the funders.

This is an environmental effects hypothesis. However, museum curators may endeavor to retain both autonomy and legitimacy through two strategies: buffering and resource shifting. By "buffering," I mean a process by which organizations protect their most crucial functions by allowing changes in more peripheral areas. Museum curators may be more interested in the actual content of exhibitions (the artistic styles of the artworks themselves) than in the format in which those exhibitions are mounted (the packaging of the works, as in a traveling show). Consistent with Thompson's (1967) idea of buffering the technical core, we might expect that the format of exhibitions will change more than the content of exhibitions. In other words, if museum curators use buffering as a strategy, the exhibition pool will change more in format than in content as museums become more reliant on external funders.

By "resource shifting," I mean a process by which organizations use discretionary funds to keep the internal balance of activities as closely aligned to the ideal balance as possible. Museums may have latitude in mounting exhibitions paid for internally. It is possible that they rely on external funders to sponsor exhibitions of the sort that both curators and funders prefer. Relying on funders this way will shift the mix of externally funded exhibitions. But museums may compensate by mounting more of excluded types of exhibitions and paying for them with museum funds. Thus, the mix of internally funded exhibitions may shift in the opposite direction, with the net result that there is no change in the overall mix of exhibitions. Museum curators suggest this is true: "'Our more scholarly projects do tend to get funded internally,' admits Diana Duncan of the Smithsonian. 'If something is not a sexy project, the inside tracks are much more important. But lack of corporate sponsorship doesn't mean we don't do those things'" (Glennon 1988, p. 42). In other words, museums would like to mount certain types of exhibitions—a mix of popular, scholarly, and accessible. They endeavor to "sell" some of them to funders and mount the rest with internal funds. Over time, they may have found more exhibitions amenable to external funders but may not have

changed the mix of exhibitions they actually mount. If curators can shift re-
sources in this way, we would expect that as museums become more reliant on
external funders, the exhibition pool will not change.

DATA AND METHODS

The core data set for this study contains information on more than 4,000 ex-
hibitions mounted by fifteen large museums from 1960 to 1986. The quanti-
tative analysis is supplemented by qualitative data from museum annual
reports. I built the data set as follows: I developed a "large museum universe"
by taking the top thirty-six museums ranked by the institutions' annual ex-
penses for museum-related items in 1978. The 1978 National Center for Edu-
cation Statistics (NCES) Museum Universe Study provided operating expense
data.[6] To collect information on museums and exhibitions, I consulted annual
reports of museums in the Thomas J. Watson Library at the Metropolitan
Museum of Art in New York City, and then in the Ryerson and Burnham
Libraries at the Art Institute of Chicago. Rather than choose a sample of
museums, I attempted to gather data on every museum in the universe. Six
museums fell out of the sample when information on them was not available
in either of these central archives. Although I collected data on all exhibitions
from the annual reports available in the archives (6,337 exhibitions from thirty
museums), I limited the quantitative data set to museums for which I found
annual reports for at least 10 of the 14 time points.[7]

I began the analysis with 1960—five years before the advent of federal
funding and about five years before the time that corporations began to spon-
sor the arts—and I collected data for even-numbered years from 1960 to 1986,
creating 14 time points for each museum. This time frame begins before ma-
jor changes in funding and covers the entire period of the move toward mu-
seums' reliance on institutional funders. The start date was set before the
advent of institutional funding to provide a baseline for comparison with the
changes that occur with the addition of new types of funders. The data stop
before the recent controversy over arts funding that began with the 1989 Map-
plethorpe exhibition (Dubin 1992).[8]

I chose to study only large museums. Large museums form a conceptually
distinct population, since they play a gatekeeping role in the visual arts sector
that small museums do not (Crane 1987, chap 7). I have also chosen to focus on
museum exhibitions rather than other aspects of museums influenced by
patronage—for example, acquisitions and programs. There are several im-
portant advantages in focusing on exhibitions. Most of the public, and many
critics and art scholars, experience art through exhibitions; consequently, ex-
hibitions may be more important than acquisitions for defining art. Further,
exhibitions are under more direct control of museum personnel than are ac-
quisitions, allowing for a broader understanding of curatorial intention and

how it might be influenced externally. Finally, the mix of funding for exhibitions has changed much more than that for acquisitions. Consequently, studying exhibitions provides a greater opportunity for understanding the impact of the institutional funders on art.

I focus on temporary, special exhibitions. In contrast, permanent exhibitions are the museum's ongoing backdrop; they remain in place for years or decades and serve to anchor the viewer in the museum. Temporary or special exhibitions are mounted in galleries set aside for that purpose. These exhibitions stay in the museum for as little as a few days and as much as several months before they are disassembled.

Coding

I developed a coding scheme for exhibitions that tapped various measures of exhibition format and content. I coded each exhibition mounted by sample museums by its format, the source of the artwork the museum used in the exhibition, and the art-historical style of the art in the exhibition. I was able to identify major funders, and I coded whether the exhibition was externally funded and by which types of funder (corporate, government, foundation, individual).

I developed the coding scheme using techniques recommended by content analysis researchers (e.g., Holsti 1969; Namenwirth and Weber 1987). I used a set coding scheme that was designed to test hypotheses about the effect of funding on a range of exhibition characteristics. I pretested my coding scheme on a sample of exhibitions not included in the final analysis. In this pretest, I looked for potential areas of ambiguity and for categories that might have been overlooked in the initial scheme. From this pretest, I developed a set of coding rules that solidified coding categories. As I coded exhibitions, I kept a coding journal that allowed me to resolve ambiguities in the same direction each time.[9]

I coded exhibitions on three different measures of format: layout, traveling status, and type. The category I called "layout" classified exhibitions into standard formats such as a retrospectives, small group exhibitions, and surveys of stylistic development. Other layouts include the accessible exhibition format called the theme show, shows that are oriented toward children, and those that are a jumble of styles with no art-historical organization. I coded exhibitions as to their traveling status; traveling exhibitions appeared in and/or were arranged by other museums. Traveling shows reach a larger number of viewers than shows that appear in just one city. The variable I called "type" categorized the source of the artworks in the exhibition. The majority of exhibitions were coded as "loan exhibitions." These are exhibitions where pieces come from a variety of sources, such as the collections of patrons or

other museums (and, perhaps, the museum's own collection). A second type of show is the "blockbuster," a loan exhibition that meets several additional criteria. Blockbuster exhibitions are large-scale, mass-appeal exhibitions, designed to attract broad audiences. Blockbusters are defined in terms of reaching a large public, and are indicated for the coding by three factors: (1) the use of advance ticketing, for instance, by independent ticket agencies, (2) high attendance figures, and (3) mentions in the annual report of long lines of people waiting to get into the exhibition.[10] Other types of exhibitions include shows drawing from a museum's own collection, a patron's collection, or an artist's collection. Exhibitions were coded as coming from these collections when the collection was the sole source of exhibited works (or the source of the vast majority of them). If a patron provides only a few works, with other sources providing additional works, the exhibition is a loan show. "Patron" usually means an individual patron, but occasionally it indicates a corporation or foundation. Each exhibition is coded for each format variable; consequently, format measures in the analysis are not mutually exclusive. For instance, some, but not all, blockbusters travel.

* * *

Operationalization of Variables

The three main dependent variables are whether an exhibition is (1) popular, (2) accessible, or (3) scholarly. Popular exhibitions (those attracting broad audiences) are indicated by two variables: blockbuster shows and traveling exhibitions. Blockbuster shows attract a large audience in one venue, whereas traveling shows multiply their potential audience by the number of cities in which they appear. Both blockbuster and traveling status indicate the format of an exhibition.

Accessible exhibitions are shows that are easy to understand without extensive training in art history, and they are indicated by both format and content variables. An accessible format is the theme show. Such exhibitions are organized around a theme, rather than around a traditional art-historical category. These are shows such as *The Window in Art*, which included only paintings and drawings incorporating windows, or *A Day in the Country: Impressionism and the French Landscape*, which organized paintings by their subject matter instead of the more traditional categories such as the artist or chronology of the work.

Scholarly exhibitions are shows resting on solid art-historical merit and research. A show can be designed in a way for scholars to learn more about the art in the show. A survey, which shows the development of a style or a series of styles, and a retrospective, which shows the development of a single artist's oeuvre, are art-historically based formats for exhibitions. In terms of content,

scholarly shows are indicated by the traditional canon: the lineage of art usually covered in introductory art history courses (e.g., Janson 1986), which is now called "the history of Western art." It is composed of three style categories: classical art, European art (medieval through the nineteenth century), and modern art. Postmodern art, a conglomeration of styles that drawn on, react against, or play with the conventions of modern art, also indicates art-historical contents.

* * *

RESULTS

How do the goals of different types of funders lead to the sponsorship of different types of exhibitions? The section below explores the connections between (1) the type of funding and the format of art exhibitions, (2) the type of funding and the content of art exhibitions, and (3) indications in the exhibition pool of museum autonomy. When in the late 1960s and 1970s funding became increasingly available (DiMaggio 1986b; Crane 1987) and museums expanded (Blau 1989), museums increasingly relied on external funders, especially the new institutional funders, to support the exhibitions they mounted. The average number of exhibitions per museum sponsored by corporations, government, and foundations was level until around 1972, after which the average number increased steadily. Individual funding, stable before 1972, rose only slightly by the end of the study.

Table 2 classifies descriptive statistics for the exhibitions by the type of funder. An interesting point about Table 2 is that each funder type sponsors at least some of each exhibition format and content (with the exception of American ethnic exhibitions, which were not supported by foundations in my sample, and child- or community-oriented shows, which were not supported by individuals). But that said, it is more important to recognize the patterns of each funder, as analyzed below.

The new institutional funders have funding goals quite distinct from those of the traditional funders of museums. In addition, I cross-tabulated format and content variables by number of funders (table not shown). Two variables had notably high degrees of overlapping funding: 40% of blockbusters had multiple funders, as did 14% of traveling exhibitions. I report on the coalitions of funders for these variables below.

Format of Art Exhibitions

Funders differentially prefer various kinds of exhibitions that appear in museums; here I show this for the format, or "packaging," of art shows. This section examines the association of funder type with blockbuster and travel-

Table 2

DESCRIPTIVE DATA BY TYPE OF FUNDER: MUSEUM EXHIBITIONS, 1960–86

	No. of Exhibitions Sponsored*				No. Internally Funded†	N (Total)
	Individuals	Corporations	Government	Foundations		
Format:*						
Traveling exhibition	58	101	121	53	386	604
Blockbuster exhibition	5	25	23	15	27	57
Theme show	16	47	25	18	269	344
Art-historical exhibition	70	97	176	81	944	1,258
Patron's collection	269	26	8	19	48	346
Content:‡						
Modern	66	34	79	25	434	596
European, medieval–19th century . .	40	30	41	30	331	440
Classical	9	5	6	3	31	47
Postmodern and contemporary	16	17	44	6	100	162
American old masters	35	21	16	12	182	247
American ethnic	4	4	5	0	42	53
Asian	39	12	10	17	174	232

ing exhibitions (i.e., popular exhibitions), theme shows (accessible exhibitions), and art-historical formats (scholarly exhibitions), along with the association with patron collections.

Corporate and government entities disproportionally sponsor both traveling exhibitions and blockbuster exhibitions. The results support the hypothesis that both government and corporations fund more popular exhibitions than other funders. Foundations, which were expected to fund fewer popular exhibitions, actually funded more of them. This suggests that the large, visible foundations DiMaggio (1986c) spoke about are important for museum funding, at least concerning the sponsorship of popular exhibitions.

Both blockbuster and traveling exhibitions are funded by more than one type of funder. Government and corporations together sponsor 33.3 percent of blockbuster exhibitions, while 9.9 percent of traveling exhibitions share both corporate and government funding. Just about a quarter of blockbusters are supported by a combination of corporation and foundation dollars (though only 5 percent of traveling shows are supported by this combination of funders). Similarly, just over a quarter of blockbusters are supported by government agencies and foundations (and just over 5 percent of traveling exhibitions are thus supported). No combination of institutional and individual funders together sponsored more than 3.5 percent of either traveling blockbuster exhibitions, indicating a broadening of audiences for exhibitions.

Corporations sponsor more exhibitions of accessible art, as indicated by their sponsorship of theme shows. Individuals fund fewer accessible exhibitions than other funders, as expected. Government and foundations have no statistical relationship to accessible exhibitions. Art-historical exhibitions are disproportionally favored by government and foundation donors; both sponsor more of these formats. Corporations are not associated positively or negatively with this format. Individuals, however, sponsor fewer shows that are organized along art-historical lines.

Individuals sponsor a great deal of exhibitions that are composed of their own collections. Foundations also play a role in supporting patron collection shows. Foundations represented here are most likely family foundations. Government funds disproportionally fewer patron collections—no surprise, since government does not usually own art. The finding that individuals sponsor their own collections but not scholarly or accessible show formats may indicate that individuals are connoisseurs but not scholars or educators. The finding that individuals sponsor fewer theme and art-historical formats may be artificial, however. Since individuals are strongly associated with exhibitions of their own collections, they are sponsoring a good number of exhibitions that are of a heterogeneous layout (a variety of styles not otherwise ordered), this lowers the proportion of both art-historical and theme layouts they support.

Table 2 (continued)

DESCRIPTIVE DATA BY TYPE OF FUNDER: MUSEUM EXHIBITIONS, 1960–86

Content: (continued)	No. of Exhibitions Sponsored*				No. Internally Funded†	N (Total)
	Individuals	Corporations	Government	Foundations		
Photography........................	7	20	28	11	229	282
Craft, costume, decorative, and folk ...	42	20	12	8	250	317
Commercial........................	7	12	6	5	100	124
Mixed styles.......................	55	29	20	17	304	402
Local artists.......................	7	6	9	7	180	201
Child or community oriented.........	0	4	2	2	305	312
Other styles.......................	35	45	25	28	507	611
Total by funder type................	362	259	303	171	3,171	4,026

*Format and funder type variables are not mutually exclusive

†"Internally funded" refers to exhibitions not funded by the four funder types, so this variable and the category of funded exhibitions (not reported) are mutually exclusive.

‡Content variables are mutually exclusive

Content of Art Exhibitions

In addition to patterned associations with the format of exhibitions, funder type is associated with particular kinds of content. This section addresses the predicted corporate desires for accessible art, government preferences for accessible, scholarly, and ethnic art, as well as for shows of living artists, and individual patrons' desire to fund scholarly but not accessible exhibitions.

As suggested, corporations fund disproportionally fewer of the canonical styles (they are especially unlikely to sponsor modern art) and individuals and government fund more canonical styles, with individuals positively associated with exhibitions of modern and classical art and government positively associated with exhibitions of modern and European art. Foundations are not particularly associated with scholarly art.

Government sponsors a disproportional share of postmodern and contemporary art, thus supporting shows of living artists. It is interesting that government sponsors a larger share of both modern and postmodern art. Two characteristics distinguish these styles: they predominantly contain American artists, and they tend to require some art-historical training to appreciate. Government sponsors are negatively associated with additional style categories: crafts and costumes, commercial art, mixed styles, child- and community-oriented art, and other styles. With the potential exception of mixed styles, these categories all represent more accessible and nontraditional exhibition contents.

Contrary to prediction, government agencies did not tend to sponsor ethnic art. Indeed, virtually no funder sponsored art produced by nontraditional artists, as measured by the American ethnic variable. It is possible that this is not a good measure of support for minority artists. There are very few exhibitions captured here. Although I suspect that minority artists are underrepresented even in contemporary art exhibitions, it is possible that funders sponsor ethnic artists who are categorized by museums by their style, rather than in the "affirmative action" exhibitions that explicitly focus on painters and sculptors from disenfranchised groups.

Corporations fund fewer of the modern exhibitions, and it is perhaps no surprise that they sponsor more of the commercial art shows. Commercial art shows may include artworks that are actually corporate products, and they indicate more accessible contents. Corporations are not interested in children or in community shows (none of the funders are).

In addition to the modern and classical canonical styles, individuals sponsor more exhibitions of American old masters, Asian art, crafts and costumes, and mixed styles. (The last, mixed styles, largely reflects sponsorship of patron collections containing mixed styles of art). Individuals sponsor fewer shows of photography, local artists, and other styles, and they sponsored no child- or

community-oriented shows. Thus, individuals have a mixed pattern, preferring both scholarly (canonical) and accessible (American old masters and crafts and costumes) styles of exhibitions. The only style that foundations have a positive association with is Asian art. Foundations, like other funders, sponsored few child- and community-oriented exhibitions; they also sponsored no ethnic art.

Funder Pressures

The evidence here shows that corporations are more interested in audiences than in traditional art forms, as indicated by their support of popular formats, accessible formats, and accessible styles, along with their disinterest in scholarly formats and contents. Government supports popular formats but also scholarly formats, and fund only scholarly content, with an active avoidance of accessible content. Thus, it would appear that government funders tend to serve two masters: art historians who care about art scholarship, and middle-class audience who attend large, popular exhibitions. Government appears not to focus on disenfranchised, marginalized, or other nontraditional groups in museums, perhaps because these groups cannot give political, economic, or cultural capital either to museums or to government funders. Foundations parallel government funders in supporting both popular and scholarly formats but do not mimic individual sponsors in their effects. Individual patrons are uninterested in popular formats, actively shun accessible formats, but at the same time sponsor fewer art-historical formats. Individual sponsors fund both canonical styles and accessible styles, and overwhelmingly support their own collections, legitimating their own, elite tastes. Note that individuals and government agencies—those funders who claim to judge exhibitions using some measure of artistic scholarship—fund fewer exhibitions in the category other styles. It is interesting that of corporate sponsorship in the other category, the lion's share is in the subcategory "other" (table not shown). Styles that were classified in the subcategory "other" were so classified precisely because they did not fit in well with traditional and contemporary classifications.

In general, institutional funders are especially associated with blockbusters and traveling exhibitions, important types of mass-appeal, broad-audience, and wide-exposure shows. Government may attempt to reach more geographically diffuse audiences by sponsoring traveling shows, and corporations increase audience size and name recognition by sponsoring more broadly based exhibitions. The overlap in government, corporate, and foundation sponsorship of such exhibitions suggests that, along the audience dimensions, institutional patrons have similar goals.

Museum Autonomy

To test for funder effects on the exhibition pool, I divided the sample into two periods, 1960–72 and 1974–86. This division separates the time that institutional funders were not prevalent in the museum environment from the time that institutional funders were more prevalent. The format of exhibitions has changed substantially in the latter period. Popular formats (blockbuster and traveling exhibitions) increase, as do accessible formats (theme exhibitions) and scholarly formats (art-historical exhibitions). Patron collections decrease as a proportion of the total.

In terms of content, exhibitions of classical art, postmodern and contemporary art, photography, and other styles have increased. Shows of local artists, exhibitions of children's art, and community-oriented shows have also declined significantly. Mixed exhibitions have declined, although this occurs as a result of the decline in patron collections, as these two categories overlap. Nevertheless, the content seems to have changed less than the format, which lends support to the idea that museum curators have some autonomy and discretion in choosing exhibitions.

That exhibitions of postmodern and contemporary art have increased is not surprising, as postmodern styles are new during the period studied. As we have seen, however, government funds a great deal of these types of art. Although one would expect there to be more postmodern and other contemporary styles in museums as these styles are invented, it is not possible to know whether the availability of government money has increased the proportion of these styles in museum exhibitions more than would have occurred without such funding.

The big losers seem to be local artists, although it is possible that museums exhibit local artists under the rubric of "contemporary art" during the later period. It is interesting that exhibitions that are mounted less frequently are mostly of contents that have been peripheral to museums (e.g., children's art). Indeed, these contents may represent an old style of community-outreach exhibitions: small, local, child- or community-oriented, unfunded exhibitions. The current way to exhibit art that may draw a similar middle-class audience is through popular and accessible formats (rather than content) that are also—notably—large, visible, and funded.

Contents that are mounted more frequently appear to be more accessible styles, though not all the change seems to be associated with funding. For instance, photography, generally an accessible style, has increased as a proportion of the exhibition pool. It is interesting that individual philanthropists sponsored disproportionally fewer photography exhibitions. Corporations, foundations, and government agencies all sponsored some photography

exhibitions, but not out of proportion to such exhibitions mounted without such sponsorship.

Interpretation

Why have funder preferences translated into changes in format but not in content? I argue that curators use a combination of buffering and resource-shifting strategies to maintain their own interests in exhibitions. The fact that the content of the exhibition pool does not change much after the advent of the institutional funders suggests that museums may retain autonomy from their environment through a strategy of resource shifting. They may sell exhibitions they want to mount, but which also have funder appeal to external grantors, and may then use resources leftover to mount exhibitions that also appeal to curators but not to funders.

The research demonstrates that museums are faced with pressures for increasing popularity and accessibility of art exhibitions. However, museums have not responded, in general, by mounting masses of low-quality but popularly appealing shows. This is because museums must maintain their legitimacy as houses of high culture. I suggest that curators allow the format to change more, to protect the core of museums—shows containing a variety of artistic contents.

Resource shifting may be an important strategy for donative nonprofit organizations (Alexander 1996a). For instance, in a study of donors to a university, Stout (1992) found that university officials used internal and unspecified grant funds to subsidize departments underfunded by external entities, reducing the disparity between them and more richly supported departments.

The evidence I have for resource shifting is more anecdotal than systematic; consequently, this interpretation is tentative, and more research will be needed to understand the phenomenon. I conducted interviews with museum directors, curators, and educators as part of the larger study from which this article is drawn. I did not ask the respondents about resource shifting or their strategies for avoiding external influence; rather, I asked how exhibitions were funded and what influences funders might have on museums and exhibitions. Nevertheless, some of what the curators said supports my contention that museum managers react strategically to environmental pressures. For instance, the director of a large, encyclopedic museum told me that funding in the museum is a "matching process." Curators plan exhibitions that then "go looking" for funding. At the same time, the development department tries to find funding possibilities then look for exhibitions curators are planning. This process has some affinities to the garbage can decision model (Cohen, March, and Olsen 1972). The director, however, keeps a general mix in the exhibition schedule, which is planned several years in advance: "I try to shape shows on a yearly basis. That is, strike a balance between large and small shows, shows

with a broad audience and those with a small audience, those [shown only in the museum] and those for outside travel." Funding usually happens after these decisions are made. In a telling setback, the museum found itself short of funding (and time) for a Chagall exhibition. The museum managers had anticipated easily obtaining support for the show and were quite surprised when several possible funders turned them down. But the show went on as scheduled, and the museum used an internal source for underwriting the show: They charged a hefty fee for the opening dinner.

A curator in a second museum avoided funder pressures by avoiding funding. The modern art department he ran did not pursue corporate funds, but as a result, also did not mount major exhibitions in modern art and had reduced opportunity for scholarship published in the catalogs that accompany such exhibitions. The curator said to me: "It's a tradeoff. Contemporary art here is a low-budget operation. It was a very conscious trade off."

In addition, my reading of the annual reports of thirty museums suggests two other strategies museums use to retain autonomy: "multivocality" and a related strategy, "creative enactment," both of which require innovation on the part of the museum personnel. By multivocality, I refer to programs or activities that have many facets, and therefore, the ability to appeal to a variety of stakeholders. Museums have mounted many more shows that are multivocal—that appeal to different audiences on different levels. Museum curators innovate to find art that is both accessible and can be viewed with a critical eye. Since corporate funders of large, traveling blockbusters may be less interested in the art, per se, than they are in the press coverage, some writers have argued that blockbusters are just low-quality pabulum designed to bring in mindless crowds (Balfe 1987). It is important to recognize, however, that many blockbuster and traveling exhibitions solve the problems posed by multiple stakeholders pressing for different sorts of exhibitions. Curators, along with NEA panels, are interested in the art-historical merit of exhibitions. These stakeholders often have input into popular exhibitions. Popular exhibitions, especially blockbusters, attract large, middle-class audiences, many of whom are not particularly schooled in the intricacies of art history. Along these lines, popular exhibitions also attract corporate sponsors. The resources of a large, traveling, blockbuster exhibition, however, can also finance scholarly advantages: well-researched and nicely designed exhibitions often (1) bring together a large number of objects from overseas museums, objects that have not been seen together before, or objects that have not been seen in the United States, (2) publish blockbuster catalogues, full of new scholarly analyses alongside the pretty reproductions, and (3) provide an opportunity to conserve and repair artworks, obtain display cases, or otherwise improve a museum's holdings. That some blockbuster exhibitions can have a scholarly component points to the ability of curators to use funding to meet their own ends.[11]

For instance, a traveling exhibition appearing at the Art Institute of Chicago offered a valuable scholarly opportunity to its curators and allowed an added local interpretation that pleased community elites: "The superb survey of 'Master Drawings by Picasso,' organized by the Fogg Art Museum, gave us both an insight into the private decisions behind many of the artist's public statements and a better understanding of how works from the Institute's superb holdings and those of a number of private Chicago collections—which were added to the Chicago showing—related to his entire oeuvre" (Art Institute of Chicago, 1980–81, p. 10). The exhibition also provided a scholarly and beautiful catalog and attracted quite a few Chicago viewers. In addition to the Fogg, this show also traveled to the Philadelphia Museum of Art; the exhibition was supported by the NEA, the Ministry of Foreign Affairs of Spain, and the Alsdorf Foundation, as was the catalog, which mentioned each of the 102 objects displayed in the show (and also included an addendum on items appearing at only one venue). The exhibition was indemnified by the Federal Council on the Arts and Humanities.

Museum managers innovate to find multiple uses for available funding as well as to mount mutivocal exhibitions. The Fine Arts Museums of San Francisco used a strategy that "was creative, fulfilling needs beyond those of the immediate exhibit" (Fine Arts Museums of San Francisco, 1983–85, p. 13). The museum expanded its temporary exhibition space to accommodate a large traveling blockbuster—art from the Vatican. Funds for the gallery expansion came from donations supporting the special show. The Vatican show was installed in the special exhibition galleries and the newly created space. After the exhibition was over, the American galleries, which were adjacent to the temporary exhibition rooms, claimed the new space and American works were installed there.

To define "creative enactment," I draw on Weick's (1979) concept of an enacted environment. Weick argues that people in organizations actively construct their environment through the sense-making process people use to order all reality. To enact is to bring imagined things to life. Here, I wish to say that managers who extend the possibilities of their environment beyond the standard limits are creatively enacting their environment. Museum managers appear to creatively enact their environment as they seek external funding. They may think of clever ways to attract funding for an exhibition they wish to mount by appealing to an interest a corporation might have that is not ordinarily associated with art. For instance, the Philadelphia Museum mounted an exhibition of seventeenth-century Dutch art sponsored by Mobil Oil, which owns offshore drilling rigs in Dutch waters. Theme exhibitions sometimes have theme sponsorship. For instance, Polo/Ralph Lauren sponsored the show titled *Horse and Man*, filled with hunting pictures, other canvases of people and horses, and hunting apparel (see Silverman 1986). *Undercover Agents: Antique Undergarments from the Costume Collection of the*

Fine Arts Museums of San Francisco, was supported by Victoria's Secret, the lingerie firm. Folger's has sponsored a traveling exhibitions of its silver coffee pot collection. And Fisher-Price Toys underwrote *Jouets Américains*, an exhibition of American toys, organized by the Musée des Arts Décoratifs in Paris, which toured the United States.

Museums continue to mount exhibitions of more esoteric art, past and present, but these shows tend to be funded by museum sources, sometimes supplemented by government grants, rather than by the combination of government and corporate monies that support the more popular exhibitions. For instance, in 1987 the San Francisco Museum of Modern Art started a program for small, flexible exhibitions that would complement its main program of larger exhibitions that are planned well ahead. An auxiliary group, the Collector's Forum (in this study, considered an internal funder) supported the program, which was later also subsidized by the NEA: "The *New Work* concept was to give the Museum a program that could be reasonably nimble in responding to new ideas and opportunities, in contrast to a large museum's usual scheduling, which occurs several years in advance. It consists of a series of five or six serious but modestly scaled projects annually that are intended to provide West Coast museum audiences with a timely opportunity to see and consider some of the most interesting and important artistic accomplishments—regional, national, and international—of the day, by both younger and established artists" (San Francisco Museum of Modern Art 1988, p. 11). This may suggest that unfunded exhibitions represent true curator desires. Although curators most likely value exhibitions that are internally funded (they would not be mounted otherwise), curators may equally value at least some of the funded exhibitions. Further, if museums plan ahead and shift resources, then it is important to recognize that to a considerable degree, unfunded exhibitions should be seen as a residual category, not just as art for curators' sake.

Nevertheless, funding has clearly encouraged museums to mount shows accessible to broad audiences. This has been the big change in museums in the past two decades (Alexander 1996c). It is important to recognize, however, that the situation in museums today is not a result only of constraints imposed by the new funders. Instead, a different set of funders (and attached opportunities, as well as constraints) has come to rival an older set of funders: the institutional funders versus the traditional philanthropists. Museums have always mounted popular and accessible exhibitions (see Coleman 1939; Meyer 1979; and Zolberg 1974); today these "middlebrow" exhibitions take the form of funded blockbusters, traveling exhibitions, and theme shows, rather than unfunded community-outreach contents.

Still, this new emphasis on blockbusters, theme exhibitions, and popular subject matter does not make most curators happy (McGuigan 1985). They often assert that corporations and government have distorted the types of

shows that museums put on. A general theme among curators (but not among museum directors) is a belief that corporations especially constrain and flaw exhibitions. However, museums clearly have some discretion in balancing large, crowd-drawing exhibitions with much smaller ones that lack external support. Museums attempt to balance mass-appeal shows and smaller, more academic shows. Indeed, I believe that the new funders have given curators more freedom than they have had in the past. One piece of evidence for this is the increase in art-historical formats of exhibitions. If museums are primarily funded by wealthy, elite donors, then curators are limited by the ability and desire of those patrons to fund their ideas. Additional funders create more options. Each type of funding has its own limits, but now there are several types of limits from which to choose. Nonetheless, questions of discretion and constraint are analytically complex. Clearly, even if curators are free to choose within a set of possibilities, the universe of possibilities is determined by funding.

DISCUSSION

These results suggest that the type of funding has important influences on art exhibitions. Funders sponsor certain types of exhibitions, although they have a lesser influence on the overall mix of exhibitions because curators engage in buffering and resource shifting, mount multivocal exhibitions, and creatively enact their environment to maintain autonomy and their vision of museum legitimacy. Even so, museums mount a larger share of exhibitions in popular formats now than they have in the past.

*　　*　　*

Organizations and the Sociology of Culture

Sociologists have come to understand that art is not produced in a vacuum. Social and production features of arts distribution channels have perhaps as much or even more influence on the content of art as aesthetic criteria. Researchers have proposed a variety of mechanisms that shape art. These include filtering by gatekeepers (Hirsch 1972), industry competition, which stifles or encourages creativity (Peterson and Berger 1975), legal incentives, which favor certain styles or genres of art (Griswold 1981), and popularizing effects of market systems in contrast to patronage systems (DiMaggio and Stenberg 1985). All of these effects are organizational: the mundane, daily actions of decision makers acting in contexts such as a concentrated industry or a patronage system profoundly shape the art that constitutes that organization's output. Thus, to understand art, we must study the organizations that produce, distribute, or create it.

This article focuses on major American art museums, key organizations in the fine arts distribution system. The main focus of the article is how types of funding are related to the presentation of art. I study the exhibitions produced by museums and determine how external funding arrangements shape these exhibitions. Strategic institutional theory provides the frame for understanding the pressures funders exert on museums and to understand the museums' response. More specifically, the research provides a model of how funding arrangements affect art. Museum funders provide opportunities to museums, which museums are free to accept or reject. Funders do not force museums to change exhibition policy. Nevertheless, funders have a general idea of the types of exhibitions they wish to fund, and museums have ideas of exhibitions they would like to mount. More exhibitions happen where these areas overlap. Such opportunity-providing institutions stand in contrast to more frequently studied (and opportunity-reducing) gatekeeping institutions.

Art is a social product, and what is seen in museums is an important component of what art becomes institutionalized in the canon (Crane 1987; Danto 1987; Williams 1981). To the extent that museums legitimate and signal current definitions of the artistic canon, museum exhibitions influence artistic boundaries. Along these lines, the research suggests that art is shaped by mundane organizational processes. The research suggests as well that funder pressures for accessibility are mainly handled by changes in exhibition formats, and because of the actions of professional museum curators, the basis for inclusion of artworks in exhibitions remains art-historical merit, rather than popularity.

APPENDIX A

Museums and Time Points in Sample
(Even Years Only)

Art Institute of Chicago, 1960–86
Brooklyn Museum, 1960–72, 1980–84
Cincinnati Art Museum, 1960–82
Cleveland Museum, 1960–80, 1984–86
Detroit Institute of Art, 1960–86
Metropolitan Museum of Art, 1960–86
Museum of Fine Arts, Boston, 1966–84
Museum of Modern Art, 1960–86
National Gallery, 1966–84
Philadelphia Museum of Art, 1960–84
Saint Louis Art Museum, 1960–78, 1984–86
Toledo Museum of Art, 1960, 1964, 1968–86

Wadsworth Atheneum, 1960–86
Whitney Museum, 1960–74, 1978–82
Yale Art Gallery, 1960, 1966–78, 1982–86

REFERENCES

Alexander, Victoria D. 1996a. "Environmental Constraints and Organizational Strategies: Complexity, Conflict, and Coping in the Nonprofit Sector." In *Private Action and the Public Good*, edited by Walter W. Powell and Elisabeth Clemens. New Haven, Conn.: Yale University Press.

———. 1996b. "From Philanthropy to Funding: The Effects of Corporate and Public Support on American Art Museums." *Poetics: Journal of Empirical Research on Literature, the Media and Arts*, vol. 23.

———. 1996c. *Museums and Money: The Impact of Funding on Exhibitions, Scholarship, and Management*. Indianapolis: Indiana University Press.

Allen, Barbara Jacobsen. 1974. "Organization and Administration in Formal Organizations: The Art Museum." Ph.D. dissertation. New York University.

Art Institute of Chicago. 1980–81. *Annual Report*.

Balfe, Judith Huggins. 1987. "Artworks As Symbols in International Politics." *International Journal of Politics, Culture, and Society* 1:195–217.

———. 1993a "Art Patronage: Perennial Problems, Current Complications." Pp. 306–23 in *Paying the Piper: Causes and Consequences of Art Patronage*, edited by Judith Huggins Balfe. Urbana: University of Illinois Press.

———. 1993b "'Friends of . . . ': Individual Patronage through Arts Institutions." Pp. 119–33 in *Paying the Piper: Causes and Consequences of Art Patronage*, edited by Judith Huggins Balfe. Urbana: University of Illinois Press.

———, ed. 1993c *Paying the Piper: Causes and Consequences of Art Patronage*. Urbana: University of Illinois Press.

Becker, Howard S. 1982. *Art Worlds*. Berkeley and Los Angeles: University of California Press.

Benedict, Stephen, ed. 1991. *Public Money and the Muse: Essays on Government Funding for the Arts*. New York: Norton.

Blau, Judith R. 1989. *The Shape of Culture: A Study of Contemporary Cultural Patterns in the United States*. New York: Cambridge University Press.

Bourdieu, Pierre. 1984. *Distinction: A Social Critique of the Judgement of Taste*, translated by Richard Nice. Cambridge: Harvard University Press.

Cohen, Michael, James G. March, and Johan P. Olsen. 1972. "A Garbage-Can Model of Organizational Choice." *Administrative Science Quarterly* 17:1–25.

Coleman, Lawrence Vail. 1939. *The Museum in America: A Critical Study*. Washington: American Association of Museums.

Crane, Diana. 1987. *The Transformation of the Avant-Garde: The New York Art World, 1940–1985*. Chicago: University of Chicago Press.

Danto, Arthur C. 1987. *The State of the Art*. New York: Prentice-Hall.

Dauber, Kenneth. 1993. "The Indian Arts Fund and the Patronage of Native American Arts." Pp. 76–93 in *Paying the Piper: Causes and Consequences of Art Patronage*, edited by Judith Huggins Balfe. Urbana: University of Illinois Press.

DiMaggio, Paul J. 1982a. "Cultural Entrepreneurship in Nineteenth-Century Boston: The Creation of an Organizational Base for High Culture in America." *Media, Culture, and Society* 4:33–50.

———. 1982b. "Cultural Entrepreneurship in Nineteenth-Century Boston, Part II: The Classification and Framing of American Art." *Media, Culture, and Society* 4:303-22.

———. 1986a. "Introduction." Pp. 3–13 in *Nonprofit Enterprise in the Arts: Studies in Mission and Constraint*, edited by Paul DiMaggio. New York: Oxford University Press.

———. 1986b. "Can Culture Survive the Marketplace?" Pp. 65–92 in *Nonprofit Enterprise in the Arts: Studies in Mission and Constraint*, edited by Paul DiMaggio. New York: Oxford University Press.

———. 1986c. "Support for the Arts from Independent Foundations." Pp. 113–39 in *Nonprofit Enterprise in the Arts: Studies in Mission and Constraint*, edited by Paul DiMaggio. New York: Oxford University Press.

———, ed. 1986d. *Nonprofit Enterprise in the Arts: Studies in Mission and Constraint*. New York: Oxford University Press.

———. 1988. "Interest and Agency in Institutional Theory." Pp. 3–21 in *Institutional Patterns and Organizations: Culture and Environment*, edited by Lynne G. Zucker. Cambridge, Mass.: Ballinger.

———. 1991a. "The Museum and the Public." Pp. 39–50 in *The Economics of Art Museums*, edited by Martin Felstein. Chicago: University of Chicago Press.

———. 1991b. "Decentralization of Arts Funding from the Federal Government to the States." Pp. 216–56 in *Public Money and the Muse: Essays on Government Funding for the Arts*, edited by Stephen Benedict. New York: Norton.

———. 1991c "Constructing an Organizational Field as a Professional Project: U. S. Art Museums, 1920–1940." Pp. 267–92 in *The New Institutionalism in Organizational Analysis*, edited by Walter W. Powell and Paul J. DiMaggio. Chicago: University of Chicago Press.

DiMaggio, Paul J., and Walter W. Powell. 1983. "The Iron Cage Revisited: Institutional Isomorphism and Collective Rationality in Organizational Fields." *American Sociological Review* 48:147–60.

———. 1991. "Introduction." Pp. 1–38 in *The New Institutionalism in Organizational Analysis*, edited by Walter W. Powell and Paul J. DiMaggio. Chicago: University of Chicago Press.

DiMaggio, Paul J., and Kristin Stenberg. 1985. "Why Do Some Theatres Innovate More than Others?" *Poetics* 14:107–22.

DiMaggio, Paul J., and Michael Useem. 1978. "Social Class and Arts Consumption: The Origin and Consequences of Class Differences in Exposure to the Arts in America." *Theory and Society* 5:141–61.

Dobbin, Frank. 1994. *Forging Industrial Policy: The United States, Britain, and France in the Railway Age*. New York: Cambridge University Press.

Dubin, Stephen C. 1991. *Arresting Images: Impolitic Art and Uncivil Actions*. New York: Routledge.

Feld, Alan L., Michael O'Hare, and J. Mark Davidson Schuster. 1983. *Patrons Despite Themselves: Taxpayers and Arts Policy*. New York: New York University Press.

Feldstein, Martin, ed. 1991. *The Economics of Art Museums*. Chicago: University of Chicago Press.

Fine Arts Museums of San Francisco. 1983–85. *Report*.

Frey, Bruno S., and Werner W. Pommerehne. 1989. *Muses and Markets: Explorations in the Economics of the Arts.* Oxford: Blackwell.

Galaskiewicz, Joseph. 1985. *Social Organization of an Urban Grants Economy: A Study of Corporate Contributions to Nonprofit Organizations.* New York: Academic Press.

Galligan, Ann M. 1993. "The Politicization of Peer-Review Panels at the NEA." Pp. 254–72 in *Paying the Piper: Causes and Consequences of Art Patronage*, edited by Judith Huggins Balfe. Urbana: University of Illinois Press.

Gingrich, Arnold. 1969. *Business and the Arts: An Answer to Tomorrow.* New York: Eriksson.

Glennon, Lorraine. 1988. "The Museum and the Corporation: New Realities." *Museum News* 66 (3): 36–43.

Griswold, Wendy. 1981. "American Character and the American Novel: An Expansion of Reflection Theory in the Sociology of Literature." *American Journal of Sociology* 86:740–65.

Hirsch, Paul M. 1972. "Processing Fads and Fashions: An Organization-Set Analysis of Cultural Industry Systems." *American Journal of Sociology* 77:639–59.

Holsti, Ole R. 1969. *Content Analysis for the Social Sciences and Humanities.* Reading, Mass.: Addison-Wesley.

Janson, Anthony F. 1986. *History of Art*, 3d ed. New York: Abrams.

Jepperson, Ronald L. 1991. "Institutions, Institutional Effects, and Institutionalism." Pp. 143–63 in *The New Institutionalism in Organizational Analysis*, edited by Walter W. Powell and Paul J. DiMaggio. Chicago: University of Chicago Press.

Lieberson, Stanley. 1985. *Making It Count: The Improvement of Social Research and Theory.* Berkeley and Los Angeles: University of California Press.

Lowry, W. McNeil, ed. 1984. *The Arts and Public Policy in the United States.* Englewood Cliffs, N.J.:Prentice-Hall.

Martorella, Rosanne. 1990. *Corporate Art.* New Brunswick, N.J.: Rutgers University Press.

———, ed. 1996. *Art and Business: An International Perspective on Sponsorship.* Westport, Conn.: Greenwood, in press.

McGuigan, Cathleen, with Shawn Doherty, Janet Huck, and Maggie Malone. 1985. "A World from Our Sponsor: Increasing Ties between Big Business and the Art World Raise Some Delicate Questions." *Newsweek*, November 25, pp. 96–98.

Meyer, John W., and Brian Rowan. 1977. "Institutionalized Organizations: Formal Structure as Myth and Ceremony." *American Journal of Sociology* 83:340–63.

Meyer, John W., and W. Richard Scott, eds. 1992. *Organizational Environments: Ritual and Rationality*, 2d ed. Beverly Hills, Calif.: Sage.

Meyer, John W., W. Richard Scott, and Terrence E. Deal. 1983. "Institutional and Technical Sources of Organizational Structures: Explaining the Structure of Educational Organizations." Pp. 45–67 in *Organizational Environments: Ritual and Rationality*, edited by John W. Meyer and W. Richard Scott. Beverly Hills, Calif.: Sage.

Meyer, Karl E. 1979. *The Art Museum: Power, Money, Ethics.* New York: Morrow.

Moulin, Raymonde. 1987. *The French Art Market: A Sociological View*, translated by Arthur Goldhammer. New Brunswick, N.J.: Rutgers University Press.

Namenwirth, J. Zvi, and Robert Philip Weber. 1987. *Dynamics of Culture.* Boston: Allen & Unwin.

Netzer, Dick. 1978. *The Subsidized Muse: Public Support for the Arts in the United States.* New York: Cambridge University Press.

Odendahl, Teresa. 1987a. "Foundations and the Nonprofit Sector." Pp. 27–42 in *America's Wealthy and the Future of Foundations*, edited by Teresa Odendahl. New York: Foundation Center.

———. 1987b. "Independent Foundations and Wealthy Donors: An Overview." Pp. 1–26 in *America's Wealthy and the Future of Foundations*, edited by Teresa Odendahl. New York: Foundation Center.

———. 1990. *Charity Begins at Home: Generosity and Self-Interest among the Philanthropic Elite*. New York: Basic.

Oliver, Christine. 1991. "Strategic Responses to Institutional Processes." *Academy of Management Review* 16:145–79.

Orrù, Marco, Nicole Woolsey Biggart, and Gary G. Hamilton. 1991. "Organizational Isomorphism in East Asia." Pp. 361–89 in *The New Institutionalism in Organizational Analysis*, edited by Walter W. Powell and Paul J. DiMaggio. Chicago: University of Chicago Press.

Peterson, Richard A., and David G. Berger. 1975. "Cycles in Symbol Production: The Case of Popular Music." *American Sociological Review* 40:158–73.

Pfeffer, Jeffrey, and Gerald R. Salancik. 1978. *The External Control of Organizations: A Resource Dependence Perspective*. New York: Harper & Row.

Porter, Robert, ed. 1981. *A Guide to Corporate Giving in the Arts*. New York: American Council for the Arts.

Powell, Walter W. 1991. "Expanding the Scope of Institutional Analysis." Pp. 183–203 in *The New Institutionalism in Organizational Analysis*, edited by Walter W. Powell and Paul J. DiMaggio. Chicago: University of Chicago Press.

Powell, Walter W., and Paul J. DiMaggio, eds. 1991. *The New Institutionalism in Organizational Analysis*. Chicago: University of Chicago Press.

Robinson, Rick E. 1987. "Why *This* Piece? On the Choices of Collectors in the Fine Arts." Paper presented at the annual meeting of the American Sociological Association, Chicago.

San Francisco Museum of Modern Art. 1988. *Annual Report*.

Scott, W. Richard, and John W. Meyer. 1991. "The Organization of Societal Sectors: Propositions and Early Evidence." Pp. 108–40 in *The New Institutionalism in Organizational Analysis*, edited by Walter W. Powell and Paul J. DiMaggio. Chicago: University of Chicago Press.

Sewell, William H. 1992. "A Theory of Structure: Duality, Agency, and Transformation." *American Journal of Sociology* 98:1–29.

Silverman, Debora. 1986. *Selling Culture: Bloomingdale's, Diana Vreeland, and the New Aristocracy of Taste in Reagan's America*. New York: Pantheon.

Stout, Suzanne Kay. 1992. "The Dynamics of Organizational Linkages: The Case of Higher Education and Philanthropy." Ph.D. dissertation. Stanford University, Graduate School of Business.

Thompson, James D. 1967. *Organizations in Action*. New York: McGraw-Hill.

Useem, Michael. 1985. *The Inner Circle: Large Corporations and the Rise of Business and Political Activity in the U.S. and the U.K.* New York: Oxford University Press.

———. 1987. "Corporate Philanthropy." Pp. 340–59 in *The Handbook of Non-Profit Organizations*, edited by Walter W. Powell. New Haven, Conn.: Yale University Press.

Useem, Michael, and Stephen I. Kutner. 1986. "Corporate Contributions to Culture and the Arts: The Organization of Giving and the Influence of the Chief Executive Officer and of Other Firms on Company Contributions in Massachusetts." Pp. 93–112 in *Nonprofit Enter-*

prise in the Arts: Studies in Mission and Constraint, edited by Paul DiMaggio. New York, Oxford University Press.

Weber, Max. 1946. "Class, Status and Party." Pp. 180–95 in *From Max Weber: Essays in Sociology*, edited by H. H. Gerth and C. Wright Mills. New York: Oxford University Press.

Weick, Karl E. 1979. *The Social-Psychology of Organizing*, 2d ed. Reading, Mass.: Addison-Wesley.

Williams, Raymond. 1981. *The Sociology of Culture*. New York: Schocken.

Zolberg, Vera L. 1974. *The Art Institute of Chicago: The Sociology of a Cultural Organization*. Ph.D. dissertation. University of Chicago.

———. 1981. "Conflicting Visions in American Art Museums." *Theory and Society* 10:103–25.

———. 1986. "Tensions of Mission in American Art Museums." Pp. 184–98 in *Nonprofit Enterprise in the Arts: Studies in Mission and Constraint*, edited by Paul DiMaggio. New York: Oxford University Press.

Zucker, Lynne G. 1991. "The Role of Institutionalization in Cultural Persistence." Pp. 83–107 in *The New Institutionalism in Organizational Analysis*, edited by Walter W. Powell and Paul J. DiMaggio. Chicago: University of Chicago Press.

NOTES

1. I would like to thank Paul DiMaggio, Peter Marsden, John Meyer, Ann Swidler, the members of FSC at Harvard/MIT (Robin Ely, Hermie Ibarra, Maureen Scully, and especially Elaine Backman) and several anonymous reviewers for their very helpful comments.
2. Interested readers should consult Balfe (1993c), Benedict (1991), DiMaggio (1986d), Feld, O'Hare, and Schuster (1983), Feldstein (1991), Galaskiewicz (1985), Lowry (1984), Martorella (1990, 1996), Netzer (1978), Odendahl (1990), and Porter (1981), for a start. The funding of museums also gets lively attention in such trade journals as *ArtNews, Art Forum*, and *Museum News*.
3. The popularity of exhibitions is extremely important to corporations. However, it is important to keep in mind that contrary to what some have argued, corporations do not want to fund mindless pabulum. Rather, the art itself must retain some legitimacy if the "halo effect"—the association of sacred art with the profane corporate name—is to work its magic (Balfe 1987).
4. Curators do not represent the entirety of museums and the decision making that goes on within them. Directors, trustees, and educational personnel are among the other important actors. Various factions of museums are often in conflict (DiMaggio 1991a; Allen 1974). I have chosen to focus on museum curators, because (1) they are directly responsible for planning and mounting exhibitions and (2) they represent traditional museum goals.
5. Institutional funders are those donors who are based in formal organizations, including government organizations and nonprofit organizations such as foundations. This terminology is a standard way of indicating such organizationally based funders; however, it has the disadvantage of implying "institution" as that term is used in institutional theory, meaning a cultural rule or schema, along with its intended sense of a collective actor or formal organization.
6. I based the sample on 1978 expenditures because (1) it was approximately in the middle of the time period and (2) the Museum Universe Survey was available in 1978. Lists of museums that include budget information are scarce. I ended up with thirty-six museums in the universe through a rather complex procedure that involved excluding museums inappropriate to the sample (e.g., those that do not mount special exhibitions) and adding large museums that were missing from the

NCES survey. The museums on this list had annual expenditures of approximately $1 million or more in 1978 (see Alexander [1996c] for further details.

7. This selection procedure further biased the sample toward large museums, as major museums were more likely to send their reports to archives like the two I visited.

8. The time frame has the advantage of not including what may prove to be a new era for museums. Controversies over the NEA and "obscene art," Reagan-era-induced cuts to federal funding of the arts, tax reform in 1986 reducing tax rates and deductions for donating art objects (both of which reduced individual contributions to museums), and a stagnant economy (which has reduced corporate giving) have made the 1990s financially difficult times for museums.

9. Coding data was a full-time effort for three and one-half months.

10. There is no established definition of a blockbuster. In the art world, some people consider blockbusters to have, by definition, corporate funding. This definition was not helpful, as it did not make sense to define away variation in one of the four independent variables, corporate sponsorship. Blockbusters can also be seen as shows that museums mount with the express purpose of attracting a large audience. My coding scheme was designed to find shows that museums planned to be large (as shown by advance ticketing) and that did reach large audiences (that had high attendance and lines). It is worth mentioning, however, that my definition leans toward discovering successful and/or unplanned blockbusters, as museums may not report the failure of shows they had hoped would appeal to a large audience but that did not draw crowds, and museums may also gleefully point out the popularity of a show that was not designed as a blockbuster. Consequently, it is important to note that my coding scheme does not necessarily come up with a perfect correlation between shows I deem to be blockbusters, based on the information in a museum's annual report, and shows that would be considered blockbusters by some other definitions.

11. Not all popular shows solve the stakeholder dilemma, however. The exhibition must contain a scholarly as well as a public component to resolve the conflicts involved and to gain art-historical legitimacy for the museum.

Making Change:
Museums and Public Life

We have been asked to speak about the cultural policy context within which museums operate; no easy question, as it turns out. Recently, I asked a panel of museum professionals at a conference in Newark what they—as working professionals—think about museums and "cultural policy." Each of them said that practice motivated them, that policy was unconsidered, and that a next set of questions for them, as professionals, should be to face the policy questions appropriate to their field. At a recent conference in Los Angeles, another panel of arts professionals spoke—ostensibly—about issues of museum policy; they spoke—actually—about issues of museum practice. Each of the panelists described recent exhibitions, or education commitments, or funded programs; none of them—as the organizer of the panel pointed out somewhat impatiently—addressed issues of policy at all.

In both instances, I was impressed by the admissions. Here were serious, dedicated specialists, running or supporting major museums in this country, who were concerned about the lack of policy substance in their world. In the last two years, as "cultural policy" has become a lively subject, the questions and comments around it are generally at a much more skeptical level—arts and humanities professionals ask, "cultural policy? What's that?" and "do we have a cultural policy in this country?" and "why do we need cultural policy?" or they quarrel about the vocabulary, the phrasing of the discussion. But museum people, many of them, have gotten beyond such questions. They are quizzical and interested; they are not defensive, and they are not dismissive of policy concerns.

I realize that I need to define what I mean by "policy." We will have many answers, tentatively offered, for this will continue to be an ongoing discussion. From my point of view, there are three aspects of "policy" relevant to cultural organizations.

The first is policy at the research level, the collection of information, data, facts, statistics which inform a field and provide the foundation for policy

formation. A year and a half ago, a national convening was held under the auspices of Columbia University's American Assembly to examine questions of the arts and the public purpose. A major finding of that Assembly is that in the arts, in all dimensions of cultural life in this country, we lack basic, consistent, coordinated information, the kind of information that is essential to the making of an informed and valued sector. Recently, major universities have begun to address this need (Princeton, Ohio State, Rutgers are examples); funders are becoming interested as well (the Pew, Gilman and MacArthur foundations, among others). A think tank, the Center for Arts and Culture, has been established in Washington, D.C. There is progress and some hope in this area of policy research. And, in fact, museums have always taken responsibility to know about themselves; they are probably among the better researched of the not-very-well researched cultural entities in the country.

A second aspect of policy, as I am using the word, lies in the formulations it makes possible, the identification of policy objectives or policy alternatives, the sorting of policy decisions which might be taken by government, private and/or not-for-profit agencies. Policy formulation is most often based on policy research, on analysis of conditions and needs, on diagnosis of the public purposes, or the economy, or equity demands, of ways to best address the conditions under which we live as citizens. Familiar questions of this kind in culture relate to tax policies, intellectual property issues, trade regulations, issues of access, funding and financing guidelines, training expectations, certification or evaluation devices. You will think of others. Such policy formulation is becoming more essential for culture. As entertainment, the commerce of communication, the new technologies, the demand for content, increase in the new century, the array of cultural policy issues to be considered, and formulated, and put to public scrutiny, also increase. This work will be based, inevitably, on the quality of the research and analysis that we have available, and on the numbers of scholars and other specialists who will devote themselves to it. Most of us recognize that the serious study of culture and its institutions is still a very small corner of intellectual life. Museums, and other cultural institutions, could usefully become more directly engaged in policy formulation, and they have a great deal to contribute. Museums, more than other cultural entities in society, have experience, some edge in the conversation. Probably historians and lawyers and urban planners, for instance, have thought more about museums than they have about dance companies or English departments, poets or philosophy.

A third area of cultural policy, what I will call policy initiative, is less external to cultural institutions themselves. Both policy research and policy formulation do consistently locate themselves at distances from most cultural institutions, including museums. Policy analysts sit at policy schools or policy

institutes, for the most part, or they work through think tanks. Policy professionals also inhabit government, law firms, planning organizations, business and consulting firms, marketing agencies, financial institutions. Most of them do not work within cultural institutions; they are external to them, and they think about them from their distances. Yet, and this is my chief point, policy is made most significantly, most powerfully, at—and by—the institutions themselves.

If this is true, it may seem ironic that the museum professionals I cited earlier, those empaneled professionals, so disarmingly bemoaned their own lack of policy engagement and understanding. It is ironic, and that irony constitutes the bulk of my message. Museum professionals have great opportunity, they are actually enlisted in the construction of cultural policy on a day-to-day basis in their very undertakings as professionals. The answer to this irony lies in practice—in the articulation of aims, the self-consciousness and deliberateness, the examination of assumptions, the dedication to ends, that should accompany museum practice at its best. Policy, in this third sense, is policy action, policy assertion through examined action. It is policy initiative.

To identify policy offerings of this third kind, the most important, cultural professionals, including museum professionals, are obliged to uncover the knowledge base, the policy base, that is inherent in institutional activity, in institutional practice. This is also no easy matter. It involves uncovering the essential ideas that connect programs and exhibitions. It involves knowing the relationships of these activities to the needs or interests of contingent communities and to the society as a whole. In uncovering the policy base that drives their institutions, cultural professionals uncover the values dimension, the true motives, the enduring mission of what they do. It is possible to build programs, to make presentations, to raise funds, to fill the walls and fill the halls and fill the cafeterias without this kind of cultural theorizing. But policy considerations matter because they can help to delineate and then to enrich the conditions within which Americans conduct their lives. Cultural policy matters because cultural institutions, including museums, have that kind of generative responsibility for the ways in which Americans learn.

In some respects, constructing policy is as inevitable as speaking prose. Policy is implicit in the rounds of daily business, in the selection of priorities—in the making of budgets—in the titles and tactics and technicalities that move us through an institutional day or month or year. At such a seemingly mundane level, questions of policy stir, just waiting to be asked. What are the fundamental contributions of these activities? Where in the collective or communal life of the society does the work fit? What are the essential connections that we are building? What is the philosophy that motivates the practice? What effects will we look back and boast about in a decade? (not an easy question to answer). How deliberate, how examined, are the institutional

lives we lead beyond the funding needs, the curatorial concerns, the mainte-
nance and marketing and management issues? What are the national pur-
poses met by the arts and humanities?

At the Rockefeller Foundation, from about 1985 forward, we built a fund-
ing program for museums that I am going to try to use as a specimen of policy
initiative. Rockefeller had not funded museums systematically before that
time, and—indeed—there are few foundations, then or now, that focus on
supporting museums. Rockefeller's interest began when officers of the foun-
dation, building new guidelines, recognized that museums bring the disci-
plines of the arts and the humanities together, making them unusually
opportune targets for a foundation devoted to both. That was a practical ob-
jective, which led us quickly to a larger rationale. Museums play major roles,
we realized, in urban and communal life; they are repositories of history and
belief, of artifacts, but also of ideas and ideals. Museums, we realized, are
durable agencies for reflecting issues and changes in the society. We wouldn't
have phrased it this way at the time, but, in fact, we were realizing that mu-
seums shape policy within the society.

We tried to build a museum program that would reinforce priorities of the
most venturesome professionals in the field. The deliberations of the officers
were structured around these questions: what does the field identify as impor-
tant? What does the foundation, given its particular history and interests,
identify as important? What sorts of interventions, what kinds of grants,
might have an impact in addressing the first two questions? We thought of
this as building a program, supporting projects at museums. We were also
constructing policy, although we did not think of what we were doing
that way.

Because Rockefeller as a whole is committed to third-world countries and
to minority Americans, officers in the arts and humanities were putting these
themes into place in their new guidelines. This was pragmatic; it aimed for a
kind of parallelism, or joint purposefulness, with other parts of the founda-
tion. But we also found ourselves moved by the real need in these areas in the
United States, at that point in time, and by the readiness of some in the mu-
seum community to undertake certain kinds of work. Again, we were evolv-
ing policy without the wit to say so. In 1989, the new museum program was
described to Rockefeller's Board of Trustees in this way:

> By and large, American art museums have focused on painting, sculpture, and
> architecture that are rooted in Western traditions. Natural history or natural
> science museums have presented non-Western materials, but have selected and
> displayed them as archaeological objects from the past or as curiosities, without
> reference to current realities or to intercultural connections. The work of
> American minority artists and that of contemporary third-world artists has
> been exhibited to a limited extent in alternative or ethnic museums.

Officers argued that these practices were beginning to change, and that emerging trends could "provide more complex and relevant, and consequently more informative, treatments of cultures and communities." The museum program was intended to help advance such trends, to support efforts by American museums to include third-world and minority cultures in scholarship, curating, and presentation.

The early funding went to major, "blockbuster," exhibitions that challenged the conventional expectations of what established museums could do. To the St. Louis Art Museum for *Caribbean Festival Arts*, displaying the gorgeous ephemera of the West Indies carnival tradition; to the Houston Fine Arts Museum for *Hispanic Art in the United States*, the first mainstreamed exhibition of Hispanic artists; to the Metropolitan Museum for *Thirty Centuries of Mexican Art*; to the Corcoran Gallery for *Facing History: The Black Image in American Art* and to many other shows. All of these shows traveled, some of them extensively. This was the period in which venturesome museum directors and curators were changing the exhibition and academic boundaries of their institutions, exposing all Americans to the work of cultures that had been considered marginal or uncuratable, silent, or—even— dead. The extent to which this activity reflects change in museum policy is reflected by the change in the description of Rockefeller's museum program that the trustees received in 1995. Officers wrote:

> Museums are key civic institutions in which definitions of identity and culture are both asserted and contested. Museums of art, history, or natural history have deep power derived from their socially assigned role to classify and define people and societies and to posit standards for excellence focused on culture, artifacts, and works of art. The specific activities of museums—collecting, preserving, studying, interpreting, and exhibiting—can support or challenge the constantly changing core values of society.

Rockefeller would support projects, again, "focused on . . . diverse American cultures and . . . third-world cultures."

Clearly, by 1995 some museums had moved from early efforts to become more inclusive to new understandings about the politics of representation, and the increasingly sophisticated needs of diverse populations. By 1997, officers and museums were identifying a related priority—"projects promoting conversations across boundaries and cultural divides, with special attention to . . . new technologies, explorations of diasporic culture, and the encouragement of collaborations between mainline and community-based organizations." Museums and the foundation have moved from broadened inclusion, to complex considerations of identity, to interaction across communities, as goals for exhibition and scholarship.

These are significant shifts in the incorporation of ideas and the aspirations

of national institutions. In this decade and a half, leaders in American museums had moved from a mostly mono-cultural to a determinedly multicultural agenda, from a Western-centered aesthetic to a global span of aesthetics, from the scholarship of Euro-America to a global scholarship. As Yale's Robert Ferris Thompson said, commenting on the Caribbean carnival arts show, "several art histories, not one, flourish today upon our planet." This is, though it was hardly identified as such, a major shift in cultural policy. Increasingly, museums now evidence the existence of "several art histories." The Guggenheim has recently presented grand exhibitions of Chinese art and of African art in its very American architecture at its very American address. The National Gallery in Washington presented work from every region of the world in its 1992 exhibition. Twice at the Venice Biennial, Rockefeller funding helped the Studio Museum of Harlem and the Museum of African Art place exhibits of contemporary sub-Saharan African artists in the central pavilion. In U.S. museums generally today, in all kinds of U.S. museums, artists from other countries, artists from the many diverse American populations, are shown with regularity. And, in fact, at Rockefeller today, the museum funding goes less and less to blockbusters, to ground-breaking, assertion-making exhibitions. More of the funding supports intense, scholarly, sharply focused shows and curatorship that advance the particulars of diversity, the multiple facets and facts of diversity. The advocacy is less; academic inquiry and assuredness of purpose are greater. In this basic, multicultural dimension, policy—and practice—have changed in American museums.

Museums throughout the country are giving more attention to education and to outreach efforts. In a recent issue of the *New York Times*, several commentators offer their views of museums' efforts to find and build their audiences, including the model program called "A Place for All People" at the Houston Museum of Fine Arts, which invites residents of the city to interpret works of art in their own terms, in their own way. At the Seattle Museum of Art, an exhibition room I recently visited contained the works of local children based on museum master works that they had made their own. The children's work and their master sources were displayed side by side. The artist Fred Wilson, commissioned by the South East Center of Contemporary Art in Winston-Salem, turned an abandoned African-American church into an installation recalling the neglected history of the neighborhood and asking the entire region to reconsider its terrain of meaning. Imaginative, engaging outreach projects are multiple and growing, many of them encouraged by grants from the Lila Wallace/Readers' Digest and other, often regional, foundations.

This movement of our silent, sacrosanct museums into the streets, to ancillary and transient spaces outside the museum, is a movement in policy. The sense of the public has changed in American museums—the sense of public

participation, of partnering, the sense of public purpose. Museums are increasingly involved in economic development in their communities, and increasingly dedicated to community and neighborhood development.

I believe that this new inclusivity, the attention to pluralism that American museums undertook in the recent two decades is a policy achievement of the first magnitude. But it is a policy achievement that was under-acknowledged and less well understood than it might have been, because neither the institutions nor their supporters were deliberate about documenting the movement, articulating it, connecting and disseminating ideas across the cultural community as they developed. Policy evolved despite itself. Each museum and funder involved had its own arguments and justifications for each exhibition or experiment. But the work was not viewed as a force, a shift in purpose, the magnitude of it was not visible as it ensued. The making of multi-culturalism, the movement of many museums from mere palaces to modern public places is largely unrecorded. Rockefeller's museum program was evaluated in 1995; officers were stunned to learn that its focus was simply not known except to its grantees. The recent essays on museum outreach appear years after the policy phenomenon itself.

How bad can it be if policy changes occur without full articulation or full attention? How bad can it be if policy just happens? Of course, these changes have taken place whether or not we theorize about them; they have had their effects on budget, on personnel, on neighborhoods and artists and museum visitors. But—because these activities were not perceived as policy and presented as policy—they have not achieved full airing, full amplitude; they have not benefitted from reasoned debate. An example: maybe multi-culturalism, which is just an awkward name for democracy, after all, has made more enemies than it deserved because such debate has not usefully, openly, taken place. Multi-culturalism may also have had more mindless support, less instructed development than it might have had. Perhaps, because we in culture are so innocent of policy, we have made multi-culturalism a mere shorthand or sound bite when it might have been a meaningful description of the particular diversity of the diasporic twenty-first century.

The point is that to be practice-rich and policy-poor in culture, to lack intentionality, may disadvantage our ideas, diminish our issues, leave us less powerful than we could be.

Those of us concerned about culture have this choice. We can continue to let our activities add up, and achieve policy by chance. (An option, by the way, that has given great latitude for critics of the arts and humanities to identify our trends for us and denounce them.) Or we can try, mobilized as a policy community, to describe more fully, with greater exactness and evidence, the work we do. As I look at the museum world, right at this time, I see exhibitions and other activities which do seem to reveal fresh practices, fresh interests, activities worth studying for their policy implications. Not surprisingly,

these developments evolve from much that has already happened in museums, and in culture more generally, in the last decade and a half.

The Newark Museum mounted an exhibition called *Crowning Glory: Images of the Virgin in the Arts of Portugal.* The objects, internationally curated, covered a time span from the fifteenth century to the current day. Works from Portugal are seldom shown or studied here; so the art historical contribution was significant. The exhibition was spectacular, well funded, well promoted, surrounded with educational offerings. By any of the usual measures, Newark was doing its work well. But as the title of the exhibition suggests, Newark had given itself some extra work to do. In undertaking an exhibition centered on the Virgin Mary, the curators were dealing with questions of belief and faith, questions that would take them well beyond conventional museum concerns. These works are objects of art, but they are also religious objects, many of them in living religious use. The Museum negotiated successfully with a range of authorities, from Portugal's ambassador in Washington to Newark's archbishop, with churches and other collectors around the world, with funders in two countries. They addressed successfully questions about the appropriateness of a Marian exhibit, citing recent scholarship and the importance of this iconography in the art history and the political history of Portugal.

But the Museum's incentive, and its real challenge, were local. Newark is home to this country's largest Portugese-American community, a deeply rooted and growing community, richly traditional, its Catholicism centered on the Virgin Mary. The concern for the Museum was whether its focus on the Virgin, on the beloved icon of this community, would seem appropriate to the community itself. Devoutness, the living divine, the mystery of belief, are not usually in a museum's care, and new lessons were needed. Ultimately, the interests of museum and community did come together. The exhibition included a local celebration that drew 4800 participants, a public television broadcast and museum showing of the community's annual candlelight procession honoring Our Lady of Fatima, Portugese–speaking guides and docents from the community, funding from, for instance, the Portugese Sports Club, Our Lady of Fatima Church, Teixera's Bakery, the Don Pepe Restaurant. Liturgical banners from local churches swung in the museum's halls. More important, the Marian traditions were honored in spiritual terms. The exhibition itself was structured not in art historical or in geographic or stylistic terms; the images were arranged in the chronology of the Virgin's own life. Believers were received by the museum; reverence was made possible in it.

In a volume of essays called *Exhibiting Cultures*, Stephen Greenblatt describes "two distinct models for the exhibition of works of art, one centered on what [he calls] . . . resonance and the other on wonder. By resonance [he means] . . . the power of the displayed object to . . . evoke in the viewer the complex, dynamic cultural forces from which it has emerged . . . By

wonder [he means] . . . the power of the displayed object to stop the viewer in his or her tracks, to convey an arresting sense of uniqueness, to evoke an exalted attention." Resonance and wonder, Greenblatt's terms, are persuasive to me as "models" for exhibition; resonance surely has been enhanced by our attention to cultures previously under-represented; by the new pluralism of our institutions. And wonder in Greenblatt's sense of the word is made more capacious by the commitment to outreach; more people can wonder, and do so more confidently. I wonder if Greenblatt would consider a third, emerging model for the exhibition of works of art, which might be called "inspiration." Resonance and wonder are both afforded by *Crowning Glory*, for instance, but what is also allowed by this exhibition is inspiration—the deep and personal experience of the work as revelation, the breaking of the usual boundary between the object and the individual, between comprehending and feeling, a response to objects based on their living meaningfulness.

A reviewer of *Crowning Glory* wrote that it treats Western religious art "as part of a continuing tradition rather than as a relic of the past . . . an intermeshing of art, history and devotion . . . very moving to see." A resident of Newark says simply in the face of an exhibition experience, "is it art, or is it life?" A Portugese government official writes, in the catalogue, that the exhibition opens "a quick rip in the consciousness" that turns us from the rational and usual to the splendor of personal faith and spiritual quest. We are, in short, freed for feeling by this exhibition, moved, inspired.

In Mashantucket, Connecticut, a Tribe of Native Americans brought to the brink of extinction—the once-mighty Pequots—rallied in the 1970s to gain federal recognition, to reassert their historic claim to the land, and to bring Tribal members back to the reservation to join those who had remained there. From the start of their revival, the Pequot leadership was determined to recapture their history and that of other Native people. They were, in the phrase of the anthropologist Eric Wolf, "a people without history." Even as they struggled for self-sufficiency, their intention was to write their record. This year, the Pequots opened a museum that combines permanent exhibitions, objects, archaeological remains, computer simulations and interactive technology, libraries, laboratories, theaters, and gathering spaces, to tell the story. The exhibition details centuries of Native life. The last two of many galleries (there is a total of 85,000 square feet of exhibit space), contain one of the trailers in which they lived on the reservation until recently, and a series of photographic portraits of individual, living Pequots. The Pequots' faith, their ferocity of purpose, the passionate attachment to land and legacy, are what, in fact, are actually on exhibition. As one archaeologist writes, the museum is "the embodiment of a people's dreams and determination and a symbol of national rebirth under the most extraordinary circumstances." The museum

elicits resonance and wonder; it elicits inspiration, an immediate and personally felt sense of courage, a sense of loss, of outrage, and—above all—the felt cogency of belief and hope, against all odds.

In Louisville, teams of religious leaders and lay leaders are working with the Speed Museum to re-situate objects and architecture in the region to connect with spiritual claims as well as with aesthetics. The project, funded by the Luce Foundation, is called *Art and Soul: Spirituality in the Nineties*. Fred Wilson's installation in that abandoned African-American church in Winston-Salem has inspired its restoration and possible re-use as a place of worship. A Rockefeller Foundation project is supporting researchers around the world to curate contemporary works of visual art that depict images of loss in current-day societies, loss through war, genocide, political devastation. The planned exhibition will address the deepest hollows in the human experience, calling up horror, surely, but also inspiring a commitment to respond. In these and other examples, inspiration—the evocation of feeling, evidence for the heart—is added to resonance (the force of memory) and wonder (appreciation) as a function of culture.

My point, to round back to the beginning of my remarks, is that we need to be articulate about such practices as these, to be self-aware, analytic, policy-minded, if we are to fasten these practices—make use of them—in the life and outlook of the nation, in the shaping of values. Obviously, no exhibition, no single museum, can take on such a mission. But if the arts and humanities do connect to the nation's purposes, it is not too much to ask that museums play this policy-conscious role. Museums, after all, are our most privileged and permanent, best patronized, most expert, most visited, most beloved cultural entities. The policy initiatives to which they commit themselves, if they make them clear, could help to take Americans past cacophony to conscience in our time.

COERCIVE PHILANTHROPY

For a number of years now, American culture has been asked to shoulder obligations once considered the exclusive responsibility of American politics, and this has radically altered the way we now regard the arts. The activization of culture in recent times has come about, one suspects, because legislative solutions to the nation's social problems have been largely abandoned or tabled. Instead of developing adequate federal programs to combat homelessness, poverty, crime, disease, drug abuse, and racial tension, our governing bodies have responded with depleted federal subsidies, dwindling programs for the poor and unemployed, congressional boondoggles, and other instances of systemic inertia. Aside from the debates over competing health care programs, the most significant action advanced by liberals for solving America's more urgent social needs has been to increase the cultural representation of minority groups.

This state of affairs has a history that goes back to the Carter years, but it was clearly intensified during the Reagan-Bush administrations, with their neglect of economic inequities and indifference to social injustice. The powerful conservative revulsion against traditional liberalism led not only to a restructuring of national power but a redistribution of the country's wealth, while the burgeoning deficit and a growing taxpayers' revolt frightened lawmakers away from passing any incremental social programs. Add to these political and economic retrenchments a new ideological vacuum created by the collapse of the Soviet Union. Not only was Marxist economic theory discredited by the failure of communism, but so were the related though considerably milder platforms of socialism, liberal humanism, the welfare state, the New Deal, the Great Society, perhaps even the whole construct of democratic politics. For the first time in more than a hundred years, there exists no viable theoretical alternative to laissez-faire capitalism with its unregulated greed and unequal income structure, no collective idealism to temper unrestrained individualism, no Marx or Keynes to dispute with Adam Smith or Milton Friedman, not even a radical national magazine (if we discount the intellectually weakened *Nation* and *Dissent*) that still gives voice to opinion on the left.

This is not the place to debate the strengths and weaknesses of opposing political ideologies. What I am arguing, rather, is that the weakening of the political left and the absence of a genuine political dialectic has led to paralysis in an arena of social action usually serviced by legislation. It is because of this inertia that the nonprofit cultural sector is being pressed into compensatory service, as a way of sustaining hopes disappointed by the political system. The result is a scene that would be comical were it not so disheartening—a limping gaggle of have-not geese honking loudly for the same small handful of feed. Not only is America's underclass crippled by poverty and hopelessness, but federal money for artistic projects, always pitifully inadequate by comparison with other civilized countries, has been flat or diminishing since 1980, while the National Endowment for the Arts is threatened with extinction every time it spends two hundred dollars on a controversial grant. Staggering under massive deficits, and teetering on the edge of bankruptcy, our nonprofit cultural institutions are nevertheless being asked to validate themselves not through their creative contributions to civilization but on the basis of their community services. This condition was accurately predicted by Alexis de Tocqueville early in the nineteenth century when he expressed doubts about the possibility of serious art in the United States: "Democratic nations," he wrote in *Democracy in America,* "will habitually prefer the useful to the beautiful, and they will require that the beautiful be useful."

Current pressures on the arts to be useful cause funders to measure their value by outreach programs, children's projects, inner-city audience development, access for the handicapped, artists in schools, etc., in addition to demanding proofs of progress in achieving affirmative-action quotas among artistic personnel, board members, and audiences. This social utilitarian view of culture has some undeniable virtues. Certainly, few people of goodwill would dispute the artistic advantages of genuine multiculturalism or interculturalism in the arts (as opposed to unicultural programs primarily designed to empower single-issue groups). And there are unquestionably deep humanitarian impulses governing the new philanthropy. Given the limited resources available for both social and cultural programs, the civic-minded agencies that disburse grant money no doubt sincerely believe that a single dollar can fulfill a double purpose, just as many contemporary artists would prefer their works to function not only as a form of self-expression but also for the public good.

Looked at in the long perspective, however, the push to transform culture into an agency of social welfare is doomed to failure. To demand that creative expression be a medium for promoting minority self-esteem may seem like a thrifty way to respond to the urgent needs of the underclasses. But whatever the immediate effects of such well-meaning civic experiments, they are not long-lasting. Works of art have occasionally been known to transform consciousness and alter individual destinies. They have rarely been known to

change society. Culture is not designed to do the work of politics, nor will inspirational role models even begin to compensate for the unconscionable neglect of arts education in our schools. No wonder inner-city children prefer rap or salsa when so few qualified teachers have been employed by the system to expose them to serious theatre, art, or music. No wonder the infrequent visit of a performance artist or a dance company on a grant often leaves them baffled and sullen when no money exists for developing their imaginations. Effective projects like the Teachers and Writers Collaborative, in which poor kids are introduced to language and poetry by practicing poets, are rare and privately subsidized. Anything short of daily arts education in the public school curriculum will register as little more than tokenism. Indeed, such cosmetic procedures may even be exacerbating the problem since they tend to varnish the surface instead of probing root causes.

Whatever its impact on education, for philanthropy to administer nonprofit funding by utilitarian rather than traditional aesthetic criteria is almost certainly likely to doom the arts as we know them. It is very ominous indeed that the word "quality," the standard by which art has habitually been measured, is now avoided in the majority of funding circles, being considered a code word for racism and elitism. This is true not only in federal, state, and city cultural agencies, where one expects the arts to be subject to populist and egalitarian political pressures, but even in most private funding organizations. With a few lonely exceptions (most notably the Andrew W. Mellon Foundation and the Shubert Foundation), large and small private foundations now give their money not to general support as in the past but overwhelmingly to special programs conceived by the officers of the foundation. Active rather than receptive in relation to the choices of artists and the programming of artistic institutions, the foundation world is now engaged in what we can only regard as coercive philanthropy. Artists and institutions are obliged to follow the dictates of officious program directors, or be exiled to an economic Gulag.

The Lila Wallace-Reader's Digest Foundation, for example, which handed out $45 million to the arts in 1993, describes its three-year program for resident theaters in the following manner: "To expand their marketing efforts, mount new plays, broaden the ethnic makeup of their management, experiment with color-blind casting, increase community outreach activity and sponsor a variety of other programs designed to integrate the theatres into their communities," and also to encourage "dynamic interactions between artists and communities . . . to develop new audiences . . . [and] to address the interests of children and families." These are all benevolent social goals, but they are also all peripheral to the true work of most theaters. What the foundation fails to "expand" or "broaden" or "sponsor" is an artistic goal. As a result, the great preponderance of Wallace funds each year goes to increasing "the African-American audience" or "doubling the number of Asian

Americans in the overall audience "or "increasing the number of Latino theatergoers to 40 percent of the audience" or deepening "the involvement of . . . Latino immigrants, emerging Latino business and professional leaders" or attracting "new theater audiences from . . . Hispanic concert-goers and African-American concert-goers" or diversifying "through the addition of actors of color . . . with the input of its new African-American artistic associates" or including "greater promotion within the African-American community" or developing "new audiences from New York City's Asian-American communities," and so on (I quote a few typical citations from recent grants). Only one award last year went to an institution proposing a project with any artistic dimensions, and that one was designed to broaden the base of childrens' audiences.

Similarly the Rockefeller Foundation, once among the most enlightened supporters of artists and artistic institutions in America, now disburses about $15 million annually, mostly to scholarship but also to arts projects indistinguishable from its equal opportunity and social science research grant recipients. Rockefeller's arts and humanities division describes its mission as encouraging scholars and artists "whose work can advance international and intercultural understanding in the United States . . . extending international and intercultural scholarship and increasing artistic experimentation across cultures." It should be noted that "international and intercultural understanding" no longer includes any understanding of Europe. To judge by the grants, the phrase refers almost exclusively to African, Asian, and, especially, Hispanic countries and cultures. (Only eight of eighty-seven grants could be construed as escaping these categories.)

As a result, Rockefeller's three granting categories advance such noble objectives as "Extending International and Intercultural Scholarship," "Fortifying Institutions of the Civil Society," and "Increasing Artistic Experimentation Across Cultures," while the grants go almost overwhelmingly to African-American, Native American, Asian, and Latino artists or institutions engaged in social objectives (Rockefeller's largest grant in recent years, amounting to almost $2 million, was awarded to the "Intercultural Film/Video Program" in order to enable visual artists not to experiment with new visions or advance film and video techniques but rather to "create work that explores cultural diversity"). One is not surprised to learn that Rockefeller is considering a new play initiative designed to fund works that deal with an issue the program directors call "conflict resolution." Heaven help the playwright with other issues in mind.

As for the Ford Foundation, whose enlightened arts division under W. McNeil Lowry was largely responsible for the massive explosion of American nonprofit dance, theater, symphony, and opera companies since the sixties (including many racially diverse institutions), the lion's share of program budgets now goes to urban and rural poverty, education, governance and

public policy, and international affairs. This is entirely understandable, given such pressing needs at home and abroad. But once again a reduced arts budget—$5.5 million in 1993, out of $54 million for education and culture— goes to institutions devising projects similar to the foundation's civil rights and social justice programs. Ford describes its art division as pursuing two goals, "cultural diversity and strengthening creativity in the performing arts," and adds, "Both goals have become increasingly interconnected, particularly since mainstream arts institutions have become more interested in culturally diverse art and audiences in recent years. At the same time, much of the new performing art the Foundation has supported has been that of minority artists and arts organizations."

Rockefeller also claims that a new "interest in culturally diverse art and audiences" exists among mainstream arts organizations. One might question whether this new "interest" is quite as widespread as recent foundation applications would suggest. Has this passion for culturally diverse art arisen spontaneously, or is it the result of external pressures, notably a desperate need to qualify for subsidies? Whatever the answer, there is no doubt that a lockstep mentality is ruling today's funding fashions where the flavors of the year (or decade) are cultural diversity and multiculturalism. Examples of this can be furnished from any number of private foundations—not to mention federal, state, and civic funding agencies, and private corporations such as AT&T. In a recent issue of *Corporate Philanthropy Report*, a contributions manager bluntly states: "We no longer 'support' the arts. We *use* the arts in innovative ways to support the social causes chosen by our company." The entire arts budget of the Nathan Cummings Foundation (approximately $800,000) goes to what the officers call "culturally specific arts institutions" and "community-based arts organizations." Well, at least it goes directly to minority organizations and not to coercing mainstream institutions into changing their nature.

Even the John and Catherine T. MacArthur grants, originally devoted to identifying and rewarding American "genius" regardless of race or ethnic background, now has a largely multicultural agenda under its new program director, Catharine Stimpson. As a result, of the four grants awarded to performing artists this year (three to gifted people of color), the only white male recipient is listed as a "theatre arts educator," whose main qualification for genius was to have founded "a theater company for inner-city children of Manhattan's Clinton Neighborhood and the Times Square welfare hotels." This project is no doubt of significant value, and its director deserves support, recognition, and funding. But the question remains: Is this award for a "genius" or for a deeply committed social worker?

It is difficult to criticize this kind of philanthropy without being accused of insensitivity to minority artists. But it may be a serious error to assume that all the foundation dollars being poured into developing inner-city audiences are successfully democratizing American culture. What we need is some rigorous

documentation regarding the impact of these grants. And, indeed, advance reports of a survey commissioned by the Lila Wallace-Reader's Digest Foundation suggest that what typically attracts minority audiences to the arts is not mass infusions of audience development money, or even special racial or ethnic projects. Rather it is the *quality* of the art itself.

Whatever its success in the minority community, the new coercive philanthropy is having a demoralizing effect on artists and artistic institutions. The entire cultural world is bending itself into contortions in order to find the right shape for grants under the new criteria. (Like other institutions that poorly perform the new calisthenics, my own theater has received no money for its customary activities from Ford, Wallace, or Rockefeller for more than four years.)

And the pressure comes from many directions. Recently a report issued by the American Symphony Orchestra League threatened the constituency of this service organization with loss of funding if orchestra programs didn't start to "reflect more closely the cultural mix, needs, and interests of their communities." In order to accommodate cultural diversity, in short, institutions of high culture were being asked to include popular, folk, and racial-ethnic expressions in their classical repertoire, as if there were not sufficient outlets for this music in the popular culture. In a typical stab at conformity with the new orthodoxy, a major symphony orchestra management recently invited its own inquisitor. It hired a "Diversity Initiative Consultant," who issued a memorandum to that symphony's "family" in the form of a questionnaire designed to induce "cultural awareness" and "to elicit your perceptions of the organizational culture and diversity of cultures in your work environment."

The dopey questions were framed in a benevolent enough fashion ("Have you realized that your own upbringing was not the same as other races or culture?" "Have you avoided people of a different or certain racial, ethnic, or cultural group?"). But I trust I am not alone in detecting a certain Orwellian cast to these diversity experts who roam the corridors testing everyone's sensitivity to racial slights. When they enter the corridors of culture, they inspire an atmosphere of fear, constraint, and mistrust. It may not be long before anxious employees, prodded by the batons of vigilant thought police, will be fingering fellow workers who neglect to display sufficient "tolerance" or "sensitivity" as measured by such politically correct indicators.

This insinuation of politics into culture comes at a time when tribalism has begun to shatter our national identity, when the melting pot has turned into a seething cauldron. It is only natural, under such conditions, that philanthropy should rush to the aid of racial, ethnic, and sexual groups clamoring for recognition through the agency of creative expression. But the thing about a group with special interests is that in order to achieve power, influence, strength, and unity, it must display a common front. And this often means

suppressing the singularity of its individual members and denying what is shared with others—neither good conditions for creating the idiosyncrasy and universality associated with great art.

What seems to get lost in all this separatist clamor for cultural identity is that the most pressing American issue today is not race or gender or ethnicity but rather what it has always been—the inequitable distribution of the nation's resources, which is an issue of class. This makes our concentration on culture as an open door to equality and opportunity look like a diversion from the pressing economic problems. It reminds me of how, beginning in the fifties, our attention was distracted from the depredations of an unregulated economy and focused on the evils of network television. Thirty years ago, in an article called "The Madison Avenue Villain," I argued that since the whole purpose of the mass media was to peddle consumer goods, to hold the account executive or the TV packager responsible for brutalizing mass culture was to blame the salesman for the defective products of his company. In short, by concentrating on the "wasteland" of mass culture instead of the economic necessities that were driving it, we were effectively blocking a remedy, which could only be political.

Much the same thing seems to be happening today, except that while we are still blaming the failures of our mass society on mass culture (consider the debates over TV violence), we are now asking high culture to compensate for the failures of our affluent society. But by forcing artistic expression to become a conduit for social justice and equal opportunity instead of achieving these goals through the political system, we are at the same time distracting our artists and absolving our politicians. Indeed, it seems to be an American habit to analyze a problem correctly and then come up with the wrong solution.

The right solution, I believe, will only be found when we recognize that we are all members of the same family and that the whole society bears responsibility for the woes of its more indigent relatives. This means responding to unemployment and its consequences in crime and drug abuse with a strong legislative initiative like that employed in the thirties by Roosevelt and the New Deal—a new Civilian Conservation Corps to turn gun-toting inner-city youth into skilled artisans repairing roads and building brides, a reformed welfare system that emphasizes the dignity of work, a public educational system devoted to teaching subjects and developing skills rather than promoting diversity and managing crowd control, and, yes, a federal works project to provide opportunities for anyone who seeks employment, including artists. All this, of course, requires pots of money and goes directly against the grain of the new mean-spirited, Republican-dominated Congress. But we Americans, for all our complaining, are now the most undertaxed citizens in the Western world, and we are in a deepening crisis that needs attention. It will not be resolved by demolishing the small fragile culture we still have.

Artists, Humanists, and Public Life

The Humanities,
the Universities, and
Public Policy

*The humanist's task is to provide continuity, to educate each generation
about the intellectual, spiritual, moral, and political birthright to which it
is heir and from which, in the end, public policy must flow.*

The most important contribution the study of the humanities makes to
public policy is the sound education of the young men and women
who will make public policy in the future. Through the development of the
minds and sensibilities of the young, the humanities can critically influence
public life.

The purpose of education in the humanities—indeed, in all the liberal
arts—is the cultivation of large-minded amateurs. Education takes place,
William James said, when a person learns the difference between what is first-
rate and what is not. The purpose of a liberal arts education is to teach stu-
dents to know when a person is talking rot. Because of the amount of rot
around these days, educating students to know it when they see it is no small
achievement. As Isaiah Berlin has pointed out, the world's ills are not to be
ascribed to an oversupply of rationality. Similarly, the conception and direc-
tion of public policy today are not to be ascribed to too great an influence of the
humanities. Public policy is not suffering from a surfeit of excellence in think-
ing and knowledge. But exactly how and where should the humanities have
more influence?

The humanities are *not* a technique, knack, or subbranch of public policy.
The best work in the humanities generally does not address and is not in-
tended to address issues of public policy, as the term is commonly used.
Rather, the humanities address the circumstances, dreams, hopes, fears, dis-
appointments, failures, and aspirations of those who make and are affected by
public policy. The humanities, particularly literature, usually speak not to leg-
islation nor to administrative decrees but to the heart, not to the external but
to the spiritual circumstances of our civilization, and their focus is usually

narrower than the purview of public policy. The subject of the humanities is most often the elucidation of the quotidian, the commonplace, rather than of large political or social questions. George Steiner, writing about the focus of the novel, has in effect demarcated the focus of all the humanities.

> It is one of the responsibilities of the novel to chronicle small desolations. These are sold short in that harsh artifice of selective recall we set down as history. Whose birthday party was cancelled by the fires that leaped over Troy? Who, on the Friday after Robespierre's execution, paid the laundress who had kept the great man's linens starched? What notes of felicitation, bitingly missed, what letters of condolence waited for by the hurt, impatient heart went to oblivion in the mailbags of the Titanic? In the troves and vestiges of Pompeii, it is the form of a dog, wide-eyed with terror, still chained to his post, that numbs the spirit. The skein of experience is woven of these threads, of the immemorial weight of the particular.[1]

And Wordsworth expressed the same thought thus:

> Thanks to the human heart by which we live,
> Thanks to its tenderness, its joys, and fears,
> To me the meanest flower that blows can give
> Thoughts that do often lie too deep for tears.[2]

Granted, this philosophy is not the stuff of which public policy in Washington, D.C., is made, but what is the utility of such a viewpoint? Holmes was right when he said that the place for a man who is complete in all his powers is in the fight. But it is also true that the person who lives only for pertinent action runs the risk of neglecting the development of the sensibility and intellect required to put these issues in perspective, to act wisely as well as pertinently. Ironically, the difficulty with adjusting one's intellectual life to the measure of what is deemed important now, to what is happening now, is that, as a steady diet, it foreshortens perspective.

The humanities keep men and women from forgetting that, although the news normally embraces issues no smaller than the measure of a city's disaster or a national goal, the experience—the life—of the individual who will affect or be affected by public policy is particular. As Yeats reminds us, "All the drop-scenes drop at once / Upon a hundred thousand stages."[3] The smooth, glib student whose perspective includes nothing less than all the contemporary issues, but who does not thoroughly understand one issue should not be trusted. A nation's public policy should not be framed by men and women whose only interest is public policy.

In the annals of public policy is proof of the humanities' potency. Some of

the most effective makers of American public policy—James Madison, Abraham Lincoln, Reinhold Niebuhr, Martin Luther King, Jr.—were not students primarily of what is called public policy. All were students of the humanities—primarily religion, but also literature, philosophy, the classics, and history. They took their sights from Virgil, Aristotle, and Shakespeare; they all knew and told stories; and when they spoke to matters of public choice, they thought about the shape, character, ambivalence, and destiny of individual lives. They had a depth of sensibility. They did not suffer from dry rot, and they did not flog us with flat and neat and bloodless formulae for adjusting the lives of men and women.

The humanities encompass ideas that develop the sensibility and the intellect of the young, ideas that are not dry rot, ideas that should underlie public policy, ideas about human nature. All these ideas should inform students, who one day will inform public policy. Tacitus, for example, at the beginning of his histories, instructs a sensibility that may in time help put a Watergate in perspective:

> I am entering on the history of a period rich in disasters, frightful in its wars, torn by civil strife, and even in peace full of horrors. . . . things holy were desecrated, there was adultery in high places. . . . Yet, the age was not so barren in noble qualities as not also to exhibit examples of virtue. There were brave and faithful sons-in-law; there were slaves whose fidelity defied even torture; there were illustrious men driven to the last necessity, and enduring it with fortitude; there were closing scenes that equalled the famous deaths of antiquity.[4]

Arthur Miller, in *Death of a Salesman* defines the one equality all persons seek and need:

> I don't say he's a great man. Willy Loman never made a lot of money. His name was never in the paper. He's not the finest character that ever lived. But he's a human being, and a terrible thing is happening to him. So attention must be paid. He's not to be allowed to fall into his grave like an old dog. Attention, attention must finally be paid to such a person.[5]

E. M. Forster, in *Two Cheers for Democracy*, tells us of the value of certain elites and why some elites must be preserved:

> I believe in aristocracy, though—if that is the right word, and if a democrat may use it. Not an aristocracy of power, based upon rank and influence, but an aristocracy of the sensitive, the considerate, and the plucky. Its members are to be found in all nations and classes, and all through the ages, and there is a secret understanding between them when they met. They represent the true human tradition, the one permanent victory of our queer race over cruelty and chaos.

Thousands of them perish in obscurity, a few are great names. They are sensitive for others as well as for themselves, they are considerate without being fussy, their pluck is not swankiness but the power to endure, and they can take a joke.[6]

Public policy ignores these ideas as its peril. If read carefully, they might do something for a student's sensibility.

Now consider the contrast with contemporary public policy. An article in an issue of one of America's most influential public and social policy journals contained the following statement:

This article develops a formal framework to aid political designers in the comparison of social choice functions. It generalizes earlier assumptions of "impartial culture" so that we may begin to investigate the effect of politically interesting variations on the probability that different social choice functions will satisfy given performance criteria. As an application of the framework, a detailed Monte Carlo study compares the ability of four different social choice functions to select a Condorcet winner when voter preference orders have been generated from a spatial representation of ideal points and alternatives.[7]

Another piece is on "committee games":

This essay defines and experimentally tests a new solution concept for n-person cooperative games—the Competitive Solution. The need for a new solution concept derives from the fact that cooperative games theory focuses for the most part on the special case of games with transferable utility, even though, as we argue here, this assumption excludes the possibility of modeling most interesting political coalition processes.[8]

I submit that these thoughts do not lie too deep for tears—these thoughts do not even irrigate. They leave a desert where there should be a sensibility. "Monte Carlo studies," "n-person cooperative games," and "modeling" are inert conjectures. These concepts are less factual and more inert than the concepts elucidated by Tacitus, Miller, and Forster.

The contrast between the quality of the ideas and language embodied in the humanities and the quality of the ideas and language embodied in the public policy arena is exposed in George Orwell's translation of a well-known biblical passage into modern public prose. The passage, Ecclesiates 9:11, appears thus in the King James version: "I returned, and saw under the sun, that the race is not to the swift, nor the battle to the strong, neither yet bread to the wise, nor yet riches to men of understanding, nor yet favour to men of skill; but time and chance happeneth to them all." In Orwell's hands the passage is

transformed: "Objective considerations of contemporary phenomena compel the conclusion that success or failure in competitive activities exhibits no tendency to be commensurate with innate capacity, but that a considerable element of the unpredictable must inevitably be taken into account."[9]

Too often in public policy, too often in formulating public ends and means under the inspiration of the country's ideals, confusion of thoughts becomes confusion of tongues. Talk and writing become impenetrable, unfathomable, and unconscionable, and, invariably, reality becomes distorted. The study of the humanities, the study of the best of all thinking and knowledge, should make its students attentive to language and to the thoughts that language is supposed to convey. Sound education in the humanities ought to immunize students from attaching undue importance to inert conjectures and from speaking dry rot for long without coming up for air, which here means without coming up for meaning.

After William Levi has written that the humanities are the arts of communication (language and literature), the arts of criticism (philosophy), and the arts of continuity (history). By this definition, much public policy fails to qualify as one of these arts or as any sort of art at all. And what is the consequence? If public policy cannot communicate and cannot prove critical perspective, it cannot aid in the responsibility of providing continuity. Of itself only, it cannot go beyond itself. Linguistic and conceptual barrenness do not invite an understanding of human and societal conditions, which the humanities record and which public policy should address.

The purpose of education in the humanities is to encourage students to think, write, and speak carefully and critically, mindful first of the human condition in its particulars, those small desolations and victories. Not only do the humanities encourage such skills by contagious exposure to good thinking, writing, and sentiment. At best, the humanities fix our gaze on what matters: they testify to what deserves attention and what does not. In this way they mediate between the student's understanding of what is going on in the world and public plans and schemes about it. Thus they refuse both the imperial ambitions of the preset category and the reduction of the difficult into the merely specious. If the humanities could speak to us, as do the laws in Plato's *Crito*, they would insist that public policy, which aims to improve conditions for men and women, retain a respect for irreducible complexity but represent this complexity with a human countenance and, as much as possible, with a public meaning.

While the humanities may not speak to us directly, some humanists do speak out. Some complain that they are not listened to, that the domination of the social sciences in today's thinking in public policy is unfortunate. However

justified these complaints, humanists are obliged to do more than complain: they are obliged actively to bring the humanities to public policy planning. As Chekov pointed out, a man does not become a saint through other people's sins. No person or profession achieves a worthy end solely by the cultivation of negative superiorities. If we humanists argue for the study of the humanities rather than the unnecessary arcana of public policy, then we teach by example, and this we do not always do. Sadly, much work in the humanities has made obscurity an achievement. By example, we must teach otherwise.

Most of the work done by humanists is directed not immediately but *mediately* to public policy, and rightly so. But too much of our current work is directed to things that inform or develop the sensibility. Too much of our work is directed only to a few other specialists rather than to our students. Removed from its former task—the study of men and women and their spiritual circumstances—some current work in the humanities has even degenerated into another form of dry rot. The study of humankind has become the study of the study of the study of humankind, and trenchant commentaries on human experience, such as those quoted earlier, have degenerated into untrenchant commentaries. Charles Frankel once said that too many humanists have refused the public invitation and have settled for just taking in one another's laundry. Nor is an excessive preoccupation with minutiae endemic only to contemporary social science. The humanities also suffer from such preoccupation, as well as from other contemporary academic diseases.

The "highest function of history," Tacitus says, is "to let no worthy action be uncommemorated and to hold out the reprobation of posterity to evil words and deeds."[10] But much history today knows nothing of commemoration and reprobation. Mired in quanto- or psychoanalysis, it not only does not record "worthy actions" or "evil words and deeds"; it denies them or ignores them. Worthy actions and evil deeds—memorable particulars—are swept away in a torrent of unmemorable details.

Kant raises philosophical questions: What can I know? What should I do? What may I hope? Plato asks: What is a just state? A just man? Is pleasure the good life? Aristotle says a person must study ethics in order to become good. But much philosophy today studies not these questions but the study of the study of the study of these questions, so far removed from the original issues that the ancient connection is indiscernible. Today many philosophers are interested only in the residue of the residue of these vital questions.

But here is the hitch: Although many current paths of inquiry are more and more distant from vital matters, the needs of each generation have not become more remote. The answers given in Cambridge, Berkeley, and Ann Arbor have become more and more ephemeral, but the *questions* of the young men and women in those cities are as concrete, specific, and vital as they were in

Socrates' Athens. In educational institutions today, young men and women, with blood in their veins and uncertainty in mind and heart, are too often met by practitioners of "ghost disciplines."

Peter Shaw has chronicled the abuses in the most influential literary movement today—literary revisionism. He speaks harshly but truthfully of what he calls the literature professors' "uncoerced embrace of absurdity and inconsequence."[11] When the novel becomes not what Steiner described but "a self-consciously fictive construction" that reflects not small desolations and immemorial particulars but only "the world's unknowables," much is lost. The invitation to the nonprofessional student is not one to passion, interest, or action in the world the novel presents or to the study of it, but only to despair about both. We humanists can hear our students say, adapting a phrase of J. Alfred Prufrock's, "'I cannot hear the cuckoos sing: I wish they would not sing to me.'"[12]

A few recommendations and suggestions may be in order. Although these recommendations are addressed directly to higher education, they may also be applied to public policy. First, in regard to research, the professional community of humanists should clean up its shop by inviting its members to speak more often in responsible and understandable ways about individual and public matters. In other words, humanist-citizens must be encouraged to come out of the closet and speak in the public classroom.

Second, humanists may also be encouraged by reward. University presses can provide humanists with encouragement, inducement, and invitation to the public classroom. As to scholarly journals, witness Alasdair MacIntyre's comments in a recent issue of the *Hastings Report*: "Part of the destruction of the generally educated mind, the mind of the large-minded amateur, is accountable to the sheer multiplication of professional journals and 'pure' journal articles. . . . The increase in the number of professional journals—and the pressure to write the kind of stuff that goes in them—are almost unmitigated evils."[13]

The recommendation should be obvious. Yet in some places faculty members who write for newspapers or nonscholarly journals on issues of general interest are not allowed to count these "nonscholarly" publications in their appeals for promotion or tenure. Thus, ironically enough, in some instances the only generally understandable contribution to public discourse a faculty member may make does not count, while his or her indecipherable work results in a permanent slot in front of students.

Third, the university must think of the humanities as, first, the vital *teaching* of the humanities. It must think of the needs of undergraduates in the humanities as more important than the needs of graduate students in the humanities, who ought to be able to work more independently.

Too often the opposite happens. A philosophy professor in a large university was thanked for what the chairman called his "sacrifice"—his volunteering to teach the freshman course every year. The chairman's use of the term *sacrifice* clearly indicates his own notions of where the action is. To this chairman, the vital activity of the university was the graduate school's parsing of A. J. Ayer, while to argue with eighteen-year-olds about why they should study philosophy, about what equality means, about why values may not be subjective, about why the rule of law is a mark of a healthy society, was a sacrifice, not the heart of a teacher's time.

If the most important contribution the humanities can make to public policy is the education of the young men and women who will make public policy in the future, then efforts at education must be made in the places where education is supposed to occur. In a classic statement, *The Future of Teaching,* William Arrowsmith pointed to the arrogance of scholarship and the fact that in some places the teacher enjoys no honor. The scholar has disowned the student—i.e., the student who is not a potential scholar—and the student has retaliated by abandoning the scholar. Arrowsmith pointed to the dangers inherent in this mutual abandonment. "If the university does not educate," he wrote, "others will. Education will pass to the artist, to the self-appointed intellectual, to the gurus of the mass media, and the whole immense range of secular and religious streetcorner fakes and saints."[14] Arrowsmith was—and is—right. We have reaped the whirlwind of mindlessness.

What, then, should humanists be talking about if they are to inform students about proper public policy? For a somewhat concrete answer, consider two concrete examples—the *Bakke* and *Weber* cases. In light of these cases, consider also the versions of affirmative action involved and how the humanities, through higher education, should have been educating students to improve knowledge and debate about these matters. Humanists, if they had been interested, could have instructed Americans about the spiritual circumstances of *Bakke* and *Weber.* Philosophers and those who work in the history of ideas could have explored with students and colleagues in the law schools the meaning of the promise of equality in America: Jefferson's understanding, the equivocation of the founding fathers at the Constitutional Convention, and the arguments—full, heated, and passionate—between Lincoln and Douglas on the meaning of equality; debates that, as Harry Jaffa has taught us, did no less than determine the doctrinal foundation upon which American government and public policy rest.

Historians attentive to what matters—by the example of John Hope Franklin, Vann Woodward, and Benjamin Quarles—obviously could have helped in this instance by tracing the atrocities of Reconstruction and the rise of Jim

Crow. Literature scholars might have joined with Margaret Walker and instructed Americans (and with us, the courts) about the persistent dream of equality recorded in the literature of slavery—the particular and memorial perceptions of the slave as well as the desolation (moral, if not physical) of the slave master. Students of the American legislative process and of the biographies of statemen and presidents could have told us and the courts of the efforts of Booker T. Washington, Martin Luther King, Jr., Harry S Truman, Franklin D. Roosevelt, John F. Kennedy, Lyndon Johnson, and the first Justice Harlan to erase once and forever the color line as a badge of servitude. Working together, humanists might have made some contribution to this critical matter of public policy.

But survey the record number of *amicus* briefs in these cases, and very little of the humanities can be found there. And it is no use to protest that the *Bakke* and *Weber* cases were narrow legal matters, not "humanistic" matters, for the good briefs on both sides were unanimous on one point: these cases were, at bottom, cases about the meaning of equality—about the nature, quality, and substance not of mere law but of an informing ideal, promise, and commitment. These were cases not about the form of logical inconsistencies, Rawls's "Original Position," or mere legal precedent, but about Americans as a people—our heritage, our ideals, our purpose—and about an enormous history of small and large desolations. These were cases about the humanities. But where were the humanists?

Now if, as happened in these instances, we humanists abandon the nurture of the heritage—the recall of the desolations and the victories, the dreams, the hopes, fears, disappointments, and aspirations of a people—then we abandon instruction about humankind's spiritual circumstances. Abandoning this, we abandon our task of providing continuity, of educating each generation about the intellectual, spiritual, moral, and political birthright to which it is heir and from which, in the end, public policy must flow. If we abandon this responsibility and yield to absurdity and inconsequence, then we will deserve the ignominy and even the contumely so many critics seem prepared to give us.

In the end, no structure, no program, no technique, no government subvention even, can by itself give the humanities greater potency in the formulation and execution of public policy. That potency must come from *inner* vitalities of sensibility and intellect. Rot of all kinds—whether of an individual soul, of a whole society, or of the teaching of humanities for the marketplace—is removed by regeneration, and regeneration comes from within. What the American culture needs is a few more good men and women who, through their own drive and excellence, will accept the always present public invitation, who will write good books, do well-considered and well-directed research that will put good ideas into circulation, and, most important, who will

teach what the humanities can do, not merely by proclaiming what they can do, but by doing it.

NOTES

1. George Steiner, "Unsentimental Education," *New Yorker*, 15 August 1977, p. 85.
2. William Wordsworth, "Ode: Intimations of Immortality from Recollections of Early Childhood." in *The Norton Anthology of Poetry* (New York: W. W. Norton & Co., 1970), p. 583, lines 202–5.
3. William Butler Yeats, "Lapis Lazuli," in *The Norton Anthology of Poetry*, p. 922. lines 22–23.
4. Tacitus, *The Histories*, Book 1, No. 2, in *Tacitus*, ed. Mortimer J. Adler, Great Books of the Western World, No. 15 (Chicago: Encyclopaedia Britannica, Inc., 1952), p. 189.
5. Arthur Miller, *Death of a Salesman: Text and Criticism*, Gerald Weals, ed. (New York: Viking Press, 1967), p. 56.
6. E. M. Forster, "What I Believe," in *Two Cheers for Democracy* (London: Edward Arnold, 1972), p. 70.
7. John R. Chamberlin and Michael D. Cohen, "Toward Applicable Social Choice Theory: A Comparison of Social Choice Functions under Spatial Model Assumptions," *The American Political Science Review*, December 1978, p. 1341.
8. Richard D. McKelvey, Peter C. Ordeshook, and Mark D. Winer, "The Competitive Solution for N-Person Games without Transferable Utility, with an Application to Committee Games," *The American Political Science Review*, June 1978, p. 599.
9. William Strunk, Jr., and E. B. White, *The Elements of Style* (New York: Macmillan Publishing Co., 1972), p. 17.
10. Tacitus, *The Annals*, Book 3, No. 65, in *Tacitus*, ed. Mortimer J. Adler, Great Books of the Western World, No. 15 (Chicago: Encyclopaedia Britannica, Inc., 1952), p. 60.
11. Peter Shaw, "Degenerate Criticism," *Harper's*, October 1979, p. 99.
12. See T. S. Eliot, "The Love Song of J. Alfred Prufrock," in *The Norton Anthology of Poetry*, p.999, lines 124–25.
13. Alasdair MacIntyre, "Why Is the Search for the Foundations of Ethics So Frustrating?" *Hastings Center Report*, August 1979, p. 22.
14. William Arrowsmith, "The Future of Teaching," *Improving College Teaching,* ed. Calvin B. T. Lee (Washington, D.C.: American Council on Education, 1966), p. 58.

THE ARTIST AS PUBLIC
INTELLECTUAL[1]

Surely this is one of the most startling historical junctures any of us in America can recall. It is a time when many feel that much of the collective work of the sixties, seventies, and eighties—to rid society of conformism and prejudice, to introduce progressive legislation into labor, to change the way in which people are educated and the content of their education—is being eroded daily. It is a backlash, a "counter counter-cultural backlash," as the *New York Times* has called it, using words like "radical" and "revolutionary" to denote their opposite and reminding us that not even progressive language is safe from appropriation. Those of us in the arts and education suspect we might be seeing the end of the National Endowment for the Arts as well as the National Endowment for the Humanities. We know we are experiencing serious threats to these organizations—attacks that have little to do with budgetary necessities and everything to do with politics. We have for quite some time seen the decimation of the public school system in America; and we may well be witnessing the end of the concept of the public sector. Given this upheaval, where are the forums for serious debate? Certainly they are not to be found on talk shows, where all social issues are personalized, psychologized, and trivialized. Serious political debates are conceptually at the heart of a democratic society, yet we rarely experience them any longer. We are also seeing a return of the most reactionary use of the term "values" thrown at us with a vengeance. An issue of *Newsweek* magazine was devoted to "Shame: How Do We Bring Back a Sense of Right and Wrong?" On the cover was a sepia-toned photo of what appeared to be a nineteenth-century child with a gigantic dunce cap on his or her head. What are we supposed to think? Is shame the way to gain control of inner-city youths, gang violence, drug lords? —to return America to its puritanical origins, the proud Hester Prynn with the bold letter A plastered to her chest? America must find a way to grapple with what it has become, the extremes to which it has fallen. But because these reactionary conditions and values are not confined to America

alone, now is a crucial time to look closely at the relationship between the personal and political, to articulate where we are positioning ourselves, and to find a group with whom to work and to think through the complexity of this moment so as to be most effective—in other words, to take one's life as a public citizen quite seriously. It is also necessary to evaluate our individual life goals against the pedagogical intentions of the institutions within which we study and work.

Because I cross worlds and live on the borders of several disciplines, I often find myself juxtaposing categories and thus bringing together what are often understood as disparate realities. In this essay, I will bridge some of these realities. I will first discuss the educational situation within which I work, then offer some relationship between the concept of the public intellectual and the artist—focused on the pedagogical work of each—then finally state specifically why I believe in the importance of the place of art and artists in society, especially at this most pressing time.

I am dean of faculty at the School of the Art Institute of Chicago. The school was founded 128 years ago, and the museum followed some years later. Together they form an institute, a very nineteenth-century construct—a school and museum brought into partnership as one educational entity. The school has grown considerably from those early days, when mostly men with smocks over suits and ties painted and sculpted mostly women who were often naked. Now it has almost 2,000 students and 350 faculty members, and at least half of each group are women. The school has twenty-three departments, from the most traditional to the most cutting edge: painting and drawing, of course, printmaking, ceramics, sculpture, fiber, art education/art therapy, liberal arts, art history, theory and criticism, filmmaking, video, performance, sound, art and technology, electronics, kinetics, holography, arts administration, historic preservation, interior architecture, and creative writing.

Some students still work in clay or make paper by hand, and others work only in cyberspace or make computer-generated holograms. Some hide in their studios, so shy they can barely stand next to their paintings and discuss them in a critique situation, and some love to create public spectacles involving hundreds of Chicagoans. Matthew Wilson, a former international student from the United Kingdom who now teaches part-time at the school, staged a piece to commemorate Earth Day. He asked two hundred people—many of them students—to dress up in business attire, and to meet in front of the Picasso sculpture in Daley Plaza on an assigned day, and at noon to fall to the ground as if dead and remain there for fifteen minutes. With hundreds of people routinely eating lunch in the plaza that day, the effect was startling.

Some students would define their goal in life as having a loft in Tribeca, a gallery in SoHo, an international arts center, and reproductions of their work on the cover of *Art in America*. In other words, they hope to become art

stars/art-world celebrities. Others imagine a more serious and perhaps less lucrative life as an artist, struggling to make work that externalizes a vision of the world that grows from the inside out, a sense of communicating by whatever means necessary, a representation of how they see the world or how they prioritize their personal concerns and position themselves in relation to their work. Some students whose intent is overtly political (as they would say) see themselves almost as interventionists, wanting to make strong statements about the world to the world through the medium of art. Our students come from a range of class, racial, and ethnic backgrounds and from some thirty-three countries. They are undergraduates and graduates, many returning to school after having lived lives in other professions. They come back determined to be artists, knowing there is no clear career path to follow but determined nonetheless. We also teach about 200 younger students on weekends in our multi-age programs, where students range from ages five to eighty. This Saturday program has gone on for decades; some of our faculty actually began their careers as artists by attending its classes.

But in a world that does not offer artists many possibilities and does not understand the complexity of the making of art, what do we who are art-school educators think we are doing as we turn out hundreds of artists each year into an unsympathetic economy? I should say first that we at the school educate our students to become *artists*. We do not train them only as painters or sculptors, or as those who create virtual realities. What we mean by training artists (and probably almost every faculty member would have a different way of stating this) is imparting a commitment to the notion that being an artist means developing a creative approach to the complexity of the world, and solving the problems that one poses to oneself through a visual medium, whatever that medium may be. To encourage this, students at the school are given the maximum space in which to develop. We do not place structural boundaries around their development; for example, they are not evaluated on the basis of a final product. They are measured by their commitment to the process, a much less tangible result, which is why there are no grades—only credit or no credit. They are not wedded to one or two disciplines but may explore as many as are needed to find the form within which they work best. That is to say, at the undergraduate level there are no majors, and at the graduate level, although students are admitted in particular disciplines—painting, art and technology, performance—they can roam among disciplines. Those who come in as painters and then decide that they want to say something in performance art or video or film are free to move among these mediums until the right form or the right combination of forms enables them to actualize their vision. They may invent a new medium altogether. Several years ago, two of our students invented computer-generated holography; as a result, one can now create a three-dimensional holographic image from a

two-dimensional, computer-generated image, thus greatly broadening the range and complexity of possible holographic subjects. It is this spirit of invention at its best that makes the analogy between art making and scientific experimentation appropriate.

What we hope to achieve through this seemingly free-wheeling approach is the development of individual artists as well as the development of new forms in art—the realization that art changes and transforms, and that, ideally, artists themselves determine the future direction of art and art schools. When artists want to cross or transgress boundaries, they need a place to work that will allow and encourage such new forms to evolve. We are also committed to the idea that breaking down the barriers between forms—divisions that have often proved in the history of twentieth-century art making to be artificial—helps to create an environment that allows for this fluidity.

At the same time that we are interested in the mastery of form and the obliteration and transformation of form, we are also interested in turning out artists who have a solid foundation in liberal arts and art history, who can discuss, defend, and explicate their work, and who can attempt to position themselves within history. Traditionally, art students have learned history through art history, never envisioning a world larger than that framed through art historical references. We are trying to help students to imagine themselves as citizens within the world—not only the art world. This is the most difficult, least understood, and perhaps most radical venture we are engaged in.

There is no doubt that the predominant image for the artist in American society is the romantic, one of the artist on the fringes—wild, needy, visionary, alone, ahead of his or her time, misunderstood, somewhat like the prophet raging in the desert. And there is also the image of the artist as bohemian, somewhat irresponsible, less than adult, immersed in the pleasure principle, who at times makes something truly extraordinary and at times fools the general public with work that passes for art but is really fraudulent, or is so esoteric that only a handful of people "get it" or want to "get it." And we do have an image of artists as working out of their intuitive selves, envisioning the future. But we do not have in our collective consciousness, or probably unconsciousness as well, images of artists as socially concerned citizens of the world, people who could help determine, through insight and wisdom, the correct political course for us to embark on as a nation. We would not "ask" artists what they think about the degeneration of our cities, our school systems, our young people. On one hand we revere artists, give them a lofty place, and, when we like what they do, pay exhorbitant prices for the objects they create—a recognition and profit that often comes too late. On the other hand we mistrust them, see them as self-serving and lacking in the practical skills

that would enable them to be statesmen, to represent our best interests as public personalities, or to run the world. Artists have also played into these contradictions, defining themselves as a subgroup relishing their otherness. And, as a traditionally puritanical culture, Americans fear the power of graven images and want to inhibit the right of secular individuals to create images that might become icons or focal points of adoration or controversy. Perhaps this is why Americans do not condemn the moving images of pornography, degenerateness, violence, and voyeurism of various kinds that appear on TV but become indignant as a society when such images are frozen in time, transformed and manipulated by artists, then presented back to us.

I mention this because it is this ambivalence, predominant in the culture, that our students suffer from in themselves, often in their work, and in their general ontological insecurity—the primal fear and uncertainty with which they go out into the world to meet an unarticulated and probably precarious fate. And I have tried for years in my own writing to articulate the vital place of artists in society because I believe in the educational process that produces artists, a process that encourages the crossing of all creative and intellectual boundaries and affirms the importance of the type of work that results from such training. Were artists to be taken seriously within American society, were they sought out for their opinions and concerns, they would enter their chosen profession with a much greater sense of self-esteem. Were society ready to accept them into its fold as participating citizens whose function might well be to remain on the margins asking the difficult questions, refusing to become assimilated, socialized in the traditional ways, refusing to accept the simplistic moral values that reflect the present political climate, there would be a great deal of psychic relief and a great deal less clamoring for the top of the art-world pyramid. Artists would be freer to focus on what they do best—concentrated visual experimentation on the relationship of form and content, a type of work that, when successful, advances the entire civilization's ability to see.

In their role as spokespersons for multiple points of view and advocates for a critique of society, artists may well be understood as public intellectuals— those who believe in and take seriously the importance of the public sphere and who create, for an increasingly shrinking collective arena able to house real debate, work they expect the world to respond to. It is the absence of that response and the miscommunication of artists' intent when there is response that are most devastating for artists. In their role as critics of society and as mirrors of society, I have come to see artists as negotiating the public realm— often ignored, unheard, and misunderstood, but nonetheless tenacious in their insistence on presenting society with a reflection of itself without regard for whether society seeks such representation or chooses to look at it when it is offered.

My way of understanding this role of the artist is furthered by the work of Edward Said, especially in a series of essays called the Reith Lectures, which were presented in 1993 and then broadcast on the BBC. Out of these lectures came a very important small collection called *Representations of the Intellectual*.[2] The way in which Said posits the place of the intellectual and distinguishes the various aspects of the role of the intellectual allows me to use his arguments as touchstones to explicate what artists do, how they think about what they do, and how their actions play out in, or could affect, American society. Writers have criticized Said's understanding of the role of the intellectual, citing the narrow theoretical basis for his analysis or the degree to which he presents himself as the prototype for the engaged intellectual.[3] However, I find the structures he creates useful, especially to illuminate the potential role of the artist in American society.

Said refers to Gramsci's notion of the organic intellectual. In the *Prison Notebooks*, Gramsci says, "All men are intellectuals, one could therefore say: but not all men have in society the function of intellectuals."[4] And within this category of those who function as intellectuals there are two groups. The first are the priests and teachers, those for whom knowledge remains stable, steady, transmittable, and at times even stagnant. These might be called professional intellectuals, distinct from what he calls "organic intellectuals," those who are "always on the move, on the make,"[5] constantly interacting with society and struggling to change minds and expand markets. These fluid intellectuals may also be what he refers to as amateur intellectuals, forever inventing themselves and renegotiating their place on the border zones between disciplines, never stuck in any one discipline. These amateurs, wedded to no fixed body of knowledge, are open to all thought and to the renegotiation of ideas as that becomes necessary, whether through the merging of disciplines to solve complex problems as in the creation of cultural studies, or in the evolution of knowledge, as a discipline questions its own history, motivations, and methodologies and becomes self-reflexive—as in the philosophy of science. Important to these distinctions is the idea that the intellectual "is an individual with a specific public role in society that cannot be reduced simply to that of a faceless professional, a competent member of a class just going about her/his business." The organic intellectual is the one "whose *raison d'être* is to represent all those people and issues that are routinely forgotten or swept under the rug. The intellectual does so on the basis of universal principles: that all human beings are entitled to expect decent standards of behavior concerning freedom and justice from worldly powers or nations, and that deliberate or inadvertent violations of these standards need to be testified and fought against courageously."[6] In a sense there is "no such thing as a private intellectual, certainly not a private organic intellectual, since the moment you set down words and then publish them you have entered the public world." "Nor," says Said, "is there only a public intellectual, someone who exists just as

a figurehead or spokesperson or symbol of a cause, movement, or position."[7] He states: "My argument is that intellectuals are individuals with a vocation for the art of representing, whether that is talking, writing, teaching, appearing on television."[8] I add to this the most obvious form of representing—the re-presentation of reality through images used in art making. Said goes on to say, "That vocation [of the intellectual] is important to the extent that it is publicly recognizable and involves both commitment and risk, boldness and vulnerability; when I read Jean-Paul Sartre, or Bertrand Russell, it is their specific, individual voice and presence that makes an impression on me over and above their arguments because they are speaking out for their beliefs. They cannot be mistaken for an anonymous functionary or careful bureaucrat."[9] What makes them unique is that their voice of the particular writer/thinker is heard—booming from their particular orientation, carrying their unique inflection. We might say to ourselves, "It could be no one other than John-Paul Sartre, Toni Morrison, Walter Benjamin, Nadine Gordimer." But we could just as well say, "Picasso, Max Ernst, Louise Bourgeois, Bettye Saar, Bill T. Jones, Anselm Kiefer, Andres Serrano, Carrie Mae Weems, Bruce Nauman," and so forth. The voices of these artists and writers are unmistakable.

I would like to stop here for a moment to talk about some implications of these ideas as they relate to art, artists, and art making. Said's two categories of intellectuals—those who simply represent the information that they were trained to pass along and those who are innovative, daring, and public in their re-presentation of their own personal interaction with the world—hold for artists as well. Most of the artists whose NEA funding has been revoked in the past six years might be said to be organic artists in Said's terms. In each instance the work that was targeted for public denunciation was art that took on serious issues, passed through the individual, the private sphere, and was placed into the public sphere. It was work that crossed borders, took a powerful stance and risked upsetting the moral status quo by exposing conventional hypocrisies. What trully terrified mainstream America was that the work seemed to debunk so-called traditional values. The myriad discussions about this art never communicated the very strong political messages that the work put forth about gender, class, and sexual equality, or the fact that these artists cared about society enough to put their bodies on the line to represent its injustices to a general audience. The integrity of the artists and their commitments to social causes were never discussed.

Said quotes Isaiah Berlin, who in discussing Russian writers of the nineteenth century talks about how conscious they were that they were "on a public stage, testifying."[10] It is fair to say that several artists whom politicians have tried to humiliate because of the nature of their work were most assuredly "testifying." Ron Athey, one performance artist who lost his NEA grant, performs works focused on his HIV-positive condition. He actually does piercing

and tattooing on stage and makes imprints of the blood let from these exercises onto paper towels. The blood prints are not made from the blood of HIV-positive people, but when Athey hangs them high above the audience on clotheslines, they are a looming reminder of our own fear of the proximity of AIDS. The content of the work is precisely a testimony about what it means to be young, creative, talented, successful, and to know that you probably will not live out a normal life. The literalness of the sacrifice involved is reminiscent of Kafka's *Penal Colony*, in which an elaborate machine engraves into the flesh of the sinner words denoting the crime that society has deemed the individual guilty of. Through protracted pain supposedly comes the realization of the crime and the possibility of redemption. Through physical torture comes the spiritual recognition of sin. Redemption through the body is the task Ron Athey has set for himself. But the literalness of these performances—the stark painfulness of them—frightens those who hear about the work and makes Athey an easy target for politicians eager to discredit the symbolic value and cathartic function he attempts to give to these pieces. There is no public discussion of or interest in his actual intention.

These artists have seen their task as that of making their own personal conditions public and of taking that which is in the public domain and translating it into the personal. And yet these functions, so well articulated by Said for intellectuals, are not valued enough in this society to have these arguments secure the public funding that would support such work. Despite this complexity, all that the media have finally been interested in are the sensationalism and supposed "pornography" of the art, rather than its testimony to what Said describes as "resistant intellectual consciousness,"[11] a term he uses to describe Stephen Dedalus, Joyce's prototypical autobiographical protagonist in *Portrait of the Artist As a Young Man*. Such artists resist assimilation. They defy simplistic descriptions or literal analysis. They attempt to reach large audiences, but they refuse to render themselves benign to do so. They see themselves as engaging in these activities to "advance human freedom and knowledge."[12] And they will not compromise. But all of this is beyond Republican Newt Gingrich, who has likened the NEA and its funded projects to a "sandbox" for the rich cultural elite.

Right-wing intellectuals, especially those who write for *The New Criterion*, denounce such artists as working against the public good. But they in fact dislike these artists because, instead of falsely elevating society, they appear to drag it down; instead of offering solutions, they expose society's, inherent contradictions; and instead of pursuing absolute truth, they offer complexity, ambivalence, and at times aggressive confrontation with the status quo. This offends right-wing art critics who continue to believe that artists should idealize beauty. But these organic artists refuse to re-present the past romanti-

cality or to create art that they feel can no longer be made in good conscience in America in the 1990s. Instead they choose to confront that which haunts their own reality.

If the work cannot bring the American psyche together under one homogeneous whole, if it can no longer re-present harmonious images, this is because the world within which these artists live does not allow for such image making. They are true to their historical moment and to that which they feel has been silenced and must be stated within the public realm. Because they defy the prevailing norms and are unable to create order and continuity in their work, they are rightly understood as subversive to the silent complicity around them. They also refuse the depoliticized talk-show mentality, which gives the illusion of a public realm but in fact focuses on the personal and psychological, often negating or denying the historical/sociological moment from which these personal problems evolve. To use Oscar Wilde's phrase, they see themselves in "symbolic relationship with their time."[13]

Said adds another important distinction that I would like to extend to include artists when he says that to the intellectual's responsibility "of representing the collective suffering, and testifying to its travails . . . there must be added something else." This is to "universalize the crisis, to give greater human scope to what a particular race or nation suffered, to associate that experience with the sufferings of others."[14] I would add that all great writing, art, poetry has this capacity. Even the poetry of Neruda or the paintings of Picasso that he alludes to are not exempt from this requirement. No matter how particular its historical references, the work itself through form and the emotional weight it achieves as it moves through the individual is able to recreate and touch a deep level of human suffering. The best art goes so far into the personal that it broadens its own particularity and touches the world. Through the strength of its execution it becomes emotionally, intellectually, and aesthetically available to a more heterogeneous audience. So no matter how particular the images of Picasso's *Guernica* may be, he has plunged into the nature of civil strife so deeply and found images so rooted in the historical/collective consciousness and unconsciousness that the subject becomes bigger than the Spanish Civil War, and the painting is transformed into an icon for all the monumental horror and devastation of war.

Artists also identify with the exile, the one who is spiritually, if not literally, removed from his or her own land—and is neither assimilated or assimilable. Adorno, Said reminds us, always placed a great premium on "subjectivity," always mistrusting the "totally administered society."[15] It is finally the refusal of the artist to fit in, to conform to this regimentation, that makes the image of the artist so powerful within the culture. The artist is the living negation of the society; at the same time, he or she is the best representer of that society. Once artists admit that society makes no place for them, they feel a sense of freedom and abandon. It is a lonely position but also an enviable one, and can

readily be attributed to the intellectual as well. Artists and intellectuals alike rarely expect to have direct impact on society. Rather, they long to be understood, to be read, in Said's words, as "they intended the text to be read"[16] or to have their work seen as they intended it to be seen. They are grateful when they connect to one other person through their work, if that connection does not simplify or distort their intention.

Very few people in American society grasp the complexity of the role of the artist or the potential pedagogical function of art. Few artists themselves are able to articulate the range of possible roles they might play, and even fewer have been trained to see their function as parallel to that of the intellectual— and yet it is and should be. Artists stand at the edge of society. Few ever dare to hope they might create an image or representation that actually affects or changes society. This is because the task of artists, which is to pull what is personal into the public sphere and to give shape to what is public as it occurs in the private sphere, is rarely valued. Few artists would describe themselves as attempting to enter political life through their work; however, Said quotes Genet as once saying, "The moment you publish essays in a society you have entered political life; so if you want not to be political do not write essays or speak out."[17] This is also true of artists. Once work is hung on a wall, placed on a floor, projected into a space in public view, performed, its statement becomes part of the public sphere, the public discourse, and is subject to all the strengths and limitations of the society it has entered. Artists reject the notion that they are not in control once work enters the public sector. Even those artists who have made very provocative work often do not understand why people respond as they do. Once the work is in the public domain, the public feels it has the right to respond as it wishes. And however much artists try to imagine what the response will be, they often cannot. The deeper the work goes, the more likely it is to upset someone who will feel violated by the work's intent. And if the work is making a strong statement in America, it had best not be funded with public dollars or else its function as a vehicle for public debate about real societal concerns will surely be eclipsed. American society has tried to position art in a small, insignificant, restricted, commercial, and mystified space, yet it keeps being pulled into a more complex relationship to society arena. This is infuriating to some.

At a time when America is pitted against itself and the push to conformity shocks our waking hours, intellectuals and artists would do well to align. The battle is about to be too gory and go on too long for any one group to enter into it alone, especially when the desired goals of each group are so well suited to the other.

I return now for a moment to my roles as writer, educator, and arts administrator. I should say that although I see the role of the artist as a public one, only certain artists would choose to embrace this identity, and would identify their task and their life's purpose as serving the public sector through the rigor

and unconventionality of their work. As radical as artists and art students often seem, unfortunately many will fall into Said's category of "professionals." They will find a form within which to work—one that is safe, one that receives a certain level of recognition. They will be content within traditional art-world parameters—and that is where they will stay. They will become, in their own ways, as conservative as intellectuals who remain claustrophobically within their circumscribed fields, never expanding, venturing forth, crossing over, making alliances with any other worlds, speculating on the relationship of their work to the larger whole, or attempting to place their work in a more public arena. And, as Said asks, what would it mean, anyway, to be a private intellectual? And I would add, what would it mean to be a private artist? One would have to write books, make paintings, and simply lock them in a closet to achieve such an end. I suggest only that I see the job of those of us who teach and take seriously our pedagogical roles—those of us who will be writers, artists, and educators training the next generation of public intellectuals—to up the ante in our own educational environments, to provide every opportunity imaginable for our students to be challenged in both form and content, to encourage them to become as radical in form as they are in content, to help them learn to ask themselves the most difficult questions, to push themselves as far as they can go, and to be educated in such a way that they cannot hesitate to take their stand within the public arena.

NOTES

1. An earlier version of this essay was presented as a part of Henry Giroux's Waterbury Lecture Series at Pennsylvania State University on February 16, 1995.
2. Edward W. Said, *Representations of the Intellectual* (New York: Pantheon, 1994).
3. Michael Walzer, "The Solipsist As Hero," a devastating review of *Representations of the Intellectual,* in *The New Republic,* 7 November 1994, 38–40.
4. Antonio Gramsci's *Prison Notebooks,* as cited by Said in *Representations of the Intellectual,* 3.
5. Said, *Representations of the Intellectual,* 4.
6. Ibid., 12.
7. Ibid.
8. Ibid., 13.
9. Ibid.
10. Ibid.
11. Ibid., 15.
12. Ibid., 17.
13. Ibid., 43.
14. Ibid., 44.
15. Ibid., 55.
16. Ibid., 57.
17. Ibid., 110.

COMMENCEMENT ADDRESS:
THE GIFT OF GOOD WORK

A commencement carries as many meanings as there are graduates in this gathering. It is above all a ritual, complete with robes and a recessional, a ceremony of change. We need to mark endings and beginnings: our baptisms, bar mitzvahs, and our burials. We need rituals just as we need art; those acts belong to the unquenchable part of us, the part that must expand beyond the personal, that seeks connectedness, that recognizes the transcendent. Both art and our ceremonies help us make sense of this fleeting world of things, ideas and feelings.

If you have not been reminded already today, you will be expected to count your blessings—the support of family, friends, teachers, even banks and government programs, other artists, and your own resiliency, that brought you to this May morning.

I want to add in your count one of the greatest blessings in life, along with love, and one that is too rare: the gift of good work. Work you love, work you feel compelled to do, work without which you would not believe yourself to be a Self.

You wouldn't be here today if you didn't believe in the transforming power of art: if you had not chosen the life of the imagination, believing its work to be as valid and important as that of the healer, the farmer, the person of commerce.

The next ritual reminder is this: "For those to whom much has been given, much is required." The question is, what are you going to do with your gift of good work, with your skills and your azure blue imaginations?

You may make art alone but art does not exist alone. Just like the individual, it exists in a social context. The self that leaves here today is not, as educator John Dewey said, "something ready made, but something in continuous formation through choice of action."

It is that choice of action that shapes your drawing; that choice of action also draws the web of relationships and the community you will live in.

The New York Academy challenged you to choose the self as artist. I ask you to choose the artist as citizen: to carry your talents into the community as an act of citizenship.

Not only will institutions like this Academy, your future community and your country itself depend on your exercising that citizenship—I believe the support of art in the twenty-first century will as well.

Let me tell you a story. At least sixteen years ago after the presidential election, the new political order vowed to eliminate the National Endowment for the Arts. I was then directing the Vermont state arts council and believe me, that threat galvanized the arts community. We organized and used our powers of expression to press the Congress. We learned to compare the entire federal arts budget to one foot of nuclear submarine. Sounds like 1997, doesn't it? Only now it is one wing of a B-1 bomber.

As part of the new arts lobbying campaign, the novelist Bernard Malamud journeyed from Bennington, Vermont, to Washington, D. C. When I asked him why, in his sixties, a famous writer whose work reached millions, he went to sit in congressmen's offices and to wait outside the hearing rooms to have a word with them, he said: "Because the work alone is no longer enough."

I am not asking you to become a lobbyist nor to produce "political art." I believe that no act is a-political. The best art is political with a small "p" in that it enters and shapes the body politic—your fellow citizens.

Now, your government will regard you as a citizen whether or not you vote or go to a school board meeting. You are a citizen when you work alone in your studio and when you pay your taxes—whether or not you touch the lives of others in ways that bring their separate selves into connection with each other and into connection with the arts.

And yet, and yet, the work alone is no longer enough.

Not in a world where children, deprived of creativity, turn to destruction. Not in communities made chaotic by lack of order and beauty and civic space. Not in a country where fewer people are schooled to the history and skills of the arts and more and more feel no need to support the arts, and even alienation from, and hostility to, some creative expression.

Benjamin Barber, political scientist at Rutgers University, wrote a wonderful essay for the President's Committee on the Arts and the Humanities as it prepared *Creative America*, its report to President Clinton. Barber reminds us that "absent subsidy, absent even democracy . . . the arts survive." But he cautions that the very survivability of art does not mean we should avoid the tough questions of arts policy in a democracy. "Democracy is not just a matter of formal governing institutions and a constitutional framework . . . its success rests on the existence and heartiness of the civic domain."

He develops his theme:

Artists in turn, although they certainly have the "right" to isolate themselves from society and pursue their muse free from interference, may discover that by assuming responsibility for arts education and civic engagement, they contribute to a climate that is tolerant and pluralistic. Artists as artists are responsible only to their art; but artists are also citizens and as citizens they have a particular responsibility to contribute to and nourish an arts-supportive civil society.

Barber declares, "Democracy ultimately rests on the arts' commitment to free creativity . . . and unfettered imagination."

Our democracy is defined in the ever-tense balance between freedom and responsibility. An American does not have to exercise his or her citizen rights, yet each time the voter turnout goes down or fewer people go to the school board meeting where the arts programs are cut, the society is impoverished. Few understand better the exercise of that balance than the artist. The artist practices an exacting discipline, a form of responsibility—perfecting a gesture, a shape, a sound—then from that habit and history creates new ideas and new forms that emerge from the disciplined freedom of the imagination.

Imagination allows us to enter into the life of the other and to find ways to overcome isolation, and create the lineament of community. Inevitably you will try to find, or make around you, the community of individuals with whom you will communicate—carrying out that basic impulse behind art-making. That community, in turn, will feed, challenge, and shape your art.

Case: Sculptor Lily Yeh had a small grant to make a work in an ugly abandoned lot in North Philadelphia. As she gathered "found" materials, neighborhood children hung around and asked to help her. She put them to work and built large mosaic sculptures surrounded by gardens and pathways. Next she and neighborhood residents renovated an abandoned building next to the lot and established a headquarters, called "The Village of the Arts and Humanities." The Village now offers art classes of all kinds for youth after school and in the summer. The Village brings architects and residents together to reclaim decrepit buildings and spaces. Lily explains: "Using arts as 'bone structure,' the Village is building an urban community where members care for each other and are interconnected."

Case: Since 1981, the 52nd Street Project in this city has given children the experience of success through writing and performing their own plays. Young participants are paired in "one on ones" and "two on twos" with professional actors to create and produce a play. Says artistic director Willie Reale, "There is no way to fast forward and know how the kids will look back on this, but I have seen the joy in their eyes and have heard it in their voices and I have watched them take a bow and come up taller."

Case: Twenty-one years ago potter Bill Strickland created Manchester Craftsman's Guild in North Pittsburgh. He told his story at a White House

ceremony with Mrs. Clinton to release the President's Committee's study: *Coming Up Taller: Arts and Humanities Programs for Children and Youth at Risk:*

> Many years ago, I was a young person in an inner city school whose life was transformed by a public school teacher who trained me in ceramic art. Through my apprenticeship, I learned about clay, and I learned that I could achieve recognition from my peers and from my community through creative activity, and that having ideas had value. My teacher also introduced me to the architecture of Frank Lloyd Wright, the importance of jazz music, the necessity of good food and for beautiful objects in the environment.
>
> In Pittsburgh, I have reproduced my apprenticeship experience by building a facility designed by a student of Frank Lloyd Wright that features a music hall devoted to jazz, a culinary arts program devoted to food and its presentation, and a ceramic art and photography program that is devoted to reclaiming inner city children. They come to my facility after school and during the summer and for nine years in a row, approximately 80 percent of these children who are at-risk of failing at life, go on to college. The antidote for these "at-risk" children, we have discovered, is to surround them with good architecture, good food, good artists, and good teachers who are allowed to function in a well-equipped environment and who will not accept anything less than the best human imagination can provide. The school is located in the middle of one of the worst neighborhoods in Pittsburgh, but there are no bars on the windows, no cameras in the building, and no security during the day. Given the current enthusiasm for building prisons to lock people up, I would challenge us to build centers like this one to set children free.

Lily Yeh is a sculptor.
Willie Reale is an actor.
Bill Strickland is a potter.
Their work alone is not enough.

They may be saving some children's lives. Certainly for the life and future of art, by both nurturing and interpreting creativity, they are assuring that art will find its public. They are giving people an entry way into that art, breaking down the barriers of over-specialization and of insider language, allowing people to make things, and to understand, not by over-simplification but by talking up to them, by opening a window to the imagination.

The increasing professionalization of the twentieth century—the professional doctor, lawyer, broker—has grown away from the duties that define the citizen. This is also true of the artist, and it is tragic because the artist has the capacity to integrate ideas into concrete forms in ways that people—ordinary people—can feel and know.

In many ways, artists work in no greater isolation than other professions. In fact, when artists come together to critique a show or perform their works,

they are acting in community. They are risking inviting the wider community in to see and perhaps to reject their work. The more artists take this risk, and the more the intermediary organizations—the museums, the arts councils, the schools, and neighborhood associations—assist this offering of their creativity, the more the imaginative forces of the surrounding community will be reflected and released.

As poet-physician William Carlos Williams told us: "No ideas but in things."

Part of the burden and blessing of being an artist today is to participate in overcoming the isolation of art, so that art does not belong only to other artists, and a few critics, curators, and gallery owners.

If you who have attained the skills engage in acts of citizenship toward art—as well as responsible actions toward your fellow citizens—then you will have the opportunity to transform the art and the democracy of the next century.

My medium is words and so I will end with a favorite poem by Mary Oliver from her recent *New and Selected Poems*. First, I'll open a window into the poem for you. You have spent two years learning about bone structure, and finding the blue line under the model's chin; you can see the ideas in things. And if you haven't spent much time lolling around in a Vermont field lately, think of blue azures as dragon-flies.

Spring Azures

In spring the blue azures bow down
at the edges of shallow puddles
to drink the black rain water.
Then they rise and float away into the fields.

Sometimes the great bones of my life feel so heavy,
and all the tricks my body knows—
the opposable thumbs, the kneecaps,
and the mind clicking and clicking—

don't seem enough to carry me through this world
and I think: how I would like

to have wings—
blue ones—
ribbons of flame.

How I would like to open them, and rise
from the black rain water.

And then I think of Blake, in the dirt and sweat of London—a boy
staring through the window, when God came
fluttering up.

Of course, he screamed,
seeing the bobbin of God's blue body
leaning on the sill,
and the thousand-faceted eyes.

Well, who knows.
Who knows what hung, fluttering, at the window
between him and the darkness.

Anyway, Blake the hosier's son stood up
and turned away from the sooty sill and the dark city—
turned away forever
from the factories, the personal strivings,

to a life of the imagination.

You have entered the life of the imagination—a life of real burdens and great blessings. You are the new masters. I want to honor the actions you will give this world. My benediction for you today is this: may other citizens be able to receive your gifts of good work.

Culture and Policy from the Local to the Global

INTRODUCTION
Glenn Wallach

Thus far, authors in this anthology have identified the boundaries for defining a field of culture and policy and outlined significant issues challenging support for the cultural sector as a whole. The essays in this section assess the impact of culture and policy at some local levels of experience and then look ahead to challenges that policymakers and citizens will face in the future.

When policy makers speak of local impact they rely on a cluster of words that begins with "the community." Policy questions facing communities, in turn, often serve as a sort of short-hand for issues facing "the city." Urban areas are clearly only one kind of community, but their connection to culture has been the focus of more studies than rural and suburban communities. More work needs to be done on all types of communities as concerned individuals map this emerging field. These articles can only highlight some of the relevant issues.

The relation between culture and cities is implicated in a range of questions including urban revitalization, the image a city projects as a potential source of tourist or investment interest, and the effect of artworks on spaces meant for a broad public. Specific questions have emerged about everything from controversial public art installations to the role of cultural institutions in a neighborhood, to the way a cultural district or metropolitan planning process reflects the significance of culture. In those cases, "culture" is used as a synonym for arts and cultural *institutions*.

Culture can also mean the glue that holds together members of a community, or the force that links a locality to the larger society. The articles

that follow are primarily about assessment and action and not as much about specific policies, nevertheless policy choices can unfold from them. They provide, in particular, different perspectives for understanding the idea of impact itself.

Judy Baca's work in Los Angeles offers a rich example of ways artists can affect a wide population. Her effort is one aspect of the community arts movement that began in the 1960s and flourished during the 1970s [See the references in the *For Further Reading* section]. This work raises fundamental questions about how citizens can be educated and their lives enriched through cultural activity; it is linked to a tradition of social engagement by committed individuals from community organizing to social work. More than ten years after this discussion with Baca was recorded, the Social and Public Art Resource Center continues to produce murals and involve members of several communities. Baca's example of the unifying features of art's interaction with people offers a new perspective for understanding the civic significance of art and is a helpful corrective to the often- exaggerated controversies around public art installations (For some careful assessments of these issues, see works by Casey Nelson Blake, Erika Doss, and articles in *Paying the Piper*, all in *For Further Reading*).

Impact has different meanings in the next two essays. Bruce Seaman's discussion treats what is probably the most common avenue for local public officials to discuss cultural institutions—in relation to potential economic impact. A model study published more than twenty years ago observed, "the primary purpose of artistic and cultural institutions is not to create jobs, generate business for local entrepreneurs, or boost sales of durable goods. . . . Nonetheless, arts institutions intentionally or not, generate a number of economic effects on the local community" [David Cwi and Katherine Lyall, *Economic Impacts of Arts and Cultural Institutions* (National Endowment for the Arts, 1977), 1]. The multiplier effects have provided a powerful argument for municipal authorities and arts advocates in seeking support from public and private funders of arts institutions. Seaman notes the value of understanding the significance of the arts in a city's economy. His critique of arts impact studies underlines the need for more sophisticated models of analysis. One response can be seen in a 1994 study by the National Assembly of Local Arts Agencies, *Arts in the Local Economy*. While the methodology is more complex, some fundamental interests remain the same, however; "the non-profit arts are a significant industry in the United States, supporting jobs and stimulating local economies" [*Arts in the Local Economy*, 6]. What kinds of resources do the arts and culture provide to specific communities beyond the measurement of economic effects?

Initiatives around the nation by the Urban Institute's Maria Rosario Jackson, the Getty Research Institute's Josephine Ramirez, and the Social Impact of the Arts Project at the University of Pennsylvania (represented here in the

essay by Mark Stern and Susan Seifert), are only three examples of efforts to understand the nature of community in cultural terms. Do we define community by those things that divide or unite us, Stern and Seifert ask. They suggest that cultural institutions make fundamental contributions to the coherence of community. The challenge for public officials, advocates for cultural institutions, and citizens will be how they incorporate and interpret these insights in a policy environment focused on fiscal measures of progress.

The perspective shifts in the next set of essays from the local to the global community. On the world stage "cultural policy" takes on a new set of meanings and symbolism attached to multilateral trade agreements and intersections between localities and commercial forces associated with American consumer culture. We can no longer speak of a single culture or even a unified cultural sector, but must think in terms of flows between various cultural streams (Arjun Appadurai has provided one important interpretation of this transformation). The state in many nations around the world has a complex and layered set of policies regarding culture as Néstor García Canclini notes in his essay. As seems appropriate for this excerpt from the UNESCO *World Culture Report*, Canclini considers initiatives that emphasize cooperation across cultures. The United States is party to many international agreements about intellectual and cultural property but has a variable involvement with many multilateral bodies, including UNESCO.

Cultural policy transcends national boundaries and requires engagement in many other arenas. Many of the most challenging policy frontiers will be in the virtual rather than the physical world. Susan Siegfried places us directly in the middle of one medium that has many claims made for its potential to shape our future—the World Wide Web. Perhaps any discussion of the presentation and dissemination of cultural content must focus on the institutions that produce and possess the images. Siegfried traces the development of policies about access, control, and stewardship of images and information that will affect many more persons than are represented by the institutions making the policies. One of the appeals of the World Wide Web is that content producers need not be based in major institutions; how will future policies apply to both providers and producers who range in size and authority? Will the nature of authority itself change in the era of the Web?

The museum has been one site for balancing and presenting claims of authority. Richard Kurin's work at the Smithsonian Institution has been devoted for some time to the celebration and study of cultural plurality. He uses his curator's perspective to assess the interplay between the state, cultural diversity, tourism, and consumer culture. This is a heady mix of challenges that the community of scholars, policymakers, and citizens who think about culture and policy will be facing for years to come. Kurin's zest for the future seems an appropriate place to close this volume.

Impacts of Culture
on Communities

JUDY BACA: SPARC —
THE SOCIAL AND PUBLIC ARTS
RESOURCE CENTER[1]

THE GREAT WALL

Los Angeles has a mural tradition that dates back to the 1930s. Spurred by the Depression, job programs developed by the Federal Works Progress Administration provided artists such as David Sequieros an opportunity to ply their skills on the walls of public buildings throughout the city. Some of these murals, now considered masterpieces, remain today. In the 1970s this legacy and a growing political awareness gave rise to a new generation of muralists. The community murals movement, as it came to be called, has continued into the 1980s. The results, works created by hundreds of artists, can be found in every Los Angeles neighborhood.

Tucked amid the constantly changing urban sprawl is a growing, sometimes tenuous collection of what muralist Dick Crispo calls the "the walls of change." The average life span of a mural in Los Angeles can be twenty years or more, with proper care. The city of the angels, though, is not immune to change. As Los Angeles has reconstituted itself over the years, many murals have been lost to the wrecking ball, and others have succumbed to the adverse effects of the sun and the smog.

If you are adventurous enough to seek them out, you will find yourself gazing up at wall murals as high as five stories in unlikely locations all over the city. But the longest mural in Los Angeles, in the world actually, is found on the walls of a flood control channel that has been carved twenty feet into the floor of the San Fernando Valley. It is called the Great Wall of Tujunga Wash. The Great Wall is one-half mile long and took nine years to complete.

Murals traditionally are designed and rendered by one artist or a group of collaborating artists. The Great Wall was more of a group project, a large group project. By its completion, hundreds of people had had a hand in the epic undertaking, which was begun as a Bicentennial project in 1976. All but

a few of those stalwart collaborators were teenagers with arrest records and no previous art experience. Their efforts depict the history of Los Angeles from its founding in 1781 to the present. Although most of the painting was accomplished by untrained hands, it doesn't look like a high school art project. That's because it isn't. The Wall is the product of an extraordinary educational and artistic process that has been developed by the founder and current artistic director of the Social and Public Art Resource Center (SPARC), Judy Baca. The result is as beautiful as it is challenging.

When the officials of the Los Angeles County Flood Control District gave SPARC permission to paint a mural in the Tujunga Wash, they saw it as a beautification project. Baca saw it differently. She approached the Great Wall as she had the many other Los Angeles mural projects she had initiated. She designed the project "as an urban environmental artist concerned not only with the physical aesthetic considerations of a space, but the social and cultural as well."[2] The result was more than a mural. The Wall became an historical document that portrayed not only the familiar historical past but the forgotten and ignored, as well. Baca admits to the discovery of her own historical ignorance and eventual education as a result of the project.

> When I first saw the wall, I envisioned a long narrative of another history of California, one of which included ethnic peoples, women, and minorities who were so invisible in conventional textbook accounts. The discovery of California's multi-cultured peoples was a revelation to me as well as to the members of my teams. We learned each new decade of history in summer installments. . . . Each year our visions expanded as the images traveled down the wall. While our sense of our individual families' places in history took form, we became family to one another. Working toward the achievement of a difficult common goal shifted our understanding of each other and most importantly of ourselves.[3]

The mural's familiar images include the faces of Thomas Edison and Luther Burbank and milestone events such as the coming of the railroad and the Great War. But there is far more space devoted to personalities and events that, to the average viewer, are far less recognizable. In 1981, writer Kay Mills described the then work-in-progress for readers of *Ms.* magazine:

> The mural reminds passersby that black performers were shut out of white hotels, that Mexican-Americans were deported by the thousands in the 1930s, that California was no cornucopia for Dust Bowl refugees huddled in hobo camps, and that Japanese-Americans were carried off from their own land homes to World War II detention centers.[4]

MURAL MAKERS

Baca calls the multi-racial group of teenagers who volunteered for the project "Mural Makers." Each summer teams, fifty to eighty members strong, would

spend their vacations learning and carrying out the various jobs that contributed to the making of the mural. Most would spend their days (which began at 7 a.m. to avoid the heat) preparing the surface and transferring the complex images from the design cartoon to a grid that had been placed on the wall.

The Wall is, in fact, the left bank of a river that runs only five days a year. The majority of the year it is drenched in direct sunlight. Because of this, the surface required painstaking preparation. This process involved sandblasting, waterblasting, and the application of a sealant. While this was going on, a smaller group of artists and students were engaged in the research and design of the mural's content. As images emerged, they were drawn onto one-foot by two-foot blueprints by Baca. Down in the "wash," each blueprint corresponded to a numbered grid space on a prepared section of the wall. One inch on the cartoon translated to one foot on the mural itself. Then, beginning with a dotted outline, the students and a handful of supervising artists transferred the images from the blueprint to the thirteen-foot wall.

For the students who spent their summer vacations working as Mural Makers, the Great Wall was an opportunity to learn and work together and contribute to their community. For Judy Baca the project was a twelve-months-a-year struggle to keep afloat. It took $150,000 to provide the paint, brushes, scaffolding, port-a-potties, and other materials for one summer's work. Most of this came in the form of goods and services that were donated by the broad range of unlikely partners who supported the project. By the summer of 1980, Baca had put together a corps of sponsors that included the Army Corps of Engineers, the Teamsters Union, the National Endowment for the Arts, the National Guard, and a whole host of community-based organizations.

Through their efforts Baca and the Mural Makers not only produced a landmark artistic work, but they used that achievement as a catalyst for community development and community education. As a result of the Great Wall, many of the social and economic barriers that tend to separate various urban communities were transgressed. The Army, gang members, and community organizers all found common ground in the Tujunga Wash.

MURAL TRAINING

On the final day of the Art in Other Places conference, Judy Baca invited the conferees into one of the organization's Venice, California, studios to view and discuss a work in progress. Baca began with a brief description of SPARC's history and then spoke in detail about the Mural Training Program and the half completed Skid Row Project, which occupied the studio where the conferees had gathered.

This morning you are getting a look at the SPARC facility. This is an old jail. It was built in 1929. We liberated it from the City of Los Angeles in 1977. Previous to that it had been deserted for about five years. The area downstairs, which is the gallery, was originally the old cell block. The narcotics division of the new police department is the size of this entire building.

One of the programs that SPARC is currently involved in is the Mural Training Program. It has come about after a lot of years of working with apprentices and people in various communities to produce public art. This is work which has been described very often by the press as "public art for the public good." The majority of our work is done in consultation with the community in which it will be placed.

The Skid Row Project is typical. The artists are a group of students who come from five different art schools and universities in the local area. The work is a mural for the Skid Row homeless. My task was to teach them about the issues they were becoming involved in through their painting and then help them to produce pieces which had some relevance to a constituency that had no art.

What we are working on are two small panels which will be placed on the front of a single occupancy (SRO) hotel located in Skid Row. The hotel provides housing for people whose relief funding has been exhausted. The relief cycle is a significant problem for the community we are trying to effect. The $228 per month relief payment will pay a person's rent for roughly half the month. If they want to eat, too, they might have some trouble making ends meet, so they end up back on the street.

These panels are being painted in the studio because painting in the street there would be really dangerous. We decided to do the work in pieces here and take them to the site to install them. Usually, I work right in the community with the people who live there. But I couldn't really make a team in Skid Row because so many of the people in that area are transient. I decided to use this project to educate people, like my students, on the issue.

We are working with a community-based social service organization called Las Familias. We have also received some help from a group called the Corporate Volunteer Corps. They send volunteers from IBM or Security Pacific out into the community to try to help. This group came out and cleaned up the graffiti in the area to prepare the way for our bringing in the mural.

SKID ROW ON THE MAP

Before we began the mural we found out everything we could about the issues and characteristics of the area. This research is always the first step in the painting of a mural. The process is really one of asking basic questions. What's the difference between the West Side homeless and the Skid Row homeless? What happens with the system of relief? How does the homeless cycle begin? What is the difference between a homeless woman and a homeless man?

Where do the women hang out? The men? What are their lives like? What can you expect if someone has been on the street two weeks? Three weeks?

To answer these questions, we began to interview people in all the different agencies in the area. One good source, a woman named Nancy Lindy from the Legal Aid Foundation, talked to us about the relief system and how it treats people with mental illnesses. If you are mentally deficient you have to go through what Nancy calls the "148-step exclusionary process." There actually are 148 steps on twelve pages of forms which these people, who can't take care of themselves, have to go through to get relief. She is suing the county for this.

Nancy had a jar on her desk which contained a formaldehyded rat from one of the SRO hotels. She gave us a lot of information about what it was like in those hotels. She said it would be ludicrous for us to paint something in the Skid Row that was a decorative piece. Even though it is within walking distance of the major art world in Los Angeles, there is no art for these people. They need immediate food, shelter, and medical care. She said anything other than that would be a silly waste of time. We went back thinking maybe we shouldn't do any art.

After a while we began to brainstorm. This is the point in the process where we have to start setting criteria for design and content. We decided that if we were going to do this work, it would have to deal with the immediate need for food, shelter, and medical care. We also felt that it should be placed in a location that really aimed at the homeless people walking in the street.

Our rationale for using art in this situation was as follows: Being poor means that you are stripped of amenities. The perception of the public is that providing for these essentials is all that must be done. Alice Callahan, a Presbyterian minister who is an activist and director of Las Familias Del Pueblo, has articulated a different point of view, which we subscribe to. She said, "People need to retain their humanity through periods of extreme hardship." We feel the arts are even more necessary for the poor to counter the degrading aspects of their lives.

As we started to focus on the idea of providing useful information, we spent a lot of time looking at maps of the area. We noticed how the typical map was laid out for various constituencies. Looking at the downtown area, we were amazed at how every map made Skid Row disappear. If you came into downtown Los Angeles from someplace like the Near East, you would think you could have a picnic in Skid Row because on the map it looks like pastures. We knew from even our limited experience with the homeless that this was one of the ways our society deals with the issue. We literally try to make them disappear. So we made putting Skid Row back on the map one of our goals.

We began to design a map, one that would help people find immediate shelter, food, and medical care, within walking distance if possible. That really gave us an education. We had to figure out which places to include. Should we include the missions where the people can't eat without getting

a sermon? We had to check out these places to find out what they were like. The students went down there and came back with a real understanding of the minimal services that were available, and the struggle these people had to survive.

The typical map of Los Angeles places City Hall at its center. Our design focused on the services and people of Skid Row. We also took a little liberty with the names of the places as well. The average Angeleno would not recognize them, but the people on the street will. The Catholic Workers Kitchen is called the Hippie Kitchen. Immanuel Baptist Church, where they must serve everything with gravy, is Gravy Joe's.

Each one of these locations or landmarks was assigned to an individual student. They began by photographing their building and coming back here and working up the drawings. After that it was all tightened up, blueprints were made for the mural, and we went to work.

The second piece, which will go up on the SRO Hotel, addresses the third goal we set for ourselves, which was to find a way to talk about the rights of the homeless. If one of these people makes a mistake in the relief process, they can get a sixty-day penalty. This results in a loss of support for three months. To help them, we wanted to do something which was empowering. Most of them have no idea what their rights are in this situation. Now these basic rights will be staring them in the face when they come to the SRO Hotel. Some of them will also see themselves because the people represented on the murals are Skid Row regulars. The homeless are depicted as phantom-like images, transparent; the streets are seen through their bodies. They are invisible and the streets run through them like veins.

The two pieces together are called "The Street Speaks." It will have taken ten to fourteen weeks from beginning to end. Through this experience we have tried to give our students a perspective on the power and tradition of the medium. We were not interested in turning them into decorative painters or corporate advertisers. We are teaching them to do an analysis of an issue, to image content, and then produce a work that has some relevance to the location in which it is placed.

GUADALUPE

In 1989, Baca began a project far removed from the urban intensity that had been her focus for so many years. The project, a series of four murals designed with and for the people of the small California central valley town of Guadalupe, has presented Baca with new challenges and opportunities. The town is small enough to allow her to work with an entire community for the first time. In a recent letter she described the project's progress and what she hopes it will accomplish.

Guadalupe has a population of 5,000. It is an agricultural area on the coast with one hundred miles of dunes spread north and south. It has remained relatively unchanged for a hundred years, and is remarkable in a number of ways. The town is a cross section of the ethnic peoples so much a part of California's history. Portuguese, Filipino, Japanese, Chinese, and Mexican are the prominent groups that have labored in the fields, and their descendents are still present. I am producing a historical colonnade with four panels. The first panel is on the founders of Guadalupe, the second on the ethnic contributions, the third on agriculture and its concurrent problems for the farm workers, the fourth and last is entitled "Hope for the Future."

I have set up a studio in an old Druid temple there. It is a place where farm workers, growers, and other factions of the city all feel welcome. Part of my plan for the city of Guadalupe's mural is to employ many of the techniques I have applied on other projects. I have hired youth from the town. To assist on the project they have been conducting oral interviews with aged peoples in the area as well as assisting in producing the first collection of historical photographs and other materials. The City Council has, as a result of our efforts, moved to form the first Historical Society of Guadalupe. The Guadalupe population has a ratio of sixteen men to each woman. Many of the population is a transient population that travels back and forth between Mexico and California. Sharecropping is very much evident in the area, as well as polluted water sources, work-related injuries, and pesticide health problems. Integrating myself into this place has been an interesting task. I believe, after four months, I have finally accomplished this to the degree that makes me effective. I have a photographer on my team as well as a full-time assistant. We are documenting the farm workers at work as well as some of the more severe problems that are occurring there. . . . The city. . . . has become a ghetto for the nearby Santa Maria, with a history of drug busts and prostitution. Because of this we are addressing the image of Guadalupe as well. We have invited the entire town, all 5,000 people, to step into the streets of Guadalupe for a family portrait, which will be taken from above. This poster will be published as a testimony of the humanity of the place.

Perhaps the most significant development in Guadalupe, for my work, is that once again I am addressing the issue of the architecture specifically built to house the mural (a historical mural colonnade). The second development is that in order to plan the future panel we had to do much historical research on the past. The "Ethnic Contributions" panel shows the city's downtown street filled with its past notable residents—some ghosts, some living—all together on the streets once again. I have held a number of larger community meetings, one of which was a brainstorming session, with all the factions of the community present to speak about the future of their town. This brainstorming session was highly successful in developing common ground between the factions.[5]

Whether they are working on river walls of concrete, on skid row buildings, or historical colonnades in a small central California rural town, Judy Baca and the other artists affiliated with the Social and Public Arts Resource

Center have been dealing with the issues of communication, empowerment, and change. Baca and her fellow artists use many languages to reach their audiences and to make their points. The languages range from Spanish and English to bureaucratic, economic, and aesthetic. SPARC uses these languages and art to translate, mediate, and inform. Through their work these artists have become a valuable public resource that transcends cultural and political barriers. A wall that becomes a mural becomes a bridge to useful knowledge, ideas, and inspiration.

NOTES

1. Unless otherwise noted, all quotations by Judy Baca are taken from transcripts of the AOP conference held on August 21, 22, and 23, 1986, or from interviews conducted by the author in December 1988.
2. Judith Baca, "The Great Wall of Tujunga Wash." Social and Public Art Resource Center, 1981.
3. Ibid.
4. Kay Mills, "The Great Wall of Los Angeles," *Ms.*, Oct. 1981.
5. Judith Baca, letter to the author, Jan. 1989.

Arts Impact Studies:
A Fashionable Excess

Arts impact studies have become something of a growth industry. People may grumble about their inadequacies, but there is a great reluctance to simply say "enough!" If one were dealing with clothing instead of research agendas, there might be hope. Just when everyone has purchased a new collection of madras shirts, they are certain to be out of style. Unfortunately, the popularity of a particular research product does not as reliably foretell its doom.

A personal anecdote can exhibit this observation. As a discussant at a session on impact studies at the Third International Conference on Cultural Economics and Planning in Akron, I had just finished raising some fairly standard suspicions about the legitimacy of the conclusions drawn by the Port Authority of New York/New Jersey study (mentioned later). I was approached in the hall by a few arts administrators who good naturedly noted that my questions had never really been satisfactorily answered—an apparent source of concern. It soon became obvious, however, that, despite their doubts, they could hardly wait to return home to initiate their own similar studies.

As advocates for the arts, their enthusiasm for yet another weapon is certainly understandable. As an economist, however, I fear that impact studies are focusing on the wrong issues, using an inappropriate tool, and perhaps reaching false conclusions. At best, one might reach the correct conclusions for the wrong reasons. It is time to make the case that, despite the generation of some useful information from the studies to date, the social value of one more arts impact study is nearly zero. In a costless world, a few more could be justified. In this world, one cannot afford to divert more resources from other, more valuable research projects in the arts.

THE ARGUMENT IN BRIEF

There are three basic justifications for the kind of arts impact study under discussion: (1) to clarify industry and sectoral interactions in local economies

and to improve predictions about income and output changes; (2) to serve as a particular case study to help resolve the various weaknesses in regional development models such as input/output analysis and economic base multipliers; and (3) to improve public policymaking regarding the allocation of an economy's scarce resources, or the achievement of "noneconomic" goals such as fairness or enlightenment. These justifications address forecasting, scientific, and policy goals. Arts impact studies have been useful in achieving the first goal, are largely irrelevant to the second, and are deceptive and misleading as applied to the third. Even their success in clarifying intersectoral relationships and documenting the distributional effects of arts expenditures has been marred by technical flaws in the analysis. While the economists involved in these studies are aware of the problems and try to provide sufficient caveats, the warnings often go unheeded and the limitations unresolved. And, as usual, the proliferation of these studies leads to more abuse than the professionals claimed there would be.

The studies usually are interpreted as adding some economic evidence to the usual array of noneconomic considerations relevant to cultural policymaking. Properly and cautiously used to supplement other economic analysis, such studies do provide information relevant to the forecasting function. Interpreted, as they too often are by arts administrators and perhaps policymakers, as sufficient or even necessary evidence for additional public financial support, they are an abuse of economic analysis. In essence, the studies try to add some cost/benefit analysis to the discussion of rational arts policy without being particularly true to the principles of that methodology. And the derivation of the benefits that *are* emphasized—namely, the impact of arts spending on regional income and employment—fails to incorporate fully critical macroeconomic lessons for accurately estimating the important multiplier effects.

Attempting to link the arts to economic development and a healthy local economy, some have only tenuously connected the arts to the research economists have done on regional development. As David Cwi has noted, "By ignoring the export base issues and concentrating solely on multiplier effects, earlier studies have almost completely ignored the questions raised by the regional economist."[1] Even the more economically sophisticated studies, including the Cwi and Lyall prototype National Endowment study of Baltimore and the very recent Port Authority study of New York and New Jersey, do not address the export issue adequately. Ironically, even if it could be shown that the arts *were* an essential basic industry (an unlikely result), there would be no presumption at all that such an industry would remain basic, that basic industries should be subsidized, or that differential growth in regions could be linked closely to differing demands for exportable products.[2] And, ironically, by focusing on the multiplier effects of arts spending, the studies' pitfall is that the very cities for which the arts might legitimately have a large export component will likely be cities for which "leakages" of such

spending injections from the local region are relatively extensive, thus reducing the value of the multiplier. For example, considerable evidence exists that the nonbasic-to-basic ration (a way of measuring the magnitude of the multiplied spending effect) is, on the average, larger for bigger cities than for smaller ones.[3] Yet, except for the atypical case of New York, cities in which the arts are apt to provide a net positive injection of spending into the community as an export product are probably very small—Jiri Zuzanek's examples were Stratford and Niagara-on-the-Lake.[4] Thus, a careful study probably would find that where the arts are legitimate export product, the local leakages are due largely to the necessity of a small city obtaining many of its products and services from other regions; hence, the multiplier effect is small. And the multiple effect of truly exogenous additions to total spending is large for those self-sufficient cities for which the arts are less apt to be exports and more likely to represent a diversion of spending from other products and activities.

In essence, impact studies have diverted attention from the kinds of research most appropriate to building a legitimate case for further public support for the arts. By focusing on the similarity of the arts to any other human endeavor—the "we have an economic impact, too" syndrome—they almost have overshadowed the research being done by Throsby, West, and others in designing experiments to estimate the degree to which there really *is* a market failure in providing arts services.[5] Their efforts to measure the magnitude of citizens' willingness to pay for more arts services—i.e., the degree to which there may be a "marginally relevant externality" beyond the direct benefits to attenders of arts events—is more directly germane to improved policymaking.[6] These studies stress the unique difficulties involved in allocating the "optimal" amount of resources to the arts.

It generally has been recognized that impact studies have not been useful in investigating the types of arts effects that could generate marginally relevant external benefits.[7] Effects on a city's image, revitalization of certain neighborhoods, and even increasing worker productivity and emotional health are factors not captured in aggregate spending effects. Yet, these effects would tend to make the arts more like other popularly subsidized activities, such as education, having relevant, unaccounted-for external benefits. Efforts to analyze and measure these effects would be much more useful than yet another spending impact study. Furthermore, the success that economists have had in dealing with these more intrinsic, difficult-to-measure benefits can go far in diffusing a more radical critique—that the arts are so different from other economic goods that economic analysis is simply inapplicable.[8] In fact, legitimate methodological problems exist with even well-designed, willingness-to-pay, cost/benefit studies. Such arguments, however, may not be needed to defend the arts if it can be shown that even the "flawed" cost/benefit approach can justify expanded public support.

In short, it is time to halt the proliferation of arts impact studies that focus on multiplied spending efforts on local regions. The only justifiable expression of this research might be to elaborate further and update actual input/output tables for both the New York/New Jersey region and, for comparison's sake, selected other regions. But this research should be done strictly as an exercise in input/output analysis with the focus on improved short-run forecasting. As a tool in the debate over public arts policy, resources should be diverted to other more relevant projects. The following sections more thoroughly defend these assertions.

I HAVE IMPACT: YOU HAVE IMPACT

No one wants to blunder through life without being noticed, without making waves. A casual reading of the popular press suggests that "economic impact" has become the latest version of ego-enforcing psychotherapy. In Atlanta alone, (1) the miserable Atlanta Falcons had between a $37 million and a $59 million (depending on the particular study) effect on the city's economy in 1984[9]; (2) the *commercial* music industry of Georgia contributes $200 million to the state's economy annually[10]; and (3) Georgia State University boosted Atlanta's income by a whopping $227 million last year. The implications of such calculations, which are similar to scores of others produced regularly in other parts of the country, are profound.

Limiting oneself to just Georgia State, Georgia Tech, Emory, and the Atlanta University complex, the university sector apparently could have generated as much as $908 million in income yearly. Assuming about half of the commercial music industry's impact was in Atlanta would create another $100 million. Taking the average estimate for the Falcons ($48 million) and multiplying that by the three professional sports teams in the city would yield $144 million in income from the professional sports industry (higher estimates have been given for the Braves alone). Even if one is conservative and cuts the university figure in half (to get $454 million), the average industry impact for this small sample of three is $232.67 million annually. A reasonable estimate of the total personal income for the Atlanta metropolitan area, as reported by the Georgia State University Economic Forecasting Center, is $32 billion for 1984. By dividing this $32 billion by the estimated industry average impact of $232.67 million, one finds that Atlanta can have no more than 138 separate industries without totally exhausting its annual income.[11]

Industry definition is a matter of careful analysis and can vary depending on the problem at hand. But relying upon the often-used U.S. Government standard industrial classification (SIC) system allows for the identification of 1,002 separate "4-digit" industries. So Atlanta, with a well-admired diversified economy, must have no more than about 14 percent of all the 4-digit industries represented within its borders for this average industry impact to

be plausible. Of course, one might argue that this obviously limited sample is unrepresentative, perhaps because those three industries are uniquely powerful—an assertion returned to later. It is this kind of extrapolation, however, that has made economists uneasy about the accuracy of the claims made in impact studies.

It is doubtful that too many newspaper readers are diligently cross checking the various claims for logical consistency. So it is certainly no surprise that the noncommercial performing arts industry would feel terribly hurt if it had no economic impact as confirmed by a similar highly publicized report. Thus, with almost endearing innocence, the publicists for most arts impact studies proudly proclaim that, at least in this respect, they are just like everyone else. To some extent, such a finding is a bit like proclaiming the existence of oxygen on the planet earth. A truly noteworthy discovery would have been that spending by the arts industry did not have widespread effects on other product supplies and incomes in those related sectors. After all, a dollar spent by an artist at the grocery store should have the same effect on check-out-counter jobs as one spent by a steelworker. Only the traditional unfamiliarity of many talented people in the arts with the notion of themselves as economic agents could account for the perceived novelty of this insight.

THE ACTUAL MEASUREMENT
OF THE ECONOMIC IMPACT

Challenging the value of the finding that the arts have a measurable impact on economic aggregates does not imply that nothing has been learned from the dozens of impact studies completed to date. Extremism in opposition to misconception may be no vice, but moderation in pursuit of accuracy is certainly a virtue. For example, the Port Authority study concluded that the arts in the New York/New Jersey metropolitan area are a larger industry than advertising, hotel and motel operations, management consulting, and computer and data processing services. The particular industries benefiting indirectly from arts spending, in order of importance, are real estate, business and professional services, wholesale and retail trade, eating and drinking establishments, hotel and personal services, utilities, transportation, medical and educational services, finance, and insurance.[12] Even though some of these indirect effects were documented as early as the *Report of the Mayor's Committee on Cultural Policy* in 1974, the relative rankings were clarified and updated. Both the Port Authority and the National Endowment studies were especially useful in demonstrating differences among the various types of arts organizations and art forms. And both made an effort, although not fully successful, to identify export components of total spending. As Wassily Leontief, father of modern input/output analysis, said recently, "A major problem in economics is to be able to describe an entire forest in terms of individual trees and their

interrelationships—to perceive the totality, while preserving all the minutiae in clear detail."[13] Impact studies are capable of adding to the stock of knowledge about the minutiae of these interrelationships.

It is critical, however, that the actual dollar estimates of these impacts be consistent with economic principles. Economists, who from their earliest collegiate declarations as economics majors, have been fighting a losing battle with their families and the general public about just what it is that an economist does—"oh, you're studying economics; what's the GNP going to be next year?"—have been defensively determined to avoid any taint from number-crunching, double-counting, causally confused, and conceptually implausible financial impact estimates. Most economists involved in conducting these studies have done credible jobs in trying to keep the record straight and at least pay lip service to the practical difficulties in avoiding conceptual errors. Inevitably, however, this approach becomes reminiscent of the person who always precedes some questionable behavior by announcing, "I know I shouldn't do this, but. . . ."

It is important to recognize that the impact calculations consist essentially of two component parts of a simple equation: Full impact = (multiplier) × (net additions to total spending). Estimating the multiplier requires the researcher to trace the degree to which any spending "circulates" around the local economy and has indirect effects on spending by other people and industries. The primary determinant of the size of that term in the equation is the magnitude of "leakages" from the local economy as the additional spending goes to firms and individuals outside the local economy. The greater the leakages, the smaller the magnified multiplier effect. Studies using input/output tables (such as the Port Authority study) are particularly good at tracing these indirect spending flows so that the so-called "marginal propensity to consume locally" is correctly identified. But the other part of the equation, "net additions to total spending," is an even more treacherous problem that no study has adequately confronted.

To explain this point, one can refer briefly to the macroeconomic origins of these regional multipliers. In "Keynesian" terms, the net additions to total spending, the so-called "injections," consist of consumption, investment, government spending, and net exports (exports—imports). If the marginal propensity to consume is, say, .75, it is common for introductory textbooks to conclude that a $100 increase in "exogenous" consumption demand will create a total change in national income of $400. The multiplier is 4. Using monetary aggregates to make a similar point, it is clear that there is some "money multiplier" in evidence when gross national product is some multiple of the existing money supply. So the existence of multiplier effects from any of the types of net additional spending is a commonplace result.

Students who have never gone beyond the simplest versions of this multiplier analysis, however, are perfect examples of those for whom "a little learning is a dangerous thing."

The multiplier reductions have been due largely to a more accurate treatment of the net additions to total spending part of our simple equation. For example, it is well known that the standard textbook increase in government deficit spending (i.e., government spends more without raising taxes) may have only a muted effect on expanding the economy due to effects of reducing the *other* components of aggregate spending. Thus, if the additional government spending raises interest rates, investment demand likely will decline, and consumption also may fall due to a combination of interest rate effects and the recognition that the government bonds used to finance the deficits may not really constitute an increase in net wealth.[14] "Supply-side" production constraint problems can complicate this even further. Suffice it to say that when inquiring as to the source of these quasi-mysterious "exogenous" increases in overall spending, one often discovers that they may not constitute net increases, but merely changes in the composition of spending demand. Government might increase at the expense of investment and consumption.

This problem also has plagued the consumption component of aggregate demand. Students for decades have asked, "Just what is an exogenous increase in consumption demand? Where does it come from?" Silly students—always asking uninformed, brilliant questions. Being at a point in their lives where the term "budget constraint" is not just a test question, they do not easily see how they, or the economy for that matter, can just decide to "dissave" and increase consumption. Of course, when savings are positive for the economy as a whole, savings can be reduced, or a change in the distribution of income from savers to spenders could have the same effect. But the students are clearly on to something. To avoid having to confuse them further with more abstract explanation, the savvy instructor gives export demand as the foolproof example. Since most American students are notoriously poorly informed about the external world beyond U.S. shores, this truly exogenous increase in spending coming from "out there" causes few problems as an example of a legitimate injection into the U.S. economy.

This conceptual difficulty with an increase in consumption spending clearly extends to regional applications of multiplier analysis. While no problem occurs with identifying even more sources of export demand (there is more "out there" when studying an individual city), the same issue is raised when the increase in overall spending is alleged to occur fully within the city. Again, the possibility exists of consumption rising while investment and/or government spending falls so that there is not net increase in demand. Obviously, the potential for a diversion of spending from one type to the next is many times greater when one further disaggregates and considers not just total consumption or total investment, but consumption spending for

a particular product, like the arts. Now one does not even have to ask whether other types of nonconsumption spending are adversely affected. It is problematic enough that just a different *type* of consumption spending is affected adversely.

This problem is clearly recognized, but not adequately corrected, by the economists conducting impact studies. Among the many caveats provided by Cwi and Lyall in their prototype Baltimore study is a section entitled "Negative Effects on Business Volume." The key observation in this section is "to the extent that the institutions operate enterprises or provide services in competition with local businesses, their receipts from these activities should be recognized as a substitution for other private business earnings in the community."[15] They then attempt to justify their decision to consider most arts-related spending as a "net addition to total business volume, perhaps competing with activities outside the area but not reducing sales within the region."[16] To the extent that they can identify "import substitutes" of this kind, they are on safe ground in considering such spending net additions to local demand. But it is clear that their examples of such import substitution are too limited and cannot account for the primary volume of direct expenditure within the arts sector. They cite gallery sales in museums as "items that were largely unobtainable elsewhere." Furthermore, "museums stimulate other private sector purchases through heightened interest in the purchase of art."

Even if they are correct that someone wanting to purchase a copy of an oil painting exhibited in the museum could not have gone to a competing local gallery and obtained such a print, the question must still be asked: how is the person financing that purchase? If it is from savings at a local bank, the secondary effect would be a reduction in the available pool of loanable funds for, perhaps, local investment or consumption projects far removed from the arts. If it is from a reduction in restaurant visits, the secondary effect will be a reduction in income generated in the restaurant industry. If it is from fewer clothing purchases, that sector declines. This applies far beyond the so-called subsidiary activities of the arts institutions (the gallery shops, theatre souvenir stands, opera cash bars). As admitted by Cwi and Lyall, "No data are available on which to make an evaluation or assumption of the transfers from other recreational, entertainment, or educational areas that may be represented by all or a portion of the ticket and related expenditures associated with attendance at arts events."[17]

Now this is getting serious. When one remembers that the first-round spending effects on all of the impact studies are simply the budgetary outlays of arts organizations—labor expenses, payroll taxes, space rentals, advertising equipment, travel—it becomes clear that this entire amount of spending in fact may be simply a diversion of spending from other products. How can one say this? One has only to take note of the accounting identities involved in

an arts organization's ledger. Total spending must equal the sum of (1) ticket revenues; (2) contributed income; (3) government grants and subsidies; (4) subsidiary activity revenues; and (5) net borrowed income from banks and other sources. Cwi and Lyall admit there is a potential problem with (1) and (4) being diversions of spending rather than net additions, and they did not even consider spending being diverted from the *non*entertainment/ educational sector. But the problem extends to all five revenue sources. Admittedly, contributions can be made from outside the community, and some of the ticket revenues clearly come from visitors, a category that most studies attempt to measure. Government funding is partly federal or state and, in fact, might be a net increase to the local community after subtracting local tax contributions to those higher level treasuries. Local government support might come partially from bonds sold to nonlocal financial institutions. The point is that this problem of confirming that even the first-round, direct-spending components of the economic impacts are net additions to community income is much wider than even Cwi and Lyall allow.

It is revealing to note how the Atlanta sports, university, and commercial music studies handled this problem, as well as to check how other arts studies have fared in isolating real exports and import substitutes. One can see immediately that one reason for the likely inconsistency of the Atlanta results is the failure to consider local spending substitutions. And, even the best of the arts studies, the Port Authority study, does not adequately avoid this error.

For example, the reported Atlanta Falcons impact is the sum of two columns of spending nicely portrayed in an easy-to-read graphic. In one column is a list of the spending in thousands of dollars by local fans and in the other the same categories of spending by out-of-town fans. Local fans spent $6,513,000 in 1984 on tickets, concessions, parking, and food, while out-of-towners spent $5,225,000. This total of $11.7 million, when multiplied by an unexplained multiplier of 3.16, yields the $37 million impact (a New Orleans study credited the Falcons with a $59 million effect on Atlanta and the Saints with a $78 million effect on New Orleans). At least, in this case, no one denies that the Falcons are partly a legitimate export product. While no attempt was made to estimate the additional costs of having these visitors to the city, one can assume that the result would still be a net positive one, although less than half as potent as that in the headlines. Similar problems plague the Georgia State estimate. Knowing quite a few of these students myself, I can attest that much of their tuition and ancillary spending is coming from painful reductions in what they sometimes view as higher priority consumer goods. And while GSU attracts students from other parts of the state, country, and world, a majority are Atlanta-area residents, not "export products."

As for the Port Authority study, no one can fault the attempted conservatism of the approach. In determining how to define the initial base of direct expenditures, the all-important first-round effects, the authors correctly note

that "direct expenditures made by arts institutions outside the seventeen-county area exert no regional impact; they are leakages and must be subtracted from direct expenditures before impact analysis can begin."[18] And the category of spending called "expenditures of arts motivated visitors" is carefully analyzed. Such ancillary spending is counted only "when a person from outside comes into the region, or alternatively, extends a trip to the region made for another purpose, primarily because of the arts."[19]

Confusion still exists, however, between net increases in total spending in the region and transfers of spending from one sector to another while holding total spending constant. Consider, for example, the specific examples cited to help the reader visualize these complicated impacts.

> A museum orders a catalogue to be printed by a New Jersey firm. The amount billed to the museum indirectly pays for some of the printer's rent, new machinery, and expansion. Thus, the museum expenditures support the commercial real estate, printing, and machinery sectors of the economy.

> A motion picture production company employs a local film crew for a location shoot. Members of the crew use their paychecks for rent, food, and other household expenditures. The movie company's expenditures for labor, therefore, induce support for residential real estate, retail food, and other sectors of the economy affected by the level of personal consumption.

> A family travels from Pennsylvania to attend a Broadway show. Once inside the region, they spend money not only for theater tickets, but also for tolls, parking, dinner, and a hotel room. Their trip expenditures thus help to support not only the arts but also a number of tourist-related industries.[20]

The study treats all three of these examples as if they were conceptually identical. They are not. The museum is able to order its catalogue because it has revenues from one of the sources identified in the accounting identity earlier. A large part of this revenue may have come from a diversion of local spending from other sectors of the local economy. The fact that this purchase has improved the economic status of the real estate and printing sectors of the economy is primarily a distributional effect, not an aggregate output and income effect. Someone is better off and someone else is apt to be worse off. The pie is sliced differently; it is not a bigger pie.

The family traveling from Pennsylvania is going to have aggregate income and output effects as well as distributional effects on the local economy. The fact that it travels to attend a Broadway show rather than a Mets game will mean that its impact will be channeled to the economy via actors' incomes, theater expenditures, and perhaps midtown restaurant receipts rather than through beer vendors' incomes and hot-dog-stand receipts. And depending

on the particular marginal propensities to consume from this additional income, the indirect effects may be of a different magnitude. But either way, there has been a net injection of new spending into the region.

The motion picture example has elements of both of the above, depending on the export versus purely local spending nature of this particular set of transactions. The point is simply that even a very carefully conducted study typically does not adequately distinguish purely distributional effects from aggregate income effects. Identifying distributional effects is an important enterprise. Based on the three examples, I would guess that the already heavily subsidized real estate industry would welcome an expansion of the arts sector. And simply documenting the relative size of arts spending versus nonarts spending is a useful exercise in data gathering. But these effects should be distinguished carefully from claims related to the overall growth and health of the local economy.[21]

IMPACT STUDIES
AND REGIONAL DEVELOPMENT

The attempt to establish a uniquely important role for the arts by focusing on its size relative to other industries and the extent of its widespread financial consequences is understandable given the woeful quality of popular discourse on economic affairs. Everyone has been a victim of nightly news economics correspondents who blithely identify the fate of a particular industry, nay, often a particular firm, with the ultimate destiny of the entire economy. To this entertaining crew of mythmakers, the U.S. economy is synonymous with the auto industry or the steel industry, the textile industry or the agricultural sector, depending on which set of current crises provides the most vivid visualization of the amorphous notion of an "economy." Thank goodness, there were a few feature stories about the American slide-rule industry. There would have been mass panic.

It is no wonder that when a Secretary of Defense wants to justify the continued existence of even the most superfluous and militarily unproductive army base, he stresses the financial impact on the local community rather than the intrinsic value of that particular facility to the taxpayer "consumers." It is much easier to visualize a reduction in beer sales on the periphery of the base than to determine if the marginal social value of one more base exceeds its marginal social cost. And make no mistake: For many small communities for which such bases are *the* primary industry and the source of unambiguous net additions to spending from outside the community, the demise of those bases may have more than just short-term "adjustment effects." But the economy as a whole doubtless would be better off reallocating scarce resources to more productive uses, and the local community itself may be able to develop other basic industries better designed to meet consumer and taxpayer demands. As

hard as this lesson may be, the history of this and other economies is that there are no truly essential industries. In fact, societies that try to treat particular industries as essential often suffer the consequences of slower growth and stymied development. The so-called "British disease" is only the most popular example because of its familiarity to Western observers.

True as this may be, those responsible for local and regional policy and those living in a particular geographical area are legitimately more interested in what will improve their own individual situations. Abstract arguments about overall efficiency in the economy and the inevitability of change can be recognized without necessarily being compelling. It must be asked whether arts impact studies can help policymakers who necessarily have less global perspectives, and to what extent these studies can contribute to an improved understanding of the process of regional development.

In this regard, there are four conclusions: (1) Arts impact studies have established little evidence that the arts are a basic industry, defined as an export industry, an import substitute industry, or an industry providing services critical to an export industry; (2) even if the arts had been established to be a basic industry, their importance for regional growth would not necessarily be proven due to the recognized weaknesses of economic base models of development; (3) the role of the arts as an important part of a city's or region's infrastructure may have "induced" effects on firm and household interregional location decisions, but little evidence exists that the interregional mobility of firms has been an important factor in differential growth rates, nor have impact studies been useful in establishing interregional location effects of either firms *or* households; and (4) the most important role of the arts in local development probably is related to intraregional location decisions, the distribution of intraregional economic activity, and the enhancement of the quality of the "human capital" within the region, thereby having real productivity effects similar to education. This last effect, as well as the consumption externalities discussed in the following section, are not, however, the domain of the traditional arts impact study. Therefore, arts impact studies are of little use to policymakers interested in development issues. And arts impact studies have not been designed to advance the "science" of development studies and are of little interest to the development specialist.

In the previous section, the distinction between net additions to spending and substitutions among different categories of spending was emphasized in order to put the findings of impact studies into better perspective. When someone reports that the Chicago Symphony Orchestra has added, say, $150 million to the Chicago economy in a particular year, one should realize that the disappearance of the institution, tragic as that would be for other reasons, would be unlikely to reduce total personal income in Chicago by $150 million. It certainly would affect individual suppliers of inputs to the orchestra and all of the subsidiary results that an input/output table could trace. But unless

aggregate spending in the area were reduced rather than simply transferred, the effects again would be largely distributional. This is why taste changes among a sometimes fickle public usually are viewed with more bemusement rather than terror (unless one is producing the now out-of-fashion product). Someone's tragedy becomes another's opportunity. In this context, exports become a useful example of net additions to local spending.

It would be a misconception, however, to infer that the economic growth of a city or region depends solely on its ability to increase the demand for its exports. One can image a small town producing brooms, for example, and selling them elsewhere in the county. Then the county, having many textile mills, exports to other people in the state. And the state produces products partly for sale to the rest of the country, and the country sells products to other countries elsewhere in the world. The obvious problem is that at this point one has run out of likely candidates for further export markets. Planet earth cannot yet export products to other planets. Obviously, the degree to which one is dealing with an "open" economy or a "closed" economy depends on the level of aggregation one uses. Even at the level of a city, it is possible to imagine a very large, entirely closed city with no access to the outside world. Could this city grow? Could it provide an ever-increasing quality of life for its residents? Of course. Although it almost certainly will be poorer than if it availed itself of the opportunities for mutually advantageous trade with other cities.

The overemphasis on spending flows that characterizes all impact studies is a logical extension of the Keynesian influence on macroeconomics, from which regional multiplier analysis grew. The "supply-side" revolution in economics is just a return to a more balanced perspective that reminds one of the essential factors responsible for long-term economic growth—the increased specialization and division of labor that is possible among larger populations, increases in the quantity and quality of physical capital, education and training as ways to enhance the quality of "human capital," and technological change. In this context, the arts would not have to be exportable to be important. One might suspect that the role of the arts in this overall development scheme would be easily overwhelmed by that of other enterprises. But, at least arts proponents would not have to worry about whether impact studies have established the arts as a basic industry.

It is difficult to overemphasize the importance of this argument to the entire case being made against arts impact studies. For even if such studies were to succeed beyond the wildest dreams of their proponents, they would be essentially superfluous. That is, even if the arts could be shown to be the major export industry in a city, a true candidate for "basic" industry status, there would not necessarily be a strong reason for local public officials to view that industry as a critical lever with which to influence growth.

A COHERENT POLICY FRAMEWORK:
A REAL ROLE FOR ECONOMICS IN ARTS POLICY

Perhaps the greatest tragedy of the popularity of arts and other impact studies has been the widespread confusion they have created regarding optimal public policy. Conducted largely for public relations, they contain an implicit premise that the identification of multiplier income effects is somehow germane to the debate regarding public support for the arts. Regardless of the disclaimers of those economists involved in these studies, the motive of the arts community is clearly to establish the relationship between the size of the industry and the legitimacy of its claims upon the public purse. This premise may or may not be good politics. It is certainly bad economics. Ironically, it also may be exceedingly detrimental to the cause of the arts in seeking additional resources.

Economics provides a powerful set of guidelines for policymakers considering controversial social problems, even if an exact calculation of the "optimal solution" is not feasible. For products that survive the market test, the private benefits as measured by what one is willing to pay clearly exceed the private costs, as evidenced by what the seller is willing to accept. However, goods or services that generate "external costs" or "external benefits" *may* be either under or over-provided by that standard, depending on what type of externality is involved.

There are important differences between "pecuniary" and "real" externalities, as well as between "marginally relevant" and "marginally irrelevant" externalities. Pecuniary externalities are ubiquitous and reflect changes in prices and incomes that naturally occur as consumer demands or product supplies change in a market economy. Consumers shifting, for example, from diskettes to compact discs will generate such "external" effects on those producing and distributing those and related products without generating any "market failure" that might justify government intervention via taxes or subsidies. By contrast, a "real externality" occurs when market prices do not fully reflect the "marginal benefits" or "marginal costs" of the goods produced, making possible a genuine misallocation of society's scarce resources. Furthermore, only those examples of real externalities that are "marginally relevant" (i.e. that actually lead private individuals motivated only by private costs and benefits to make the "wrong decision," like perhaps obtaining too little fundamental education) would justify some modification in the market outcome. While all industries generate pecuniary externalities, most industries do not generate marginally relevant real externalities. Unfortunately, the typical economic impact study merely documents the pecuniary impacts of a particular industry.

Arts proponents, therefore, are involved in a dangerous game when they resort to impact studies. In a sense, they are choosing to play one of their weakest cards, while holding back their aces. The resort to impact studies that simply document the kinds of pecuniary effects common to all industries unnecessarily obscures their uniqueness as a potential source of real, marginally relevant externalities. They simply cannot win in the fight about who has the biggest impact or who is most critical to economic development. And some of the results of the studies can be detrimental to their cause. What is the socially responsible reader to think after being informed that the arts in New York are a larger industry than advertising or management consulting? Now there is an industry worthy of public support? What about the distributional implications of the fact that among the most heavily indirectly enriched industries are real estate, utilities, and finance, and insurance—industries surely on everyone's Christmas list? While it is certainly no surprise, the Port Authority's finding that one-third of the audience visiting arts events had incomes over $50,000 and another third had incomes between $25,000 and $50,000 has ambiguous implications at best. If there is going to be an influx of visitors making additional demands on local public services, they may as well be rich. No one denies that these visitors, as a legitimate source of "export" earnings to the local community, are apt to be more welcome guests than an international conference of hobos. Does this observation, however, justify the jump in logic to the next step—that tax money should be used to make their consumption of the arts less costly or the income of arts organizations more substantial? By this reasoning, one should really become socially responsible and hurry to subsidize the yacht industry in hopes of luring a convention of Greek boating enthusiasts. To the extent that the purely local population of arts consumers has similar incomes, the question can again be raised—why can't the arts pay for themselves?

Years of economic analysis suggest reasons why the arts, even given these demographics, might not be able to pay for themselves. Arts impact studies, however, are a poor vehicle to make the case that people perceive more value in the arts than the arts have been able to capture in tangible revenues. Even if such studies were better able to make the case that the arts are critical for economic development, the policy implications would hardly be clear.

Efforts to confirm the public benefits from the arts have taken two basic forms: statistical estimation and willingness-to-pay surveys. Although the statistical estimation results provided some support for the notion that the arts have public good dimensions, they were methodologically flawed and did not speak directly to the issue of whether the arts were—or are underprovided.[22] It is in recent willingness-to-pay studies for both Australia and Canada that real success has been achieved in measuring public benefits from the arts and their degree of underprovision.

A public good is one that is both "nonexcludable" and "nonrival in consumption." Nonexcludability means that the benefits of the good cannot be kept from someone who does not pay—the benefits cannot be limited to those who pay for the good's production. Nonrivalry is present when one person's consumption of the benefits of a good does not reduce the benefits accruing to someone else. An apple fails to meet either criterion. National defense is the textbook example of a product meeting both.

The concept of a public good is quite distinct from that of a "merit good," something that provides only limited private benefits and/or public benefits and thus is produced in relatively small quantities or not at all. Yet, it is suspected, at least by a few people, that the good "should" be produced in greater quantities. Public goods may not be provided in adequate quantities because of the technical inability of their producers to capture the revenues that citizens would be willing to pay *rather than do without* the good. Merit goods may not be provided because citizens have an insufficient willingness to pay for them at all.

Most goods can be justified in society as purely private goods. Others failing to meet that test can be justified as public goods or as "mixed goods." Only out of desperation would one argue that a good is intrinsically "meritorious" even though it has no apparent *economic* value as measured by willingness to pay. Too often, arts proponents have stressed the merit-goods argument rather than the public-goods argument, due no doubt to the difficulty of documenting either. New evidence, however, provides tangible support for the arts as a public good.

In a technique first suggested by Bohm, a sample of people are asked questions designed to elicit both over- and understatements of their willingness to pay for various goods suspected of providing public benefits.[23] In this way, the classic difficulty of having people correctly reveal their willingness to pay for a product essentially nonexcludable can be partially resolved. The basic "trick" is to ask them what they are willing to pay for more of a product, first when they are expected to be actually held liable for that amount, and second, when they are told they will have no personal liability. By first obtaining an expected understatement of willingness to pay, and then an expected overstatement of willingness to pay, one can conclude something fairly reliable about their "average" willingness to pay.

Throsby and Withers have conducted these experiments in Australia; West, assisted by Morrison, has conducted them in Canada.[24] Both studies were done carefully to avoid biases in question format that might overestimate public benefits of the arts. Comparisons were sought with other potential sources of similar benefits such as sports, and the distinction between total benefits and marginal benefits was drawn. The following results are among those reported by Throsby and Withers that refer to the level of national public support for the arts in Australia:

We note that 72 percent of respondents favored an increase in art outlays, which is precisely consistent with those who previously expressed accurate willingness-to-pay under no liability exceeded the current actual level of per capita assistance. Of these respondents, 80 percent preferred reduction in other government outlays, rather than increased taxes. . . . The mean level of support suggested by those favoring an increase, $43 per head, is less than the individual willingness-to-pay results from the earlier tables [in which less information was provided in the questions regarding current support levels relative to other services], but is still substantially greater than current assistance levels. . . . The weighted mean of the nominated levels of assistance across the whole sample assessed from this group of questions is about $32.50. [Current per capita support in Australia is about $6.00.][25]

Other answers to more nebulous, less economically interesting questions provide additional evidence that the arts generate sizable nonexcludable benefits to the general population. Fully 94.8 percent of respondents agree or strongly agree that "the success of Australian painters, singers, actors, etc., gives people a sense of pride in Australian achievement." Other substantial majorities agree that "the arts should not be allowed to die out," that "arts help us to understand our own country better," and that "it is important for school children to learn music, painting, drama, etc., as part of their education."[26] While these answers do not address the question of the optimal level of public arts support, they clearly substantiate the notion that the benefits from the arts are not limited to the direct consumption rewards of arts enthusiasts.

Important in understanding West's study done for the Canada Council is this distinction between the existence of public benefits and the degree to which there are any marginally relevant external benefits yet to be captured by further arts expansion. West asked whether respondents considered the $3.35 paid by each taxpayer in Ontario toward the support of the arts to be "too little," "too much," "just right," or "don't know." After dropping the "don't know" responses, he found that a bit more than 50 percent considered the level of support to be "just right." Over 40 percent, however, did believe that current support was "too little." In further exploring the views of those dissatisfied with public support levels, West discovered that the median preferred amount was between $6 and $9, with the median support of the particular subsample group who thought support was too low being close to $10. This last figure would require a tax increase of about $7 per person.[27] It is important to remember that while a majority did not support *more* funding, a sizable group would have been willing to pay about $7 per person for the arts.

The results also were mixed when a general attitude survey was conducted similar to that of Throsby and Withers cited above. For Canada, fully 40 percent of respondents could cite no specific external benefit from the arts. The highest positive response was that 20 percent cited "anticipated future use" of

the arts and 11 percent "welfare of future generations."[28] These results are clearly not as supportive of the arts as major providers of external, public benefits, as are those of the Australian experiment. Nevertheless, this type of research can provide direct evidence to elected officials about the magnitudes of relevant externalities.

SUMMARY

Economic analysis is an important tool for almost any public policy issue and will be until the law of scarcity is repealed.[29] It is helpful due more to the quality of the reasoning it requires than to the quantity of statistics it generates. There is nothing inconsistent about an argument that looks askance at the proliferation of arts impact studies, while at the same time supporting a more thorough analysis of the economics of the arts. It is the art of economics to be able to uncover those impacts that are unique and of value to the people who live in the nation's communities. The impacts uncovered by the multiplier income studies are important for their distributional effects, but not of great relevance to the question: "How many resources should be devoted to cultural enlightenment?" The pecuniary impacts are not especially unique nor especially useful or even favorable to the cause of a healthier arts industry.

Many questions yet are unanswered regarding the actual impact of the arts on the location of economic activity *within* communities, the number of arts institutions necessary to enhance the attractiveness of a city to mobile households (when do diminishing marginal returns occur, and have they already become zero?), the ability of the arts to tap revenues from ticket sales more creatively, the public's additional willingness to pay for the real external benefits the arts bestow, and the particular role of the arts in the infrastructure of a city at various stages of development.[30] There are indeed many impacts to be analyzed. Continuing studies of the motives of business firms who contribute to the arts might clarify further the degree to which the arts simply provide status to the contributor or actually add to the valuable human capital stock of a community.[31] If arts impact studies were to investigate these issues, there would be no complaint. The authors of these studies usually do mention how useful such further investigations would be before compiling yet another batch of ever more redundant spending flaws. It is time to recognize that there is little more to learn from those traditional impact studies. Their impact has been spent.

NOTES

1. David Cwi, "Models of the Role of the Arts in Economic Development," in *Economic Policy for the Arts,* ed. William S. Hendon, Alice J. MacDonald, and James L. Shanahan (Cambridge, Mass.: Abt Books, 1980), p. 311.

2. See, for example, Richard F. Muth, *Urban Economic Problems* (New York, N.Y.: Harper and Row, 1975), p. 41.

3. For further references to this literature, see James Heilbrun, *Urban Economics and Public Policy,* 2nd ed. (New York, N.Y.: St. Martin's Press, 1981), p. 169.

4. Jiri Zuzanek, "Recent Trends in Arts Participation and Cultural Spending," in *Economic Support for the Arts,* ed. James. L. Shanahan, William S. Hendon, Izaak H. Hilhurst, and Jaap Van Straalen (Akron, Ohio: Boekman Foundation, 1983), p. 114.

5. See C. D. Throsby, "Social and Economics Benefits from Regional Investment in Arts Facilities: Theory and Application," *Journal of Cultural Economics* 6 (June 1982): 1–14; C. D. Throsby and G. A. Withers, "Measuring the Demand for the Arts as a Public Good," in Shanahan, et al., eds., *Economic Support for the Arts,* pp. 37–52; and E. G. West, *Report to the Canada Council on Canadian Policy Towards the Arts* (Ontario, Canada: Ontario Economic Council, 1985), Chapter 8.

6. A marginally relevant externality is an external effect that is not only applicable to earlier provisions of a product but also extends to additional quantities of the product.

7. In Cwi, "Models of the Role," such issues as changing a city's image and retaining business for the downtown area are discussed in a separate section from that reviewing the results of impact studies. The lengthy list of speculations about the arts and development accumulated by James L. Shanahan, "The Arts and Urban Development," in *Economic Policy for the Arts,* ed. William S. Hendon, Alice J. MacDonald, and James L. Shanahan (Cambridge, Mass.: Abt Books, 1980), pp. 295–304, is provocative largely because these speculations have not been resolved by the mass of impact studies.

8. Economists themselves have been prime contributors to this interesting debate because they are so intimately aware of both the strengths and limitations of the subject. Among the many notable contributions, see the entire section, "Caveats to Cultural Economists," in *Managerial Economics for the Arts,* ed. Virginia Lee Owen and William S. Hendon (Akron, Ohio: Association for Cultural Economics, 1985), pp. 1–22. See also note 48.

9. *Atlanta Journal and Constitution,* July 29, 1985, pp. 1B, 8B.

10. *Atlanta Journal and Constitution,* October 28, 1985, pp. 1B, 18B.

11. *Profile,* brochure (Atlanta, Ga.: Georgia State University, Department of Public Information, October 14, 1985), pp. 1–2, citing a study done by Ellen Posey of GSU's Office of Institutional Research.

12. Port Authority of New York and New Jersey, Cultural Assistance Center, *The Arts As an Industry: Their Economic Importance to the New York-New Jersey Metropolitan Region* (New York, N.Y.: Port Authority of New York and New Jersey, 1983), p. 5.

13. From an interview of Wassily Leontief conducted by *Challenge Magazine,* "Why Economics Needs Input-Output Analysis," *Challenge* (March/April 1985): 32.

14. For a comprehensive and modern presentation of this new orientation, see Robert J. Barron, *Macroeconomics* (New York, N.Y.,: John Wiley and Sons, 1984).

15. David Cwi and Katherine Lyall, *Economic Impacts of Arts and Cultural Institutions: A Model for Assessment and a Case Study of Baltimore* (Washington, D.C.: National Endowment for the Arts, 1977), p. 17.

16. Ibid.

17. Ibid.

18. Port Authority of New York and New Jersey, Cultural Assistance Center, *The Arts As an Industry,* p. 66.

19. Ibid, p. 28.

20. Ibid, pp. 20–21.

21. Not all studies exert as much care as that of the Port Authority Study. Harry Hillman-Chartrand, in "An Economic Impact Assessment of the Canadian Fine Arts," in *The Economics of Cultural Industries,* ed. William S. Hendon, Nancy K. Grant, and Douglas V. Shaw (Akron, Ohio: Association for Cultural Economics,

1984), pp. 53–61, cites separate effects, among the many he identifies, for an "income multiplier effect" and the arts' "contribution to external trade." Regardless of the particular merits of that study, the overall conclusion was such a high-dollar impact that when West compared it to the Canadian Gross National Expenditure for 1980, he found that it constituted fully 5 percent of GNE! A similar performance by other industries would have sent Canada beyond any standard of living it has historically accomplished. See West, *Report to the Canada Council,* Chapter 8.

22. See the discussion in G. A. Withers, "Private Demand for Public Subsidies: An Econometric Study of Cultural Support in Australia," *Journal of Cultural Economics* 3 (June 1979): 532–561; and Bruce A. Seaman, "Economic Theory and the Positive Economics of Arts Financing," *American Economic Review: Papers and Proceedings,* May 1981, pp. 335–340.

23. Peter Bohm, "Estimating Willingness to Pay: Why and How?" *Scandinavian Journal of Economics* 81 (1979): 142–153.

24. See Throsby and Withers, "Measuring the Demand"; and West, *Report to the Canada Council.*

25. Throsby and Withers, "Measuring the Demand," p. 44.

26. Ibid., Table 1, p. 48.

27. Unpublished manuscript version of West, *Report to the Canada Council,* Chapter 8, pp. 17–18.

28. Ibid., Chapter 8, p. 21.

29. In the case of the arts, however, economists have been forced to extend the limits of welfare economics in recognition of the fact that a static approach, assuming tastes are being held constant, may be misleading when analyzing a product whose primary justification might be the enhancement and beneficial change in taste that accompanies its consumption. These fascinating efforts might be viewed as a more rigorous attempt to salvage the concept of "merit goods" from the junk heap of ad hocery. With some of these arguments, even a failure in the efforts to confirm substantial public benefits from the arts as supplements to the apparently too limited private benefits, would not doom the arts to decline. See especially Roger McCanin, "Optimal Subsidies in a Short-sighted World," *Journal of Cultural Economics* 6 (June 1982): 15–31; Roger McCain, "Cultivation of Taste, Catastrophe Theory, and the Demand for Works of Art," *American Economic Review: Papers and Proceedings,* May 1981, pp. 332–334, and Dana Stevens, "The Social Efficiency of Arts Addiction," in *Governments and Culture,* ed. C. Richard Waits, William S. Hendon, and Harold Horowitz (Akron, Ohio: Association for Cultural Economics, 1985), pp. 43–53.

30. For further discussion of these issues and some initial research results, see the papers in *The Arts and Urban Development,* ed. William S. Hendon; Bruce A. Seaman, "Price Discrimination in the Arts," *Managerial Economics for the Arts,* ed. Virginia Lee Owen and William S. Hendon (Akron, Ohio: Association for Cultural Economics, 1985) pp. 47–60; and Henry Hansmann, "Nonprofit Enterprises in the Performing Arts," *Bell Journal of Economics* 12 (Autumn 1981): 342-361

31. For a good survey of these issues, see *Virginia Lee Owen, "Business Subsidies to Urban Amenities," in The Arts and Urban Development,* ed. William S. Hendon; and G. D. Keim, Roger E. Meiners, and Louis W. Frey, "On the Evaluation of Corporate Contributions," *Public Choice* 35 (1980): 129–136, and associated further discussion, same volume, pp. 137–145.

Mark J. Stern and Susan C. Seifert ⎤

Re-presenting the City:
Arts, Culture, and Diversity
in Philadelphia

Diversity is an essential feature of urbanism. Since 1994, the Social Impact of the Arts Project of the University of Pennsylvania School of Social Work has sought to understand the ways that arts and cultural institutions in Philadelphia's neighborhoods contribute to the city's social fabric. A central theme of this work is the critical way in which urban diversity and cultural engagement support one another.

In 1938, when Louis Wirth wrote his classic essay on "Urbanism As a Way of Life," heterogeneity—along with size and density—defined urbanity. For Wirth, heterogeneity had wide-ranging, and often contradictory, impacts on the behavior of urban dwellers. "Social interaction among such a variety of personality types" tended to "break down the rigidity of caste lines." Diversity, thus, led city dwellers toward an "acceptance of instability and insecurity" that manifested itself in a distinct personality type, what Wirth called the "sophistication and cosmopolitanism of the urbanite."[1]

The heterogeneity of the population also had implications for identity and social organization. According to Wirth, urbanites do not have a single identity that is reinforced in all aspects of their lives. On the contrary, "by virtue of his [sic] different interests arising out of different aspects of social life," the individual acquires a set of disparate and often competing identities which are often "tangential to each other or intersect in highly variable fashion."

Urbanism and heterogeneity feed off two contradictory impulses. Depersonalization and anonymity often threaten the stimulation of diversity; the unlimited opportunities of the city are countered by the risks of predatory and manipulative behavior. "Cities . . . comprise a motley of peoples and cultures of highly differentiated modes of life between which there often is only the faintest communication, the greatest indifference, the broadest tolerance, occasionally bitter strife, but always the sharpest contrasts."

In his essay, Wirth pointed to several aspects of city life that are very much on the minds of contemporary opinion makers. On the one hand, Wirth saw heterogeneity and tolerance as essential to urban life. At the same time, he underlined to the problems of social organization and the role of social institutions in making the city's instability and insecurity acceptable.

At the end of the twentieth century, social institutions and heterogeneity remain important concerns, but their meaning and implications have undergone significant changes. Diversity and tolerance are even more prominent as issues today than they were six decades ago. However, in contemporary usage these concepts are less likely to acknowledge race or ethnicity as just one of many "membership[s] in widely divergent groups" that individuals acquire.

In this context, diversity takes on an entirely different meaning. Rather than representing tensions within an individual's identity, diversity happens at the borders of ethnic and racially homogeneous communities. Two decades ago, Ira Katznelson spoke of the "city trenches" upon which the racial battles of the 1960s and 1970s had been fought. Today, diversity is seen more often as an armistice along still existing trenches rather than a breaching of them.[2]

Ethnic and economic segregation continues to define contemporary representations of the city. Sociologists and geographers have made a strong case that segregation has persisted over the past two decades.[3] Certainly, in a city like Philadelphia, the level of economic and ethnic segregation still gives credence to the "city trenches" view of urban space.

The persistence of "city trenches" has implications for the contemporary interest in civic engagement. In recent years, a number of scholars have pointed to community mobilization as an important revitalization strategy. Yet, if we see strong geographical communities as a solution to many urban ills and at the same time accept their ethnic and economic homogeneity, are we not, to some extent, calling for a reinforcement rather than an abolition of city trenches? If cities simply remain aggregates of ethnically and economically homogeneous neighborhoods, won't strengthened communities preserve segregation?

BEYOND "CITY TRENCHES"

In this paper, we examine the links between civic engagement and ethnic and economic diversity in Philadelphia by analyzing the relationship of the geography of civic and community organizations to their socio-economic context. Specifically, we argue that arts and cultural organizations and engagement do not parallel divisions of race and social class; rather, they tend to concentrate in neighborhoods that are ethnically and economically diverse. Thus, arts and cultural organizations provide an opportunity to avoid the contradiction between support of community institutions and the reinforcement of segregation that baffles many contemporary urban theorists.

More broadly, the findings suggest that, at the same time that we acknowledge the dominant tendency toward increased segregation, we need to recognize the extent to which there are *zones of diversity* within the geography of segregation. We could view diverse areas of the city as "no man's lands" within a landscape of trenches. However, we propose an alternative. These zones of diversity are the *focus* of another view of the city, one in which heterogeneity is central to urban geography. Diverse neighborhoods and the social institutions that serve them provide an avenue for moving beyond the urban impasse, for reconciling our beliefs in community and cosmopolitanism.

Cultural policy and urban policy cannot afford to ignore the connections between diversity and cultural engagement. Arts and cultural institutions and engagement give identity to diverse urban neighborhoods. Community arts and cultural institutions are among the most prominent and numerous organizations in these neighborhoods. At the same time, diverse neighborhoods furnish a large part of the audience that supports regional and community cultural institutions. Finally, diverse neighborhoods with high levels of cultural engagement are often the engine of economic revitalization for urban communities.

Certainly, a different image of the urban life will not change the facts of poverty, conflict, and despair that characterize contemporary cities. However, as we seek to transform those realities, an effort to "re-present" the city with a focus on strengthening the neighborhoods and institutions that foster integration and diversity may point us in a more promising direction.

This paper grows out of our broader study of the connections between arts and cultural organizations, other types of community institutions, and the socio-economic context in which they operate. We wanted to find out:

> Where are arts and cultural organizations located in metropolitan Philadelphia? How is the geographical pattern of arts and culture compared to that of other types of social institutions? What neighborhood characteristics are related to the presence of arts and cultural and other types of social institutions? To what extent is the presence of particular types of institutions associated with the economic and ethnic diversity of a neighborhood? Do diversity and the presence of neighborhood cultural organizations influence regional cultural participation?

MEASURING DIVERSITY

We used four data sources to answer these questions: (1) the United States census tabulations for block groups in Philadelphia metropolitan region; (2) an "arts and culture data base," developed by the Social Impact of the Arts

Project, on nonprofit arts and cultural organizations within the metropolitan area; (3) a regional inventory of other types of community and social institutions: (4) a data base on levels of regional and community cultural participation in Philadelphia's census block groups.[4]

We used the census data to define two dimensions of neighborhood diversity. **Economic diversity** was measured using data on poverty and the percent of the working population in professional and managerial occupations. A block group was defined as economically diverse if it had a *poverty rate* higher than the median for the city of Philadelphia's block groups (17 percent) *and* if the proportion of the civilian labor force in *professional and managerial* occupations was above the median for the city's block groups (19 percent). **Ethnic diversity** was measured by examining the representation of African-Americans, whites, Latinos, and Asians within the block group. A block group was identified as homogeneous black or white if more than 80 percent of the residents were of that race. A Latino block group was one in which more than 40 percent of the residents were so identified. The remainder of the city was considered ethnically diverse.[5]

TRACKING VOLUNTARY ORGANIZATIONS

The arts and culture data base consists of a compilation of all known arts organizations in the five-county region (Southeastern Pennsylvania). The core of the data base is registered nonprofit arts and cultural organizations. The inventory includes as well unincorporated groups involved in the arts and humanities, including participatory groups, such as artists' collectives, choral groups, or community theaters. Finally, we include non-arts organizations—such as churches, recreation centers, or social service organizations—that provide arts and cultural programs to the broader community.[6] The data base includes variables on the location, size, and type of each organization and, wherever possible, its mission, activities and constituency. Approximately 1,200 organizations are included in the data base.

In order to compare arts and cultural organizations with other types of community and social institutions, we have developed an inventory of social organizations throughout the five-county region. The regional inventory contains approximately 15,000 organizations.[7]

MEASURES OF ORGANIZATIONAL ACCESS

We calculated the number of organizations within one-half mile of each block group in the Philadelphia metropolitan area as an index of organizational access. Based on these calculations, we used two measures of organizational presence:

Frequency. The number of social organizations within one-half mile of (the boundary of) the block group. Dominance. The proportion of all social organizations within that one-half mile area that are of a particular type.

This distinction proved to be important because of the finding that social organizations of all types tend to cluster in particular sections of the metropolitan area. Therefore, we must distinguish neighborhoods with many groups of a particular kind (frequency) from those in which a particular type composes a large proportion of all groups (dominance).

GEOGRAPHIC DISTRIBUTION OF ARTS AND CULTURAL ORGANIZATIONS

Metropolitan Philadelphia is home to approximately 1,200 nonprofit arts and cultural organizations and informal associations. We have identified an additional 200 groups that are engaged in culturally-related activities—such as, "friends of" cultural institutions or historical sites, historical and genealogical research, or historical reenactment.

As we would expect, Philadelphia's Center City (what would be called "downtown" in other cities) has the greatest aggregation of arts and cultural groups. People living in some sections of Center City have 225 cultural organizations accessible within one-half mile. At the other extreme are the roughly 20 percent of all block groups that have no cultural organizations located within one-half mile. Although many of these areas are located in the extreme outlying sections of the metropolitan area, the residents of some sections of the city itself have no cultural organizations within walking distance.

Although Center City is certainly the dominant concentration of arts and cultural organizations, more than 80 percent of the metropolitan area's cultural organizations lie outside of Center City. Neighborhoods to the north, south, and west of Center City are also home to many arts and cultural groups. For example, the Bella Vista neighborhood of South Philadelphia includes old time residents with more modest assets as well as newcomers who are more likely to be college-educated professionals or immigrants. Whites, African-Americans, and Asians all call sections of the neighborhood home. The neighborhood's cultural institutions—ranging from established organizations such as the Fleisher Art Memorial to newer organizations like the Philadelphia Folklore Project and the Traci Hall Dance Company—are actively engaged at promoting the necessary dialogue between different parts of the neighborhood. Farther from Center City, Broad Street in North Philadelphia is now home to a variety of African-American and Latino cultural groups, most notably the New Freedom Theatre.

Arts and cultural groups make up a large proportion of all social organizations in a variety of different neighborhoods. In a number of upper-middle

class suburbs—like Swarthmore—cultural organizations compose more than a sixth of all social organizations. In a set of ethnically diverse neighborhoods within the city—including Mount Airy and Germantown—arts and cultural groups make up more than a third of all social groups. In contrast, although the African-American neighborhoods of North Philadelphia are home for many arts and cultural organizations, the large number of churches, community improvement groups, and other social organizations often overshadow them.

GEOGRAPHIC DISTRIBUTION
OF ALL SOCIAL ORGANIZATIONS

In addition to arts and cultural organizations, metropolitan Philadelphia encompasses over 14,000 community organizations of other types. These range from churches and other religious institutions to social service agencies, neighborhood groups, and social clubs. The distribution of non-arts organizations is similar to that of arts and cultural organizations. Indeed, neighborhoods that have many arts and cultural groups almost invariably have a large number of other kinds of organizations as well.

Although neighborhoods with many institutions of one type tend to have many institutions of other types as well, houses of worship do stand out. Churches and other religious institutions, because they are present in virtually all sections of the metropolitan area, are not a strongly correlated with the presence of other types of organizations. Churches and other houses of worship are the most dominant type of institution across the metropolitan area. In over half of the block groups in the region, churches represent over 25 percent of all institutions.[9] Although churches and other religious institutions are present throughout the metropolitan area, they are the dominant institutions most often in the suburbs.[10] Inside the city, neighborhood improvement associations are most often the dominant institutions (about 32 percent of city residents live in a neighborhood in which these groups are dominant). Thirteen percent of city residents and 6 percent of suburban residents live in neighborhoods in which arts and cultural groups are dominant institutions.

NEIGHBORHOOD SOCIO-ECONOMIC
CHARACTERISTICS

Much of the literature on contemporary cities points to the abandonment of the poor urban neighborhoods by social institutions.[11] Yet, our analysis of the relationship of demography and accessibility of social institutions tells a very different story. Residents of neighborhoods with higher than average poverty, more high-school dropouts, higher unemployment, fewer homeowners, and fewer family households enjoy access to more social institutions than residents

of other neighborhoods. Neighborhoods with a higher proportion of African-Americans have more institutions than those that are predominantly white. Finally, neighborhoods with a higher proportion of young adults (ages twenty to thirty-nine) have more institutions of all types. When other factors are held constant, three factors show the strongest relationship to the total number of social institutions within one-half mile of a block group: the proportion of non-family households, of African-Americans, and of families living in poverty.

Although arts and cultural organizations are generally located in the same neighborhoods that have other types of institutions, there are two subtle differences. First, block groups with more college graduates and more professional or managerial workers are more likely to house arts and cultural institutions. Second, whereas African-American neighborhoods have the highest number of other social institutions, ethnically diverse neighborhoods have more arts and cultural institutions.

The striking feature of these patterns is that they challenge our conventional image of the city. Typically, in Philadelphia, a strong correlation with poverty implies a strong relationship with race. At the same time, there are few social phenomena that simultaneously have a strong relationship to high educational and occupational attainment and a high poverty rate. Furthermore, arts and cultural organizations are most often located near block groups that are racially diverse, rather than in those that are overwhelmingly white or black. More than other social institutions, arts and cultural organizations thrive in economically and ethnically diverse neighborhoods.

NEIGHBORHOOD DIVERSITY

We were surprised by the number of diverse neighborhoods in Philadelphia and by their importance for arts and cultural activity. We have found that more social organizations of all types are present in poor and African-American neighborhoods. Furthermore, arts and cultural institutions are more likely to be located in sections of the city that are both poor and have a high proportion of managerial and professional workers and in sections that have a mixed racial composition. Thus arts and culture locate in types of neighborhoods that are generally invisible in the dominant representation of the city.

Many of Philadephia's neighborhoods are economically diverse. Approximately 11 percent of all block groups (including 8 percent of the region's population) had more than 21 percent of their labor force in professional or managerial occupations and a poverty rate over 17 percent. Economic diversity is more common in the city than the suburbs; 17 percent of the city's population lives in economically diverse neighborhoods. Economic diversity,

although not the dominant fact of city life, is not as infrequent as common representations would lead us to believe.

Two types of neighborhoods compose the economically diverse sections of the city. Many predominantly African-American neighborhoods are economically diverse. In addition, a number of economically diverse sections of the city are also racially mixed with higher than average numbers of young adults, nonfamily households, and renters.

Many economically diverse neighborhoods are predominantly African-American. One consequence of the history of racial segregation is that many "middle-class" African-Americans continue to live in neighborhoods with high poverty rates. In Philadelphia, high rates of property ownership and the requirement that municipal employees live within the city has also encouraged African-Americans with white collar occupations to stay in economically diverse neighborhoods. The rowhouse neighborhoods of West Philadelphia, for example, are home to many poor people as well as to large number of municipal and other white-collar workers.

Minority neighborhoods that are economically diverse challenge the conventional image of concentrated poverty in the "inner city." Large sections of North and West Philadelphia, as well as smaller pockets in South Philadelphia, have poverty rates in excess of 40 percent. However, a third of all block groups in the metropolitan area with poverty rates over 40 percent are economically diverse. These areas, in spite of their high poverty rates, do not conform to an image of social isolation. North Philadelphia, for example, is not a homogeneous stretch of economic desolation but is honeycombed with neighborhoods with a higher than average number of professionals and managers.

We often overlook, as well, the amount of ethnic heterogeneity in cities like Philadelphia. True, 85 percent of the region's population lives in racially homogeneous neighborhoods, in which more than four-fifths of residents are members of a single ethnic group. However, within the city of Philadelphia, ethnic heterogeneity is significantly more prominent. Whereas 92 percent of Philadelphia suburbanites live in a racially homogeneous block group (of which 91 percent are homogeneous white), the proportion is only 77 percent within the city. Nearly one quarter of Philadelphia city residents live in an ethnically diverse block group.

Eleven percent of Philadelphians live in an integrated white/African-American neighborhood; five percent live in a Latino/African-American neighborhood; four percent live in a neighborhood with a significant Asian-American population; and three percent live in other diverse neighborhoods.

Diversity is a significant aspect of city life. Taken together, about one quarter (25 percent) of all block groups in metropolitan Philadelphia—home to 19 percent of the population—are either economically or ethnically diverse. Four percent of metropolitan residents live in a neighborhood that is both

economically and ethnically diverse. Within the city, 37 percent of all block groups (including 33 percent of the population) are diverse on at least one dimension. Seven percent of city residents live in a block group that is both economically and ethnically diverse.

NEIGHBORHOOD DIVERSITY, ARTS AND CULTURAL ORGANIZATIONS, AND CULTURAL PARTICIPATION

Economic and ethnic diversity matters because these "zones of diversity" are the institutional heart of the region. Although they are home to a small proportion of the region's population, diverse neighborhoods are home to more arts and cultural organizations as well as other social institutions. In addition, cultural participation rates are higher in diverse neighborhoods than in other sections of the city.

DIVERSITY AND THE LOCATION OF SOCIAL ORGANIZATIONS

Diverse neighborhoods are more likely to have many social institutions within one-half mile than more homogeneous neighborhoods. The average economically diverse block group has 175 groups of all kinds within one-half mile, compared to only fifty-seven groups in neighborhoods with below average poverty rates. Neighborhoods with concentrated or above average poverty, although they have fewer groups than diverse neighborhoods, have more social organizations than more prosperous neighborhoods.

The same pattern holds true for ethnically diverse neighborhoods. Predominantly African-American neighborhoods have many more organizations than predominantly white neighborhoods. However, integrated black/white neighborhoods and those with an Asian presence have even more groups. Neighborhoods that are both ethnically and economically diverse have, on average, 221 social organizations within one-half mile; ethnically and economically homogeneous neighborhoods have only sixty-five.

Diversity is even more strongly related to the presence of arts and cultural organizations. Whereas block groups with below average poverty have on average only five cultural organizations within one-half mile, the economically diverse sections of the region have nearly twenty arts and cultural groups. Block groups that are ethnically diverse generally have more organizations within walking distance than homogeneous neighborhoods. Finally, neighborhoods that are diverse economically and ethnically have twenty-seven cultural organizations within one-half mile, more than five times the average.

Arts and cultural organizations are more likely to be dominant in diverse neighborhoods. In neighborhoods with high or concentrated poverty, houses of worship and neighborhood improvement groups are the most common types of organization. In more prosperous neighborhoods (those with below average poverty), social and fraternal organizations and special interest, professional, and labor organizations tend to be most prevalent. Arts and cultural organizations are dominant in economically diverse neighborhoods. In ethnically and economically diverse neighborhoods as well, arts groups compose 10 percent of all organizations, nearly twice their proportion in homogeneous neighborhoods (5.6 percent).

Take the example of Mount Airy, a diverse section of Northwest Philadelphia. As Barbara Ferman, Theresa Singleton, and Don DeMarco have noted in their study of the neighborhood, Mount Airy developed a national reputation as a stable, integrated neighborhood after African-Americans began to move into the community during the 1950s. According to Ferman, Singleton, and DeMarco, one of the critical contributors to the maintenance of diversity in Mount Airy was the presence of strong community organizations committed to a vision of ethnic diversity. A number of cultural organizations, including the Allen's Lane Art Center, the Mount Airy Learning Tree (an adult education program), and the Sedgwick Cultural Center have been critical to Mount Airy's continuing legacy.[12]

Mount Airy is only the best known of the diverse neighborhoods in the city. The Olney section of North Philadelphia has experienced an explosion of diversity since the 1980s. In 1980, most of the neighborhood was homogeneous white with below average poverty. By the 1990s, a significant number of Latinos and Asians had made the neighborhood their home, and many block groups had become economically diverse. Urban Bridges, a church-affiliated community organization in Olney, has developed a variety of culturally-based interventions that pull together children and parents from the diverse segments of the community.

Our research shows that the "fit" between arts and cultural activities and diversity operates on two levels. For individuals, artistic and cultural expression provides a means of forging identity. For example, the Asian Arts Initiative collaborated with the Samuel S. Fleisher Art Memorial on a program that explored the dual consciousness experienced by many Asian-Americans.

At the same time, arts and cultural engagement provides a means through which inter-group conflict can be addressed. Taller Puertorriqueño—a distinguished arts and cultural center in Philadelphia's *barrio*—sponsored a series of programs on the relationship between African-Americans and Latinos in North Philadelphia. It used dialogues, performances, and visual art works to explore a set of issues that—in other settings—could lead to conflict and violence.

The connection between diversity and the presence of cultural organizations is critical to a uniquely urban quality of life. As one of our informants noted: "Quality of life is not how nice a house you have. It's the neighborhood you live in. Culture is such a broad thing—it's not just going to the ballet or the orchestra. It's all art, an experience of participation that moves you emotionally."

PATTERNS OF CULTURAL PARTICIPATION

Neighborhood economic and ethnic diversity and access to many local cultural institutions are strongly related to regional cultural participation. We used the participant data bases of over twenty-five regional cultural institutions to examine the socio-economic characteristics of neighborhoods with high levels of cultural participation. We found two distinct patterns of regional participation.

The most common pattern of cultural participation, which we call the *mainstream* pattern, identified parts of the city that had high levels of participation in the city's largest cultural institutions, like the Philadelphia Orchestra and the Philadelphia Museum of Art. The second pattern, which we call the *alternative* pattern, highlighted sections of the metropolitan area with high levels of participation among a set of newer and more experimental cultural institutions, including the Painted Bride Arts Center and the Wilma Theatre.

These two patterns of regional cultural participation were strongly correlated with the presence of arts organizations in the participant's neighborhood. Neighborhoods with many cultural organizations had an average of 120 cultural participants per thousand residents, more than twice the average for the metropolitan area.

The mainstream and alternative cultural participation patterns differed, however, on their socio-economic characteristics. Mainstream cultural participation was strongly related to economic status. Neighborhoods with high mainstream participation also had high median incomes and low poverty rates. In contrast, alternative cultural participation was strongest in economically and ethnically diverse neighborhoods.[13]

We also analyzed patterns of participation in community arts in four neighborhoods in the city. We found that nearly three-fourths of the participants in community arts programs came from outside of the neighborhood in which the program was located. Moreover, these outside participants were more likely to come from the diverse neighborhoods that also had high rates of alternative regional participation.[14]

Diverse neighborhoods are not simply the homes of many of the city's cultural institutions. They provide the audience for many of Philadelphia's regional cultural institutions and for community arts programs in other parts of

the city. These findings make a compelling case for improving the links between cultural and urban policy. Efforts to stabilize and strengthen cultural institutions in diverse neighborhoods of the city would help address issues of segregation at the same time that they could support the city's cultural sector. From another perspective, strengthening community arts institutions also helps build the audiences for regional cultural institutions.

THE SOCIAL IMPACT OF THE ARTS

We have presented a dizzying array of evidence on the distribution of social organizations across the five-county Philadelphia region. How do these findings affect our understanding of the role of social structure and civic engagement in contemporary Philadelphia?

First of all, at the same time that we acknowledge the forces of isolation and polarization, it is important to recognize that within the city there is a notable counter-tendency. More than one third of all city residents live in a block group that is either economically or ethnically diverse. An image that captures only *city trenches* gives an incomplete view of the realities of urban Philadelphia.

Secondly, urban neighborhoods are homes to a wide array of social organizations. The concentration of these institutions in neighborhoods across the city undercuts the notion that poor, minority areas are suffering from social isolation. Certainly there are profound social and cultural problems that disproportionately affect the poor communities of Philadelphia, but the paucity of social infrastructure is not one of them.

Finally, the intersection of economic and ethnic diversity and the concentration of social organizations provides a way out of the contradiction noted earlier in this paper: the conflict between the desire to dismantle economic and ethnic segregation and the desire to strengthen communities. Robert Putnam, in his widely cited book *Making Democracy Work*, uses the term "social capital" to refer to the role of social networks in building trust and cooperation between community members. Alejandro Portes and Patricia Landolt, in a response to Putnam, warn that a concentration of community organizations should not be seen as a self-evident good. Rather, in many cases, social capital has been used as a powerful force of exclusion and privilege. As Portes and Landolt note, "The same strong ties that help members of a group often enable it to exclude outsiders. Consider how ethnic groups dominate certain occupations of industries."[5] If all of the communities in the city were segregated by ethnicity and economic status, there would be no way to strengthen geographic communities without also reinforcing segregation and polarization.

Our analysis indicates that many social institutions fit Portes and Landolt's image. Social, fraternal, and veterans groups and special interest, professional,

and labor organizations tend to be concentrated in neighborhoods with low poverty and low minority representation.

However, two findings of the study counter Portes and Landolt's contention. First, there are a variety of integrated, heterogeneous neighborhoods in the city that are home to a large proportion of the city's population. Second, these neighborhoods are home to many of the city's social institutions. Neighborhood and community improvement groups and arts and cultural organizations, in particular, predominate in these diverse neighborhoods.

The current literature on social capital differentiates between *bonds* that strengthen the ties within a group or community and *bridges* that link different communities to one another. Cultural engagement builds both bonds and bridges.

Community cultural programs help build their local neighborhoods. This is demonstrated in a recent study we completed of Philadelphia and Chicago. In those two cities, neighborhoods with many cultural institutions—especially those in diverse neighborhoods—were far more likely to experience declining poverty during the 1980s. Although some of this is attributable to processes of gentrification, the vast majority of it occurred in neighborhoods that remained ethnically stable. Not only do arts and cultural institutions improve the quality of community life; they appear to serve as a catalyst for neighborhood revitalization.[16]

At the same time, cultural institutions and participation build bridges. In contrast to a community development corporation or civic association, cultural organizations draw people from local neighborhoods and from the wider region into some of the city's poorest neighborhoods. In a society with so few connections between the rich and poor and among different ethnic groups, this quality alone underlines the unique contribution that cultural institutions can make to American society. If we want to strengthen urban communities and address issues of economic polarization and racial segregation, we would be well advised to focus on those social institutions that are currently serving the "zones of diversity" within the city.

To do so has the potential to change more than communities. The development of boundaries is a powerful force in shaping perception and identity. We can differentiate *us* from *them* only by drawing a boundary between us. Unless we question the reality of "city trenches," we help to strengthen them. From another perspective, if we see the reality of diverse neighborhoods and the importance of the cultural institutions that call them home, we challenge dominant beliefs about the limits of urban revitalization. What if the diverse sections of the city were viewed—by public officials, funders, and the general public—as central to social life, rather than as marginal to it? This gestalt could alter our perception of urban reality and, by influencing our actions, help to transform that reality. It might help us "re-present" the

city in a new way, one that leads out of the impasse in which urban policy is now entrenched.

Sixty years ago, Louis Wirth framed quite precisely the dilemma of urban civic engagement. City residents are attracted to the heterogeneity of social life that allows for the development of multiple identities but are required to live in homogeneous neighborhoods defined by race and class. As a result, individuals have been forced to accept a predominant identity, defined by their place of residence, which squelches their potential for growth and change. We have ended up with involuntary "communities" that distort individual identity on the one hand and breed apathy on the other.

The solution to this conundrum does not come from the suppression of individuality that some latter-day communitarians have suggested.[17] Rather, we contend that it lies in undercutting the structures that enforce a system of involuntary segregation and strengthening those that promote community engagement in *communities of choice*. Then, we may be able to construct a vision of urbanism that is worthy of a new century.

NOTES

1. Louis Wirth, "Urbanism As a Way of Life," *American Journal of Sociology* 44 (July 1938): 1–24.
2. Ira Katznelson, *City Trenches: Urban Politics and the Patterning of Class in the United States* (Pantheon Books, 1981).
3. Douglas Massey, for example, first in *American Apartheid* (co-authored with Nancy Denton) and then in his recent presidential address to the American Population Association, has argued that residential segregation along ethnic and class lines is stronger than ever, not only in the United States, but internationally. Douglas S. Massey and Nancy A. Denton, *American Apartheid: Segregation and the Making of the Underclass* (Cambridge: Harvard University Press, 1993).
4. The block group consists of an aggregation of approximately six to eight (6–8) city blocks. The five Pennsylvania counties of metropolitan Philadelphia include approximately 3,600 block groups, about half of which are within the city of Philadelphia. For more details on the data, see Social Impact of the Arts Project, *Report to the William Penn Foundation* (April 1998) and the SIAP website: http://www.ssw.upenn.edu/SIAP.
5. These diverse block groups were subdivided into those that were black and Latino, black and white, other diverse block groups in which more than 10 percent of the population was Asian-American, and other diverse block groups.
6. Data on arts and cultural organizations were drawn from a variety of sources, including city and state cultural agencies' grant applications, the Greater Philadelphia Cultural Alliance and state cultural directories, the IRS nonprofit master file, and listings in newspapers and magazines. We included religious institutions that sponsor a specific cultural program, such as an afterschool program, but not church choirs and similar groups.
7. For the present analysis, organizations in the regional data bases were classified into seven major categories: (1) arts and cultural organizations; (2) culturally-related associations and groups (such as, historical reenactment, mummers clubs, "friends of" cultural institutions or historic sites); (3) neighborhood improvement groups (such as resident and civic associations, town watch, community councils); (4) houses

of worship (churches, synagogues, mosques); (5) youth and social service organizations (including youth organizations, social service organizations, and volunteer fire and ambulance associations); (6) social and fraternal organizations (including social clubs, fraternal organizations, religious clubs and orders, and veterans' organizations; (7) special interest, professional, business, and labor organizations.

8. Although the scale of block groups provices a high degree of precision in describing the socio-economic profile of the metropolitan area, it poses a difficulty in assessing organizational access. In many cases, the location of community organizations is constrained by zoning and the availability of office space. The presence of particular kinds of organizations *within* a block group, therefore, is not an accurate measure of accessibility to the residents of that block group. For example, one block group that includes a commercial strip may be home to a number of organizations while an adjacent block group, composed solely of residential properties, has none. An analysis that treated the former as having access to a high number of organizations and the latter as having no access would be misleading.

 To remedy this problem, we used a geographical information system to aggregate the number of organizations of particular types that are within one-half mile of a particular block group. Thus, each organization was counted in every block group within one-half mile.

9. Arts and cultural activities that are part of religious observances—like church choirs—are not captured by our data. Other research, including the Surveys of Public Participation in the Arts conducted for the National Endowment for the Arts and the Social Impact of the Arts Project's survey of community participation, confirm the important role that arts and cultural activities play in many churches. See Mark J. Stern and Susan C. Seifert, "Working Paper#7: Cultural Participation and Civic Engagement in Five Philadelphia Neighborhoods" (unpublished manuscript available at http://www.sse.upenn.edu/SIAP).

10. A particular institution is defined as dominant if its proportion of all institutions accessible to a block group is twice as large as its proportion of institutions across the entire metropolitan area. For example, for a neighborhood to be defined as having houses of worship as dominant, 52 percent of all organization accessible to that block group would have to be houses of worship.

11. William Julius Wilson, *When Work Disappears: The World of the New Urban Poor* (New York: Alfred A. Knopf, 1996) is representative of this literature.

12. Barbara Ferman, Theresa Singleton, and Don DeMarco, "West Mount Airy, Philadelphia," *Cityscape: A Journal of Policy Development and Research* 4:2 (1998): 29–61. The article was part of a special issue on "Racially and Ethnically Diverse Urban Neighborhoods" edited by Phillip Nyden.

13. Mark J. Stern, "Working Paper #6. Dimensions of Regional Arts and Cultural Participation: Social Status and Neighborhood Institutions' Influence on Rates of Participation in the Philadelphia Metropolitan Area," (September 1997). Available at http://www.ssw.upenn.edu/SIAP.

14. Mark J. Stern, "Working Paper #8. Community Revitalization and the Arts in Philadelphia" (December 1997). Available at http://www.ssw.upenn.edu/SIAP.

15. Alejandro Portes and Patricia Landolt, "The Downside of Social Capital," *The American Prospect* 26 (May–June, 1996): 19. For a more theoretical view on social capital, see Alejandro Portes, "Social Capital: Its Origins and Applications in Modern Sociology," *Annual Review of Sociology* 22:1 (1998): 1–24.

16. Mark J. Stern, "Working Paper #9: Is all the World Philadelphia: A Multi-city Study of Arts and Cultural Organizations, Diversity, and Social Capital," (unpublished manuscript, March 1999).

17. Amitai Etzioni, *The Spirit of Community: The Reinvention of American Society* (New York: Simon and Schuster, 1993).

New Policy Frontiers

CULTURAL POLICY OPTIONS IN
THE CONTEXT OF GLOBALIZATION

DEMOCRATIZATION IN
THE NATIONAL PERSPECTIVE

This chapter attempts to understand how cultural policies can be revised in relation to the structural changes that have occurred in recent years in states, cultural markets, and social movements. We shall confine the analysis to three changes: (a) the recomposition of national cultures through the advance of globalization and regional integration; (b) the predominance of the mass communication industries over traditional, local forms of production and circulation of culture, and (c) the new conditions generated by these changes for democratization and multicultural cohabitation.

In the first and second sections I shall present a description of the principal patterns of change. I shall then analyse some cultural policy options that have been developing in recent years, taking into account these end-of-century trends.

One way to focus the changes that have transpired in recent decades is to compare the lines of cultural policy thinking in the 1970s and 1980s with the current situation. In short, until a few years ago cultural policies were considered to mean all the action taken by the state, private institutions and community associations to orientate symbolic development, satisfy cultural needs within the nation and obtain a consensus around a form of order or social change (Brunner, 1989; Fabrizio, 1982; Martin Barbero, 1995; Mattelart, 1991).

In the countries of Europe and Latin America, and in many African and Asian countries which have recently gained independence, nation-states were the main protagonists of cultural policies. States were considered responsible for the administration of the historic heritage, material and immaterial, from major monuments to manifestations of popular culture (language, music, traditional celebrations, and dance), i.e. the distinctive features that differentiate

one nation from another. The modern states achieved certain successes in unifying different ethnic groups and regions in a national heritage they more or less shared. In some countries this national cohesion hinged almost exclusively on the culture of the elite, of European origin, which the state endeavoured to transmit to the rest of the population through the school system. In others, like Mexico, Bolivia, and Cuba, with different strategies, elements of popular culture were included in this policy. In this way many governments promoted the study and rehabilitation of archaeological sites and historic city centers, opened museums, and produced publications designed to keep the memory of the past alive and disseminate it—all with a view to strengthening the common identity. Before the mass media and tourism, such measures succeeded in helping ethnic crafts, music and some regional knowledge to transcend their purely local dimension. In Mexico, for example, the joint dissemination of Tzotzil textiles, mural painting, Purepechan and Mixtec pottery and the Mayan pyramids formed a united iconographic repertoire that was seen, inside and outside the country, as representative of Mexican culture.

Modern art (plastic arts, literature, music) and the mass media also received support from the state which owned radio stations and television channels, publishing houses and film production units. Even in countries where this was not the case, the arts and the mass media were studied and administered as part of the national culture. Avant-garde groups endeavouring to transcend the local context were identified with specific countries, as if national profiles served to define their projects of renovation: Russian constructivism, American pop art, Italian neo-realism, and the *nouveau roman* in France.

The cultural policy debate analysed whether the many groups, ethnic communities, and regions were sufficiently represented in each national heritage, or whether states, in the organization and administration of their heritage, excessively reduced their local specificities to politico-cultural abstractions in the interest of social control or to legitimize a certain form of nationalism. There was also a controversy throughout the twentieth century over how to reconcile the traditional and the modern, how to disseminate cultural goods and messages in a more equitable manner and involve different sectors in their creation and appropriation. The positions defended by the different policies over the decades were called "statism," "populism," "nationalism," "cultural democratization," and "participative democracy" (Arantes, 1984; García Canclini, 1995; Vidal Beneyto, 1981). These terms expressed differences in cultural policies, but generally concurred in setting the debate within the national horizon and acknowledging the leading role played by the state.

In some countries, particularly the United States, private initiatives had always played an important part in the development of education and culture. Mainly, however, they promoted the arts and literature, through patronage and in keeping with the ideals of altruism and freedom to create in the fine arts. Of course the donors sought prestige and other, not necessarily symbolic,

recompenses, while claiming to support creative artists out of pure generosity, for no other purpose than to foster spiritual development (Becker, 1988; Moulin, 1992). Private patronage of the arts gradually reorganized with the growth in purchasing power of the middle classes and the emergence of art markets and specific audiences, leading to the establishment of independent fields for the arts and literature (Becker, 1988; Bourdieu, 1979). Foundations led by individuals or families sustained and continue to sustain the more costly activities or those least able to finance themselves (theater, opera, biennial exhibitions), without their financial contributions affecting the independence of the artistic research. Sometimes this notion of patronage of the arts has influenced state policies (grants, subsidies), but in general it has been prevalent mainly in the private sector.

The third category of promoters of cultural policy is composed of independent organizations: associations of artists, communicators, and cultural organizers, NGOs, neighborhood organizations or groups representing so-called civil society. Their actions are almost always altruistic in terms of financial gain, and differ from patronage of the arts because they are not motivated by the tastes of privileged individuals but by a collective conception of culture that links it with the aesthetic needs and practices of the receivers or users; their limited funds in relation to these needs, or the voluntary work they do, and the importance they generally attribute to local lifestyles mean that their policies focus on restricted areas. As José Vidal Beneyto (1981) has said, in these cases cultural policy "aims more at the activities than at the works, more at participation in the process than at consumption of the product" (p. 128). This line of work gradually increased on every continent, especially in Africa, Asia, and Latin America, with the processes of political and social democratization. It has been adopted by international organizations (UNESCO, OAS), and various foundations, and their cultural work undoubtedly favors the formation and organization of popular groups in defense of their rights to document their living conditions and their creativity. But these essentially local actions are no substitute today for the state; nor do they counterbalance the growing privatization of the public sector.

DETERRITORIALIZED CULTURES

These three sides of cultural policies still exist, and to a large extent their action continues to have meaning within national societies. A large proportion of production in crafts, arts, and the media continues to express national cultural traditions, and circulates only within the country concerned. The visual arts, literature, and increasingly the electronic media continue to fuel the imagination of each nation; they are the scene of consecration and communication for artists, expressions and signs of regional identities.

However, an increasing sector of cultural production is taking on an industrialized shape, circulating in transnational communication networks, being received by the consuming masses, who are learning to be the audiences of deterritorialized messages: what Brazilian anthropologist Renato Ortiz calls "an international popular folklore." These international communities of spectators reduce the importance of national differences. The younger generations in particular live their cultural practices in accordance with homogenized information and styles that are received by different societies independently of their political, religious, or national context. Consumers from different social backgrounds are able to read the messages of a multi-locational imagination projected by television and advertising; Hollywood movie stars, pop stars, the works of famous painters, sports champions and politicians from different countries compose a repertoire of ever available signs.

The changes that have occurred since the middle of the century, especially since the 1960s, may be resumed in the difference between internationalization and globalization. The internationalization of economies and cultures, which has marked the whole of the modern era, consists in opening the geographical frontiers of each society to messages and goods from other countries. A period of globalization, on the other hand, is marked by functional interaction between different economic activities and cultures, generated by a system with many centres, where speed in reaching other parts of the world and strategies for attracting audiences are more decisive than the inertia of local traditions (Appadurai, 1990; Arizpe, 1996; Castells, 1995; Hannerz, 1992; Ortiz, 1994).

This process is doubtless most apparent in the electronic communication networks. To a certain extent, however, it spans almost every area of cultural development, including the traditional arts and crafts. As a result, it redefines the roles of the various protagonists we have mentioned: states, private initiative, and independent organizations.

To realize just how far we have come in only two decades we need only remember that twenty years ago one of the key dilemmas in cultural policies was the extent to which imported products and messages should be accepted, interaction with international trends in art and thinking should be encouraged and endogenous creation should be protected and promoted. African and Asian artists, whose countries were emerging from long periods of colonization, and Latin American artists who were endeavouring to keep up with the cosmopolitan modernization and at the same time the independent industrial development of their societies, felt new options opening up between the local and the remote. Some opted to integrate the innovations of the international avant-garde into their local cultures, while others believed that symbolic customs barriers should be set up to control the "invasion" of foreign cultures and each nation should invest its resources in strengthening its own

independent progress. These options, taken to their extreme, have become less viable because of the technological, economic, and symbolic changes in cultural market structures. But the alternatives continue to have a certain echo in the present conditions. We shall now look at how processes are reorganizing in three fields: the plastic arts, literature, and the communication industries.

The Post-National Visual Arts

The visual arts began to be absorbed in the process of globalization in the 1980s, as the market for the works produced and expanded, prices rose and exhibitions and auctions became the scene of heavy investment. A minority of artists, although they numbered several thousand among the forty or fifty countries that made up the international market, formed a system of rivals manipulated by galleries based in cities on different continents: Buenos Aires, London, Milan, New York, Paris, São Paulo, and Tokyo. These galleries, allied with the main museums and international magazines, controlled the world market in a concentrated form. Towards the end of the 1980s, Sotheby's and Christie's accounted for almost three-quarters of the public sales of art. Although Sotheby's capital is predominantly American, giving the impression that the United States plays a hegemonic role in the art market, the firm has auction houses in fourteen countries, and has opened offices in over a hundred countries on every continent (Moulin, 1994). Other firms, of lesser stature, also have multinational structures, giving their operations a financial and aesthetic versatility that enables them to react to movements, artists, and audiences in different societies. The more or less simultaneous circulation of exhibitions, or at least of information about them, in museum networks in different countries and in international fairs and exhibitions in which the marks of individual countries have less and less importance, and the media impact of art events, have reduced the national character of creative productions.[1]

The traces of national artistic frameworks are still to be found in those countries which used their cultural policies to strengthen their national identities and mark their international diplomacy: France and the United Kingdom, which now account together for no more than 15 percent of all public operations on the world market, have lost some of their aesthetic leadership and organized fewer exhibitions in the 1990s. At the same time, the prosperity of the industrial countries of South-East Asia and the legislation through which they encourage public and private patronage of the arts has boosted the opening of museums in these countries, which acquire large quantities of works from Western and Asian countries alike. Japan, for example, in 1989 alone, imported almost two billion dollars' worth of works of art. And Hong

Kong and Singapore have become centers of international art fairs and exhibitions which attract artists from all over the world.

It should be noted that the global reorganization of artistic development is not based on economic considerations alone. The fact that the art market no longer functions as a juxtaposition of national markets but has its own worldwide structure is important, but this reorganization of the market could not take place if the museums, publishers, and academic circles which influence aesthetic values and the prestige of the artists and experts who consecrate them, did not also function on a global scale. The best-known critics and artists are not the product of a national context or a long stay in a major city, or a leading university or museum, but rather of the ability to move flexibly between numerous centers on every continent. Transfrontier relations are becoming more decisive than national representativity, and multicultural alliances more important than identification with a particular culture: it is to the artists, critics, galleries, and museum experts who combine the local with the global that we might apply the term "glocalize," coined by the Japanese businessmen to denote the ductility of those who combine the distinctive features of the different cultures in which they are active with the new global culture, i.e. that which governs both the plastic arts and the iconography produced for circulation via the transnational audiovisual and electronic communication media. In these conditions, cultural policies must consider the promotion both of national museums and of international exhibitions, and the relationship between their own national historic and artistic heritage and the global circuits on which the works are exhibited, traded, and appreciated.

The Publishing Industry

One field in which the difficulties experienced by national cultural production and the complexity of its interactions with the transnational markets are particular manifest is the production of books, magazines, comics, and *fotonovelas*. I shall take as an example what is happening in the Latin American countries, particularly Mexico, and the reorganization of their ties with Europe and the United States.

Argentina and Mexico developed prosperous publishing industries in the twentieth century. Partly under their own economic and cultural steam and partly with the help of Spanish exiles, they published a profusion of works written in their own societies, in other Latin American countries and in Spain. They also published translations of works by numerous European and American authors and some Asian authors between 1940 and 1970. It was in this field that Latin America made a successful contribution in economic, literary, and journalistic terms to the international circulation of cultural goods.

The decline of the region's economies over the last two decades and the

simultaneous rise of Spain changed this picture. Publishing houses and book-shops closed and many newspapers and magazines went bankrupt or reduced their size in almost all the countries of Latin America. Some 400 publishing houses in Mexico went bankrupt from 1989 onwards, and among the survivors less than ten which are nationally owned publish more than fifty works per year (Citesa, Era, Esfinge, Fernández, Fondo de Cultura Económica, Limusa, Porrúa, Siglo XXI, and Trillas). The global increase in the price of paper, compounded by the devaluation of the Mexican peso, is one of the reasons for this downturn. Others include the general fall-off in consumption as a result of the impoverishment of the middle and working classes and the transformation of books into simple consumer goods, depriving them of the customs and tax incentives they previously enjoyed.

Can the development of free trade help to revive publishing in Latin America? Strictly speaking, the liberalization of trade in this field began in Mexico twenty years ago. Spanish publishers in the main took advantage of this opening to sell their products on the Mexican market and to form associations with Mexican publishers or take them over. Because of the common language and cultural traditions, Spain still seems to be the commercial partner most likely to benefit in the future. Although the situation has become more complex with the 'Europeanization' of the Spanish publishing industry, several publishers in Madrid and Barcelona which had taken over Mexican publishers were themselves absorbed in the 1980s by publishers in other countries of Europe (Anaya acquired Alianza, Labor, and Nueva Imagen, Mondadori took over Grijalbo, and Planeta absorbed Ariel and Seix Barral).

Changes were also brought about by the Free Trade Agreement between Mexico, the United States, and Canada, which took effect in 1994. As I explained in greater detail in a recent book (García Canclini, 1996), several United States publishers, such as McGraw-Hill and Prentice Hall, have entered the Mexican market with dictionaries, secondary school and university text books and "personal improvement" books. Some publishers believe that the future impact of the North American industry will be felt not so much in the generation of new publishing houses as in the production process: paper, machines and, as is already happening, high-quality publications (color, glossy paper), areas in which they have the necessary infrastructures and skilled staff.

But other Mexican publishers who have cultivated relationships with the United States in recent years have a different outlook. There is reason to believe that the closer relationship between the American and Mexican publishing markets may lead to as many changes in the publishing market in the United States as in Mexico. The novel by Mexican author Laura Esquivel, *Como auga para chocolate*, sold over a million copies in English, plus 200,000 in Spanish, in the United States. Books by Gabriel García Márquez, Carlos Fuentes and Julio Cortázar in Spanish are starting to sell in Price Club and

other self-service stores in New York, California, and Texas. It is not surprising, says Sealtiel Alatriste, director of the Spanish Santillana group in Mexico, that for the first time there is a market in the United States for Spanish-language authors and their rights. Just as the Latin music section has grown in size in Tower Records and other important chains, the best-selling titles of Spanish origin take pride of place alongside the best-sellers in English. Chicano writers attribute this success to the "Latin phenomenon" which has been given frequent attention in *Time* and the *New York Times Book Review*: the initial successes of Sandra Cisneros with *The House of Mango Street* and Oscar Hijuelos with *Los reyes del mambo traen canciones de amor*, which won the Pulitzer prize, has spread to other novels in recent years. The interaction between the mainstream and the marginal is becoming less straightforward, more complex than in the past. The "Americanization" of Latin America is offset, to a certain extent, by the Latinization of the United States.

This does not mean, however, that the development gap or the uneven balance of resources between the two regions is levelling out. And while they take advantage of the new opportunities offered by the North American market, some observers, such as Sealtiel Alatriste, wonder what will happen if the American publishing industry decides to launch into full-scale competition with Mexico: their technology, production costs, and computerized data banks "will destroy the Mexican industry, which is not ready at this level."

How are Mexican books faring in Latin America, their "natural" market because of the language, the shared historical interests, and the consumer patterns of the readers? Sales have decreased because of economic and political difficulties throughout the region. The only country where the government is determined to promote the publishing industry is Colombia: the Book Law enacted in 1993, exempting resident publishers from taxes for twenty years and guaranteeing the purchase of 20 percent of all their production by libraries, is boosting the development of a thriving publishing industry, with transnational capital and increasing export potential.

In these conditions the proposals of Cerlalc, the UNESCO organization for Latin American books, on the measures needed to strengthen exchanges within the region by something along the lines of a "Latin American common market for books" remain valid: exempt inputs for the book sector from taxation (and in particular free transit for films with editorial content); encourage the importation of equipment for the graphic design industry; reduce costs through large print-runs and more intra-regional co-productions; do away with customs barriers and other levies on the circulation of books; improve and cut the cost of transport (by air, sea, and post); introduce incentives to export and credits for importing books; adhere fully to the international conventions on intellectual property rights; define national book policies; harmonize the corresponding legislation; and create steering bodies on which the social and private interests in the publishing sector are represented.

Television, Films, and Video:
Toward a Multimedia Culture

Much has been said and written about the "death of the cinema," but the figures reveal that more films are seen nowadays than ever before. The difference is that nowadays people watch films at home, on the television or on tape. More than thirteen million of Mexico's twenty million homes have television sets, and over six million have video recorders. There are some 9,500 video clubs throughout the country, including popular districts and rural areas. A similar expansion in the audiovisual entertainment sector is observed in the other countries of Latin America, although in some cases—the most noteworthy being Argentina—cable television is becoming the most prosperous growth area: at present 60 percent of homes there are cabled.

Generally speaking, Latin America is poorly placed where production for these new communication services is concerned. The export situation is even worse. Latin American countries broadcast more than 500,000 hours of television per year: in Colombia, Panama, Peru, and Venezuela there is more than one video recorder for every three households with television sets, which is more than in Belgium (26.3 percent) or Italy (16.9 percent) (Roncagliolo, 1996). Latin America is underdeveloped in terms of domestic production for the electronic media, but not in terms of audiovisual consumption.

This imbalance between the low level of audiovisual production and the high level of consumption is reflected in the poor representation of the national or Latin American cultures on the small screen, and an overwhelming presence of entertainment and news made in the United States. But the extent of the imbalance varies from country to country. Like Rafael Roncagliolo, we must distinguish between the exporting countries and the importing countries. Only two, Brazil and Mexico, are "part of the global economy of cultural goods, with giant audiovisual enterprises in Red Globo and Televisa respectively."

> Globo is basically an exporter of audiovisual products, and has placed Brazil in fourth place as a producer and third place as an exporter of audiovisual products, but it has not transnationalized its production; Televisa, on the other hand, acts as a genuine transnational corporation in the region, purchasing channels and internationalizing its production activities. (Roncagliolo, 1996)

Then there are a few "incipient exporting countries," such as Argentina and Venezuela, and to a greater extent Colombia, Chile, and Peru. As the same author says, these intermediate countries are in the second line when they attempt to accede to liberalization and integration. "Their situation is ambiguous, since on the one hand they are in search of markets for their cultural

production, and on the other they have to defend themselves against penetration not only by corporations from outside the region but also from the Latin American transnational corporations themselves, such as Televisa."

The other countries are "net importers," importing virtually all their programs from the United States. Note, however, that even where domestic production is healthier, as in Brazil, Mexico, and Argentina, more than 70 percent of films and series are imported from the United States, and American programs occupy more than 50 percent of prime time. National production is devoted essentially to news programs, covering current affairs, subjects of direct interest to the viewers, while a larger proportion of imported products is found in the entertainment sector.

The imbalance between domestic production and the increasing consumption of imported programmes continues to grow as the "conventional" mass media (radio, cinema, television) join the communication highways. In addition to this process of technological concentration, the monopolistic reorganization of the market is subordinating national circuits to transnational production and sales systems.

All this is important not only because of its cultural significance. The communication industries are among the most dynamic economic agents and the principal generators of investment and employment; so they are a key factor of development and multicultural exchanges. Knowing who will run these networks in the years to come is therefore a vital question. The audiovisual production of news and entertainment is mainly in the hands of the United States, while 70 percent of worldwide electronic consumer goods are controlled by Japanese firms.

While these two nations lead the field, however, the report by the World Commission on Culture and Development entitled *Our Creative Diversity* points out (p. 27) that British pop groups, Japanese cartoons, Venezuelan and Brazilian *telenovelas* and Kung Fu films made in Hong Kong also have worldwide audiences, and Indian films are widely screened in the Arab world. Be that as it may, most of the developing countries are in a disadvantageous position on the world market.

Even Europe is almost as ill-prepared as the peripheral nations to face this reorganization of culture around the media. Not only is the level of its production and technological innovation low, but only a few small countries— Belgium, Ireland, the Netherlands, Switzerland, and the Scandinavian countries—have developed cable television. In France, Greece, Portugal, and Spain cable only began to grow in the 1990s (Miège, 1993).

Recent European Community documents reveal an imbalance in its trade with the United States in the communication sector comparable to that of Latin America. The current deficit in this sector is $3.5 billion. According to Miquel de Moragas, Europe's deficit in audiovisual consumption will grow from 23,000 million ecus in 1993 to 45,000 million in the year 2000. "While

Europe consumed 650,000 hours of television programs in 1993, the figure will be 3,250,000 hours per year by the year 2000. But instead of the European industry, this spectacular growth looks set to benefit the United States, which sold Europe programs to the value of 300 million dollars in 1984, rising to 3,600 million in 1992" (De Moragas, 1996).

The cultural changes brought on by the communication technologies, together with other internationalization and globalization trends in production and consumption, migration and tourism, are causing almost all societies to interact simultaneously. Until fifteen or twenty years ago, attempts were made to control the challenges of these flows of communication between societies by setting quotas for the air-time devoted to the broadcasting of foreign and domestic productions in each country: an obligation, for example, for television channels to screen 50% of domestic films, or for radios to broadcast an equivalent percentage of domestic music.

These controls proved impractical for various reasons: (a) the deterritorialization of artistic production, which reduces its ties with any particular country (films, *telenovelas* and many musical shows are designed as co-productions between several countries and based on international urban cultural features), and (b) the technological facilities for broadcasting media messages all over the world, the rising cost of film- or record-making, which makes it difficult to recoup one's investment in a single country, and the monopolistic concentration of production and distribution in the hands of powerful multinational corporations.

As a result, in the 1990s certain European countries adopted other protective and promotional measures, not only for domestic but also for European productions. Spain introduced a law in December 1993, for example, based on production and distribution conditions in the region, requiring movie theatres in cities of over 125,000 inhabitants to screen 30 percent of European films. The law was amended when the Partido Popular came to power, but this progression from national to regional protective measures could be applied in other parts of the world. The promotion of regional markets for cultural goods is ineffective unless comparable protective measures are taken to protect distribution and consumption. Similarly, the measures should be applied not to each medium individually—different policies for television, films, and other electronic media—but to the media as a whole, taking into account the multimedia reorganization of the audiovisual sector. This, of course, means coordinating and perhaps merging the bodies responsible for films, television, video, and other communication sectors.

END-OF-CENTURY OPTIONS

The analysis of these three fields shows that cultural policies can no longer be approached as intranational policies implemented essentially by national gov-

ernments. At the same time, however, the complex interactions between the local, the national, and the global mean that the globalization process cannot be considered merely in terms of homogenization of the world's cultures. Nowadays any new approach to cultural policy must take at least two questions into account: the first is how many forms of homogenization are currently being developed by globalizing policies as they take on the different cultural production technologies and their communication circuits, and link up with the different communities of consumers? The second is how many artists, cultural middlemen, and consumers is each of these transnational homogenization policies capable of incorporating, and how many will be left out?

We have already seen that globalization is proceeding amidst the asymmetrical interdependence of the world system. We must now add that in order to homogenize, it uses the historical multiculturality of societies and builds new forms of multiculturality. The same globalizing process that integrates also segregates and stratifies. Lawrence Grossberg wrote that globalization is a "stratifying machine" that not only erases differences but reorganizes them to produce new stratifications or divisions linked less to territories than to market distribution.

In addition to the ethnic and regional differences within each nation there is now the stratification engendered by the unequal access of countries and their domestic sectors to the new communication media. The inequality between central and peripheral nations, and between economic and educational levels in each country, is giving rise to new forms of injustice. For large masses of people, inclusion in the global culture is limited because they have access only to the first level of the audiovisual industries: the entertainment and information broadcast on free radio and television. The middle classes and some sections of the popular classes can update and refine their information by participating in the second stage of audiovisual communication, which includes cable television, environmental and health education, and political information on video. But only businessmen, politicians, and academics have access to interactive communication media, i.e. the third level, which includes the fax, electronic mail, satellite dishes, and interactive information and games: from amateur video films to the building of international electronic networks of the horizontal type (Internet). Audiovisual consumption statistics reveal that approximately 90 percent of the population of Latin America have radio and television, 50 to 70 percent (depending on the country) have video recorders, but fewer than 10 percent have access to the technologies which provide the information necessary for decision-making and innovation (Brunner, Barrios and Catalán, 1989; García Canclini, 1995; Roncagliolo, 1996; World Commission on Culture and Development, 1995).

These macrosocial tendencies must be considered in the light of complexities and counter trends to which less attention is given: heterodox and hori-

zontal uses of the Internet and videos, community radios and television channels, local production for cable, and so forth. It will be important for future cultural policies to include qualitative and quantitative studies of these experiences, with assessments where possible of their various effects. In view of the frequent use of these technologies by social movements, it is highly likely that new forms of citizenship, consumption, and sociocultural interaction are taking shape in these interstitial practices.

In this process combining multidirectional globalization and local and regional market integration, cultural homogenization and heterogeneity, the peripheral countries need to try cultural policies that allow them to exploit their capacities and at the same time place themselves in a less disadvantageous position in relation to the central countries. In the last two decades, for example, the production of books, records, and films in Latin America has declined; cinemas, bookshops, theaters, and museums have closed their doors; and programs to support popular culture have been abandoned. What accounts for this? Cutbacks in public spending and private initiatives confront us with this contradiction: increased trade between the countries of Latin America and with the outside world is being promoted at a time when the continent is producing fewer books, films, and records; and integration is being fostered at a time when Latin America has fewer cultural goods to trade and lower wages are causing mass consumption to decline.

Only transnational communication corporations like Televisa and Globo are increasing their investments, and only in those areas where they are sure to benefit (television, video, and popular magazines). As Jesús Martín Barbero (1995) says:

> In the "lost decade" of the 1980s, the only industry in Latin America which developed was the communication industry. The number of television channels increased from 205 in 1970 to 1,459 in 1998; Brazil and Mexico acquired their own satellites, radio and television opened up worldwide links via satellite, data networks, and satellite dishes; and cable television sprang up and regional television channels developed. But all this growth was the work of market forces alone, with very little state intervention, for which there was little call and little possibility, i.e. leaving the public space without any real footing while increasing monopolistic concentrations.

Various national and regional strategies emerged from this contradictory situation. I shall examine one or two examples representative of tendencies which are very present in the debate and, as we shall see, are sometimes at the origin of innovative policies.

Entrenchment In One's Own Culture

In the face of the effects of economic and cultural opening, some countries have exalted local traditions and trusted in building alternatives to develop-

ment based on the radical autonomy of the nation, religious movements, ethnic Indian groups, or underprivileged popular minorities: this occurs in areas controlled by Islamic fundamentalism, evangelic fundamentalism in the United States, neo-Inca movements in the Andes and neo-Mexicanist and neo-Mayan groups in Guatemala. Without a doubt, there are cases of suffering inflicted from without on peripheral societies that cause them to overestimate their own resources, their particular ways of organizing society and power. But this position entails a number of difficulties when it comes to developing coherent policies.

At the end of the twentieth century, most ethnic groups and nations are economically, politically, and culturally integrated in the modern era, or are experiencing processes of intense hybridization which have given them a complex heterogeneity. Even many ethnic groups with strong linguistic and social traditions have discovered the economic benefits in the course of this century of selling their farm produce and their crafts on the national and international markets, migrating to other regions and adopting modern knowledge, practices, and entertainments. From a purely cultural and aesthetic point of view, various authors have drawn attention to the fact that the "literal and isolated representations" of each entity tend to generate a repetitive art, as is seen in the stereotyped monotony of some Chicano and new-Mexicanist art (Ramirez, 1994). The underestimation of craft work and naive art as opposed to "real" art and technological innovations, the over-ritualization of traditional emblems and situations, may hold a passing fascination for new-age consumers or lovers of the picturesque, but locking oneself up in this solipsistic insistence on the "self" can obstruct the formal innovation and the transcultural exchange so essential to creativity and critical thinking in a global society. In spite of the political, cultural, and aesthetic qualities sometimes found in artists in these localist movements, the decisive question for cultural policy is: how does one move on from the separatist exaltation of difference, which in the long term perpetuates inequality and fosters discrimination, to the shared acknowledgement of the different and the heterogeneous in symbolic searchings capable of intercultural communication?

Export Soap Operas and Folk Music

Other uses are made of traditional creativity with a view to the financial gain which the interest they may arouse in other peoples may generate. The international success of Latin American *telenovelas*, ethnic or regional music, and the dances of Africa, Asia and Latin America gives reason to believe that the exploitation of these cultural resources for entertainment could help the developing countries concerned to find their place in the global communication market.

It is not merely a matter of cultural policy inspired by film directors, tele-

vision and record producers, and publishers in the peripheral nations. European film critic Román Gubern said recently that in the face of the "controlled Babelization of the Hollywood studios" and their overwhelming control of the world market, the Latin American soap opera could be the region's greatest hope. A prolongation of the printed serial and of post-romantic theatre, the modern-day soap opera could be the most fertile way of combining and conveying the surrealist, pre-modern imaginary with an urban-industrial imaginary. Thanks to this dramatic genre the symbolic capital of the traditional sector could recover ground lost through the advance of transnational media culture. The demonstration of this is the success of the Latin American *telenovela* in 150 countries all over the world, and even its influence on the work of Pedro Almodovar, Spain's "most international film director and the perpetuator of the absurd in the post-modern urban culture." Why not expand this shared heritage of the Latin American countries through film and television co-productions, to make these nations more competitive in the "the post-Gutenbergian era"?

It is well-known that this aspect of culture is producing considerable economic benefits for Latin cultures on the global markets. But in addition to the purely economic results, there are also the cultural, aesthetic, and political aspects to be considered. Some Latin American authors wonder what connections there are in Latin America between the massive success of the soap opera—not only in fiction but also in political and social news programs, the "neopopulism of the market" (Sarlo, 1994) which governs the media with its acritical vision of the ratings and the political populism that neutralizes criticism of the structures responsible for social injustice and organizes consensus from the heights of the charismatic power of authoritarian leaders. Are the aspirations of the peripheral societies in exchanges with other regions and cultures to be reduced to recognition through the magical realism of authors like Gabriel García Márquez, Laura Esquivel, and Isabel Allende, through *telenovelas* and films which captivate by their picturesque quality and their magic? In short, is it the destiny of our societies to be content to perceive their conflicts as family dramas, and social affairs as relations forever bewitched by feelings?

Globalization As an Aesthetic Organization of Multiculturality

The countries of the so-called Third World find themselves faced on the international markets with this dual dilemma: their production is on the wane and increasingly out-of-date in comparison with the magnates of global technology, while their consumption is fast increasing. Latin America, with 9 percent of the world population, accounts for 0.8 percent of the world's cultural exports, while the European Union, with 7 percent of the world population,

exports 37.5 percent and imports 43.6 percent of all cultural trade (Garretón, 1994).

The imbalance between production and consumption in the developing countries mentioned above results in scanty representation of national and regional cultures. The contrast is accentuated by the recent expansion of transnational American toll-free and cable television virtually all over Latin America, Africa, and Asia. In Latin America the countries with the most powerful firms, with years of experience of exporting audiovisual products (Argentina, Brazil, Colombia, Chile, Mexico, and Venezuela) have succeeded in negotiating exchange deals with CNN, MTV, TVE and other transnational groups which are unevenly balanced but which make some recognition of Latin American products possible on the transnational circuits.

These innovations merit close attention, because easy access to music on different continents, even from the peripheral societies, helps to bring discoveries from other cultures to the attention of composers, performers, and audiences, and to merge them with local traditions. The strategies of the major communication firms are encouraging us all, with their worldwide expansion, to interrelate with multicultural repertoires. In this interaction, some Latin American musicians, actors, and directors are finding room to work. But the recording and reproduction technologies that bring these far-off styles to us also make them too readily commensurable by submitting them to stereotyped tastes: the drums of a samba school or a salsa band sound increasingly like the kettledrums of a symphony orchestra or the drums used in African or Indonesian religious music.

This generates misunderstandings, which José Jorge De Carvalho summarizes as follows:

> The post-modern urban listener learns to receive as something familiar what is meant by its traditional creators or makers to be singular, original; and the run-of-the-mill listener in a traditional musical community has serious difficulties in appreciating the fundamentally ironic, allegorical, or sham nature of the musical production generated by the contemporary mass media. In other words, instead of the ideal of mutual exegesis, of the hermeneutic fusion of musical horizons, what we now have to analyse increasingly frequently are situations of communicational incompatibility. (De Carvalho, 1995, p. 4)

However, these misunderstandings and this incompatibility are concealed with electronic wizardry. The equalizer can be seen not only as a device which balances the sounds of the instruments in a group in relation to the voices, but as a strategy for the aesthetic organization of globalization. Applied to intercultural differences, this ability to balance high-, medium-, and low-pitched sounds, and different tracks, so that every sound can be heard in a harmonious whole, becomes an act of multicultural policy.

Invented to serve Western tastes, equalization becomes a process of tranquilizing hybridization, reducing the points of resistance of other musical aesthetics and resisting the challenges that different cultures present. Under the appearance of a friendly reconciliation between cultures, hides the pretense that we can be close to others without trying to hear or understand them. Like hurried tourism, like so many transnational film superproductions, equalization is generally an attempt at monological acclimatization, at acoustic accommodation.

True, equalization has also served to restore the sounds of ancient, medieval, and Renaissance music, to refine the recording of non-Western music and to experiment with acoustic effects and original sounds in the composing and performance of electronic, minimalist, and random music. And you can always pull out the plug: since Eric Clapton recorded his *Unplugged* album, Sinéad O'Connor, Neil Young, and several Latin American musicians, including Gilberto Gil and Charly García, have reminded us that it is still possible to rediscover the modulations and subtleties of different styles. But the scope for resistance of this kind must be placed in the perspective of everything the transnational monopolies are doing to take control of these experiments in "alternative" styles of music. A case in point is MTV's interest in broadcasting unplugged and other dissident music, which gives an idea of the complexity of the interactions between artists, middle men, and audiences.

MTV is an eloquent example of how flexible global corporations can be in organizing the market in all its regional diversity. If this firm, which was founded as recently as 1989, manages to attract an audience of young people all over the world, it is because of its ability to combine all sorts of innovations: it subtly mixes every style and genre, from rebel rock to hedonistic melodies and "standardized liberal thinking"; it fights for worthy causes (combating poverty, illiteracy, AIDS, and pollution), proposing daily international exercises compatible with a modern, sensitive approach to everyday life. But at the same time, understanding the limitations of globalization, MTV set up five regional subsidiaries in less than five years, including two in Brazil and Miami, with staff from various countries in the region and spaces for local groups which to a certain extent counterbalance the eternal predominance of North American music. Can the hundreds of millions of teenagers and young people in the industrialized countries and in the Third World who follow MTV really be so easily reduced to and reconciled in this "advertising medium of the future," as one analyst (Eudes, 1997) calls it, where the products advertised (Levis, Coca Cola, Reebok, Nike, Apple, IBM, and Kodak) come from only three countries?

Strengthening Endogenous Production and Intra-regional Circulation

The three lines of cultural policy I have just analysed may be pertinent options for improving the representation of different sectors, if we elaborate on the

questions we have left open. But no answer will be consistent if it is not accompanied by a revision of the roles of the protagonists we mentioned initially—states, firms, and independent organizations—and of the links between them.

The convergence between these three forces must aim first and foremost to strengthen, update, and expand the endogenous production of the peripheral countries, and the fluid circulation of these goods in these countries. An important step to reduce the imbalance between the central and peripheral countries is to increase investment in the renovation of technological infrastructures and in technical training. Women and marginal (ethnic and regional) minorities must be included in the vocational training effort in balanced proportion. Also necessary is a revision of what is meant by public interest in the context of cultural policies.

It is essential, of course, to reverse the tendency simply to privatize cultural institutions and programs. In many cases privatization does not consist, as is often claimed, in a transfer from the state to civil society, but in the transfer of the function of the state to the groups with the greatest national and transnational concentrations of capital. In order to find a new role for states in the present context, we shall have to reconsider their conception and functions as agents of the public interest, of the collective multicultural heritage. The presence of the state, considered as a democratic and plural space, is essential if cultural goods and research are not to be reduced to mere saleable commodities, essential for the defense of everything in the symbolic lives of our societies that cannot be commercialized, such as human rights, aesthetic innovations, and the collective construction of our history. In this respect, we need spaces like national museums, public art schools, and art research and experimentation centers subsidized by the state, or by mixed systems in which governments, private firms, and independent groups work together to guarantee that the interests and the needs of the masses in terms of information, recreation, and experimentation are not sacrificed to profit.

Perhaps the time has come to overcome the dissociation and sometimes the oppositions between the activities of the state, private firms, and independent organizations. Increasing awareness of the sociocultural influence and the economic potential of the cultural industries seems to have made conditions more suitable for the public and private sectors to work together to develop research programs and co-operation policies focusing on the public interest on an international scale. In some cases the free trade and regional integration agreements that have been concluded or are in preparation between various countries provide a suitable context in which to develop similar initiatives in the field of culture and communication. These regional integration processes must be supported by international studies and cultural and educational policies to promote enhanced mutual understanding between the participating

societies and the intelligent handling of the challenges raised by the new forms of multiculturality.

One important factor in achieving these objectives is that cultural policies should reconsider the brokering systems. Artistic and cultural production has always required middlemen to help it reach the public and give shape to the meaning of the pyramids and temples, of the paintings and musical works. But at a time of dense interaction between art and the mass media, and of transnational circulation of culture, between artists, craftsmen or writers, and the end users of their work, there is a complex network of institutions (galleries, museums, publishers), financial support (banks, foundations, public and private sponsors) and professionals in the fields of literary criticism, communication, tourism, and other related activities, all of whom influence the social meaning cultural goods come to assume. This web is not merely intranational; it involves international organizations and global systems of commercialization and aesthetic evaluation. This is evident in the art exhibitions designed to travel to numerous countries, which adapt to the cultures of the places they visit; the same applies to Western soap operas, the endings of which are changed for distribution in Asia, so as not to offend the morals of the Islamic societies there. Sometimes, however, intercultural negotiations are more secret and dependent on economic and political strategies. Some researchers (Ramírez, 1994; Yúdice, 1996) have demonstrated the links between free trade agreements and cultural diplomacy in the exhibitions promoted by Latin American and Asian countries in the Metropolitan Museum and the Pompidou Centre, with the participation of the state, major firms, and renowned writers, in a joint effort to propose a vision of peripheral cultures which, through the fascination of their "magical realism," manage to achieve recognition for their "splendors" in the shrines of art and in political and economic operations on a global scale.

The increased anthropological and journalistic interest in the "primitive" arts, the re-reading from an aesthetic viewpoint of works which, until recently, were stored away in ethnological museums (Clifford, 1995), and the spread of multiculturalism help to amplify and enhance the vision of the modern Western world. But the protests of artists in Africa, Asia, and Latin America and the organization of counter-exhibitions, like those staged by the Chicanos and Indians in the United States show the need for further debate on how artists and creative peoples should participate in the dissemination and redefinition of their cultures, and for cultural policies that make this possible. By no means a minor problem in this respect is international trafficking in works of art and the regulation of the balance between the prices they fetch in auctions in the world's capital cities and the prices paid in peripheral countries to the producers or middlemen. The recent proliferation of new international fairs in Singapore (for the first time in 1993), the rise in sales in Taipei, Tokyo, and Hong Kong and the "sliding" of large volumes of art from

Eastern to Western Europe after the fall of the Berlin Wall show the broad geographic radius now suddenly faced with new problems of customs protection, intellectual property, and non-commercial brokering (Moulin, 1994).

If this is what happens in the physical circulation of works of art, it is all the more necessary and difficult to develop cultural policies appropriate for the distribution of media messages and the use of information networks. Needless to say, the old forms of censorship or controls at national borders—however controversial they may be—have become quite useless in these days of satellites, optic fibers, and the Internet. The global dimension of the problem evidently calls for supranational agreements and the determined participation of international and regional organizations in cultural policy research and agreements. One consequence is that training for civil servants, administrators, and promoters in the cultural field must teach them to deal with a variety of situations in an international context, so that they are able to cope with the cultural, aesthetic, financial, and political implications of transcultural brokering.

Relating Cultural Policies to the Employment and Educational Needs of Young People

There are some politicians and people in charge of economic and social programmes who continue to see art as a weekend activity. It is important that cultural policy designers bear in mind the importance of the production of cultural goods and messages in national economies and employment. In the United States, culture, especially audiovisual production and sales, accounts for 6 percent of Gross Domestic Product and employs 1.3 million people, which is more than mining, the police, or forestry. In France in 1992 it accounted for 3.1 percent of the GDP.

However, young people—who in many countries have become the main consumers of culture and communication—find little connection between cultural development and their basic needs, especially the increasingly difficult access to employment.

DEVELOPING NEW REGIONAL CULTURAL PROGRAMS AND INSTITUTIONS

Intermediate channels exist between the weakening of national local cultures and globalization. The redistribution of power in culture and communication must not be seen as a simple opposition between these two extremes. On every continent there are groups of countries which have recently formed alliances to strengthen their regional economies in the competitive global market. Sometimes they confine themselves to reducing customs barriers to trade within the region. In other cases, particularly the European Union, they are

developing integration measures which facilitate the free circulation not only of goods but also of people and information. They include joint educational programs, policies to defend the common cultural heritage, and what they call the "European audiovisual space." In an effort that respects the internal diversity of the region, they have built up forms of resistance and autonomous development in the face of the United States and Japan. The deep-rooted traditional role played by the public sector in Europe has enabled the Union not only to issue declarations and recommendations but to introduce binding regulations compelling the Member States to promote books and reading, defend authors' rights, and develop the audiovisual sector.

The audiovisual sector is regarded as a priority. Although there is a trend, as on other continents, towards the privatization of public television, post and telecommunications firms, the Member States have agreed on common standards to foster the circulation of European programmes, setting minimum requirements for program content and limits on advertising for all the members to respect; programs such as MEDIA, Eurimages, and Eureka were set up to develop Europe's audiovisual industries, and promote high-definition television and common standards for satellite broadcasting. These policies not only defend the European identity but also take into account the important role played by the cultural industries in economic growth, job creation, and the consolidation of more participative democratic societies. Without going into the details here, it must not be forgotten that the progress achieved in these cultural policies is based on extensive research on every dimension of culture, from the production and distribution economy to the habits and tastes of consumers, on a larger scale than in any other region. It contributes to the democratic and public debate on these programs, in so far as the studies are not concerned only with costs, profits, and ratings for the hermetic use of firms or government bureaucracies, but are published or readily available for consultation by all interested parties.

In other regions attempts at regional co-operation and co-operation between states, private firms, and independent bodies are being made, the innovative value of which merits attention. The last example I shall refer to is the Mexico–United States Trusteeship for Culture. In 1991 the Rockefeller Foundation, the National Foundation for Culture and the Arts (a Mexican public body), and a bank institution, the Bancomer Cultural Foundation, also in Mexico, set up a joint body to "enhance cultural exchange" between the two countries. Although there is a National Endowment for the Arts in the United States and a National Council for Culture and the Arts in Mexico, these bodies only support activities in their own countries. Throughout the twentieth century, however, geographical proximity and reciprocal interests led writers, plastic artists, film directors, and scientists from one country to live and work now and then in the other. Then the expansion of radio, television, and, more recently, electronic communication continued to develop

intensive exchanges. The interaction has been unevenly balanced, in keeping with the different levels of economic and sociocultural development in the two countries. This uneven balance has been particularly manifest in other types of contact, with mass migration from Mexico to the United States, an area in which the differences and the difficulties between the two societies have led to conflicts with which we are all familiar. The importance of these encounters and separations has increased in the last fifteen years, since the economic opening of Mexico and the trend toward globalization have made exchanges between the two countries increasingly important.

Although the Free Trade Agreement between Canada, Mexico, and the United States was designed solely as an economic instrument and not to regulate social or cultural relations, it has fostered mutual interest and communication between the societies, educational and scientific agreements, and cultural exchanges. The Trusteeship is endeavouring to boost this process, granting financial support every year to bilateral projects concerning libraries, publications, music, dance, museums, visual arts, art in the media, theater, cultural research, and interdisciplinary studies. The 2,144 applications made from 1992 to 1996, 283 of which received support, demonstrate the great impact this initiative is making in two countries which, in spite of the intensity of the interactions between them, were not accustomed to working together on joint programs, partly for want of cultural institutions to support them. A close look at the evolution over the years of this project and the criteria on the basis of which the Trusteeship distributes financial support,[3] reveals the difficulties experienced by many artists and institutions in developing programs involving both nations, overcoming the stereotypes in their perception of the other society and relating their artistic and cultural actions to the habits in each country and their respective regions. When interviewed, artists and institutions which had received support agreed on the usefulness of these experiences in "interactive co-operation" and the elaboration of the artistic imagination in everyday contacts with one another. They suggested that as well as distributing funds, the Trusteeship might organize workshops, symposia and other activities to promote awareness of one country's culture in the public sphere in the other and to help to study their differences in an intercultural light and to stimulate the "ethnic- and community-based arts" and the multicultural reflection and research which the market and the conventional institutions ignore. It was interesting to see that these confrontations, as well as generating shared experiences between different cultures, encouraged work on the differences in the very conception of diversity. While civil society in the United States was built around the rights of the individual, starting in the civil rights era democratization has come to be understood in terms of the access (or lack of access) certain groups have, access which is conditional on what defines them as groups (race, ethnic origin, gender, sexual orientation, and so forth). "Diversity" is also an important criterion in the administration

of public goods in Mexico, but it is considered in a different light. In general it refers to differences of class, region, and ethnic group (which means indigenous community in Mexico, in contrast with the multitude of ethno-racial definitions in the United States).

Another significant point arose in respect of what each society values in the art of the other. While Mexicans, and Latin Americans in general, see the United States as the center of the most advanced positions in art and science, much of American society and many of its institutions tend to value Mexico's past, but are reluctant to consider Mexican art as something competitive in the modern era. The folk culture is seen as representative of Mexico. Many of the artists interviewed criticized the fact that the exhibition entitled *Thirty Centuries of Splendour*, Mexico's main international exhibition of the decade, presented in New York, San Antonio, and Los Angeles, went no further than the 1950s. Miriam Kayser, Director of International Relations of the National Council for Culture and the Arts, confirmed that in the United States, as in other regions, "the battle horses are pre-Hispanic culture, Frida, Diego, Orozco and Siquieros." The question of how to change this relegation of Mexico to the past and show off its modern creativity and cultural studies is an essential one if we are to overcome prejudice and foster deeper understanding between different national communities.

In brief, these last two references show concrete examples of how intra- and interregional policies can be developed, working on medium-range dilemmas within globalization. It would be useful for UNESCO and other international organizations to promote encounters, workshops, and comparative studies to help the different regions to take advantage of innovations made elsewhere. This line of work would serve to transcend the limitations of purely national cultural policies. In some ways national policies could be strengthened through improved understanding of the (different) transformations afoot in the traditional arts, and the publishing and communication industries, for this would help them to find their creative place in keeping with the new demands of each of these scenarios. And as we advanced in this direction, perhaps cultural policies would no longer need to focus on self-defence and entrenchment in one's own traditions, and could set about creating new forms of inter- and multicultural co-operation in which national and foreign cultures developed side by side, in mutual enhancement.

NOTES

1. At the 1993 Venice Biennial, where most of the fifty-six countries represented did not have their own pavilions, almost all of the Latin American countries (Bolivia, Chile, Colombia, Costa Rica, Cuba, Ecuador, El Salvador, Mexico, Panama, Paraguay, and Peru) exhibited in the Italian section. But this was of little account in an exhibition devoted, under the title *Cardinal Points of Art*, to showing that art nowadays is built on "cultural nomadism." It is as if the differences between Latin American countries did

not count: the ideology of globalization and the post-modern idealization of nomadism erases contextual references.

2. Quoted from *In from the Margins*, a report prepared for the Council of Europe by the European Task Force on Culture and Development Cultural Committee, Strasbourg, 1996.

3. This information is based on the diagnosis and evaluation study (unpublished) of the Mexico United States Trusteeship for Culture made by Néstor García Canclini and George Yúdice in 1996.

BIBLIOGRAPHY

Appadurai, A. 1990. Disjuncture and Difference in the Global Cultural Economy. In: M. Featherstone (ed.), *Global Culture: Nationalism, Globalization and Modernity*. London, Newbury Park, and New Delhi, Sage Publications.

Arantes, A. A. (ed.). 1984. *Produzindo o passado: Estratégias de construção do património cultural*. São Paulo, Editora Brasiliense and CONDEPHAAT.

Arizpe, L. (ed.). 1996. *The Cultural Dimensions of Global Change: An Anthropological Approach*. Paris, UNESCO Publishing.

Becker, H. S. 1988. *Les mondes de l'art*. Paris, Flammarion.

Bourdieu, P. 1979. *La distinction: Critique sociale du jugement*. Paris, Minuit.

Brunner, J. J.; Barrios, A.; Catalán, C. 1989. *Chile: Transformaciones culturales y modernidad*. Santiago, FLASCO.

Castells, M. 1995. *La ciudad informacional*. Madrid, Alianza.

Clifford, J. 1995. *Dilemas de la cultura*, Barcelona, Gedisa.

De Carvalho, J. J. 1995. *Hacia una etnografía de la sensibilidad musical contemporánea*. Brasilia, University of Brasilia, Department of Anthropology. (Série Antropologia).

Eudes, Y. 1997. MTV: chaîne du rock et de la jeunesse: culture, idéologie et société. *Le Monde* (Paris), March.

Fabrizio, C. 1982. *El desarrollo cultural en Europa: Experiencias regionales*. Paris, UNESCO.

García Canclini, N. 1995 *Consumidores y ciudadanos: Conflictos multiculturales de la globalización*. Mexico City, Grijalbo.

———. (ed.). 1996. *Culturas en globalización: América Latina – Europa – Estados Unidos: Libre comercio e integración*. Caracas, Nueva Sociedad.

Garretón, M. A. 1994. *Políticas, financiamiento e industrias culturales en América Latina y el Caribe*. (Paper presented at the third meeting of the UNESCO World Culture and Development Commission, San José, Costa Rica, 22–26 February 1994).

Goldberg, D. T. (ed.). 1994. *Multiculturalism: A Critical Reader*. Oxford, United Kingdom, and Cambridge, Massachusetts, Blackwell.

Grossberg, L. 1997. Cultural Studies, Modern Logics and Theories of Globalization. In: A. McRobbie (ed.), *Back to Reality: Social Experience and Cultural Studies*. Manchester University Press.

Gubern, R. 1997. *Pluralismo y comunidad de nuestras cinematografías*. (Contribution to the International Congress of the Spanish Language, Zacatecas, Mexico, April 1997, and published in *La Jornada* (Mexico City), 11 April 1997.)

Hannerz, H. 1992. *Cultural Complexity: Studies in the Social Organization of Meaning*. New York, Columbia University Press.

Martin Barbero, J. 1995. *Comunicación e imaginarios de la integración.* Cali, Taller de Comunicación.

Miége, B. 1993. Les mouvements de longue durée de la communication en Europe de l'ouest. *Quaderni: La revue de la communication* (Paris), No. 19, Winter.

De Moragas, M. 1996. Políticas culturales en Europa: entre las políticas de communicación y el desarrollo tecnológico. In: N. García Canclini (ed.), *Culturas en globalización.* Caracas, Nueva Sociedad.

Moulin, R. 1992. *L'artiste, l'institution et le marché.* Paris, Flammarion.

———. 1994. Face à la mondialisation du marché de l'art. *Le Débat* (Paris, Gallimard), No. 80, May–June.

Niebla, G. G.; García Canclini, N. (eds.). 1994. *La educación y la cultura ante el Tratado de Libre Comercio,* 2nd ed. Mexico City, Nexos-Nueva Imagen.

Ortíz, R. 1994. *Mundialição e cultura.* São Paulo, Brasilense.

Ramírez, M. 1994. Between Two Waters: Image and Identity in Latin American Art. In: N. Tomassi, M. J. Jacob and I. Mesquita (eds.), *American Visions/Visiones de las Américas.* New York, American Council for the Arts and Allworth Press.

Roncagliolo, R. 1996. La integración audiovisual en América Latina: Estados, empresas y productores independientes. In: N. García Canclini (ed.), *Culturas en globalización.* Caracas, Nueva Sociedad.

Sarlo, B. 1994. *Escenas de la vida posmoderna.* Buenos Aires, Ariel.

Vidal Beneyto, J. 1981. Hacia una fundamentación teórica de la política cultural. *REIS,* No. 16.

World Commission on Culture and Development. 1995. *Our Creative Diversity: Report of the World Commission on Culture and Development.* Paris, UNESCO.

Yudice, G. 1996. *El impacto cultural del Tratado de Libre Comercio norteamericano.* In: N. García Canclini (ed.), *Culturas en globalización.* Caracas, Nueva Sociedad.

Susan L. Siegfried }

THE POLICY LANDSCAPE

Webraising is a term newly coined to refer to the construction of new sites on the World Wide Web (and the collective effort that the activity, like community barn raisings of old, entails).[1] It refers also to the consciousness-raising that goes with induction into the mysteries of communicating via telecommunications networks. The term nicely captures the great leaps in awareness of new communication systems that have penetrated even the most remote corners of academe and the art world during the past five years; most daily newspapers these days carry regular sections devoted to on-line information. The rapid expansion of information technology (IT) is having an impact on the ways information about cultural subjects is created, organized, used, and stored, which in turn directly affect museums, arts organizations, the art market, government agencies, universities, and, increasingly, academics, artists, curators, and dealers themselves. The IT revolution has generated a dynamic between, on the one hand, extreme fragmentation and multiplication of efforts—a kind of postmodern nightmare of disconnect—and, on the other, a need to define policies that will help chart a path through the chaos and the rush. Because such policies are essential to the formation of a stable and robust research environment, my interest centers on the effectiveness of groups specifically formed to make policy.

I have chosen five projects—three international, two national—concerned with policy formation at the highest level. Each embraces the arts and humanities or cultural heritage as a whole—remarkably broad definitions of the field that are politically necessary and technically logical. Each project addresses the basic "who, what, how" questions: Who has access to information and whose rights ought to be protected? What gets digitized and inventoried? What research is needed to make the technology meet the many special requirements of cultural "users"? How should our information be described and handled, organized, retrieved, and stored? Any one of those areas—intellectual property rights, user needs, or standards for the description, linguistic representation, and technical storage and transmission of data—is enormously complex, so much so that a variety of individual policy

initiatives have evolved for each set of problems. By contrast, the projects discussed here aim to articulate or implement an overall plan for the field, identifying general goals and recommending acceptable procedures in several critical areas.

Such comprehensive policy formation carries the danger of arriving at (or departing from) an extreme level of abstraction that is not tied to material interests. On the other hand, the pull of self-interest in the opposite direction can lead institutions and projects to develop their own methods, probably incompatible with one another in the larger on-line environment. In Europe (including to some extent the United Kingdom), policies tend to be overarching plans, generated through relatively centralized state or multinational bureaucracies, such as that of the European Union, and these plans are not necessarily in touch with the day-to-day operations of institutions and researchers "on the ground." In the decentralized United States, policies tend to be makeshift affairs, formulated to accommodate the existing practices of institutions and projects that have their own momentum. The image of mediation between the general and the practical proposed for this discussion can be seen as a metaphor for the nature of telecommunications networks themselves: they are radically decentralized and yet depend on tightly regulated coordination, for example, in the form of technical protocols that remain largely invisible to the user.

THE EUROPEAN UNION

At first glance Europe appears to have its act more together than the United States when it comes to putting cultural information on networks. It has big budgets, an unquestioned belief in the value of cultural content, and strong administrative infrastructures that facilitate planning and coordination. But the European projects are distributed across various bureaucracies that are not necessarily in touch with each other. There seems to be little coordination of the projects, or any specific plans for their convergence in the long term. Those sponsored by the European Union, where most of the money and the initiative reside, have a strong commercial orientation, rendering their cultural voice weak. Nevertheless, they are brimming with confidence and motivated by a sense of urgency about using technology to disseminate culture. What drives this aggressive high-tech attempt to promote culture?

In a curious way the European Union programs recall the social democratic ideologies of the American New Deal, and even nineteenth-century European and American philosophies of cultural improvement that led to the creation of so many museums and art schools. The basic idea then was that culture provides symbolic unity for the state and also benefits industry. Then as now (in Brussels), monitoring spending was less important than spreading money around, in the belief that some investments were bound to produce

good results. The European Union has sponsored nearly fifty major automation projects involving cultural materials since 1992, with more on the way.[2] These are funded at a scale that is mind-boggling by American (or other national) standards. Partly owing to an emphasis on research and development programs, projects sometimes overlap in their aims and areas of exploration. The proliferation is justified in sociological and economic terms, which follow confidently from the Treaty on European Union (signed in Maastricht on February 7, 1992). New technologies are being enlisted to "disseminate the culture and histories of the European peoples" in order to "increase the citizens' involvement and reinforce the sense of belonging to the European Union."[3] (A subtext, mounting opposition to the threat posed by "Hollywood" culture, surfaced during the Maastricht negotiations.) The language of business is not far behind: "The cultural heritage contained in Europe's museums and galleries is one of the European Union's greatest assets," and many IT projects involving culture are designed to stimulate not simply the tourist industry but also the emerging "electronic information services market and multimedia content industries."[4]

Because reflection on this deliberate multiplication of projects has not been the European Union's style, Europe-watchers are wondering what to make of its sudden entry into the field of policy statements. The European Commission (EC), which proposes projects and implements policy for the European Union, recently issued *Multi-Media Access to Europe's Cultural Heritage: A Memorandum of Understanding and European Charter*, which is the highest-profile policy document currently afoot in Europe.[5] The European Commission went to some lengths to involve everybody in the effort, obtaining endorsements from museums, organizations, and agencies large and small, inside as well as outside the European Union. It set up an elaborate structure to help the cultural community articulate a vision of its role in the information society, consisting of a steering committee established as a result of the memorandum and four working groups in the areas of standards and protocols for interoperability; public awareness, audiences, and markets; ownership and protection of intellectual property rights; and priorities in digitization.[6]

Good-faith observers take the document at face value and believe the European Commission is honestly trying to move the cultural community toward consensus:

> European museums and galleries must formulate a common vision of their role and objectives in the developing information society. If this vision is dictated only by the IT industry or by the newly emerging industry of electronic publishers, the best interests of museums themselves may not be pursued. . . . Only by working together with industry can museums expect to protect and further their own interests, and thereby safeguard the cultural dimension of activity in this field.[7]

Others are deeply suspicious of the memorandum's sponsorship by DG XIII, the EC's information and technology division, while the cultural division, DG X, acts as a silent partner. Skeptics read the document as an agreement that museums will make their information available to the private sector for commercial exploitation. Indeed, companies have rather little cultural "content" to work with and need museums to supply it. Others see the memorandum as laying the groundwork for another round of EC pilot projects, in which more money will go to companies than to collaborating museums and cultural organizations.[8]

It is puzzling that the project, having been set in motion, has no budget and surprisingly little in-house support. Although private sector interests have not, as a result, dominated the working group meetings, only a few of the larger cultural organizations can afford to participate actively since they are required to pay travel and work-time costs for staff to attend meetings and allocate time for them to do the related work. Instead of being an active broker between museums and industry, the EC has left the players to their own devices. While the EC may never have intended to do more than facilitate others to take charge, there is the problem that its policy initiative may not have the dynamics to produce practical results. It is intriguing to speculate about whether the apparent limits on the memorandum's ambitions are symptomatic of larger uncertainties about the future direction of the European Union itself, particularly as its budgets come under increasing scrutiny from member states.

With the steering committee of the EC memorandum in the capable hands of Neil MacGregor, director of the National Gallery, London, one hopes for a positive outcome. In the final analysis, the authority and conviction that the memorandum carries will depend on the European Commission's ability to involve more, especially key, museums and museum associations that presently have a hand in shaping its policy statements.

THE G7

Whereas the European Commission does not seem primarily interested in coordination and planning, the G7, or Group of Seven Most Industrialized Countries, is sponsoring a policy project focused on precisely those needs. The G7 Multimedia Access to World Cultural Heritage (not to be confused with the EC memorandum's remarkably similar title) recently identified the development of a long-term strategic plan for cooperation among countries as its major goal.[9] In a sense, coordination is the goal of the G7 project. In much the same way that ministers of the sponsoring countries come together to manage the global economy, the cultural heritage group is trying to facilitate information exchange on a global scale. This requires them to start from existing practices and work toward general agreements. The cultural heritage project is

dedicated to respecting activities already under way in each country; in fact, the group's purpose is to leverage existing work rather than to create another new project. The group's challenge is thus to devise a framework that brings pluralism and common aims together. G7 Multimedia Access will base its plan on information to be gathered in four areas: standards (led by the United Kingdom), legal rights and fair use (led by the United States and Canada), technical research and development (led by France), and testing and application, including education and training (led by Italy). Germany and Japan will actively contribute information. The group expects to make its findings publicly available on its new Web site.[10] Prestigious and truly international in scope, the G7 project hopes to set the example of convergence and coordination rather than proliferation and commercially driven competition.

PROTECTING CULTURAL OBJECTS

A strongly interventionist approach to policy formation has worked remarkably well in an international project of the Getty Information Institute called Protecting Cultural Objects in the Global Information Society. This initiative set out to establish a worldwide standard for a core set of categories of information needed to identify a specific cultural object, enabling the information about stolen objects to move as quickly as the objects themselves.[11] To bring this off, the Getty managed to bridge chasms of noncommunication among professional groups as different as museum record-keepers, police agencies, insurance companies, national inventory specialists, appraisers, dealers, commercial art-theft databases, and standards organizations such as the International Council of Museums Documentation Committee (CIDOC).

The secret of success? Beyond the Getty's diplomatic skills and expertise, it probably lies in having engaged the participants' self-interest. Art theft is global, and the only way to impede it is for all parties concerned to agree on a common method of documenting art objects and moving that information rapidly. Oddly, a strong sense of nationalism works here to reinforce international cooperation: countries want to preserve their cultural heritage as a source of national identity in the international world. They are consequently willing to support a broad-based international agreement (the standard is based on responses from eight hundred institutions in eighty countries), which is further endorsed by highly respected international organizations such as UNESCO, the International Council of Museums, the Council of Europe, the U.S. Information Agency, and a host of professional and governmental organizations. The project also appeals to financial interests vested in the transport and sale of art: dealers, for example, might consider a standard that helps them distinguish between legitimate and illegitimate transactions. All in all, people are prepared to put money and resources into cooperation if they believe they are getting a return on their investment.

NINCH

In the United States, the government believes that it needs no shared nationalist ideology, nor the attendant cultural trappings, to hold the country together. The culture of capitalism is accepted as binding. Although the mavens of American culture worry about its "homogenization . . . by mass media," they are in fact losing faith in the old model: "The inability to articulate the social values of art and culture makes it impossible to argue effectively for their support."[12] As a sign of the times, cultural organizations are making peace with the market economy as they consider their IT future.[13] The Clinton administration has recognized private-sector investments as the mainstay of IT development in all areas.[14] With little government or commercial support in sight, American cultural organizations are attempting to draw together on their own initiative.

Engaging the self-interest of these organizations is the major challenge facing the National Initiative for a Networked Cultural Heritage (NINCH). In an unprecedented move, twenty-two arts and humanities organizations, including the College Art Association, have joined forces to protect their common cultural flank, so great is the threat of being bypassed by the increasingly commercially controlled electronic superhighways.[15] The National Initiative is trying to affect rather than set policy. NINCH provides a forum on IT issues for cultural organizations busy with other concerns; in fact, part of its mission is to educate members and build a sense of community among them—no small task, given their diversity and lack of history of working together. At the same time, this new coalition needs to demonstrate value for money to its financially stretched members. The common ground they have found is advocacy.[16]

The National Initiative's first opportunity to exercise leadership is coming in the vexed area of intellectual property rights. NINCH was among those organizations that recently persuaded the Department of Commerce to suspend a proposal for copyright legislation covering the national telecommunications networks, on the grounds that any decisions would be premature. In the ongoing debates, NINCH is agitating for broader consideration of principles such as fair use in the digital environment and plans to mobilize its constituency to respond to an interim report of the Conference on Fair Use, a document that will be referenced in the revised copyright legislation.[17] In representing the diversity of the cultural community, the coalition could serve as a vital point of convergence between the deeply divided positions of rights holders and rights users and help move them toward consensus, setting an example for the field as a whole.

ARTS AND HUMANITIES DATA SERVICE

While NINCH, my American example of a national policy initiative, is situated outside and even opposite government, my British example is funded and coordinated by the state. The United Kingdom's Arts and Humanities Data Service (AHDS) is comparatively robust thanks to government funding, with an agenda that includes nitty-gritty, labor-intensive tasks (collecting, cataloguing, and preserving data, for example).[18] The Arts and Humanities Data Service has all the earmarks of pluralism that characterize the 1990s on-line environment—it is decentralized, standards-oriented, and promotes flexible frameworks. Its modus vivendi seems to be "divide and conquer," as it has divided up responsibility for collecting data among five service providers, respectively concentrating on history, textual studies, archaeology, the visual arts, and the performing arts. Each provider further specializes in knowledge of a particular format (media type); thus the consortium based at Surrey Institute for Art and Design, in charge of the visual arts, will develop an expertise in digital images.

At an epiphenomenal level the Arts and Humanities Data Service looks like a thoroughly disinterested organization. But government funding doesn't come in Britain these days without being tied to a scheme for saving money or making sure that it is well spent. The AHDS is part of a culture of accountability. "Distributed" though this "virtual collection" may be, its highly rational organization, with pods linked to a central executive in London, is conceivable only in a relatively centralized bureaucracy. The AHDS appears to make good use of that bureaucracy, in contrast with other British initiatives involving IT and culture that have issued blanket policy statements that seem remote from the organizations affected.[19] In coordinating laterally with governmental and nongovernmental agencies, the AHDS has gained the support of key grant-making bodies, such as the British Academy and Leverhulme Trust, which require or recommend that their grant holders deposit any data sets they produce with the AHDS or other national archives. The AHDS will establish benchmarks for evaluating data sets—it means to promote the creation of well-documented, reusable digital resources viable over the long term—which can ultimately help scholars gain professional recognition for their work. In turn, the Higher Education Funding Councils of England (responsible for creating the AHDS) are prepared to consider deposited databases—those accepted and evaluated by such approved archives—alongside traditional print publications when they assess scholars' research, during the so-called Research Assessment Exercise that determines the allocation of funding to university departments.[20] This is the dream that "wired" American academics in the humanities have had for some time—how to get tenure committees to evaluate computer projects on a par with print publications.[21]

But its realization in the United Kingdom comes with conditions. The AHDS makes it possible for the government to monitor its expenditures on research in a given area and helps to make that research more accountable. Whether or not Great Britain's multiplying procedures for monitoring research produce truly useful results, they create the illusion that the government is spending money in a responsible way.

The emergence of parallel policy initiatives in the area of IT and culture can be taken as a sign of health—evidence that cultural organizations are speaking up for themselves, evidence of a potential for synergy. Yet there is also concern that the efforts will amount to nothing, that they will turn out to be all framework and no substantive application or, despite calls for cooperation, will bog down in duplications of effort that the cultural field can ill afford. There is something surreal about the fragility of the present moment: the issues and developments outlined here are extremely important and bound to affect us all, but if any of the policy initiatives were to fail most of us would not even be aware of it. Yet what is at stake is nothing less than the ability of all cultural "users" to participate in the new world defined by network connections. For that reason it is worth stressing a few points.

The United States and the European Union are similar in the extent to which their development of telecommunications infrastructures has an intensely political dimension. For all their differences, policy initiatives in both places are being shaped, if not determined, by political forces that have very little to do with information technology, culture, or education. These forces contribute to the absence of administrative coordination among national and multinational projects that characterizes the field and they also make it the more difficult, yet all the more critical, for policy initiatives proactively to work together. International coordination on IT development is the greatest need facing the cultural community today. Are French leaders of the G7 working group on technical research and development aware that the American cultural community has already outlined technical needs, in *Research Agenda for Networked Cultural Heritage?*[22] To cite another example, no fewer than three of the projects discussed here, and others besides, have declared their intention to gather information on standards (descriptive, linguistic, and technical) and recommend relevant practices.[23] Even if they are aware of each other's work, awareness is not the same thing as coordinating research and recommendations within an agreed framework. Similarly, formal calls have been made for cooperation between the working groups of the European Union and those of the G7 projects, but cooperation among the lower echelons will have limited results without coordination spearheaded and supported by the top levels of administration. To be effective, coordination must proceed from a strategic plan for bringing the world's cultural heritage into the digital environment in a comprehensive and coherent way. Such a plan

would "survey existing projects, link them where such links (of whatever type) make logical sense, reduce the duplication of effort that wastes scarce resources, and address the many infrastructural issues that block the formation of a coherent cultural information universe."[24]

The problem of the distance separating some policy initiatives from the day-to-day operations of institutions on the ground is exacerbated by a gap in resources and training. In the United Kingdom, for example, institutions of higher education, the primary clients intended for on-line archives such as the Arts and Humanities Data Service, lack the front-line resources and the support and training staff that would enable academics and students to integrate digital resources effectively into their research and teaching. Where monies are available they tend to be invested in equipment and the infrastructure rather than in staff training and user support. Much the same holds true in the museum world. Only two of the projects discussed here, the G7 Multimedia Access project and the AHDS, highlight the education and training of users as priorities on their agendas. More attention needs to be paid to addressing such real needs of educational and cultural institutions, since IT development tends otherwise to support the needs of technology production.

NOTES

1. The term originates with Los Angeles Culture Net, a project sponsored by the Getty Information Institute to link electronically arts organizations and museums in Los Angeles (http://www.gii.getty.edu/lacn/).
2. These are summarized by Bernard Smith, "Some EC Initiatives in the Cultural Area," *EVA '96: Electronic Imaging and the Visual Arts Conference Proceedings; New Technical Developments, Future Strategies and Visions*, London, 1996, 12.1–12.18.
3. 3. Ibid., 12.1.
4. European Commission, DG XIII-B, *Multi-Media Access to Europe's Cultural Heritage: A Memorandum of Understanding and European Charter*, Brussels, June 28, 1996, 9; and see the DG XIII Web site (http://www2.echo.lu/).
5. European Commission (as in n. 4). The document includes translations in twelve languages.
6. A fifth working group, on integration with libraries and archives, is envisioned but not yet off the ground. Working groups submitted their first reports to the steering committee in Nov. 1996 and were to have presented revised reports in Mar. 1997.
7. European Commission (as in n. 4), 11.
8. The Info 2000 program is often the example cited since it is designed to stimulate the multimedia content industry and was introduced at about the same time as the *Memorandum of Understanding*. Info 2000 is budgeted at 65 million ECU (approximately $65 million) over a four-year period from Jan. 1996 through Dec. 1999 (http://www2.echo.lu/).
9. As indicated in the report of the Sept.–Oct. 1996 meeting of the G7 Multimedia Access project (http://www.iccd.ministerobbcc.it/g7/g7oct96.htm).
10. See http://www.iccd.ministerobbcc.it/g7/.
11. See Robin Thornes, *Protecting Cultural Objects through International Documentation Standards: A Preliminary Survey*, Santa Monica, Calif., 1995: and http://www.gii.getty.edu/gii/pco/index.htm.
12. Getty Art History Information Program, "Report on 'Strengthening the Cultural

Sector through Information Technology,'" a meeting hosted by the Getty Art
History Information Program on behalf of the President's Committee on the Arts
and Humanities, June 12, 1996, 12, 8.

13. For example, the Association of Art Museum Directors is planning an image bank
"of thousands of works of art" called the Art Museum Image Consortium (AMICO)
and intends to charge for access and other services such as "framing and packing"
digital images and text to suit the needs of educational or other clients (see
http://www.AMN.org). In effect, museums are taking into their own hands the
exploitation of digital images that Bill Gates began with his company CORBIS. In
an educational context, the final phase of the Getty Information Institute's Museum
Educational Site Licensing (MESLE) project is an economic study (funded by the
Andrew W. Mellon Foundation) of what it costs museums to ready images for
digitization and universities to use them in classrooms (see Howard Besser's home
page at http://www.sims.berkely.edu/~howard).

14. See the National Information Infrastructure Agenda for Action, sec. 3, "Need for
Government to Complement Private Sector Leadership,"
http://www.usgs.gov/public/nii/NII-Agenda-for-Action.html. President Clinton has
pledged some federal support of IT development in the educational sector, urging
the Federal Communications Commission (FCC) to mandate discounts for the
provision of telecommunications services to schools and libraries, and proposing
federal monies to help universities and national research laboratories build the "Next
Generation Internet" or "Internet 2." Progress in either area still depends on
private-sector investments. For a summary of the FCC and universal service,
including voluntary private-sector initiatives such as Net Day, see *Networked
Cultural Heritage Newsletter*, nos. 3, 4, Oct. 23 and Nov. 8, 1996 (published through
the NINCH-Announce listserv of the National Initiative for a Networked Cultural
Heritage, ninch-announce@cni.org, and in a hyperlinked version on the NINCH
Web site, http://www-ninch.cni.org/news/news.html); on Internet 2, see articles in
the *Chronicle of Higher Education*, XLIII, Oct. 11 and 18, 1996, and announcements
from Oct. 15, 1996, and earlier posted on the Coalition for Networked Information
Internet/World Wide Web site (cni-announce@cni.org). It should be noted that
museums and other cultural organizations are not on the Clinton administration's
map of the new electronic superhighways.

15. For a list of members and other information, see the NINCH Web site
(http://www-ninch.cni.org).

16. David Green, "Building the Machine: A Start-Up Strategic Plan (draft 4)," Mar.
1996 – Sept. 1997 (courtesy of the author).

17. For up-to-date information on the Conference on Fair Use, see the NINCH Web
site (http://www-ninch.cni.org/; click on "Copyright and Fair Use"). The
conference's final discussion of the report on fair use took place on May 19, 1997.

18. In 1995, the Joint Information Systems Committee of the Higher Education
Funding Councils of England committed £1,500,000 ($2,250,000) over three years to
establish the AHDS. Its annual budget ($750,000) is more than five times that of
America's NINCH ($145,000 per annum, based on three-year membership pledges).
For a detailed account of the AHDS, see Daniel Greenstein and Jennifer Trant,
"The AHDS: Arts and Humanities Data Service," *Ariadne*, no. 4, 1996, available
on-line at http://www.uk.oln.ac.uk; see also the AHDS Web site
http://www.kcl.ac.uk/projects/ahds/top.html.

19. For example, United Kingdom, Department of National Heritage, *Treasures in
Trust: A Review of Museum Policy*, July 1996, DNHJO168NJ.

20. Daniel Greenstein, "Connecting Scholarly Communities and Networked Resources:
The Arts and Humanities Data Service and the Urgency of Collaborative
Endeavor," Nov. 1, 1996, sec. 3, "Collections Development" (courtesy of the author;
a similar description is given under the heaading "Collection" by Greenstein and
Trant [as in n.18]).

21. See Carolyn Lougee, "The Professional Implications of Electronic Information," in *Technology, Scholarship, and the Humanities: The Implications of Electronic Information: Summary of Proceedings*, New York, 1993, 14–16. The full-text version of Lougee's paper has been electronically published by the Coalition for Networked Information on its Internet/World Wide Web site (http://www.cni.org/docs/tsh/www/Lougee.html) and in paper by *Leonardo* XXVII, 1994, 143–54.

22. Getty Art History Information Program, *Research Agenda for Networked Cultural Heritage*, Santa Monica, Calif. 1996; and see http://www.gii.getty.edu/agenda/home.html.

23. For instance, the United Kingdom's Museum Documentation Association also plans to survey terminology standards; see *MDA Information*, II, no. 2, 1996, 11.

Richard Kurin }

The New Study and Curation of Culture

In a world increasingly permeated with the mass cultures of Western capitalism, the drive toward homogenization seems relentless. If we cannot yet see a future with the planet being overrun by a single dominant global culture, we can nonetheless easily imagine it. Consider a rather insidious but telling example, a McDonald's television commercial broadcast during the Olympics. The commercial featured a teenage gymnast from Korea, first walking the streets of Seoul, I presume, looking for her favorite place to eat. She found it—a McDonald's. The scene shifts. She is now in Atlanta as part of the Korean national team, competing in Olympic gymnastics. She is somewhat homesick, but then relieved when she finds that she can get a hometown meal in Atlanta—from McDonald's. McDonald's seeks to have its food become everyone's hometown, standard fare.

At the same time, the world has never seen a more creative time; new and recast peoples and cultures are being formed on the basis of any one of a number of characteristics and interests, not over generations but within years. Indeed, consider McDonald's again: it recently opened stores in India that serve neither beef nor pork but rather mutton burgers, in order to make the product appealing to Hindu and Muslim consumers.

The social boundaries between populations have never been so porous. Cultural identity, once seemingly simple to determine, is now exceedingly complex. Without exception, human beings around the world find themselves caught in the tension of simultaneously moving closer together culturally and further apart. And if the world is caught between McWorld and Jihad,' scholars, curators, presenters, and brokers of culture are at its crossroads.

Grappling with and figuring out one's identity—personal, communal, racial, ethnic, occupational, national, regional—and how to represent it have become a major issue of the times. Scholarly disciplines, museums, and cultural institutions need to stand somewhere. Their publications, exhibitions,

programs, and products offer a unique forum for the practice of cultural civics. They provide an important vehicle for cultural dialogue, democracy, and self-help, engaged in by those who stand both to gain and to lose by the way they are represented. Unfortunately, cultural scholars and curators are being outgunned and eclipsed by politicians, journalists, filmmakers, television producers, theme park operators, public relations firms, tour operators, corporate marketeers, novelists, and Webmeisters. Even community groups, native peoples' organizations, and grassroots activists are out in front of scholars and curators in terms of representing their cultures and brokering those representations with larger publics—witness, for example, the profusion of Web sites for such groups. Cultural scholars and curators have something important to contribute—the research-based understandings of culture that they generate and the prestige value of the institutions in which those understandings may be delivered. But until now, their contribution has been relatively minor, their engagement limited. A new map, on which the political and economic importance of culture is recognized, is emerging and with it a greater need for refocused, rejuvenated attention to cultural scholarship and curation.

CULTURE AS POLITICAL: CULTURE AND THE STATE

Culture, understood as the values, worldviews, and identities that people construct for themselves, plays a major role in world events. Culture affects the coherence and viability of nations. This is not the "culture" of high society, the elite arts, or the commercial media. Rather it is the culture of ordinary people as expressed in daily life, on special occasions, and in trying times. Culture has emerged as a topic of public concern and political action.

Nations have been the dominant form of political organization over the past two centuries. Despite a common etymological root with the terms "native" and "nature," "nations" are not natural—they are historically forged and articulated, albeit often in mythic, naturalistic terms. By the nineteenth century, European nationhood was defined in terms of a physically distinct race of people, natively born of a particular land and speaking a language suited to them. This definition also led to invented traditions of peoplehood—of the folk—like forms of national costumes. Songs, ballads, and folktales were invested with stronger meaning as they came to stand both metaphorically and metonymically for the nation of the whole. And national destinies—generally the formation or expansion of the state—were sensed and articulated, often in reaction to the modernism of the Industrial Revolution.

Elsewhere, ideas of national culture developed from other sources and stimuli. In colonial India, Indonesia, Kenya, and Mexico, for example, an

emergent or newly uncovered national culture expressed its identity against the state. Culture was used by nationalists to fight against colonial powers.

In the former Soviet bloc, there was a disjuncture between the culture of the state (bureaucratic state communism) and forms of state-created national culture like folklore. People nowadays rebel against this invented folklore, seeing in it the symbolic projection of state control over the expressive life of its people.

Currently, there are growing attempts to redefine national culture in religious terms. Hindu fundamentalists in India, Muslim fundamentalists from North Africa and across southern Asia, Jewish fundamentalists in Israel, and Christian fundamentalists in the United States are all pursuing new forms of statehood in a supposedly traditional response to states that have become too secular. These are not people, energies, or events of the past, however, but thoroughly contemporary movements threatening to undercut the authority of the state and reconstitute it in different terms.

THE CULTURE OF DIVERSITY

Most Third World countries, emerging from colonial rule after World War II, had to contend quite centrally with the possibility of a culturally diverse state—that is, a nation consisting of a population speaking a variety of different languages, possessing a number of different religions, and coming from many ethnic and tribal backgrounds. India, Indonesia, Brazil, Kenya, and others defined the issue as "unity in diversity," "in one many," and other, similar ways. The maintenance of a central government, with an attendant core civic culture, has been a challenge in these fissiparous societies. As in the past, ethnic, religious, occupational, tribal, linguistic, and regional differences continue to rend the social fabric.

The industrialized European countries also had to knit their internal diversity into national form. Italy had to bring together various regional cultures; Germany assimilated populations of different religions; Great Britain unified nations with different languages, histories, and traditions. But because of traditions of governance and levels of literacy and education, these countries were thought to be more immune to centrifugal pressures.

The problem with this view is that some of the societies that supposedly successfully negotiated this transition have experienced a reemergence of state-threatening cultural identities. Many nations seem to be under cultural siege of a sort, threatened by the diversity of their people that results from persisting native populations, immigration, and internal divisions. A Native American nation and a Quebeçois nation may yet break off from Canada; Germany struggles with its immigrant Turkish populations and the very definition of what it is to be German—is it as national citizen or as ethnic native? Japan tries to come to grips with the way it deals with cultural mi-

norities in its own and other societies. In the former Soviet Union, the cultural wars are literally shooting wars, over land, language, and religion. And the United States, Australia, Great Britain, France, Spain, and others struggle with the issue of where the cultural center is to be found and in what it should consist. More and more, the "advanced" democracies themselves ask the question, How is a culturally diverse state possible?

CULTURAL POLICY

The question is not so much one of demographics—every nation will always have a populace with differing cultural characteristics—as one of policy. Is one way of dealing with cultural diversity to have a policy of eliminating it, as Skip Gates notes? For some, cultural diversity could be reduced through acculturation to a mainstream way of life. For others, elimination of cultural diversity involves a more coercive strategy of exclusion, cleansing, and oppression. Or should policies encourage diversity because it can be a source of strength?

National authorities exert influence over the cultural practices of people. States can and often do set up ministries and agencies to institutionalize culture. They may succeed in implementing their will to a greater or lesser extent, depending upon their power and resources. States can encourage the continuity of oral traditions and behavioral norms or their formal, literary, legalistic transformations. States can try to wipe out practices they regard as primitive and vulgar. States can promote majority culture or the culture of a minority.

State policy toward culture may even be officially neutral, but that is exceedingly difficult to effect in actuality. Use of official language, forms of adornment, even forms of entertainment offered at state functions encourage certain kinds of cultural expression and discourage others. Policy can also determine who has rights and privileges, based upon cultural criteria and the interest of the state.

The state often determines what is taught in the schools and who and what are to be respected. It decides who is eligible to be taught whose history. And state policy can include and exclude people from that history, defining some people as culture heroes, consigning others to oblivion. State policy may even decide what is defined as knowledge and what isn't. The state can encourage certain occupations with cultural roots and discourage others.

Should the state promote high culture, popular culture, commercial culture, or folk culture? Should it abstain from using culture as a tool for either national unity or the expression of personal freedom? Should the state foster a singular cultural identity among its populace or promote diversity? Should the state invest its own resources in culture, and if so, to what end, or should the state encourage participation in forms of global culture?

SUBNATIONAL CULTURAL REPRESENTATION

Though states are powerful, so too are the cultural communities that form parts of their polities. Members of these communities actively pursue strategies of forwarding their culture agendas. They use political techniques that are quite conventional—running for elected office, lobbying power holders, going on strike, writing letters to the editor. But native advocacy groups like the Shuar federation in Ecuador are also setting up their own museums and cultural centers. Others are writing their own textbooks, producing them with desktop-publishing technology, and photocopying their own histories. In South Africa, townships use community radio. In New York, the gay community uses public access cable television. The low cost and wide dissemination of modern electronic technology—tape recorders, video cameras, computers, fax machines, and modems connecting personal computers to the Internet and the World Wide Web—have broadened the ability of even the most isolated and traditional communities as well as idiosyncratic microcultures to represent themselves to global audiences. Hundreds of documentary films are being made with low-cost Handycams. Thousands of recording companies have been spawned by dual-cassette boom boxes. And even new cybermuseums are being created. Home pages for individuals, communities, institutions, and even nations have within a year or two become a widespread electronic means of cultural self-representation, of people brokering themselves.

GLOBALISM

Still, with all the internal difficulties, partitions, separations, and questioning based on or making use of cultural differences, there are new and growing unities. Global institutions, such as the United Nations, have moved in an unprecedented way to define a new global consensus. Global agreements and standards for ethical and legal conduct, human rights, and environmental policy have been forged and applied. A more united Europe has emerged, partially subsuming sovereignty and national identity for shared economic interest. New free trade zones in North America and other parts of the world are based not on identities of ethnic groups, language, religion, or kinship but on participation in regional and global markets.

Not all global unities and alliances are supranational. Many, as Arjun Appadurai notes, are transnational and involve nongovernmental organizations.[2] Voluntary organizations, advocacy groups, self-help networks, and others have joined the multinational corporation in working beyond, around, and through national boundaries to accomplish their objectives. They rely on neither governments nor a central, hierarchical form of organization. So

alliances of Native American schools communicate with each other and pursue educational goals over the Internet without going through the Bureau of Indian Affairs in Washington. Various chapters of Greenpeace achieve their goals without sanction of the United Nations. And a host of right-wing, leftist, and radical organizations move people, goods, and ideas across the globe without national approval or direction.

Indeed, there is, as seminal sociologist Émile Durkheim predicted a century ago, a division of labor and interest that has produced its own new communities across the globe. These new forms of global culture are tied to the industrial and postindustrial world and made possible by telecommunication technologies. They are themselves diverse. There is not a single global culture or "new world order." Rather, there are various global—i.e., nonlocalized and transnational—cultures, with their own languages, codes, and worldviews.

Forms of global political and economic culture are neither so universal nor so entrenched as to preclude real or perceived threats. Some, supranational forms, are fairly widespread—international law and conventions with regard to moral conduct and human rights. Others are quite narrowly defined and make little claim to universality.

Though the cold war is over, the world, particularly the former Soviet bloc, continues to ponder the alternatives of capitalism and communism. In many parts of the world, neither of these alternatives has proved viable, and in questioning both their political and their economic dimensions, new alternatives have emerged. Often characterized as nativistic, though not necessarily homegrown, some of these options suggest their own universalism, their own globalism, which contrasts with the dominant supranational one. Thus, in the United States, and in parts of Europe, some analysts see in Islam an alternative and a threat to the new world order. Domestically in the United States, some Christian fundamentalist groups are regarded in the same way and, indeed, explicitly challenge the very notion of such an order.

How much multiculturalism can the new globalism stand? How are supranational globalisms, such as declarations of human rights, to be weighed against the values of multiple cultures that may not see humanity in the same light? How much of the global definition of women's potentialities, as delineated by the 1995 Fourth United Nations Conference on Women, in Beijing, is culturally appropriate to the varied societies around the planet? What do we do with alternative cultural standards that do not accept a global institution's framework? And what do we do with those who use instrumentally acceptable means to forward unacceptable goals? Do we face conceptual paralysis, as did the U.S. government in light of the electoral victory of religious fundamentalists in Algeria who sought through the democratic process to institute a nondemocratic Islamic state?

We don't know the answers to these questions, nor, more fundamentally,

do we have the research base to begin to figure out how to answer them. But debates over cultural policy issues, the relationship of culture to the state, and the desirability and processes of multiculturalism and globalism have emerged from current events and in public consciousness around the world.

CULTURE AS ECONOMICS: TOURISM

Cultural representation is not only of political importance. It has a strong economic dimension as well. Culture is increasingly commodified, packaged, and marketed for use in a rapidly expanding culture industry. The ways in which cultural production is exploited will be a key economic issue in the early twenty-first century. A huge amount of money is spent on producing and controlling the symbols, images, values, ideas, and beliefs of the world's people. Cultural production consists of everything from advertising about what you should eat and wear to cultural tourism, entertainment, much of the education industry, and the movement of information in books and over radio, television, and computer networks. At issue is who does the representing to whom, who makes money from it, and at what cost.

The largest single cultural enterprise in the United States is the Disney Corporation. Millions of Americans learn about world cultures at Disneyland and Walt Disney World. One does not need a highly developed theory of authenticity to recognize these as entertaining but misleading representations of culture. There is nothing wrong with entertainment, and indeed fantasies can have a wonderful effect of stimulating the imagination. It is only when fantasy and theatrics are confounded with history and ethnography that there is a problem. It was with only a slight sense of irony that former minister of culture Jack Lang, interviewed about Euro-Disney, said, "They claim to present our folklore and culture, but they have taken it and returned it to us in unrecognizable form. . . . Look, not even the french fries are French."[3]

Yet we continue to see a profusion and proliferation of commercial firms exploiting culture in the form of the cultural theme park. The Japanese, having procured a Disney park, are now building their own, the clean and convenient Dutch town park. Hawai'i has long hosted a Polynesia Cultural Center, run by Mormon missionaries and featuring somewhat stereotypic depictions of exotic Pacific Island life. Indonesia's Taman Mini, with its formulaic representation of each and every province, and China's new cultural theme park are also examples of the genre. Even in a free and democratic South Africa, we see the growth of tribal shows and villages that freeze the "ethnographic present" in the more comforting 1890s or so, ignoring the living culture of townships, political resistance, modern life, various "mixed" immigrant groups, and even Afrikaaners.

Interestingly, such efforts use a notion of authenticity, sometimes taking great pains to re-create particular architectural or environmental features.

Less thought appears to be given to the people who animate such theme parks. The biographies and enactments of those who perform in them may be only loosely connected to the social life and history of the communities being represented. Contemporary people may end up "playing" their ancestors, employees may be hired to act out someone else's ethnicity, people may be scripted to perform as someone they are not.

Nevertheless, the worlds of scholarship and commerce, education and entertainment, previously separated, are becoming increasingly conjoined. "Infomercial" is a new word in our vocabulary. Commercial representers of culture have been able to invest huge sums of money and apply new forms of technology that engage tourists. These techniques—multimedia stations, holographic images, robots, hands-on activities, telecommunications—are being adapted by museums and other educational institutions. Controversy also moves between these worlds. At the same time that conventional educational genres—textbooks, exhibitions—are challenged for the ways in which they depict history and people, so too are entertainment conglomerates being forced to take responsibility for the ways in which they depict peoples and cultures in their films, television shows, and even theme parks—witness the controversy over Disney's attempt to build a history-themed park called Disney's America, adjacent to the historic Civil War battlefields of Manassas, Virginia, for example.

Still, tourism, entertainment, and commercial displays will grow. How to assure that they do some good—that their representations do justice to those represented? How to assure that the benefits of tourism are not just exported or placed in heavy capital outlay for luxury high-rise hotels but actually reach the people? How to assure that such activities do not destroy local environments and settings for community culture? Consciousness and strategies have been increasing in regard to forms of ecotourism and cultural tourism. And despite what scholars, as purists, might like, local folks need money. Increased attention on how to achieve and balance three broadly desirable goals—cultural conservation, economic development, and environmental preservation—will be the concern.

INDIGENOUS PRODUCTS

Another growing arena of cultural economics is the exploitation of cultural property the world over. Paul Simon has benefited by mining the music of South Africans, Brazilians, and Cajuns. Many cultural producers use performances from around the world for their extravaganzas. Pharmaceutical companies are now working with shamans and healers to develop new drugs and treatments that one day may cure cancer or AIDS or lead to new, moneymaking biotechnology. Many of us make a living from and get tenure by writing about and displaying the wisdom and knowledge of "our" people.

The issues of how cultural property—intangible and tangible, individual and community, owned and used—is going to be handled will be with us for some time. Questions and tensions over the commercial and ethical use of cultural creations are going to continue to emerge as the industrial and post-industrial economy appropriates traditional knowledge, wisdom, and art. More and more, the cultural knowledge, wisdom, and products of tribal groups, folk communities, and other civilizations are going to be repackaged, made and marketed for profit, and distributed far beyond their traditional audiences. Some of this may even occur under the control of the very communities that produce that culture, if the technology, knowledge, and networks are available.

Such developments will occur increasingly as corporations find that the factory model of "one size fits all" tastes doesn't quite work. The market is just too big, too diverse, and too segmented to work that way for long. Consumer product companies look for niche markets—albeit large ones—and for products that will sell. In the United States of today, that old standby—ketchup—is being outsold by salsa; there is a need for Hindi film rentals in New York, and *halal* grocers and butcheries in Detroit. In their search for new markets, producers have realized they have to be somewhat responsive to local needs. And they may have to compete with local, niche producers.

On one hand, the market has become more homogeneous—penetrated by internationally produced and widely available goods. IBM and Apple computers, JVC CD players, Toyotas, blue jeans, and CNN are available everywhere. Yet, at the same time, many products are increasingly customized for local consumption. Computer companies have developed a variety of script and language packages to serve different, non-English-speaking populations. Coca-Cola started a line of Goombay punch in the Bahamas, only to be followed by Pepsi's Junkanoo punch. What may have previously passed separately as either market research or ethnographic research is likely to become more entwined, as good marketing and needs assessment may also be good ethnography.

Among the subsets of these products are those that represent the culture and often pass as entertainment. The giants of the entertainment and media industry have the ability to produce images and products and send them around the globe to mass audiences, making money as they go. Their budgets dwarf those of local educational systems, museums, and other cultural institutions. How many more people will know, or think they know, about India from the movie *Indiana Jones and the Temple of Doom* than will learn about that country from a scholarly monograph on Indian cultural life? Or how many more people will learn about the Caribbean from going to the Pirates of the Caribbean ride at Walt Disney World than by reading a truthful scholarly book about the Caribbean—or even one about pirates?

There is money to be made by representing culture and using its resources.

As Chuck Kleymeyer illustrates, grassroots development agencies and organizations are becoming increasingly savvy about the economics of cultural tourism, local handicrafts, traditional knowledge, educational and communication programs.[4] Folks are learning that economic power can be used to promulgate and preserve their culture and that their culture may be valuable for fueling their economy.

In order for people to achieve local-level cultural and economic viability, training and experience are helpful. Strategic enhancement of local-level institutions—sometimes families and clans, sometimes church groups, other times community organizations and cooperatives—may be necessary. Analyses and an understanding of previous cases and attempts to buttress local economies in culturally appropriate ways would likely be useful. Unfortunately, in this area, as in the political arena, there is a relative dearth of research and literature on the microeconomics of cultural development. There are few practitioners, little theory, and a poor base of useful research from which people the world over can draw.

CULTURE IN SCHOLARSHIP AND THE MUSEUM: AN ASSESSMENT

What is the state of cultural scholarship in this political and economic context? Is it positioned to provide curators and other practitioners with the knowledge, information, and linkages they need to adequately present culture to the public?

Cultural scholarship faces several problems. One concerns our own standing and that of our subject matter. Everyone knows something about culture, and a lot of people think they are experts—or can't imagine others as experts. It is, in the public consciousness, difficult to separate out folk sociology, folk history, and folk anthropology from their disciplinary counterparts. The same or even worse holds for the use of knowledge about culture in a museum. More than one member of Congress has asked something like, "What do you have to know to nail a painting to a wall, put an object in a vitrine, or put a performance on a stage?"

Understandings from scholarly disciplines have to a great degree failed to penetrate popular ones. The social sciences, the arts, and the humanities are largely marginalized and trivialized in our educational systems. Museums fare no better. While many museums can boast of sizable visitorship, we still have only vague ideas of how much learning really takes place in a museum through exhibitions. Seeing things on the walls or in the cases of a museum or encountering them in performances and other museum programs does not necessarily convey knowledge.

Where are we as academic departments, public institutions, professional societies, and practitioners in the contemporary debates about culture? We

should be at the forefront of national and international debates on fundamental cultural issues. Yet we are not. Our failure is not because we are not consulted by others. It is rather because, with only a few exceptions, we have shunned engagement. In the museum world, we are engaged only inadvertently, or in a reactive mode, when we have to answer the complaints of a constituency.

This general lack of engagement has a long history, expressed in the ideas of a museum as curiosity cabinet, temple, and attic. Since the origin and expansion in the nineteenth century of museums of natural history, art, and history, these institutions have been faced with the challenge of collecting remnants and samples of natural and cultural forms before such items are lost, diffused, or forgotten. As evidence of prehistoric species is dug out of the ground, recoverable bones and fossils find their way to museums. Art museums attempt to gather collections and evidences of artistic careers and visions, lest such be scattered beyond retrieval. Historical museums collect artifacts as symbols of events that are rapidly receding in the public memory.

Museum professionals generally define the challenge of museum work as how to understand and represent the whole by the part. How to represent the epoch of the dinosaurs from bones, the eye of Picasso from several paintings, the Civil War from guns and uniforms. Motivated by this challenge, museums collect and document before the specimens, creations, and memories disappear. The traditional curatorial concern is what can be brought into the museum, not what can be taken out.

As several recent studies and symposiums illustrate, innovative programs arising from many museums, some national, some local, suggest a more active approach to museum work.[5] In such programs, a biologist views her role not as that of a collector of dead specimens but rather as that of curator and conservator of the living rain forest and the ocean planet. An art curator sees his role as one of encouraging and supporting aesthetic innovation among young artists from diverse contemporary communities. A curator of Chinese American social history encourages the children of Chinese immigrants to help document the lives of their parents. In these cases, it is the living whole rather than the dead specimen that holds meaning. Curation is not limited by what is in the museum but is directed toward the living context—natural and/or cultural—from which the object, specimen, painting, or document is generated. Still, however, within the museum world, such efforts are often marginalized and defined as "non-core" or extraneous functions.

Limited engagement is also true in cultural economics. Economically, our efforts are largely marginal—sometimes assisting with local community self-help development through the use of cultural resources. Cultural Survival has a popular program in partnership with Ben and Jerry's Ice Cream to market rain forest crunch bars and specialty ice creams on behalf of the Amazon's Indians. Aid to Artisans, Pueblo to People, the Inter-American Foundation,

and many others have a range of local-level programs that encourage communities to use their cultural resources for economic development. But for the most part, these are on a very small scale compared to the need. And compared to the more extractive mode of the culture industry, such self-development projects are hardly even considered when it comes to talking about aid and investment policies.

This problem is not just one of scale or communication. It is also one of authority—partly, and honestly, a problem of our own making. The human studies disciplines have undercut their own legitimacy and worth. Cultural scholars have—rightly, I believe—displaced an objectivist, scientific ethnography. But good cultural scholarship is methodical, quite empirical, and still requires disciplined learning about the ways and thoughts of people. When my colleagues rejoice in finding that their work tells us more about the author (and his or her society) than about the people studied, we become a bit too narcissistic. This is an originally unintended consequence of a critique that rightly examined the questions of what constituted knowledge of a culture and who had the authority to speak for it. That critique, offered by the symbolic anthropology/cultural analysis movement in the early 1970s to better understand indigenous constructions of reality around the world, and by the "cultural studies" movement in England, which developed to understand contemporary working-class culture and its intersections with popular forms and political power, seemed a healthy corrective to more imperial, ethnocentric, objectivist approaches.[6] But the result has gone astray.

The problem is not only a methodological one. It is also a disciplinary one, driven, I believe, by overspecialization on the one hand and a failure to confront, deal with, and broker the participation of the people studied. In a sense, events and circumstances have overtaken the need and raison d'être of the conventional disciplines. And the disciplines have not responded very well to such shifting relationships of need, power, and geography.

Consider the current, albeit slow, changes in academia today. Geography departments, an outgrowth of an age of shipping, exploration, and colonialism, are being dissolved in U.S. universities. Few universities are establishing new departments of anthropology, sociology, history, political science, folklore, or linguistics. Yet there is a growth in new programs in cognitive studies, women's studies, and cultural studies, among others. The social science disciplines that developed largely as a consequence of the Industrial Revolution, rapid urbanization, nation-building, and colonial administration are being superseded by new ways of organizing and seeking knowledge and its applications.

Academia will be in foment as it adjusts to a new, postdisciplinary era. In some areas, specialization in the traditional disciplines has outpaced application and synthesis, and seemingly incomprehensible abstraction and exami-

nation of minutiae have replaced both the solving of concrete problems and reflection on larger, transdisciplinary issues.

It is not that the need for knowledge or research, or academic activity, has diminished—it is just that it has changed. For example, consider the post-World War II development of area studies. Though interdisciplinary, area studies—Asian studies, African studies, Indian studies, Latin American studies, and so on—arose to increase the available knowledge on world areas of importance to American political, military, and commercial interests in the context of the cold war. While taking a generally civilizational approach, area studies served both scholarly and practical interests well for some three decades.

But new factors arose that now entail the demise of area studies and progress in new directions. Massive movements of populations meant the dislocation of people from their geographic areas. Diasporas, migrations, and the exodus of refugees occasioned by wars, drought, and the 1965 U.S. immigration law meant that one could study Indians in New York, Jamaicans in London, Salvadorans in Los Angeles, Algerians in Paris. New forms of telecommunication and air transport reduced the consequences of geographic proximity on the social life of numerous area-based communities. And the ability of information and people to move rapidly around the globe called for a more trans-areal, transnational perspective than that rendered by the older organization of knowledge.

Encrusted archaeologies of knowledge and their slow change are even more obvious when it comes to museums. For in the museum categories of knowledge are carved into the walls, chiseled in stone, and constructed with brick and mortar. We continue to have natural history museums long after the idea of "natural history" has been superseded by systems of ecological relationships. We have museums of art divorced from culture, technology divorced from history, peoples and regions divided up in ways that seem anachronistic today. Yet in many cases there is not much that can be done about it, and so we must repeatedly defend a table of organization or institutional definition that we know from the outset to be flawed.

In the museum world, the encrusted may include collections themselves, which must be cared for, housed, conserved, and sometimes exhibited. Often our knowledge does not grow through inspection and analysis of collections. In some cases, they are totally irrelevant to the museum disciplines and research engaged in by their curators.

Another challenge to the disciplines comes from the fact that neither universities nor, certainly, museums monopolize intellectual and scientific energy—much of which is coming from outside the academy these days, from the corporate research laboratory, the think tank, the community hall, and the media. For example, the need for new knowledge in the communications technology and computer industries has driven much of the develop-

ment in cognitive studies—bringing together work from linguistics, mathematics, computer science, engineering, and psychology—a congeries of departments rarely united in even the same university division.

But perhaps the most important development in the undermining of traditional social science and cultural disciplines is the growth of intelligentsias and institutions from the nations and societies of the represented. Politicians, leaders, writers, dramatists, media personalities, journalists, and others from these countries and communities do not necessarily trust scholars to represent them any more than Americans do. These intellectuals and cultural presenters have become brokers in their own right, with their own thoughts, voices, and genres of representation. The resentment between exogenous scholars and indigenous thinkers has generally been mutual, though disengaged. The political debate on culture issues will continue—but it will not be bound by the traditional social science and humanities disciplines. This situation is unfortunate, and it might have been avoided had recruitment, training, and opportunity within the scholarly fields been greater earlier on.

Cultural scholars and curators face a fundamental contradiction, one that is all too evident at the meetings of any of their professional associations. We claim a special empathy for, an understanding of, and an ethical relationship with the people we study and represent. Yet, if we are so close to the people and communities struggling with cultural issues, those people should be flocking to us for knowledge, wisdom, and insight. They—the studied, the represented, the brokered—should be coming to our meetings, enrolling their children in our courses, reading our books, and even joining our ranks. In the United States this is not happening. The participation of African Americans, American Indians, Hispanics, and Asian Americans in the cultural studies and curatorial fields is stunningly low. My guess is that this relationship also holds true in other parts of the world—low Aboriginal participation in Australia, low participation of lower castes (the so-called tribals and untouchables) in India, Koreans in Japan, Asians in Russia, newer immigrant groups in Europe, mestizos throughout Latin America, Blacks in Cuba, Pacific Islanders throughout the Pacific Rim.

Even more crippling is that instead of responding to this situation and finding new life and vitality in inclusion, the disciplines and their established scholars seem increasingly intent on defending their own diminishing turf and privilege. There is much disquiet among social scientists and humanists, a sense that the scholarly, disciplinary community is being lost. In some cases, that community is breaking into numerous subdisciplinary specialities. In other cases, it has deconstructed itself in a postmodern critique and seems to have lost its subject matter, its vitality, and its mission.

Tragically, because cultural scholars find themselves less a part of communities of researchers, they find it harder to see such communities in others. Since their own discipline, subject matter, or field has become de-

essentialized, they de-essentialize everyone else's. Fortunately, others have their own intellectual, moral, and social feet to stand upon.

EMERGING PROFESSIONAL GOALS

What are scholars and curators going to need for a world in which increasing weight is put on culture? How do we go about studying and representing culture? What should be the role of museums, cultural institutions, cultural brokers, and scholars with regard to the people represented?

Simply put, museum curators, programmers, and cultural presenters have to rely on a much firmer and sharper focus on *situated* scholarship—that is, research and analysis located in contemporary contexts, presented to the communities, leaders, and polities affected. Gone are the days of singular, monological, acontextual studies of civilizations, countries, communities, villages, and cultures. Studies that fail to situate their subjects in a contemporary world of multiple, if not contending, cultural narratives and ways of communicating them are perilously misleading.

Research work will necessarily cross-cut the disciplines, populations, and genres that have usually bound our work. In this effort, we need the active involvement and engagement of community and lay scholars who can bring to the field new understandings, assumptions, approaches, and connections. We need research on the multicultural state, on comparative cultural politics, on cultural economics, on multicultural lives, on transnational cultural flows, on cultural processes associated with immigration, acculturation, urbanization, and the relationships between culture, environmental preservation, and development. We need much stronger scholarship—not weaker scholarship—if our findings are to stand up under the scrutiny of the audiences who can seriously think about and use our work. This means students and professionals trained in several fields and methodologies. And it also means the sophisticated use of cultural scholarship to train professionals in applied fields—from lawyers who work on intellectual and cultural property rights issues to pharmacologists who will work with rain forest healers and shamans to discover new, illness-curing drugs.

We have to integrate research more thoroughly with education and public service. This means training producers and presenters of cultural performances, events, and programs who have a solid knowledge base for their work. And it means more-worldly scholars who can understand their own work—from lectures to written ethnography—as itself a form of cultural presentation. We have major work to do in developing teaching materials and upgrading teacher training to reflect the complexity of culture. We have to use fully the range of new media and forms of communication to transmit our ideas so that the young and broader publics may entertain them.

In the museums there is much to do. Given the massive destruction of tra-

ditional cultures in the twentieth century, transformations of cultures, and the creation of myriad new forms, museums are all the more important. Their lesser goal will still involve the effort to collect the artifacts and document the lifeways of those cultures before they disappear.

But the greater goal for museums is to serve as gathering places and focal points for seriously examining the knowledge, accomplishment, and creativity, as well as the failings, of these cultural forms. The Smithsonian Institution, for example, played such a parallel role at the time of its founding 150 years ago, not so much in collecting or researching but in establishing the idea that knowledge was a good, nationally important pursuit for the citizenry of a democratic country. More so now than when the Smithsonian was founded, communicating cultural subjects to broad publics is big, and serious, business. Museums—through public exhibitions, programs, performances, lectures, and products—offer a special experiential platform that can be used to represent cultures to broad audiences. Museums are empowered with a still potent discourse of scholarship, science, and legitimation. They offer an ideal crossroads for bringing together "us" and "them," the tellers of tales and the listeners, the scholar and the student, the spokesperson and the citizen, the expert and the tourist, the makers of history and its curators. They are in an ideal position to broker culture among a variety of constituents.

There is a great deal of consensus in the museum world for a new form of cultural curation. At a recent conference, "Museums in the New Millennium," held at the Smithsonian in September 1996, directors and curators of art, history, and science museums from around the United States and some twenty other nations discussed the status and future of museums. Though there are certainly differences in mission, resources, and circumstances, a paradigmatic shift in the nature of the museum when compared to the past century or even the past decade was evident. I summarized this shift in a presentation at the end of the conference, with the following table:

What's In, What's Out—What's Hot, What's Not

Museum Feature	Out	In
Collection value	Just stuff	Value-added stuff
Curators as	Collectors	Stewards
Museum experience	Awful	Awe-inspiring
	Worn out	Attractive
	Exhibits only	Whole packages
	Low tech	High tech as vehicle
Audience orientation	Our needs	User needs
	Elitist	Communitarian
	Exclusivity	Connectivity
	Divorced from the community	Engaged with the community

What's In, What's Out—What's Hot, What's Not (*continued*)

Museum Feature	Out	In
Curatorial style	Authoritative	Helpful
	Demeaning	Meaning making
	Conformational	Informational
	Monologue	Multilogue
	Giving to	Sharing with
Institutional attitude	Rigid	Flexible
	Opaque	Transparent
	Reflect understandings	Generate understandings
	Outreach	Inreach
Institutional product	Hype	Trust
	Authenticity	Authenticity
	Material reality	Virtual reality
Institutional concept	The museum	Museums
	Museum as end	Museum as means
	Attic	Forum
Staff orientation	Curator director	General manager
	Thing skills	People skills
	Finite knowledge	New knowledge
	Market averse	Market aware
Survival strategy	Mission	Promise
	Government money	Earning money
	Philanthropy	Promotion/advancement
	Stand-alone	Partnerships
	We/they	We all
	(If it's broke, then)	(If it's not broke, then)
	Fix it	Break the mold

Curation for the museum of the new millennium is processual, not static. It relies on the idea of partnership and trust between community and institution, a proactive effort to serve the public, increase understandability, and use the museum as a vehicle of inter- and intracultural communication. Helpful, skilled, and connected, the museum is enmeshed in the social and economic life of the people around it.

The new cultural curation will require a very modest public investment in the research, documentation, and presentation of human cultural knowledge, expression, and resources. Yet such seems necessary for the development of a knowledge-based, humanitarian, democratically oriented society. Conveying rich and accurate understandings of culture through public presentations, through the educational system, and by other means is vital for developing a healthy sense of self, community, nationhood, and humanity, and it strongly contributes to the maintenance of civil society. And the conservation, encour-

agement, and even enhancement of local cultural resources can be beneficial
to the economy and well-being of people the world over.

We have to expand the ability of people—regular people, common people,
people at the grassroots—to create, debate, and manipulate their culture, and
to share it with others. When culture is not created, it dies. When people can-
not share, they fight. And where the cultural dialogue stops, it is replaced with
violence, death, and destruction.

Cultural programs can address public knowledge, discourse, and debate
with considerable care, expertise, and ethical responsibility. But the scholars
and curators who labor in public cultural institutions have good cause to
worry that their efforts will be eclipsed by those with greater access to larger
audiences.

Cultural institutions can no longer be the preserve of the elite or the refuge
of the scholar or curator. In a public institution like the Smithsonian, analysis
needs to be coupled with action. As Tony Seeger, one of my colleagues, puts it:
"Knowledge of any kind should be used in the real world—where theory is
tested in the crucible of action, and where one's own actions can themselves
become the object of theoretical reflection."[7]

Scholars who labor in the public interest should be attuned to the form of
power increasingly shaping the twenty-first century's social order—the abil-
ity to produce (and control) meaning and disseminate it (some would say in-
flict it) upon others. The means of producing meaning, particularly about
things cultural, are widely distributed. Yet at a time when commodified cul-
ture is emerging as the world's foremost economic industry and issues of cul-
tural identity have become part of big-time politics, scholars have both an
opportunity and a responsibility to participate in the public understanding of
culture. We must continue to study and interpret, understand and model re-
spect for cultures; we need to bring people together so that cultures can be
presented and translated; and we can help people as they seek to negotiate and
transform their cultural reality.

NOTES

1. Ben Barber, *Jihad vs. McWorld* (New York: Ballantine Books, 1995).
2. Arjun Appadurai, "Global Ethnoscapes: Notes and Queries for a Transnational
 Anthropology," in *Recapturing Anthropology* (Santa Fe: School of American Research
 Press, 1991), pp. 191–210.
3. "Disneyland Opens in France with Mixed Views," report on National Public Radio,
 April 15, 1992, paraphrase.
4. Charles D. Kleymeyer, *Cultural Expression and Grassroots Development: Cases from
 Latin America and the Caribbean* (Boulder: Lynne Rienner Publishers, 1994).
5. Ivan Karp, Christine Kraemer, and Steven Lavine, eds., *Museums and Their
 Communities* (Washington, D.C.: Smithsonian Institution Press, 1993).
6. George E. Marcus and Michael Fischer, *Anthropology and Cultural Critique: An*

Experimental Moment in the Human Sciences (Chicago: University of Chicago Press, 1986); Richard Handler, ed., *Schneider on Schneider: The Conversion of the Jews and Other Anthropological Stories* (Durham: Duke University Press, 1995); Simon During, ed., *The Cultural Studies Reader* (London and New York: Routledge, 1993); Raymond Williams, "Advertising: The Magic System," in ibid., pp. 320–337.

7. Anthony Seeger, "Academic and Public Sector Ethnomusicology: A False Dichotomy?" *Society for Ethnomusicology, Middle Atlantic Chapter Newsletter* 14, no. 3 (1995): 1.

For Further Reading

An anthology can only offer a taste of the rich literature on each of the issues discussed in this volume. In addition to the works listed below, readers can find an extensive bibliography, as well as links to many organizations involved in culture and policy, at the Center for Arts and Culture's World Wide Web site [http://www.culturalpolicy.org].

THE SPHERE OF CULTURE

Brooks, Arthur C. *Arts, Markets, and Government: A Study in Cultural Policy Analysis*. Santa Monica, CA: RAND, 1997.

Chaney, David. *The Cultural Turn*. New York: Routledge, 1994.

Cowen, Tyler. *In Praise of Commercial Culture*. Cambridge, MA: Harvard University Press, 1998.

Crane, Diana. *The Production of Culture*. Newbury Park, CA: Sage Publications, 1992.

DiMaggio, Paul. "Nonprofit Organizations in the Production and Distribution of Culture." In *The Nonprofit Sector* Edited by Walter W. Powell. New Haven: Yale University Press, 1987.

Featherstone, Mike. "Cultural Production, Consumption, and the Development of the Cultural Sphere." In *Theory of Culture*. Edited by Richard Münch and Neil J. Smelser. Berkeley: University of California Press, 1992.

Frow, John. *Cultural Studies & Cultural Value*. New York: Oxford University Press, 1995.

Hansmann, Henry and Santilli, Marina. "Authors' and Artists' Moral Rights: A Comparative and Legal and Economic Analysis." *Journal of Legal Studies* 26 (January 1997): 95–143.

Heilbrun, James and Gray, Charles M. *The Economics of Art and Culture: An American Perspective*. New York: Cambridge University Press, 1993.

Jeffri, Joan with Greenblatt, Robert. *Information on Artists 2: A Study of Artists' Work-related Human and Social Service Needs in Four U.S. Locations*. New York: Research Center for Arts and Culture, Columbia University, 1998.

McGuigan, Jim. *Culture and the Public Sphere*. New York: Routledge, 1996.

Throsby, David. "The Production of Consumption of the Arts: A View of Cultural Economics." *Journal of Economic Literature* 32 (March 1994): 1–29.

Toffler, Alvin. "The Art of Measuring the Arts." *Annals of the American Academy of Political and Social Science* 373 (September 1967): 141–55.

PERSPECTIVES ON CULTURAL POLICY

Adams, Don and Goldbard, Arlene. "Animation: What's in a Name?" In *Crossroads: Reflections on the Politics of Culture.* Talmage, CA: DNA Press, 1990.

Bennett, Tony. "Putting Policy into Cultural Studies." In *Cultural Studies,* edited by Lawrence Grossberg et al. New York: Routledge, 1992.

Cargo, Russell A. "Cultural Policy in the Era of Shrinking Government." *Policy Studies Review* 14 (Spring/Summer 1995): 215–24.

Craik, Jennifer. "Mapping the Links Between Cultural Studies and Cultural Policy." *Southern Review* 28 (July 1995): 190–207.

Jensen, Richard. "The Culture Wars, 1965–1995: A Historian's Map." *Journal of Social History* 29 (1995 Supplement): 17–37.

Lipman, Samuel. "The State of National Culture Policy." In *Culture and Democracy,* edited by Andrew Buchwalter. Westview Press, 1992.

McQuail, Denis. "Policy Help Wanted: Willing and Able Media Culturalists Please Apply." In *Cultural Studies in Question,* edited by Marjorie Ferguson and Peter Golding. London: Sage Publications, 1997.

Miller, Toby. "Culture with Power: The Present Moment in Cultural Policy Studies." *Southeast Asian Journal of Social Science* 22 (1994): 264–82.

O'Regan, Tom. "(Mis)taking Policy: Notes on the Cultural Policy Debate." *Cultural Studies* 6 (October 1992): 409–23.

Pankratz, David B. *Multiculturalism and Public Arts Policy.* Westport, CT: Bergin & Garvey, 1993.

Pankratz, David B. and Morris, Valerie B., eds. *The Future of the Arts: Public Policy and Arts Research.* New York: Praeger, 1990.

Peacock, Alan and Rizzo, Ilde, eds. *Cultural Economics and Cultural Policies.* Kluwer Academic Publishers, 1994.

Schuster, J. Mark. "Questions to Ask of a Cultural Policy: Who Should Pay? Who Should Decide?" *Culture and Policy* 7 (#1 1996).

FRAMES FOR SUPPORT

Arian, Edward. *The Unfulfilled Promise: Public Subsidy of the Arts in America.* Philadelphia: Temple University Press, 1989.

Balfe, Judith Huggins, ed. *Paying the Piper: Causes and Consequences of Art Patronage.* Urbana: University of Illinois Press, 1993.

Benedict, Stephen, ed. *Public Money and the Muse.* The American Assembly. New York: W.W. Norton & Company, 1991.

Cleveland, William. "Bridges, Translations and Change: The Arts as Infrastructure in 21st Century America." *High Performance* no. 58/59 (Summer/Fall 1992).

Cummings, Milton C., Jr. and Schuster, J. Mark Davidson. *Who's to Pay for the Arts? The International Search for Models of Arts Support.* New York: ACA Books, 1989.

Cummings, Milton C. Jr. and Katz, Richard S. *The Patron State.* New York: Oxford University Press, 1987.

Epstein, Joseph. "W.C. Fields Was Wrong: Why, Despite Everything, Republicans Should Not Abandon the Arts." *The Weekly Standard* June 3, 1996.

Fullerton, Don. "On Justifications for Public Support of the Arts." *Journal of Cultural Economics* 15 (December 1991): 67–82.

Hofferbert, Richard I. and Urice, John K. "Small-Scale Policy: The Federal Stimulus Versus Competing Explanations for State Funding of the Arts." *American Journal of Political Science* 29 (1985, #2): 308–29.

Joyce, Michael S. "Government Funding of Culture: What Price the Arts?" *Annals of the American Academy of Political and Social Science* 471 (1984): 27–33.

McCarthy, Kathleen. "Twentieth-Century Cultural Patronage." In *Alternative Futures: Challenging Designs for Arts Philanthropy*. Grantmakers in the Arts, 1994.

Mulcahy, Kevin V. and Wyszomirski, Margaret Jane, eds. *America's Commitment to Culture*. Boulder, CO: Westview Press, 1995.

Mulcahy, Kevin V. and Swaim, C. Richard. *Public Policy and the Arts*. Boulder, CO: Westview Press, 1982.

Useem, Michael and Kutner, Stephen I., "Corporate Contributions to Culture and the Arts: the Organization of Giving and the Influence of the Chief Executive Officer and of Other Firms on Company Contributions in Massachusetts." In *Nonprofit Enterprise in the Arts*. New York: Oxford University Press, 1986.

Van Camp, Julie. "Freedom of Expression at the National Endowment for the Arts: An Opportunity for Interdisciplinary Education." *Journal of Aesthetic Education* 30 (Fall 1996): 43–65.

Wyszomirski, Margaret Jane. "Federal Cultural Support: Toward a New Paradigm?" *Journal of Arts Management, Law, and Society* 25 (Spring 1995): 69–83.

Wyszomirski, Margaret Jane and Pat Clubb, eds. *The Cost of Culture: Patterns and Prospects of Private Arts Patronage*. New York: ACA Books, 1989.

Ziegler, Joseph Wesley. *Arts in Crisis: The National Endowment for the Arts Versus America*. Chicago: A Cappella Books, 1994.

INSTITUTIONS UNDER PRESSURE

Blau, Judith R. *The Shape of Culture*. New York: Cambridge University Press, 1989.

DiMaggio, Paul and Ostrower, Francie. *Race, ethnicity, and participation in the arts: patterns of participation by Hispanics, Whites, African-Americans in selected activities from the 1982 and 1985 surveys of public participation in the arts*. Washington, D.C.: Seven Locks Press, 1992.

Filicko, Therese. "In What Spirit Do Americans Cultivate the Arts?: A Review of Survey Questions on the Arts." *The Journal of Arts Management, Law and Society* 26 (Fall 1997): 221–46.

Gray, Charles M. *Turning on and Turning in: Public Participation in the Arts Via Media in the United States*. Carson, CA: Seven Locks Press, 1995.

Harris, Neil. "A Historical Perspective on Museum Advocacy." In *Cultural Excursions*. Chicago: University of Chicago Press, 1990.

Heartney, Eleanor. *Critical Condition: American Culture at the Crossroads*. New York: Cambridge University Press, 1997.

Jacob, Mary Jane with Brenson, Michael. *Conversations at the Castle: Changing Audiences and Contemporary Art*. Cambridge, MA: MIT Press, 1998.

Kenicott, Philip, "Members Only." *Chamber Music* 11 (Summer 1994).

National Endowment For The Arts. *1997 Survey of Public Participation in the Arts*. Research Division Report Number 39. Washington, D.C.: National Endowment for the Arts, 1998.

Peterson, Richard A., et al. *Age and Arts Participation with a Focus on the Baby Boom Cohort*. Santa Ana, CA: Seven Locks Press, 1996.

Scheff, Joanne and Kotler, Philip. "Crisis in the Arts: The Marketing Response." *California Management Review* 39 (Fall 1996): 28–52.

Wallace, Mike. *Mickey Mouse History and other Essays on American Memory*. Philadelphia: Temple University Press, 1996.

Zolberg, Vera L. "'An Elite Experience for Everyone':Art Museums, the Public, and Cultural Literacy," in *Museum Culture* edited by Daniel J. Sherman and Irit Rogoff. Minneapolis: University of Minnesota Press, 1994.

ARTISTS, HUMANISTS AND PUBLIC LIFE

Bender, Thomas. *Intellect and Public Life: Essays on the Social History of Academic Intellectuals in the United States*. Baltimore: Johns Hopkins University Press, 1993.

Blake, Casey. What is it Good For? The Humanities and the Common Life." *culturefront*, Summer 1997.

Burnham, Linda F., and Durland Steven. *Citizen Artist, 20 years Of Art In The Public Arena, An Anthology from High Performance magazine 1978–1998*. Critical Press, 1998.

Callahan, Daniel, "The Humanities and Public Policy." In *Applying the Humanities*. New York: Plenum Press, 1985.

Collins, Naomi. *Culture's New Frontier: Staking a Common Ground*. ACLS Occasional Paper, No. 15. New York: American Council of Learned Societies, 1990.

Commission on Humanities. *The Humanities in American Life* (Berkeley: University of California Press, 1980).

Jacoby, Russell. *The Last Intellectuals: American Culture in the Age of Academe*. New York: Basic Books, 1987.

Krupnick, Mark. "The Critic and His Connections: The Case of Michael Walzer." *American Literary History* 1 (#3, 1989): 689–98.

Pinsker, Sanford. "The Black Intellectuals' Common Fate and Uncommon Problems." *Virginia Quarterly Review* 70 (#2, 1994): 220–38.

Quay, James and Veninga, James. *Making Connections: The Humanities, Culture, and Community*. ACLS Occasional Paper, No. 11. New York: American Council of Learned Societies, 1990.

Rich, B. Ruby. "Dissed and Disconnected: Notes on Present Ills and Future Dreams." In *The Subversive Imagination*. Edited by Carol Becker. New York: Routledge, 1994.

Shannon, Christopher. *Conspicuous Criticism: Tradition, the Individual, and Culture in American Social Thought, from Veblen to Mills*. Baltimore: Johns Hopkins University Press, 1996.

IMPACTS OF CULTURE ON COMMUNITIES

"Beyond Economic Impact." Theme Issue of *Journal of Arts Management, Law and Society* 28 (Fall 1998): 187–239.

Bianchini, Franco and Parkinson, Michael, eds. *Cultural Policy and Urban Regeneration*. New York: Manchester University Press, 1993.

Blake, Casey Nelson. "An Atmosphere of Effrontery: Richard Serra, Titled Arc, and the Crisis of Public Art." In *The Power of Culture*. Edited by Richard Wightman Fox and T.J. Jackson Lears (University of Chicago Press, 1993).

Booth, Kathy. *Culture builds communities: a guide to partnership building and putting culture to work on social issues*. Washington, D.C.: Partners for Livable Communities, 1995.

California Confederation of the Arts. "Strategies for Cultural Enfranchisement: A Cultural Equity Paper." (1994), *http://www.artswire.org/California/ooeq.html*.

Cwi, David and Lyall, Katherine. *Economic Impacts of Arts and Cultural Institutions: A Model for Assessment and a Case Study in Baltimore*. National Endowment for the Arts. Research Division Report #6. Washington, D.C.: 1977.

Darlow, A. "Cultural Policy and Urban Sustainability: Make a Missing Link?" *Planning, Practice & Research* 11 (#3 1996).

Doss, Erika. *Spirit Poles and Flying Pigs: Public Art and Cultural Democracy in American Communities*. Washington, D.C.: Smithsonian Institution Press, 1995.

Dreeszen, Craig. *Community Cultural Planning*. Washington, D.C.: Americans for the Arts, 1998.

Golden, Joseph. *Pollyanna in the brier patch: the community arts movement*. Syracuse, NY: Syracuse University Press, 1987.

Hall, Peter. *Cities of Tomorrow: an intellectual history of urban planning and design in the twentieth century*. (Basil Blackwell, 1988).

Jacob, Mary Jane, ed. *Culture in Action*. Seattle, WA: Bay Press, 1995.

Lilla, Mark. "The Museum in the City." In *Public Policy and the Aesthetic Interest*. Edited by Ralph A. Smith and Ronald Berman. Urbana: University of Illinois Press, 1992.

National Assembly of Local Arts Agencies. *Arts in the Local Economy*. Washington, D.C., 1994.

Netzer, Dick. "The Arts: New York's Best Export Industry." *New York Affairs* 5 (#2 1978): 50–61.

Petersen, Alan. "Community Arts and Cultural Democracy." *Culture and Policy* 3 (#2, 1991).

Savage, James D. "Populism, Decentralization, and Arts Policy in California: The Jerry Brown Years and Afterward." *Administration and Society* 20 (#4, 1989): 446–64.

Shanahan, James L. "The Arts and Urban Development." In *Economic Policy for the Arts*. Edited by William S. Hendon, et al. Cambridge, MA: Abt Books, 1980.

Stevenson, Deborah. "Urban Re-enchantment and the Magic of Cultural Planning." *Culture and Policy* 4 (#2, 1992).

Tryloff, Robin S. "The Role of State Arts Agencies in the Promotion and Development of the Arts on the Plains." *Great Plains Quarterly* 9 (#2, 1989): 119–24.

Wheeland, Craig M. "Empowering the Vision: Citywide Strategic Planning." *National Civic Review* 80 (#4, 1991): 393–405.

Zukin, Sharon. *The cultures of cities*. Cambridge, MA: Blackwell, 1995.

———. *Landscapes of Power: From Detroit to Disney World*. Berkeley: University of California Press, 1991.

NEW POLICY FRONTIERS

Appadurai, Arjun. *Modernity at Large: Cultural Dimensions of Globalization*. Minneapolis: University of Minnesota Press, 1996.

Bennett, Tony and Mercer, Colin. "Improving Research and International Cooperation for Cultural Policy." *UNESCO Intergovernmental Conference on Cultural Policies for Development*. Australian Key Centre for Cultural and Media Policy, 1997.

Braman, Sandra. "The Right to Create: Cultural Policy in the Fourth Stage of the Information Society." *Gazette* 60 (#1, 1998): 77–91.

Chartrand, Harry Hillman. "Intellectual Property Rights in the Postmodern World." *Journal of Arts Management, Law and Society* 25 (Winter 1996): 306–19.

Colista, Celia and Leshner, Glenn. "Traveling Music: Following the Path of Music Through the Global Market." *Critical Studies in Mass Communications* 15 (June 1998): 181–94.

Coombe, Rosemary J. *The Cultural Life of Intellectual Properties*. Durham: Duke University Press, 1998.

"Cultural Development and the Open Economy." Theme Issue of *Canadian Journal of Communication* 19 (#3/4, 1994).

Featherstone, Mike, ed. *Global Culture*. Sage Publications, 1990.

Hutter, Michael and Rizzo, Ilde. *Economic Perspectives on Cultural Heritage*. New York: St. Martin's Press, 1997.

Ingram, Mark. "A Nationalist Turn in French Cultural Policy." *The French Review* 71 (April 1998).

Jusdanis, Gregory. "Culture, Culture Everywhere: The Swell of Globalization Theory." *Diaspora* 5 (#1, 1996).

Mann, Charles C. "Who Will Own Your Next Good Idea?" *The Atlantic Monthly*, September 1998.

Sinclair, John. "Culture and Trade: Some Theoretical and Practical Considerations." In *Mass Media and Free Trade: NAFTA and the Cultural Industries*. Edited by Emile G. McAnany and Kenton T. Wilkinson.

Toulouse, Chris and Luke, Timothy W., eds. *The Politics of Cyberspace*. New York: Routledge, 1998.

Trend, David. *Cultural Democracy*. State University of New York Press, 1997.

UNESCO. *World Culture Report 1998: Culture, Creativity and Markets*. Paris: UNESCO Publishing 1998.

Van Elteren, Mel. "Conceptualizing the Impact of US Popular Culture Globally." *Journal of Popular Culture* 30 (Summer 1996): 47–89.

Venturelli, Shalini. "Cultural Rights and World Trade Agreements in the Information Society." *Gazette* 60 (#1, 1998): 47–76.

Wang, Georgette. "Beyond Media Globalization: A Look at Cultural Integrity and Policy Perspective." *Telmatics and Informatics* 14 (#4 1997).

Working Group on Cross Cultural Issues, International Council of Museums. "Museums and Cultural Diversity" (1997), *http://www.icom.org/diversity.html*

Zemans, Joyce. "'And the Lion Shall Lie Down with the Lamb': U.S.-Canada Cultural Relations in a Free Trade Environment." *American Review of Canadian Studies* 24 (Winter 1994): 509–536.

About the Contributors

Victoria D. Alexander is a professor of sociology at University of Surrey, England.

Alberta Arthurs is an Associate at MEM Associates, New York City.

Carol Becker is the dean of faculty at the School of the Art Institute of Chicago.

William Bennett is co-director of Empower America.

Gigi Bradford (Editor) is executive director of the Center for Arts and Culture in Washington, D.C.

Robert Brustein is the artistic director of the American Repertory Theater, Cambridge, Mass.

Mary Schmidt Campbell is the dean of the Tisch School of the Arts at New York University.

Néstor García Canclini is head of the Program of Studies in Urban Culture at the Autonomous Metropolitan University of Mexico.

William Cleveland is the director of the Center for the Study of Art and Community in Minneapolis, Minnesota.

Paul DiMaggio is a professor of sociology and a co-founder of the Center for Arts and Cultural Policy Studies at Princeton University.

Virginia R. Dominguez is a professor of anthropology, women's studies, and American studies at the University of Iowa.

Michael J. Gary (Editor) is a senior program officer at the Howard Gilman Foundation in New York City.

Michael Kammen is a professor of history at Cornell University.

John Kreidler is the arts and humanities program executive at the San Francisco Foundation.

Richard Kurin is the director of the Smithsonian Institution Center for Folklife Programs and Cultural Studies.

Justin Lewis is a professor in the department of Communications at University of Massachusetts, Amherst.

Ellen McCulloch Lovell is director of the White House Millennium Council and special assistant to the President.

Bruce A. Seaman is a professor in the School of Policy Studies, Georgia State University.

Susan L. Siegfried is a professor in the History of Art, University of Leeds, England.

James Allen Smith, author of *The Idea Brokers: Think Tanks and the Rise of the New Policy Elite* (1991) and other works, is President of the Center for Arts and Culture.

Mark J. Stern and Susan Seifert are Principal Investigator and Project Director, respectively, of the Social Impact of the Arts Project, University of Pennsylvania School of Social Work.

Lesley Valdes is a music critic for the *Philadelphia Inquirer*. Her contribution to this volume was written while she was a fellow at the National Arts Journalism Program of Columbia Journalism School.

Glenn Wallach (Editor) is deputy director of the Center for Arts and Culture.

Raymond Williams (1921–1988) was the author of *Culture and Society, The Long Revolution, Marxism and Literature, Keywords*, and many other works in cultural studies.

Margaret J. Wyszomirski is professor of public policy and art education and director of the Arts Policy and Administration Program at Ohio State University.

LaVergne, TN USA
06 June 2010
185191LV00005B/96/P